"This place is indeed a land where
nature rules…it is no man's land."

—Robert B. Haas

AN AERIAL VISION OF
LATIN AMERICA

Through the Eyes of the Condor

ROBERT B. HAAS

Introduction by Marie Arana

NATIONAL GEOGRAPHIC

WASHINGTON, D.C.

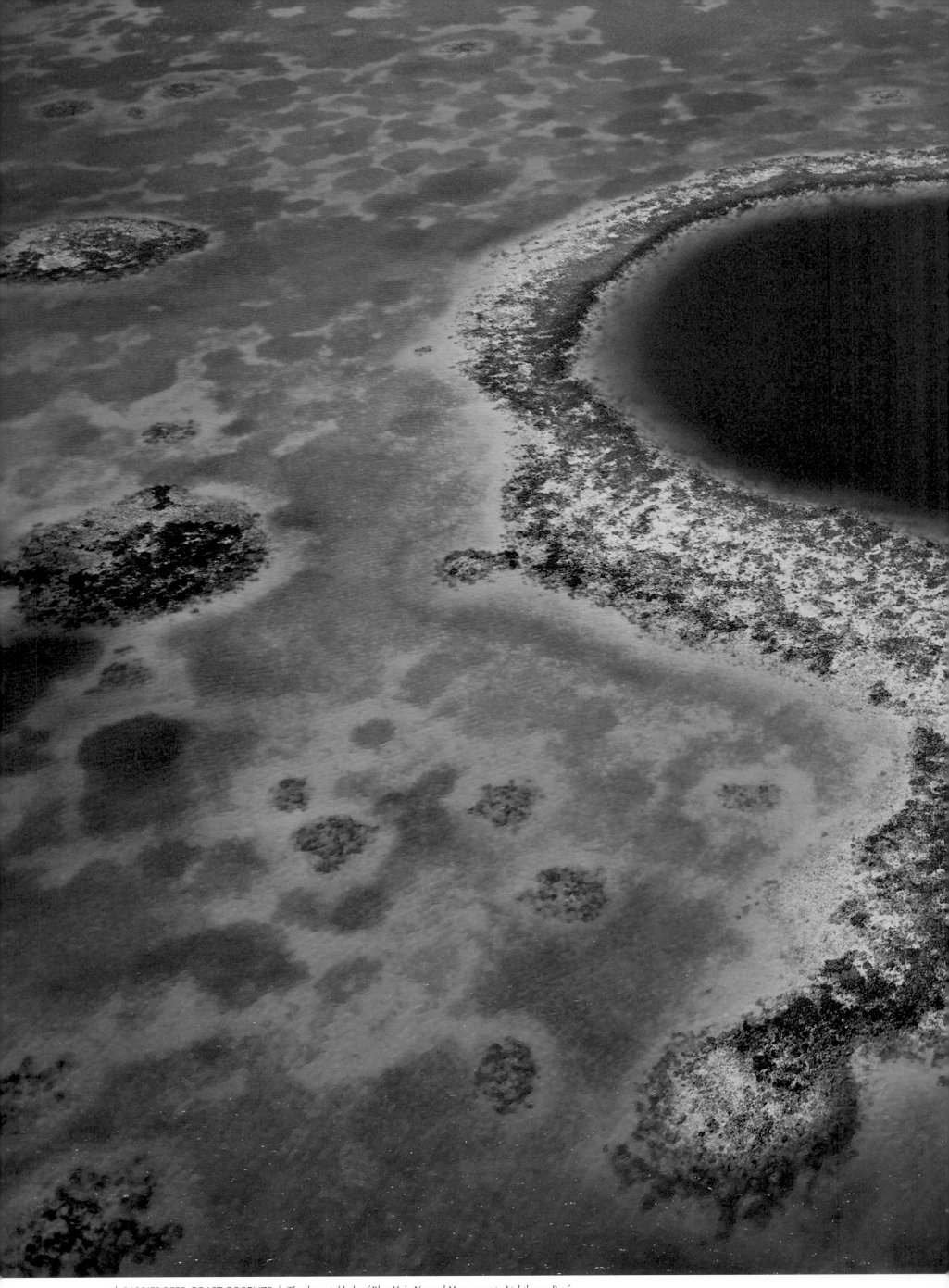

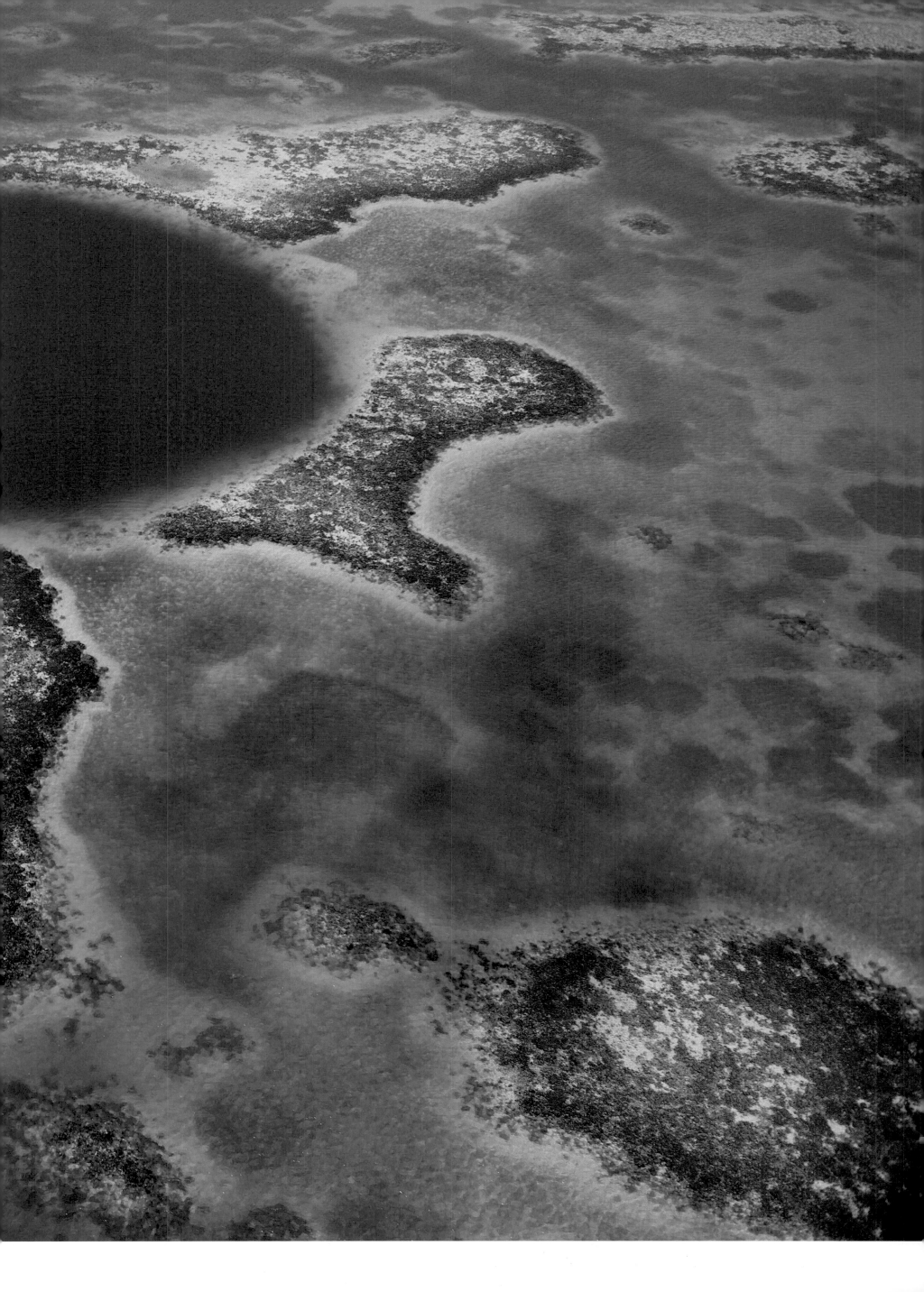

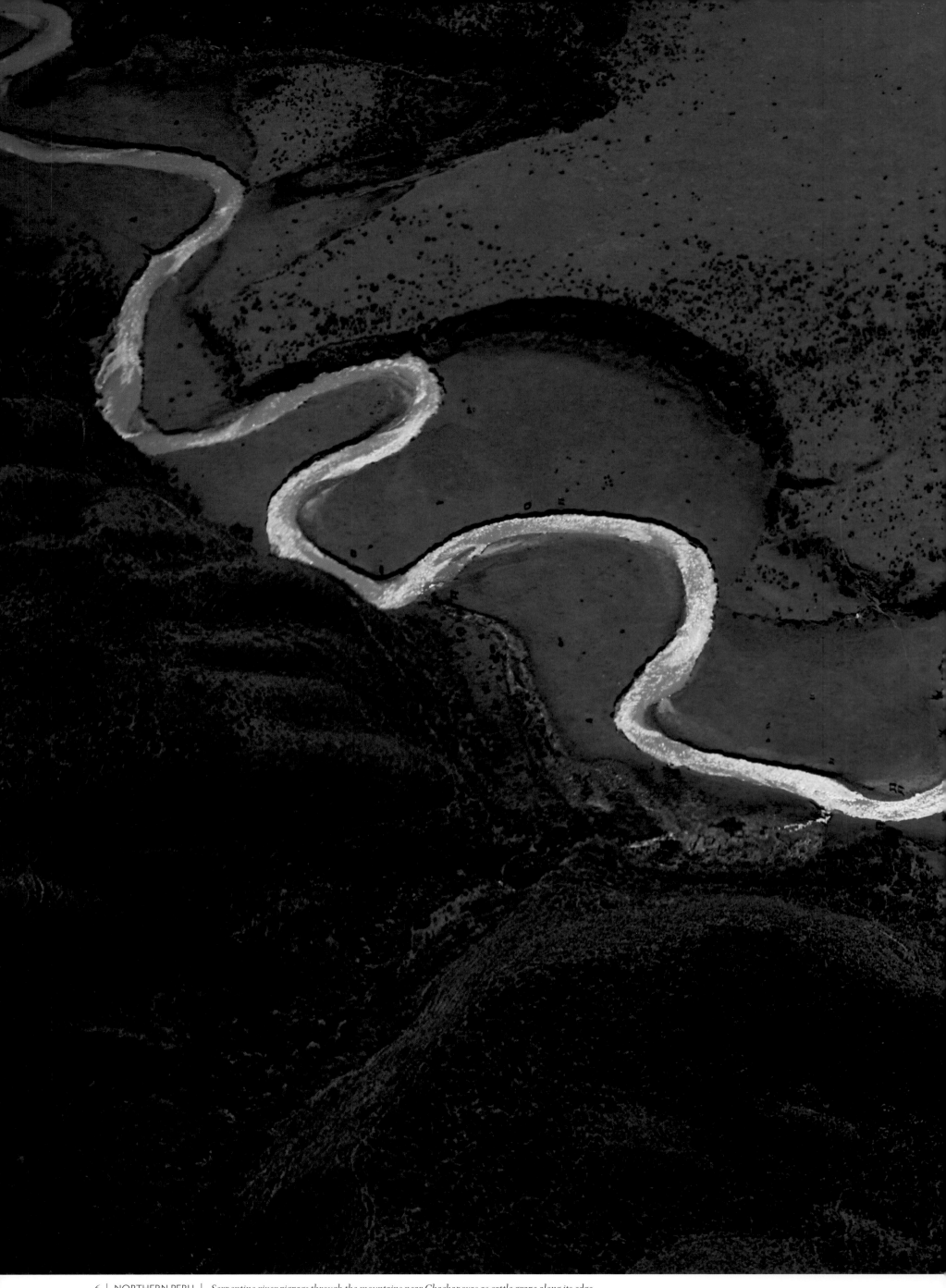

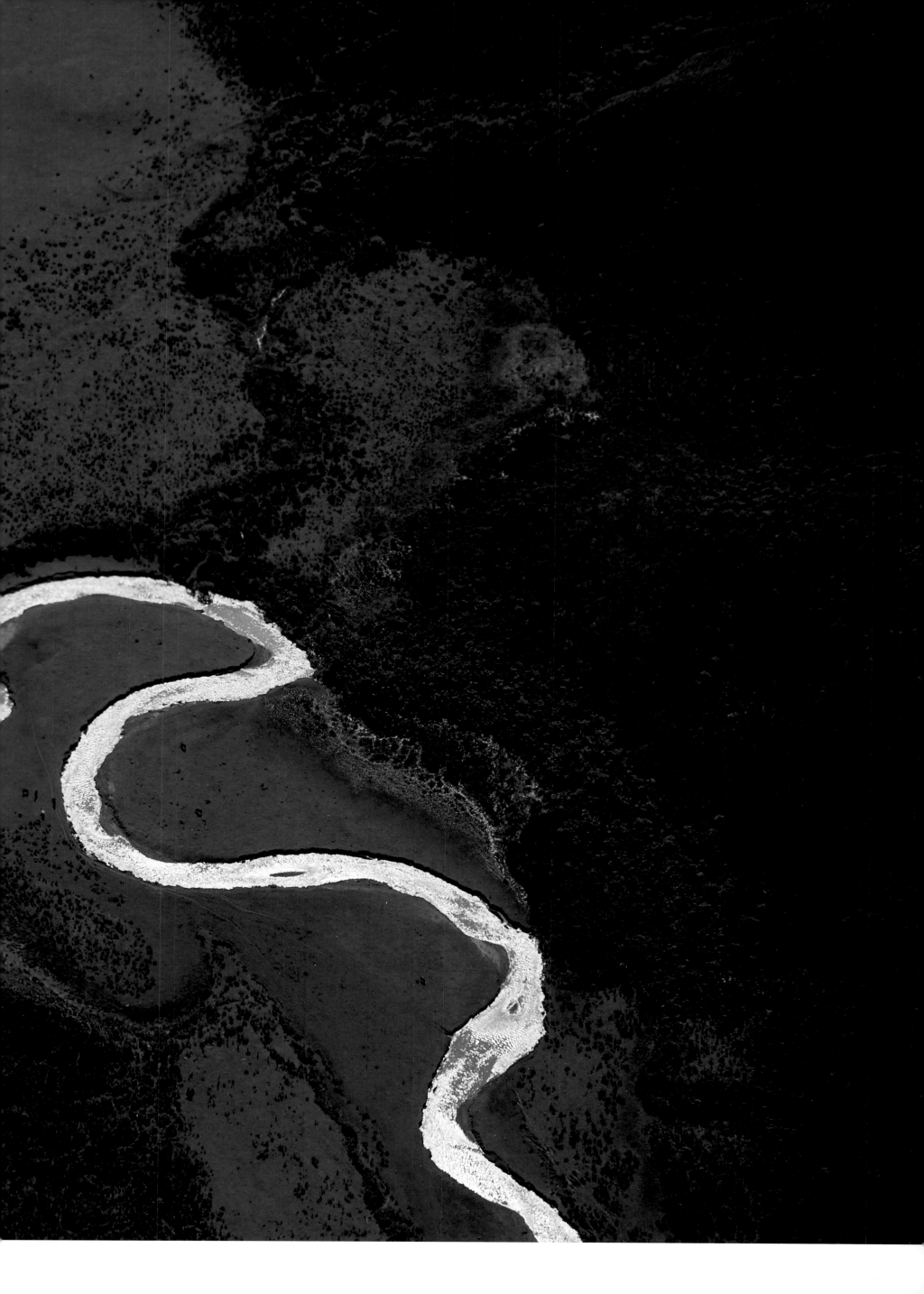

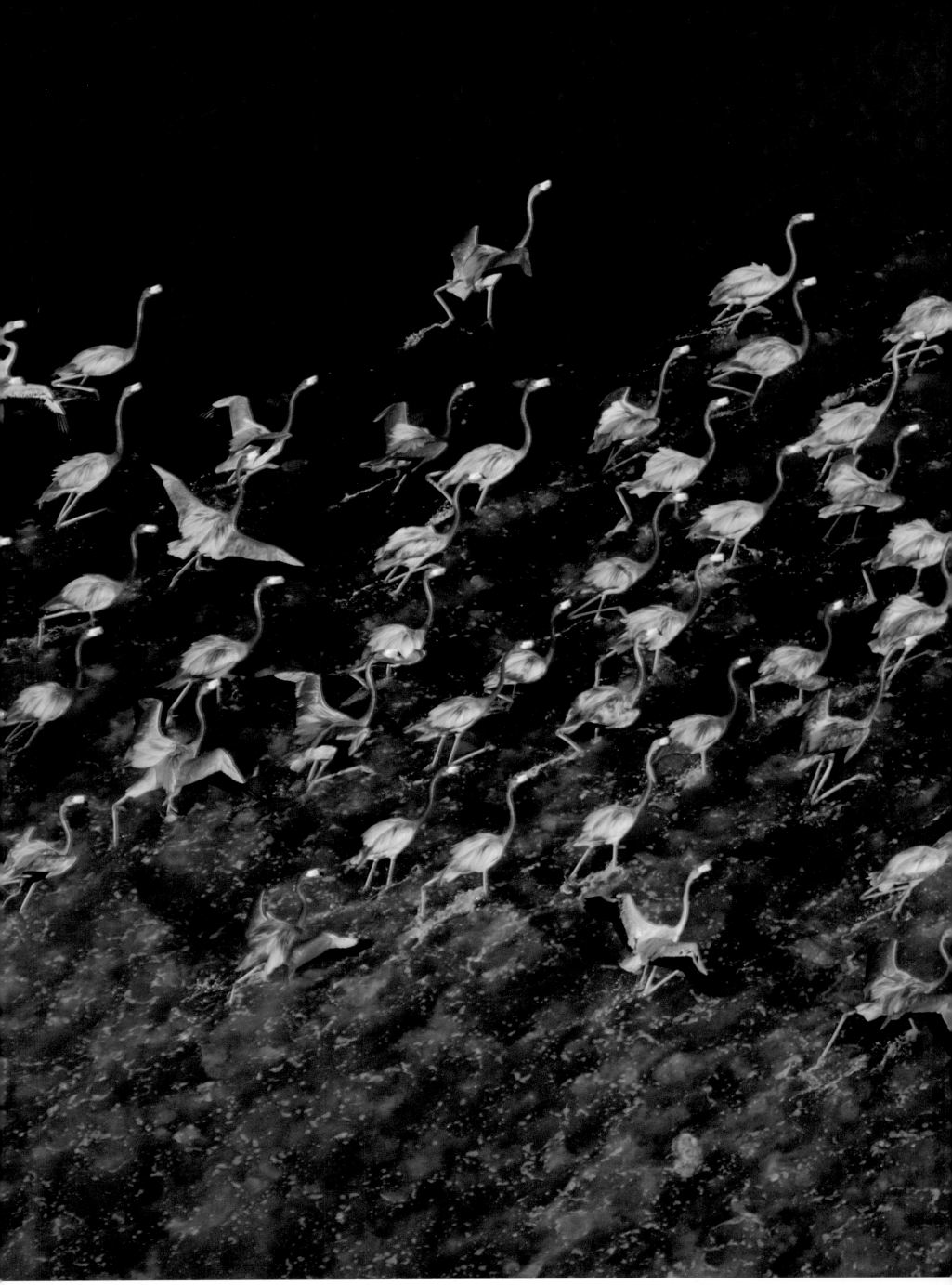

YUCATÁN PENINSULA, MEXICO | *Flamingos churn across a shallow lagoon near the village of Chuburná*

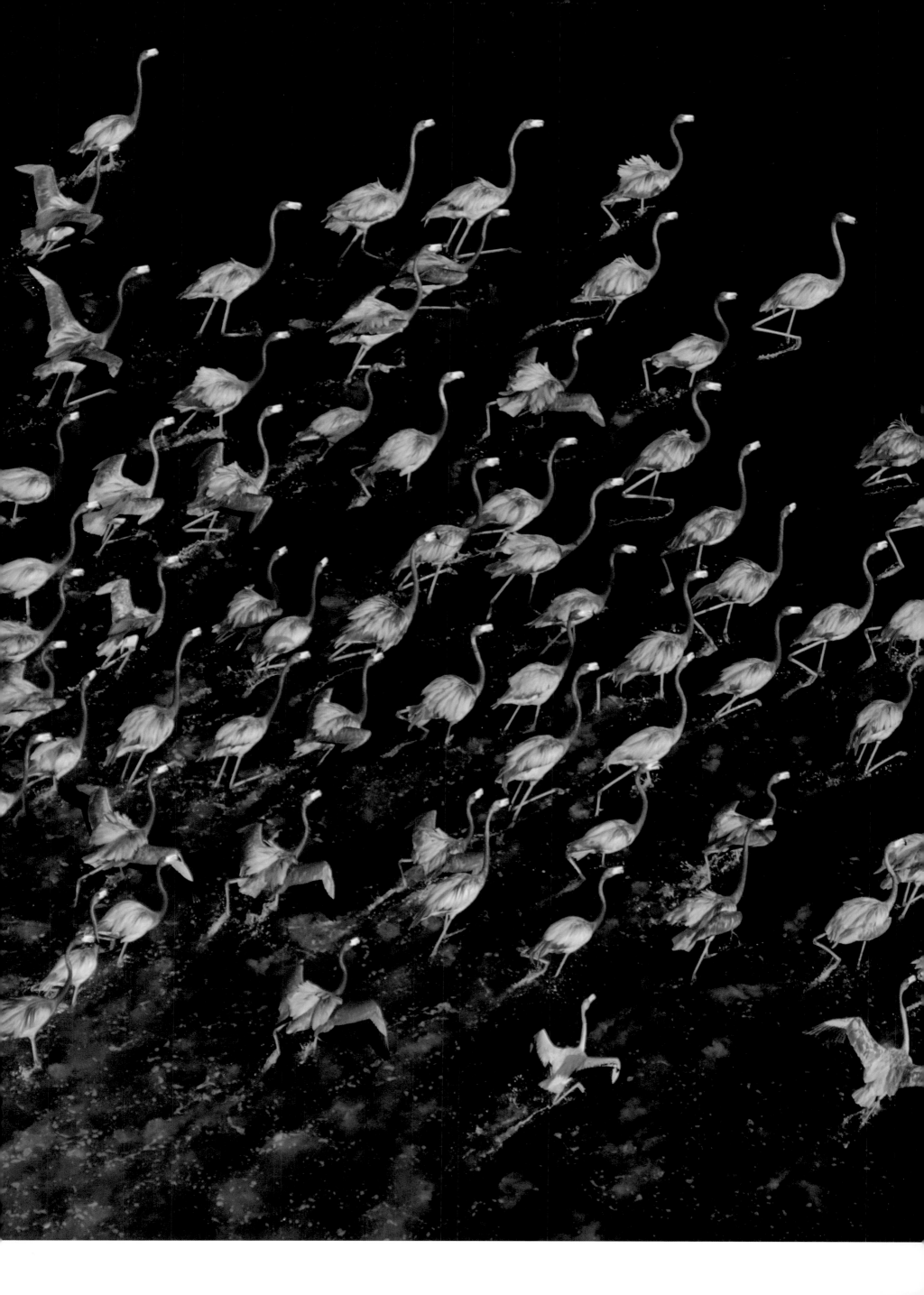

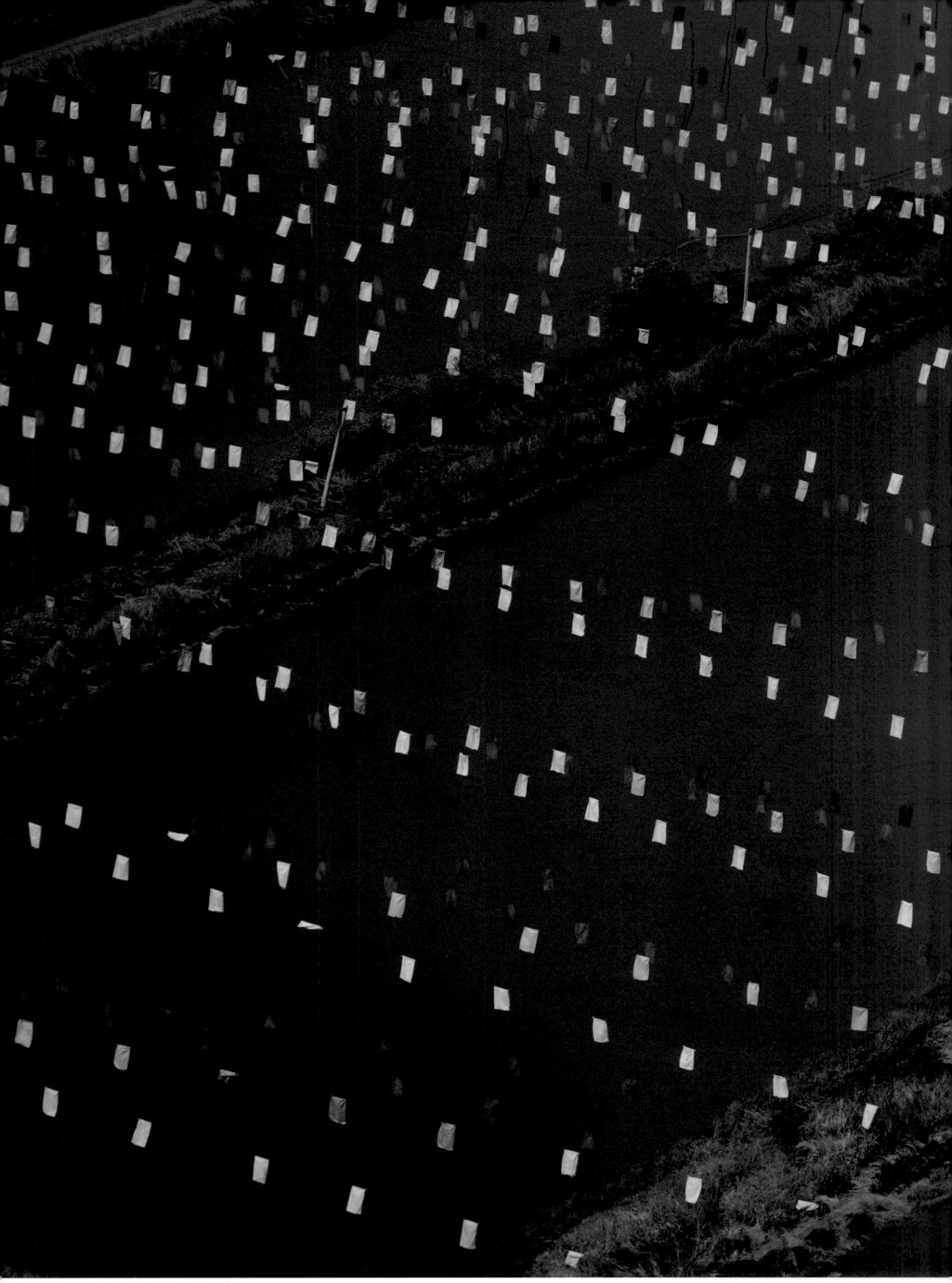

GUAYAQUIL, ECUADOR | *Shrimp farm pools protected by colorful flags against marauding birds*

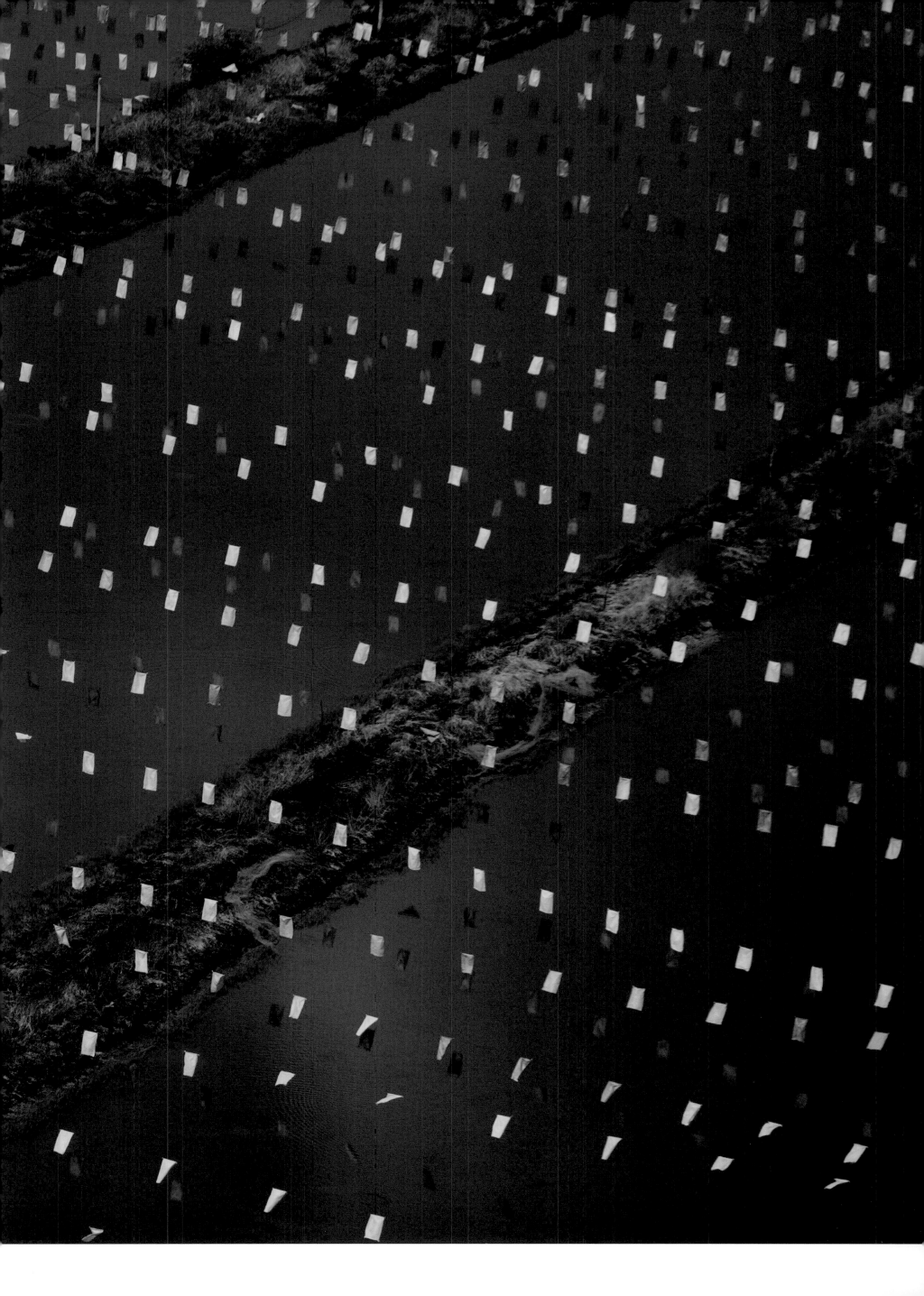

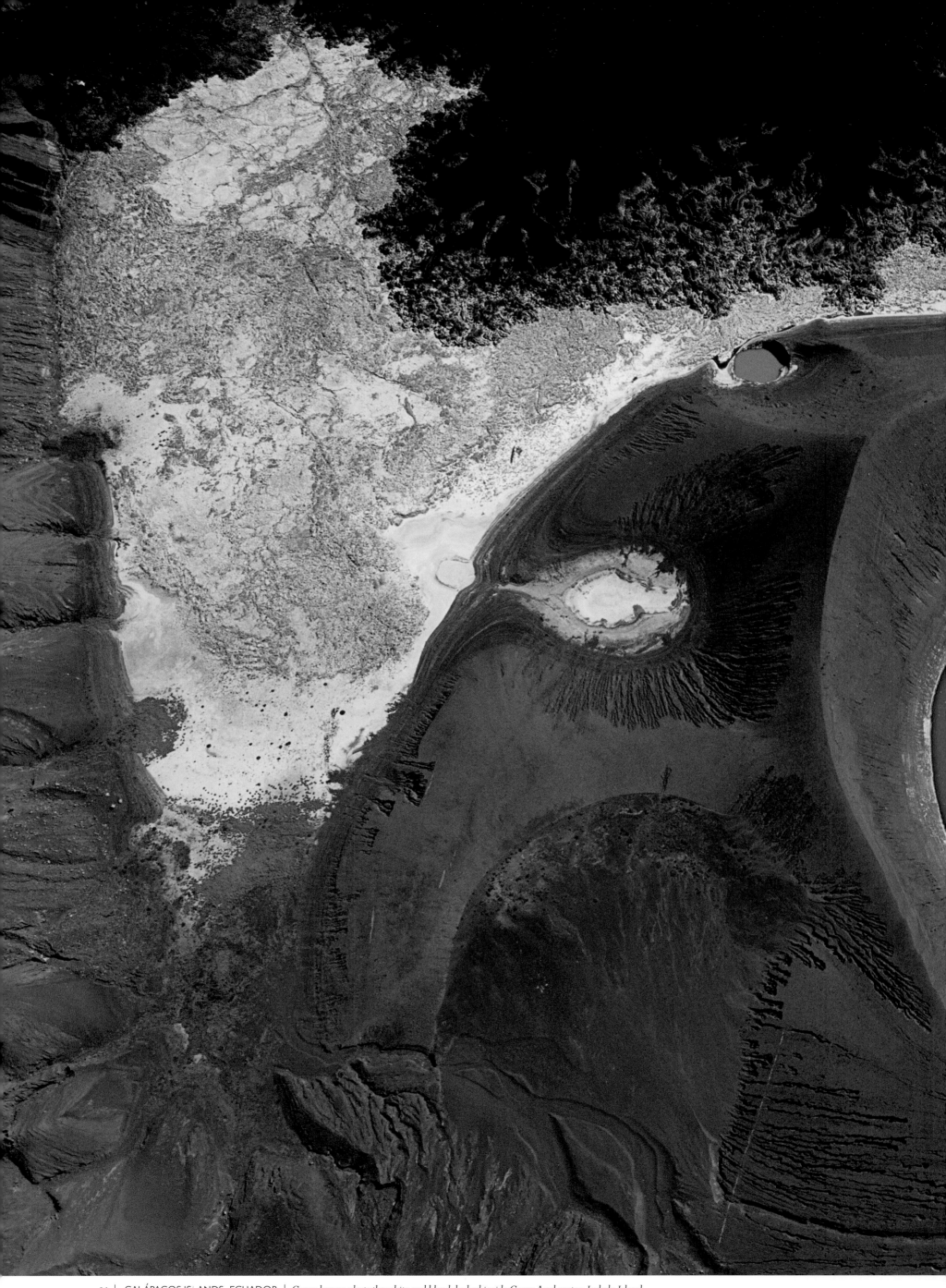

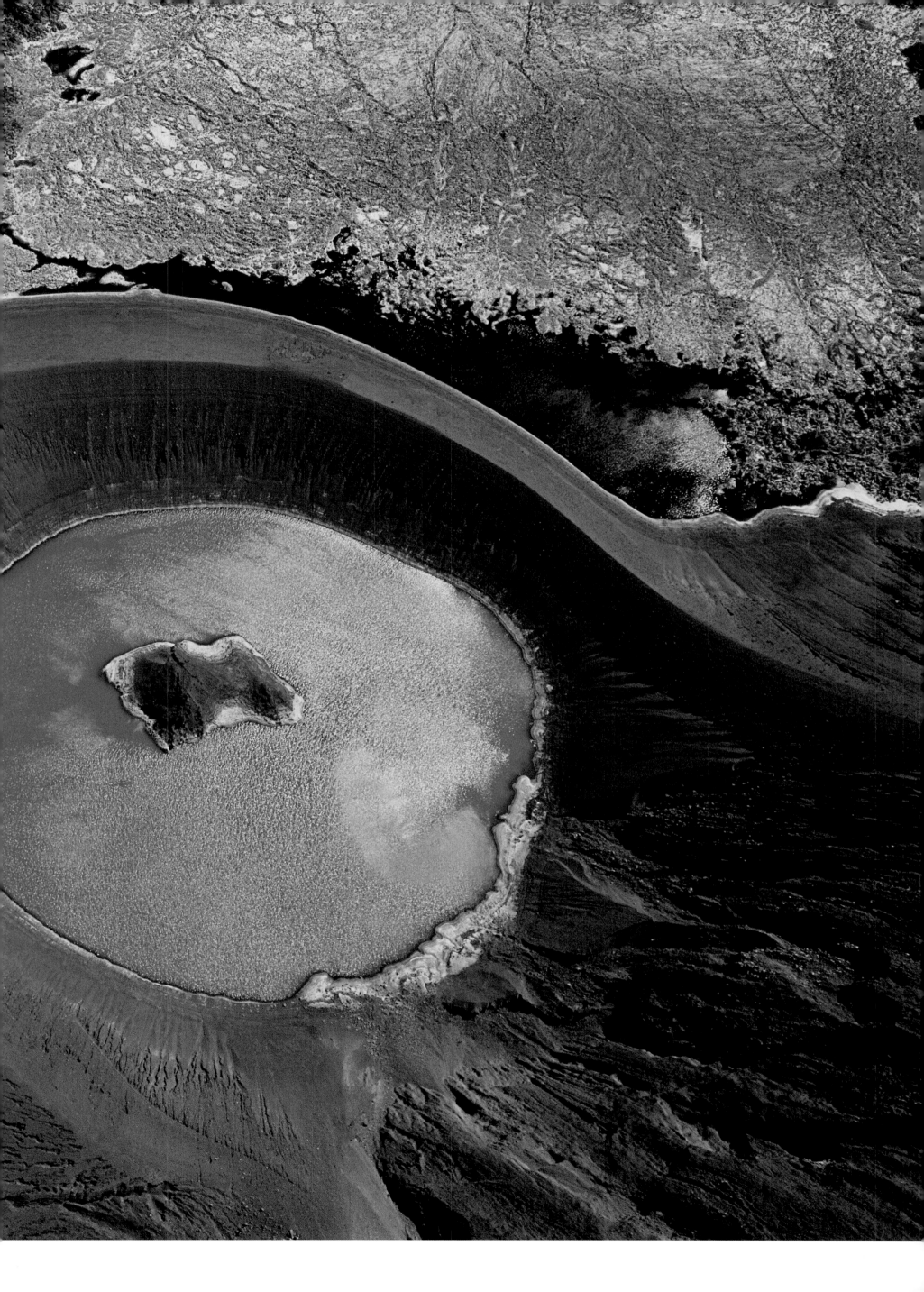

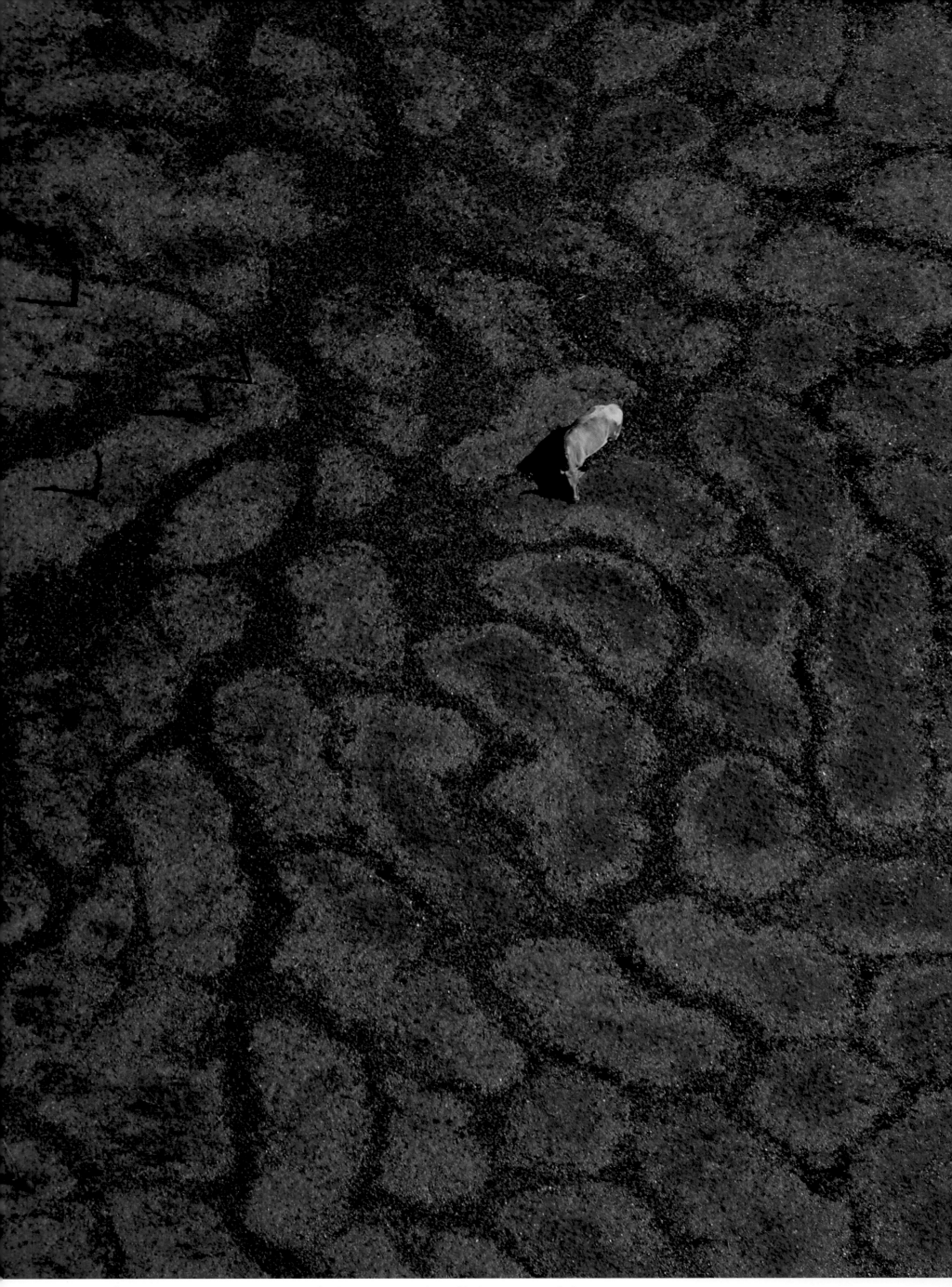

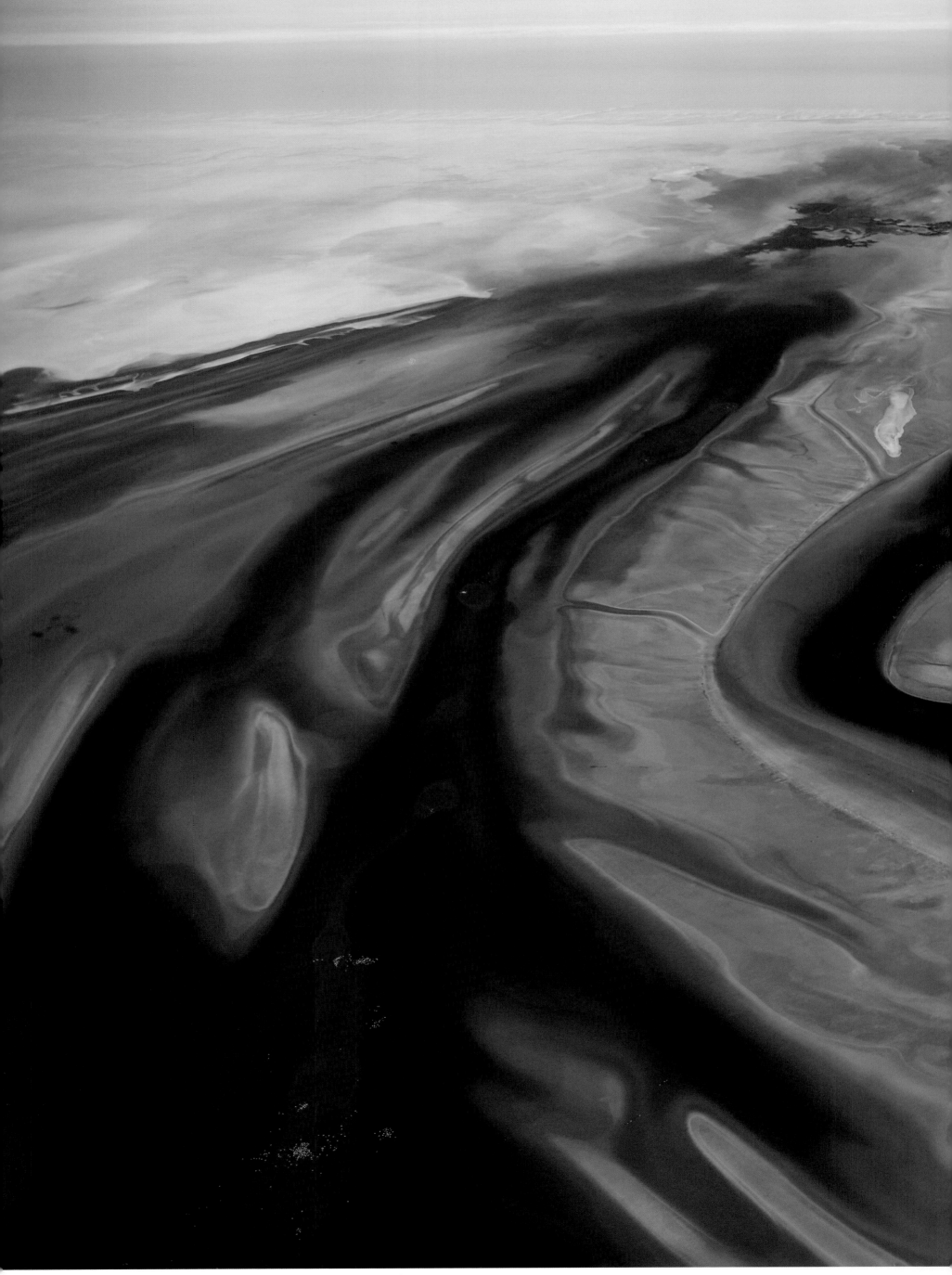

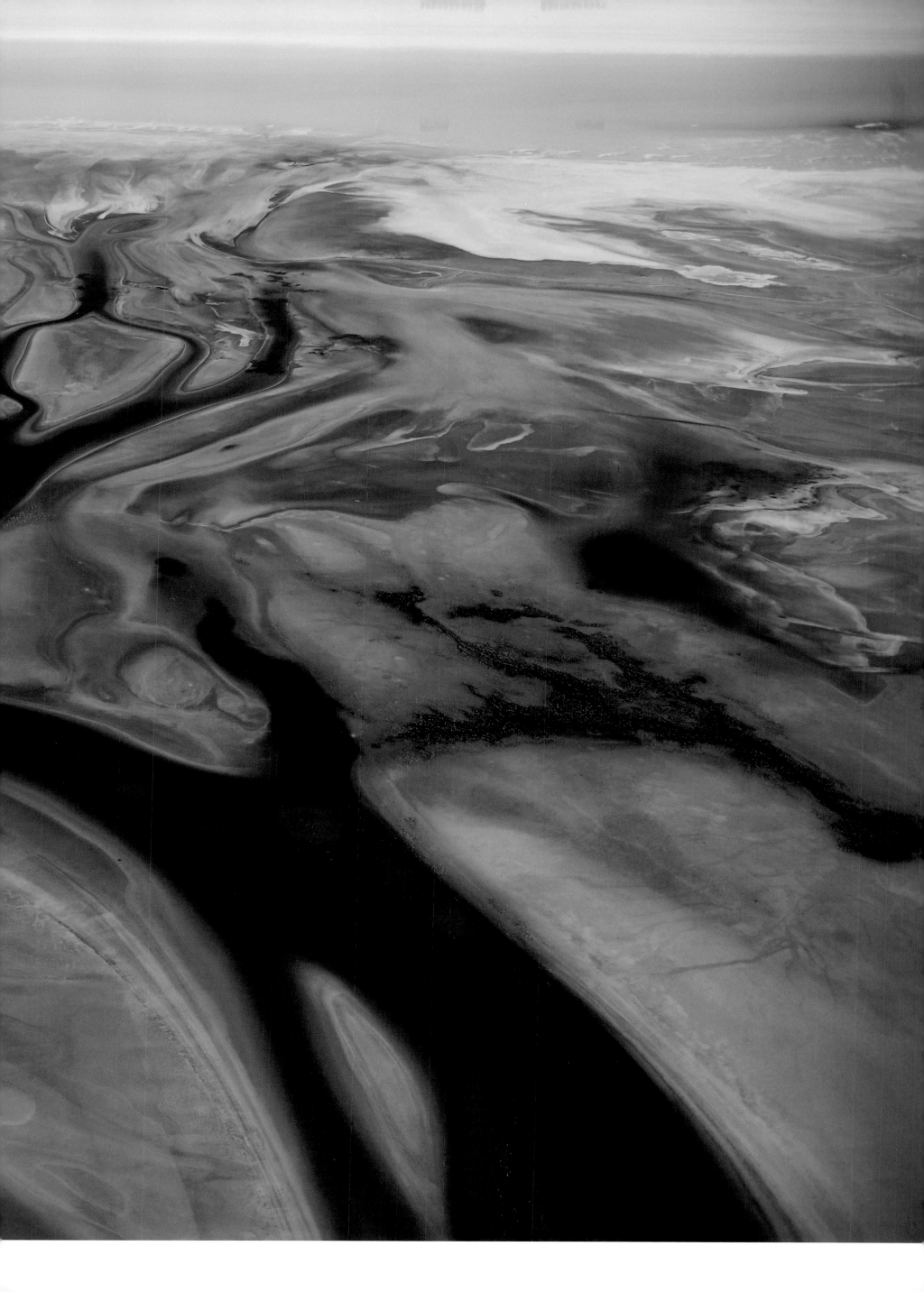

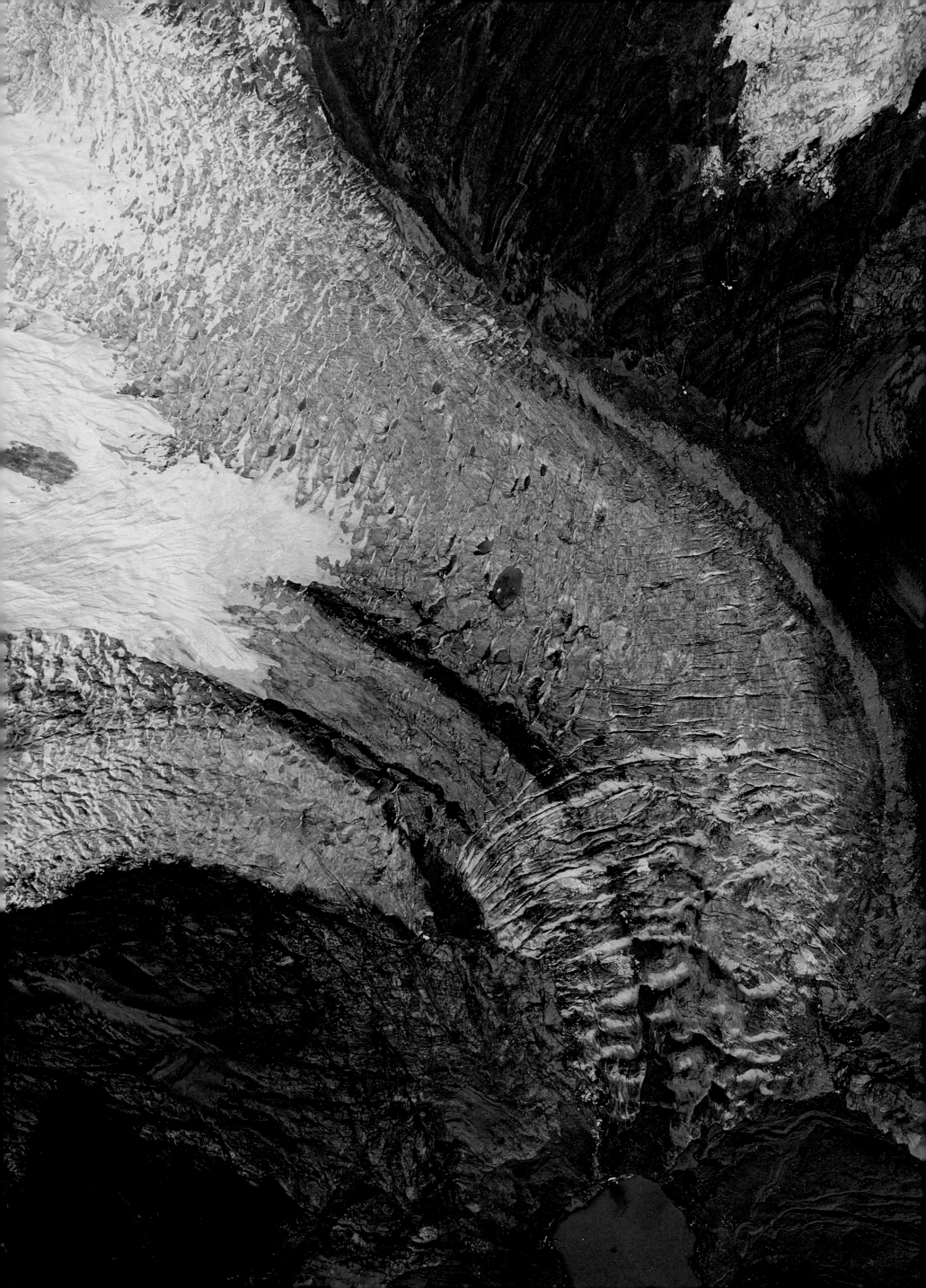

Introduction

THE PEOPLE OF LATIN AMERICA ARE CHILDREN OF THE EARTH, MOLDERS OF CLAY, MOVERS OF ROCK. Since the day of the Inca, we have believed that we spring from the soil as surely as seeds—that the ground is our mother and the forces that move her, our father. That life in this volatile home holds the promise of plenty or the shock of seismic upheaval. The Earth can feed us. Or destroy us. We are at once the blessed and cursed inheritors of a fierce and bountiful land.

Perhaps that is why the Inca so loved the sun and the Maya built stairs to the skies, and conquistadores clambered up hills to thrust crucifixes into high ground. We want to rise. Sprout wings. Fly. We long to see through the eyes of the condor.

I felt all this keenly as I sped through the clouds with the extraordinarily gifted author of this book, Bobby Haas. He was showing me my native land as my ancestors had longed to see it—as every shaman who ever drank a hallucinogenic brew hoped to experience it. I was discovering Peru from a vantage only a spirit creature can provide.

I had met Bobby Haas on the ground in Washington, D.C., one city block from where I work at *The Washington Post* and across the street from where this book was so thoroughly imagined by his editors at National Geographic. When he told me that his book would be called *Through the Eyes of the Condor,* it was all I needed to hear. I had just completed a novel about an eccentric, ambitious engineer who had come to live in the Amazon rain forest and yearned to fly like his spirit creature, the condor. So my first meeting with Bobby was graced, as rare encounters in life can be, by an irresistible, mystical connection. Six months later, I flew from one capital of my Americas to the other—from Washington, D.C., to Lima, Peru—where I was to travel a small leg of the expedition and be granted a glimpse into the nearly two-year effort it took to capture the astonishing images in this book.

It was grueling work. We rose before dawn and dressed in the many layers of thermal clothing and headgear we would need to protect ourselves against the arctic wind over the Andes. By the time the sun was overhead, we were strapped into the seats of a tiny Pilatus Porter, oxygen tubes in our nostrils, gliding through salmon skies. Shivering with cold, we peered out of our black balaclavas, surveying a surreal world below: Strings of lakes glistened like tourmaline necklaces. Hills of calcified sand seemed, from that height, colossal elephant hides. There were pools of cerulean blue. Rivers lazed in the sun like indolent, bronze snakes. Pelicans clung to high rock, turning their wary eyes toward the hum of our engines.

Bobby's excitement was palpable, infectious. He would squirm in his seat like a boy, turn this way and that to get a better vantage. Our pilot, a veteran of flight over this terrain, would take the cue and bank expertly over the subject. And then, suddenly, with a whoop, Bobby would grab his camera, push open the sliding door, and lean out like a high-wire artist, with only a long belt tying him to the airplane floor. There, battered by a subzero gale, he would move his

The Great Liberator of South America, Simón Bolívar—had he been strapped into my seat on that Pilatus Porter—would have marveled to see it. He had dreamt all his life of a unified Latin America, a place where all "otherness" would be tolerated and nations would work together to forge a new and stronger breed. Alas, Bolívar's dream never came true. He died in exile, despised and penniless, ravaged by tuberculosis. And Latin America moved ahead, in all its splendid diversity. But up in the air, it seemed to me that Bolívar's dream not only was possible, it had come true. Mankind—infinitesimal, swarming, as capable of genius as of depredation—is but one species after all.

Bolívar was not alone in dreaming about the Americas. Even before the *Conquista*, the land-hungry Aztecs of Tenochtitlán and the seafaring Alacaluf of the Tierra del Fuego had grandiose visions of imposing their ways on the world. But it was when Europe set out to conquer the continent that wholesale dreaming began. The Colombian historian Germán Arciniegas calls that nascent migration "moving toward a magical reality," which is to say that the explorers and early settlers of the Americas set out with wild fantasies in their heads: They were looking for giants, Pygmies, Cyclopes, dog-faced creatures of the Amazon. The fountain of youth. Gold. Before he steered his three caravels westward, Columbus scribbled in the margins of *Imago Mundi* and dreamt of what a new continent might bring. And then, a generation later, when that landmass was well identified, Sir Thomas More scribbled in his notebooks and dreamt of the Utopia it might become.

But for all the dreams that have been imported to Latin America and for all the magic its people await, its realities live on, indomitable. This Earth has been mined and exploited for centuries. Its geography has been disputed in wars. Its waters have been plowed and sullied. And yet the beauty of the place persists. Nowhere do we see that more clearly than from the air. We rise up over the protean landscape and are filled with a sense of wonder.

This, in the end, is the gift that this volume gives us. We leaf through its pages, offered a condor's keen power of sight, granted a regal dominion between earth and sky. We are, in one fleeting moment, high beings, all-seeing, invincible. And yet, looking down at that dazzling spectacle of Latin America, all we can feel is awe.

—Marie Arana
Lima, Peru

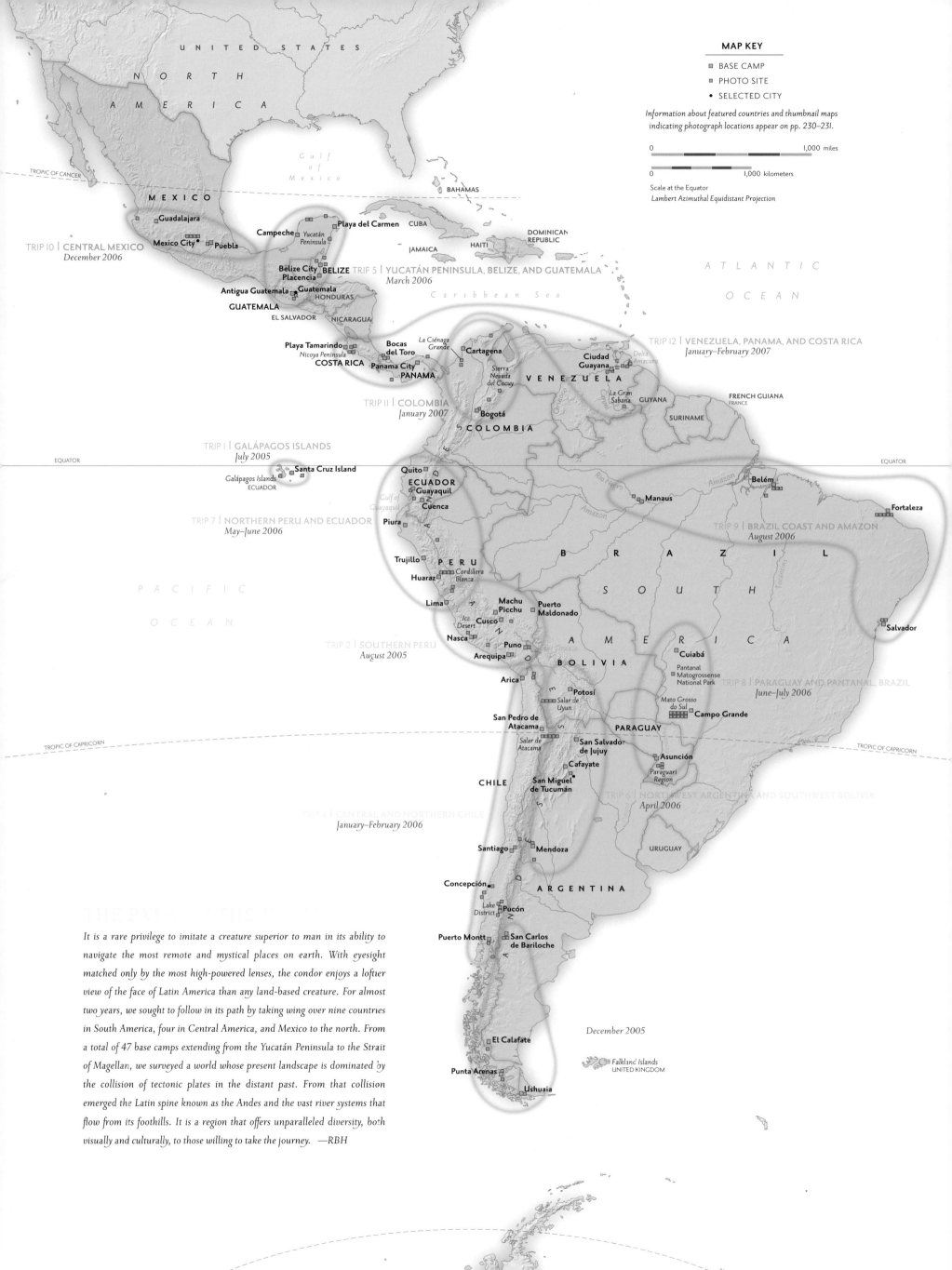

Information about featured countries and thumbnail maps indicating photograph locations appear on pp. 230–231.

MAP KEY

◼ BASE CAMP

◻ PHOTO SITE

● SELECTED CITY

0 —————————— 1,000 miles

0 —————————— 1,000 kilometers

Scale at the Equator

Lambert Azimuthal Equidistant Projection

UNITED STATES

NORTH AMERICA

TROPIC OF CANCER

Gulf of Mexico

MEXICO

Guadalajara

Mexico City • Púebla

Campeche

Yucatán Peninsula

Playa del Carmen

CUBA

BAHAMAS

JAMAICA

HAITI

DOMINICAN REPUBLIC

ATLANTIC OCEAN

TRIP 10 | CENTRAL MEXICO
December 2006

Belize City BELIZE
Placencia

Antigua Guatemala Guatemala
GUATEMALA
HONDURAS
EL SALVADOR NICARAGUA

TRIP 5 | YUCATÁN PENINSULA, BELIZE, AND GUATEMALA
March 2006

Caribbean Sea

Playa Tamarindo
Nicoya Peninsula
COSTA RICA

Bocas del Toro

Panama City
PANAMA

La Ciénaga Grande

Cartagena

Ciudad Guayana

Delta Amacuro

VENEZUELA

TRIP 12 | VENEZUELA, PANAMA, AND COSTA RICA
January–February 2007

Sierra Nevada del Cocuy

La Gran Sabana

GUYANA

SURINAME

FRENCH GUIANA
FRANCE

TRIP 11 | COLOMBIA
January 2007

Bogotá

COLOMBIA

Orinoco

EQUATOR

TRIP 1 | GALÁPAGOS ISLANDS
July 2005

Santa Cruz Island

Galápagos Islands
ECUADOR

Quito

ECUADOR

Guayaquil

Cuenca

Gulf of Guayaquil

Piura

Rio Negro

Manaus

Amazon

Belém

Fortaleza

EQUATOR

TRIP 7 | NORTHERN PERU AND ECUADOR
May–June 2006

Trujillo

PERU

Huaraz
Cordillera Blanca

Lima

Machu Picchu
Cusco

Ice Desert

Nasca

Puno

Arequipa

Arica

Puerto Maldonado

BOLIVIA

B R A Z I L

SOUTH AMERICA

Tapajós

TRIP 9 | BRAZIL COAST AND AMAZON
August 2006

Salvador

TRIP 2 | SOUTHERN PERU
August 2005

Cuiabá

Pantanal Matogrossense National Park

Mato Grosso do Sul

Campo Grande

TRIP 8 | PARAGUAY AND PANTANAL, BRAZIL
June–July 2006

Potosí

Salar de Uyuni

San Pedro de Atacama

Salar de Atacama

San Salvador de Jujuy

Cafayate

San Miguel de Tucumán

PARAGUAY

Asunción

Paraguari Region

TROPIC OF CAPRICORN

PACIFIC OCEAN

CHILE

Santiago

Mendoza

URUGUAY

ARGENTINA

TRIP 6 | NORTHWEST ARGENTINA AND SOUTHWEST BOLIVIA
April 2006

Concepción

Lake District

Pucón

Puerto Montt

San Carlos de Bariloche

TRIP 3 | CENTRAL AND NORTHERN CHILE
January–February 2006

El Calafate

December 2005

Falkland Islands
UNITED KINGDOM

Punta Arenas

Ushuaia

It is a rare privilege to imitate a creature superior to man in its ability to navigate the most remote and mystical places on earth. With eyesight matched only by the most high-powered lenses, the condor enjoys a loftier view of the face of Latin America than any land-based creature. For almost two years, we sought to follow in its path by taking wing over nine countries in South America, four in Central America, and Mexico to the north. From a total of 47 base camps extending from the Yucatán Peninsula to the Strait of Magellan, we surveyed a world whose present landscape is dominated by the collision of tectonic plates in the distant past. From that collision emerged the Latin spine known as the Andes and the vast river systems that flow from its foothills. It is a region that offers unparalleled diversity, both visually and culturally, to those willing to take the journey. —RBH

ANTARCTICA

ANTARCTIC CIRCLE

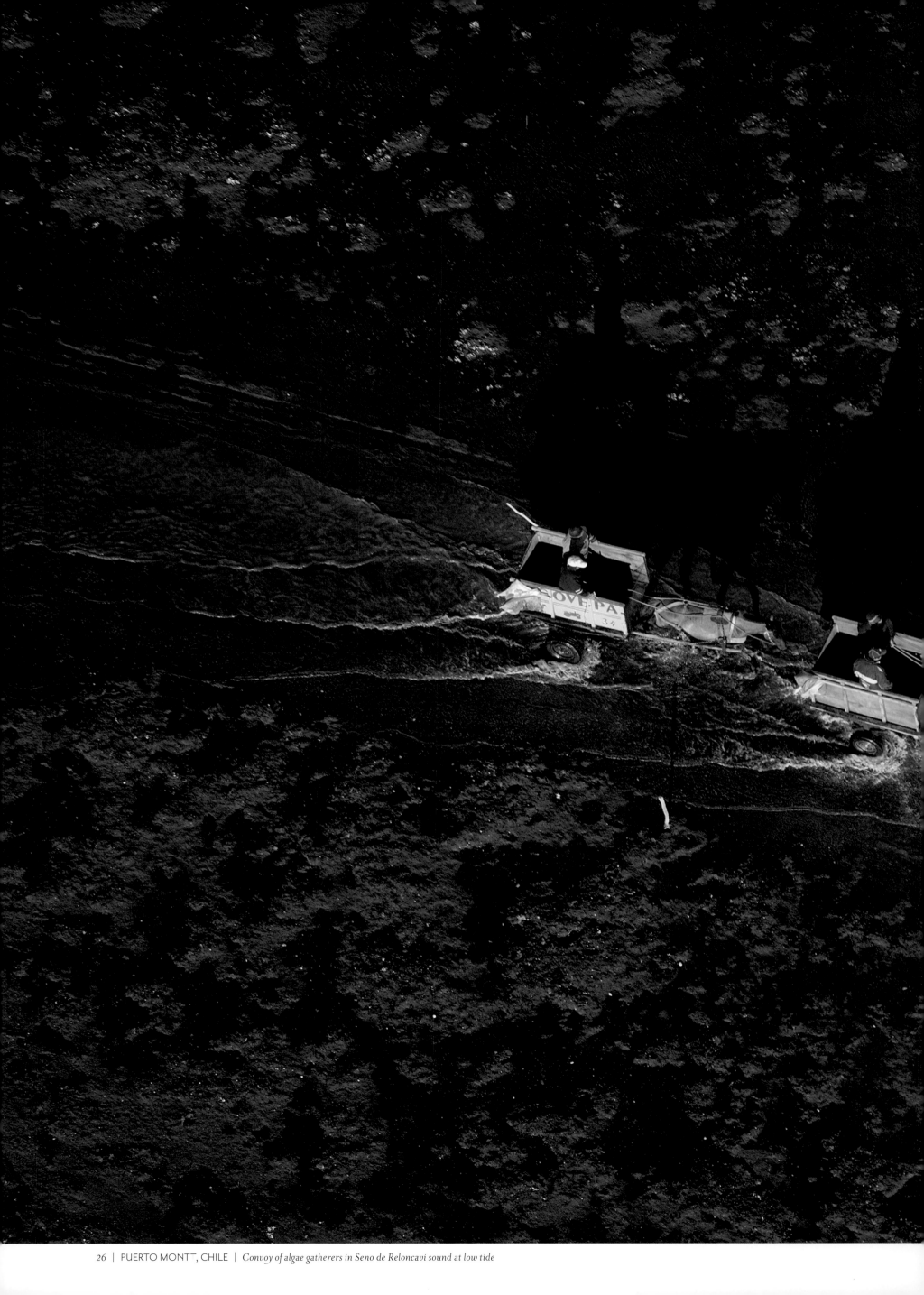

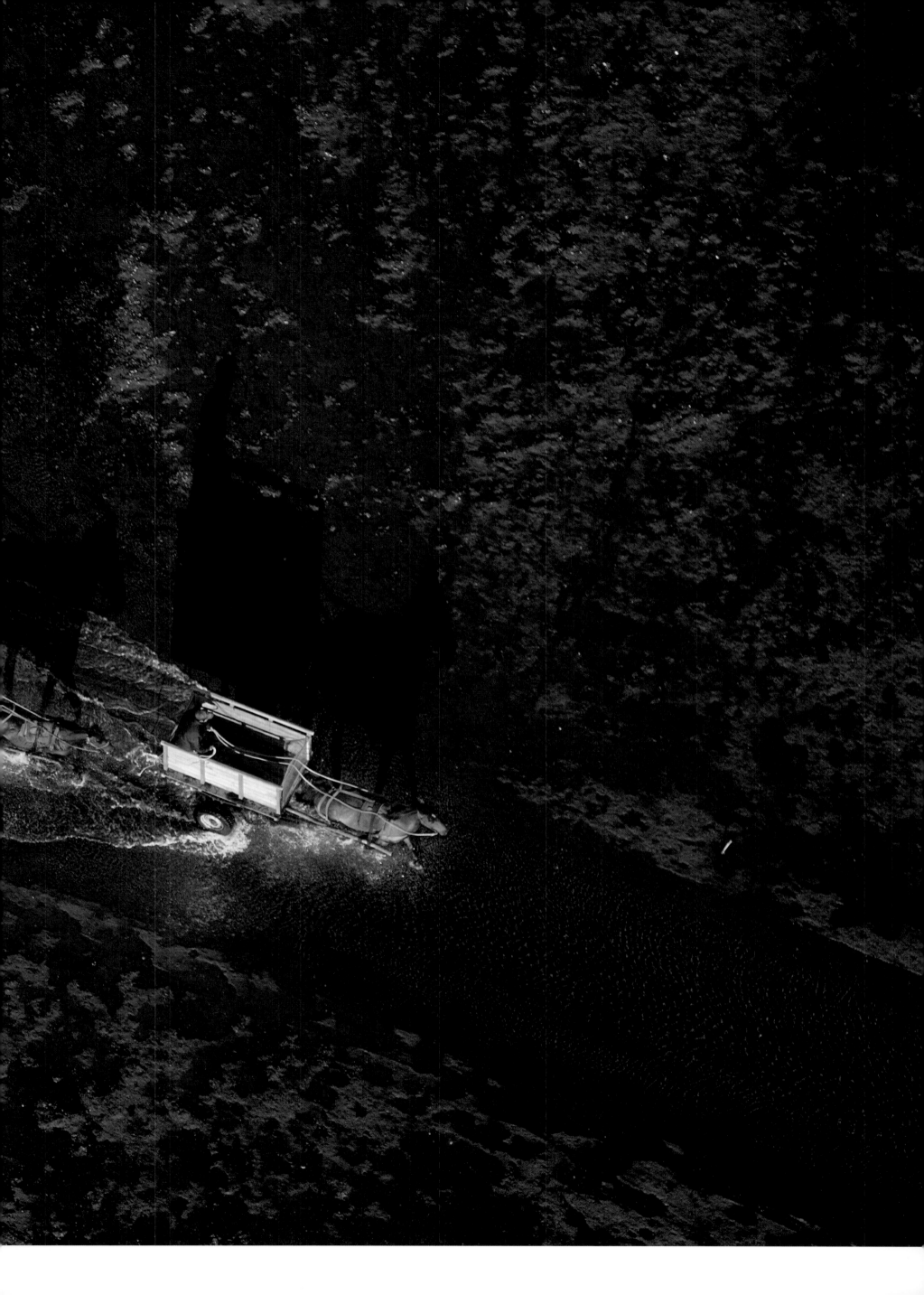

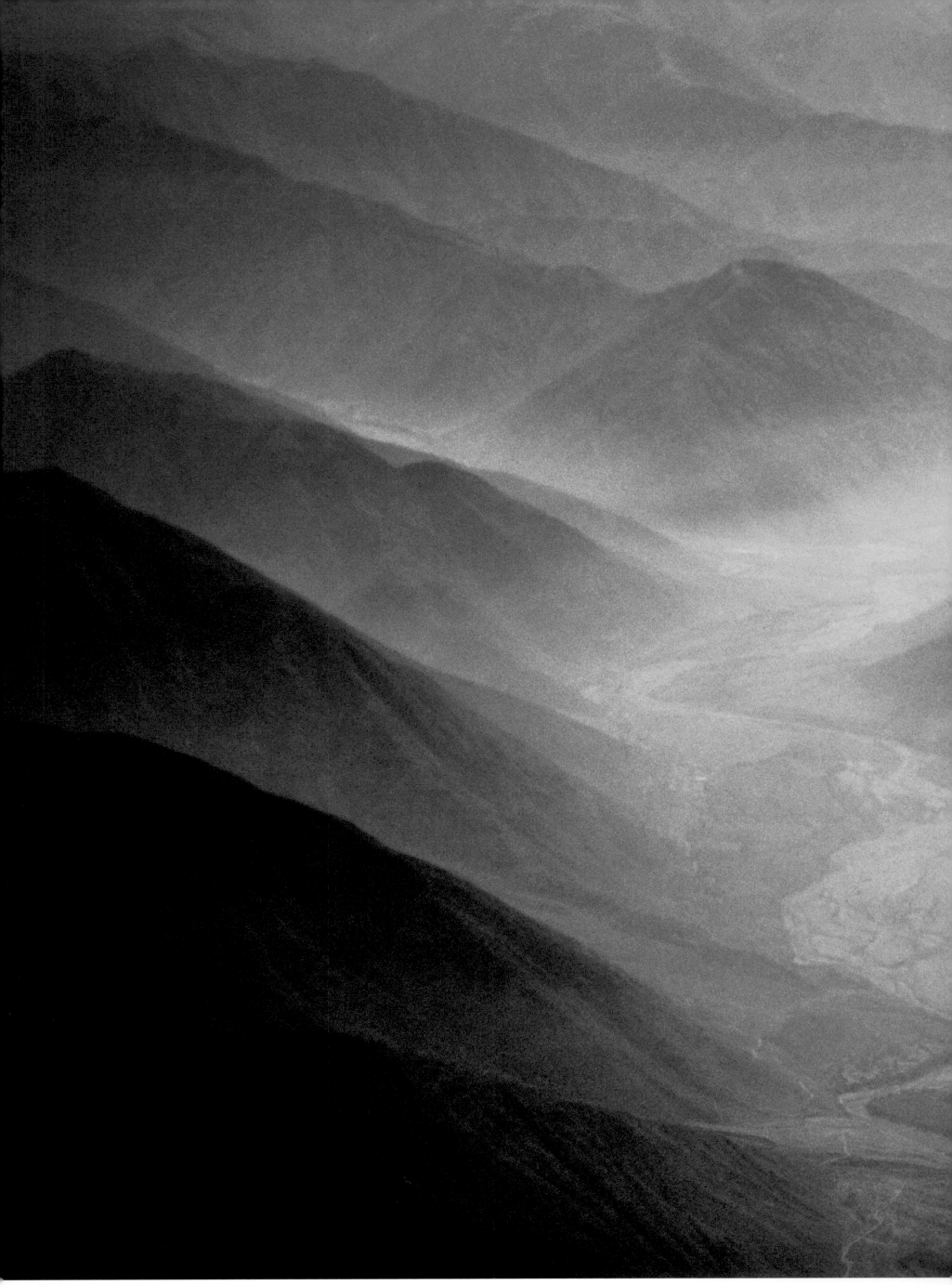

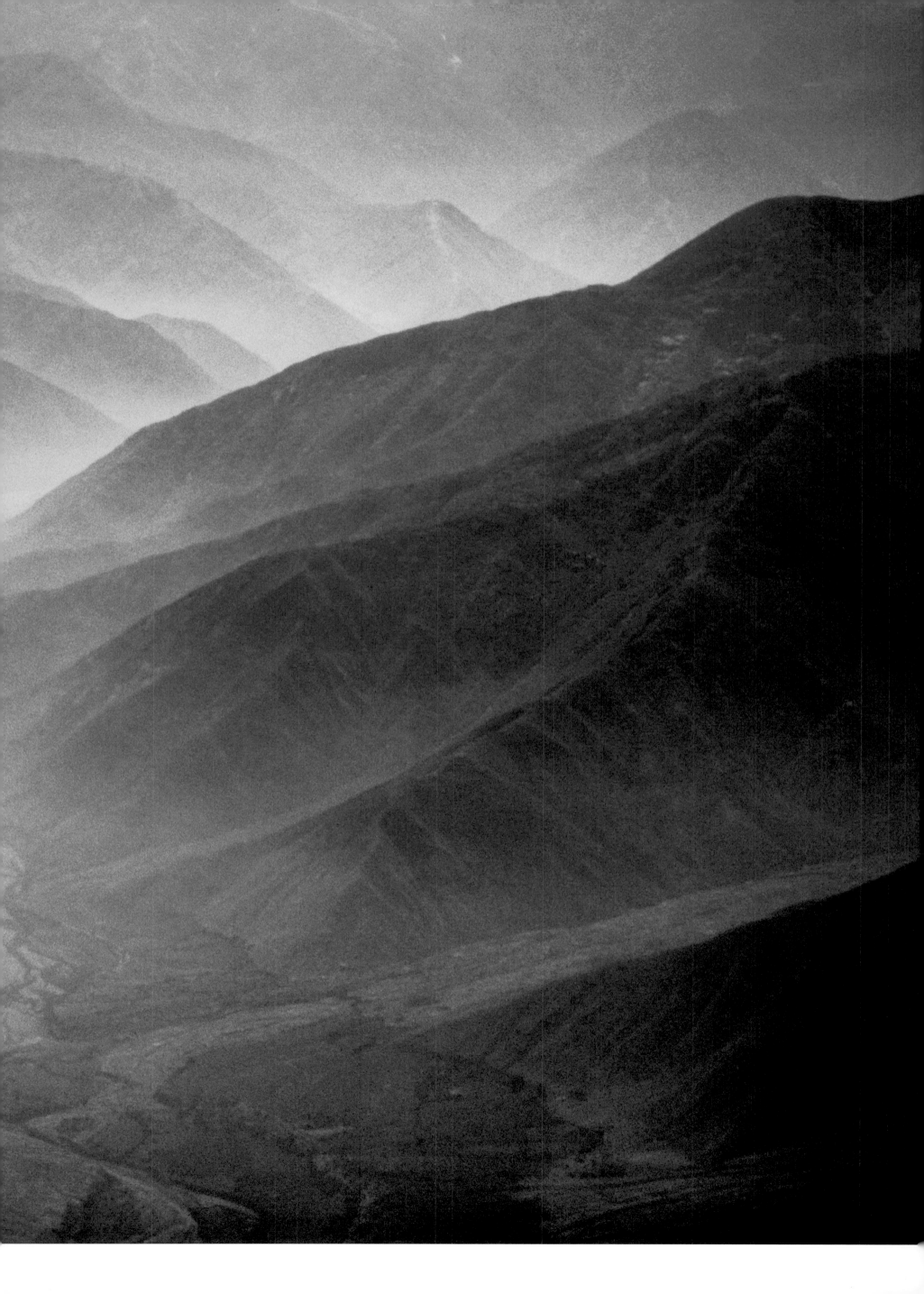

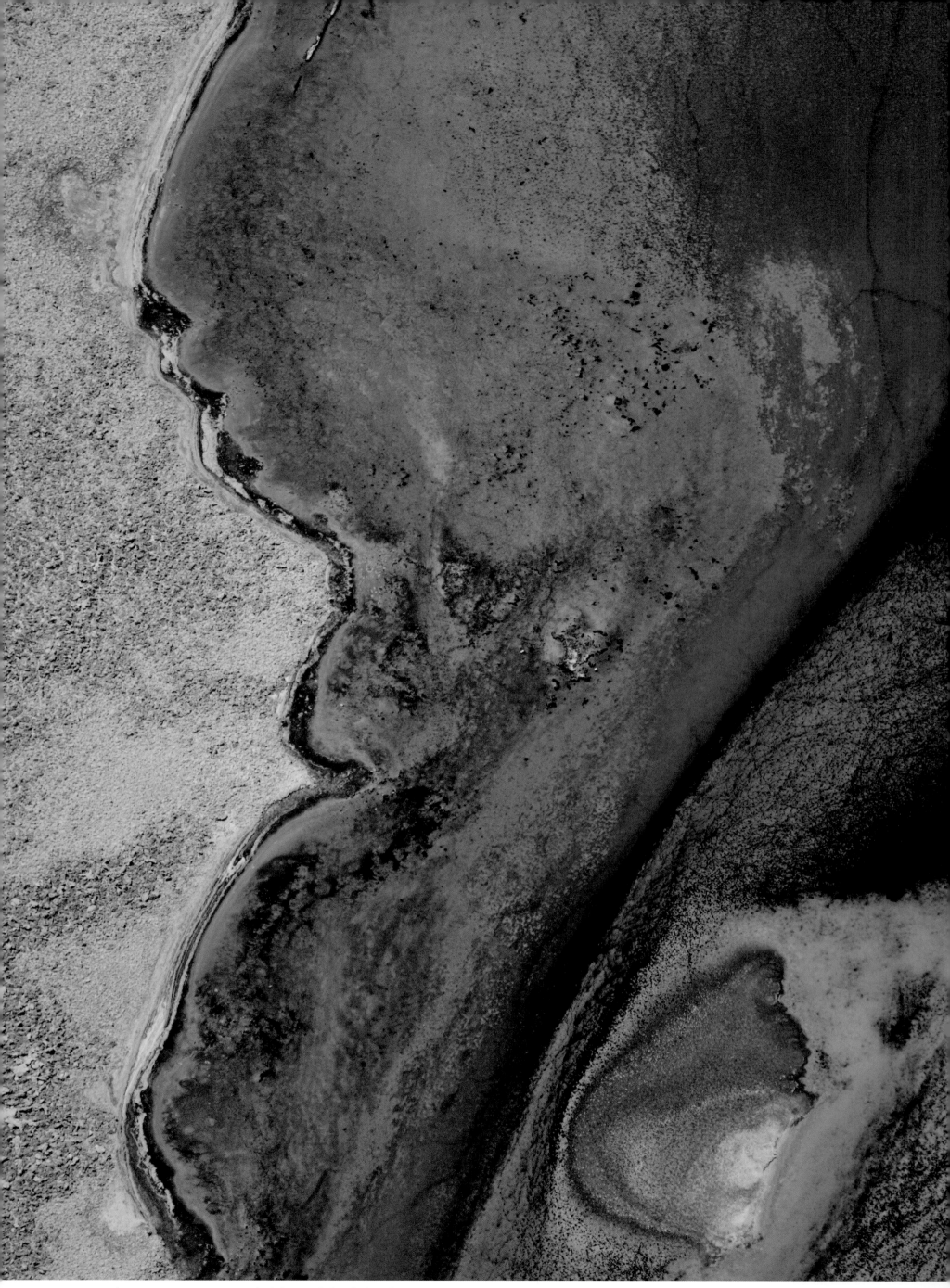

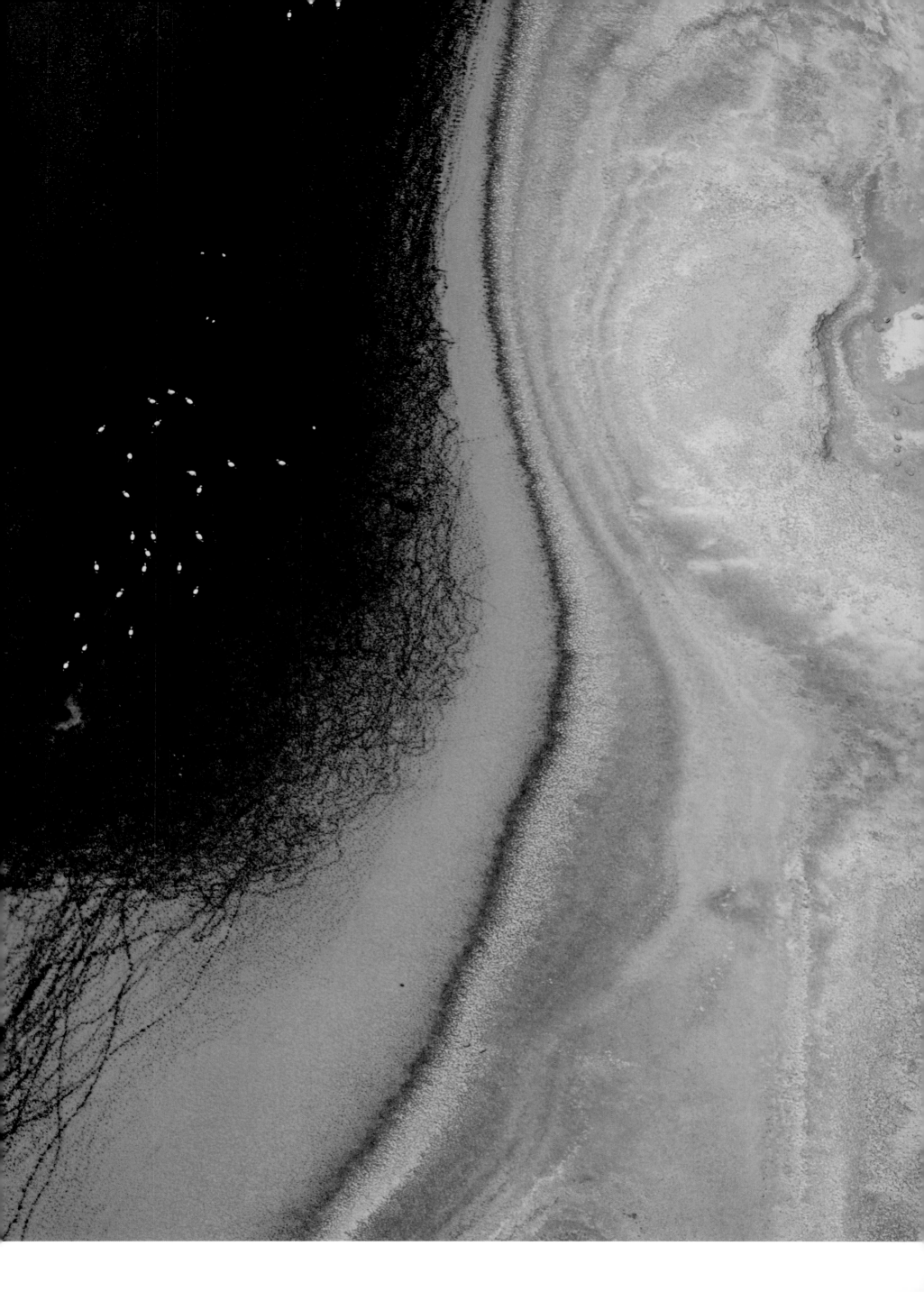

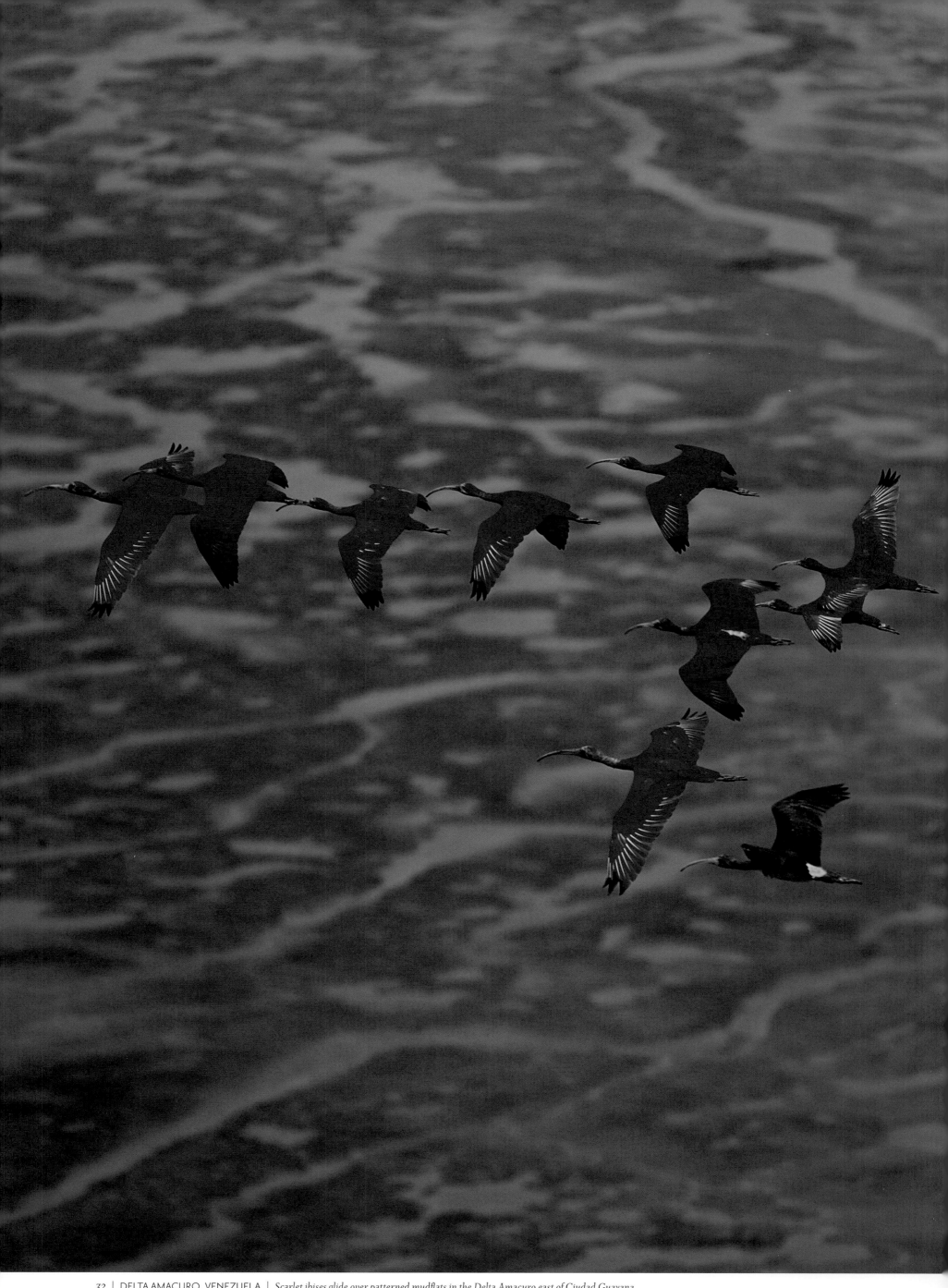

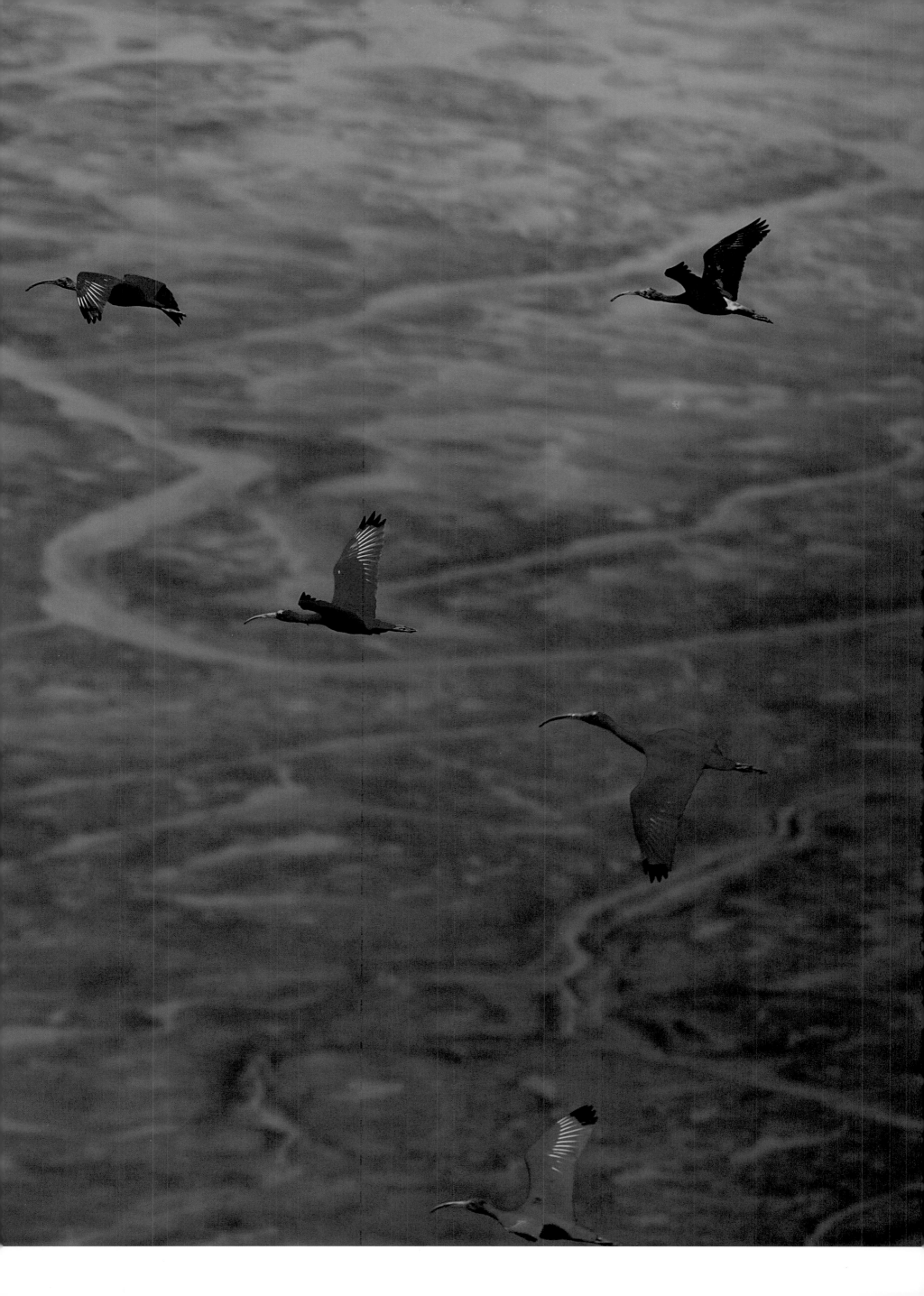

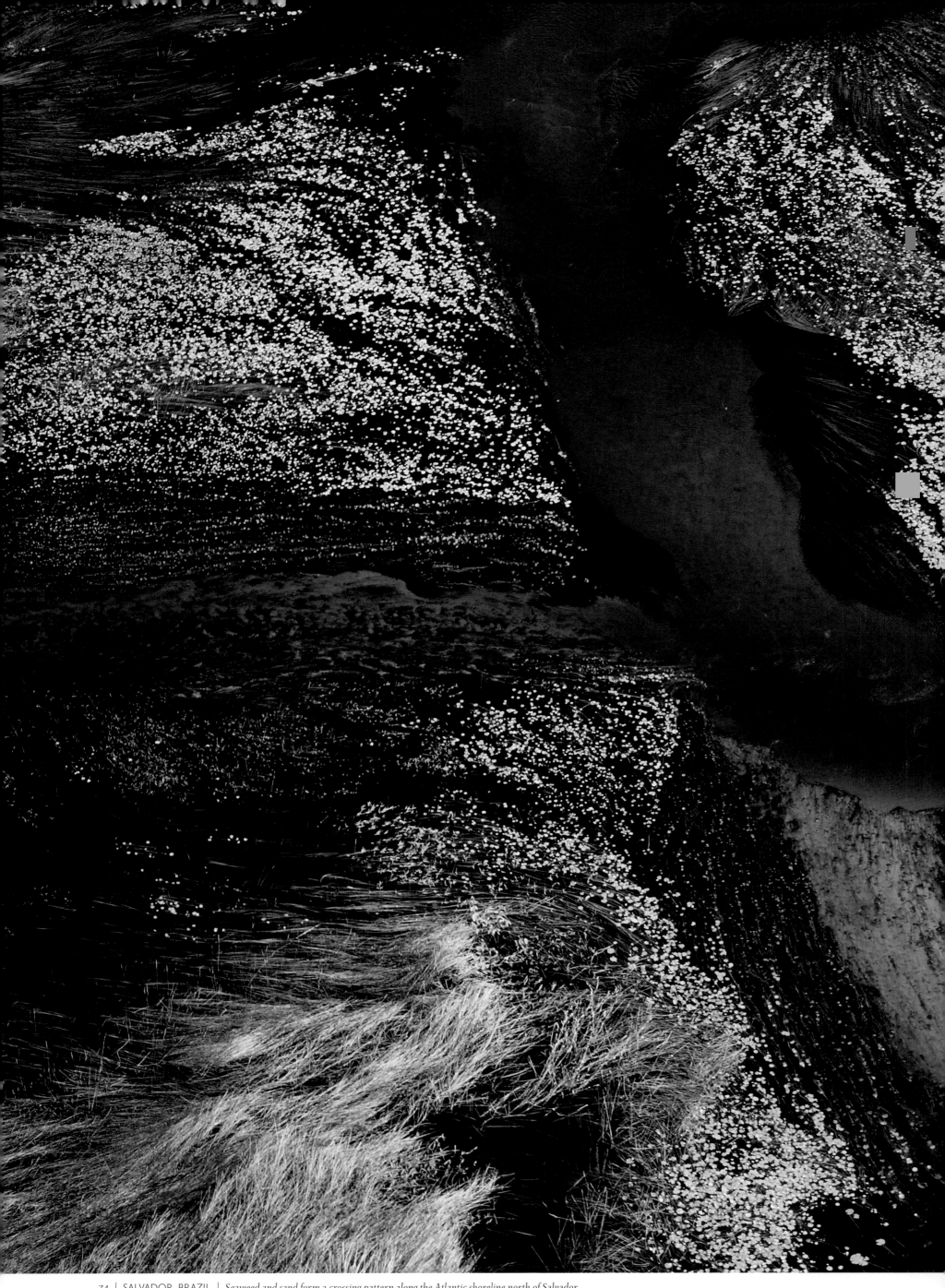

Seaweed and sand form a crossing pattern along the Atlantic shoreline north of Salvador

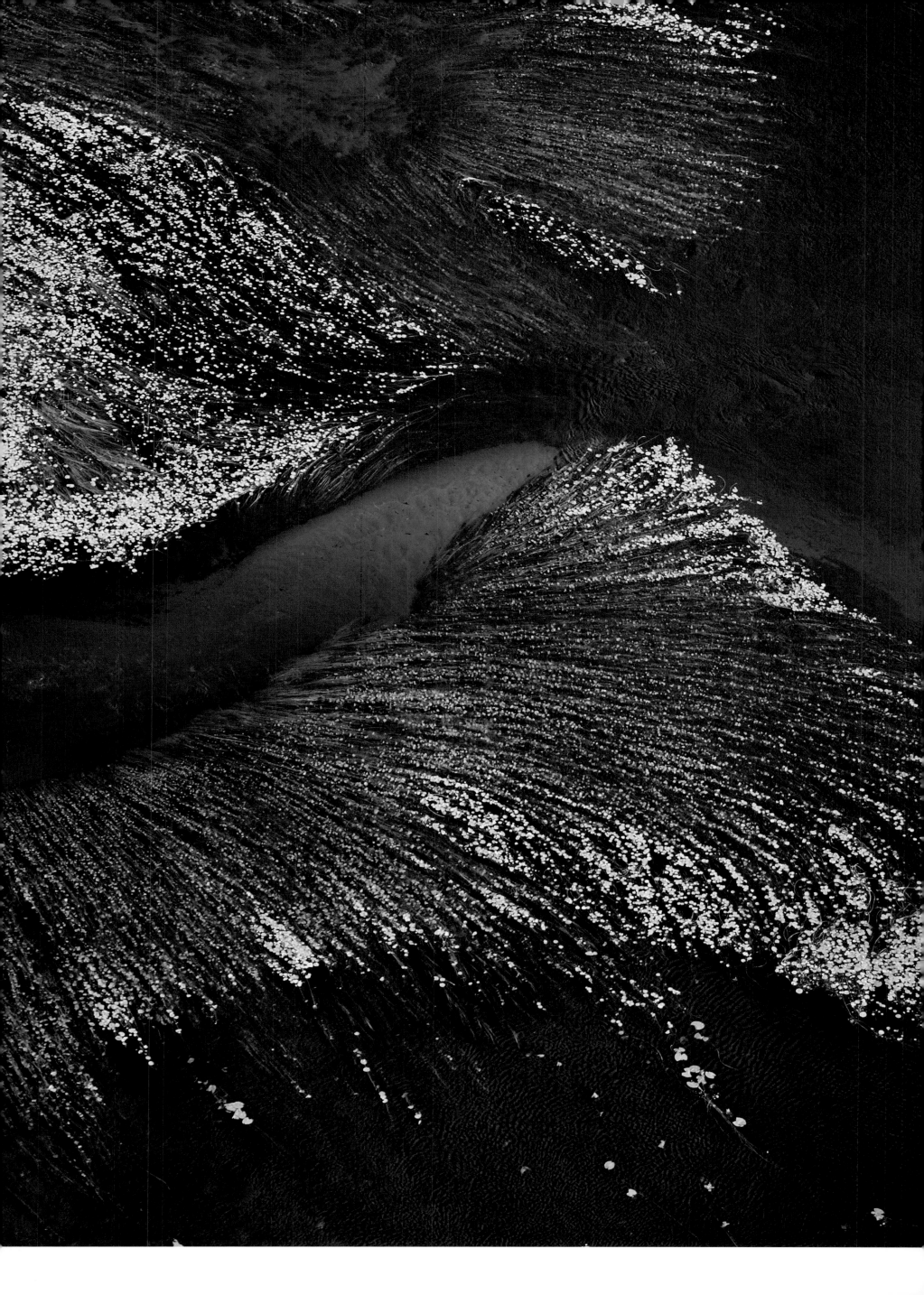

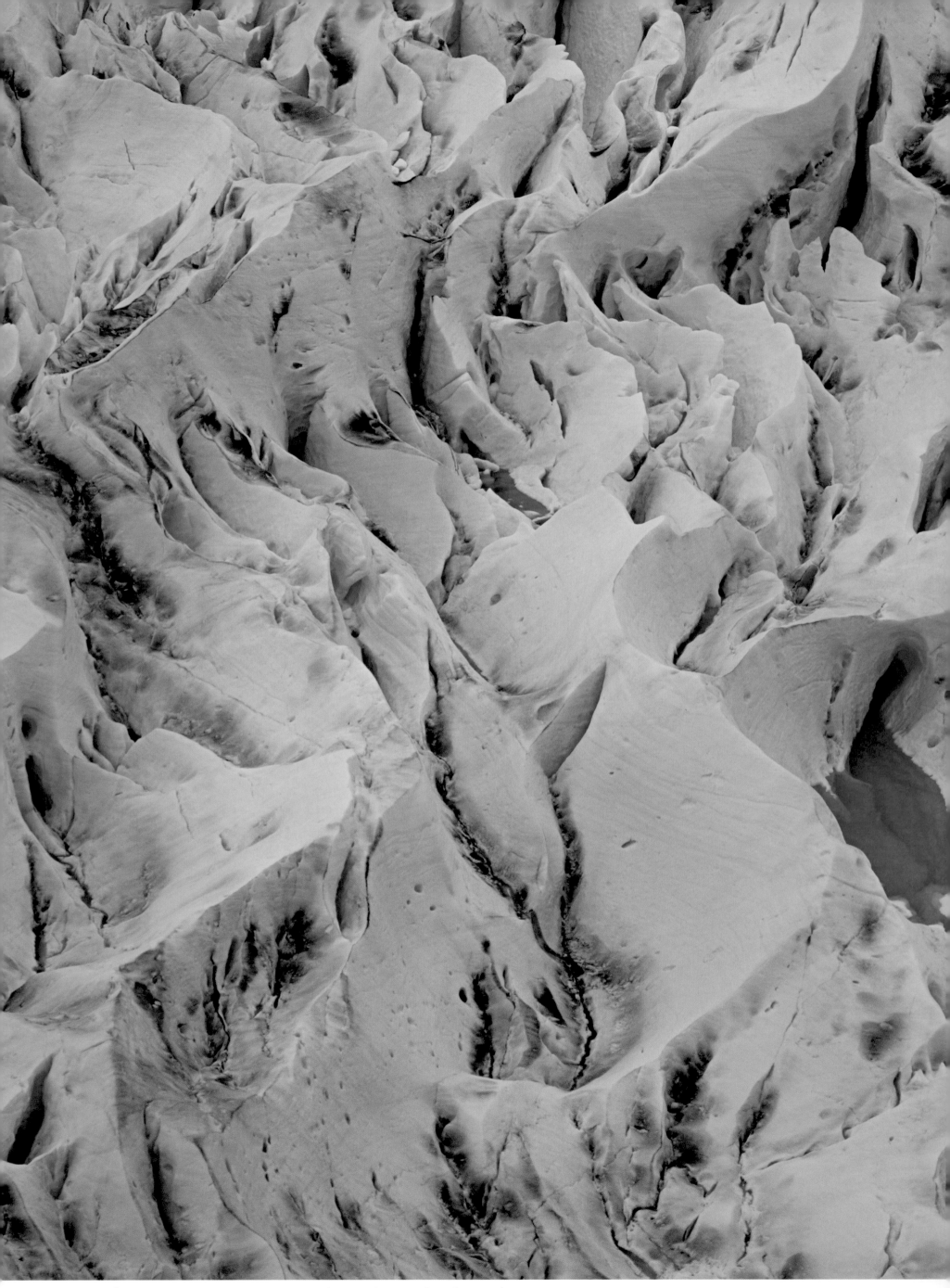

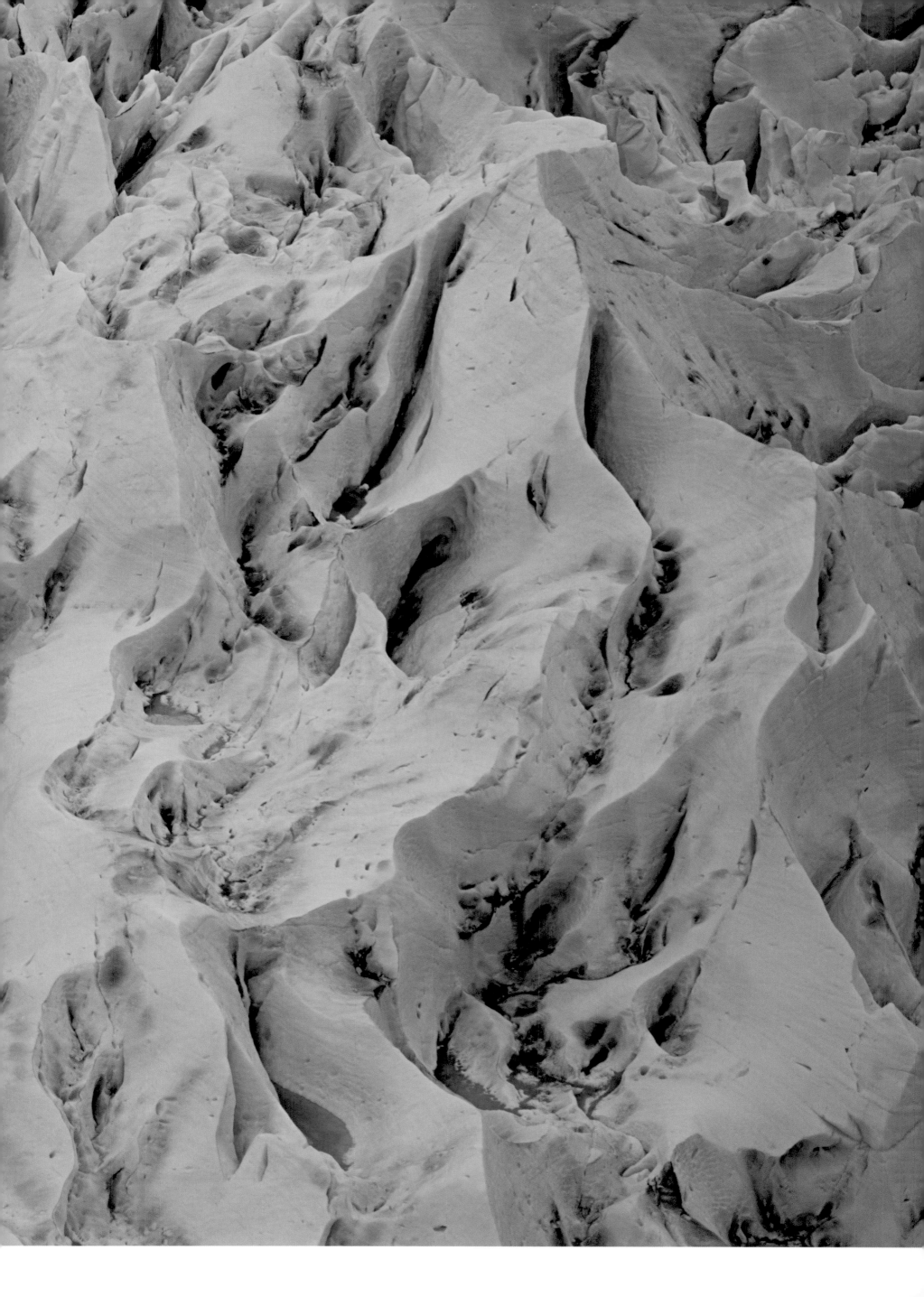

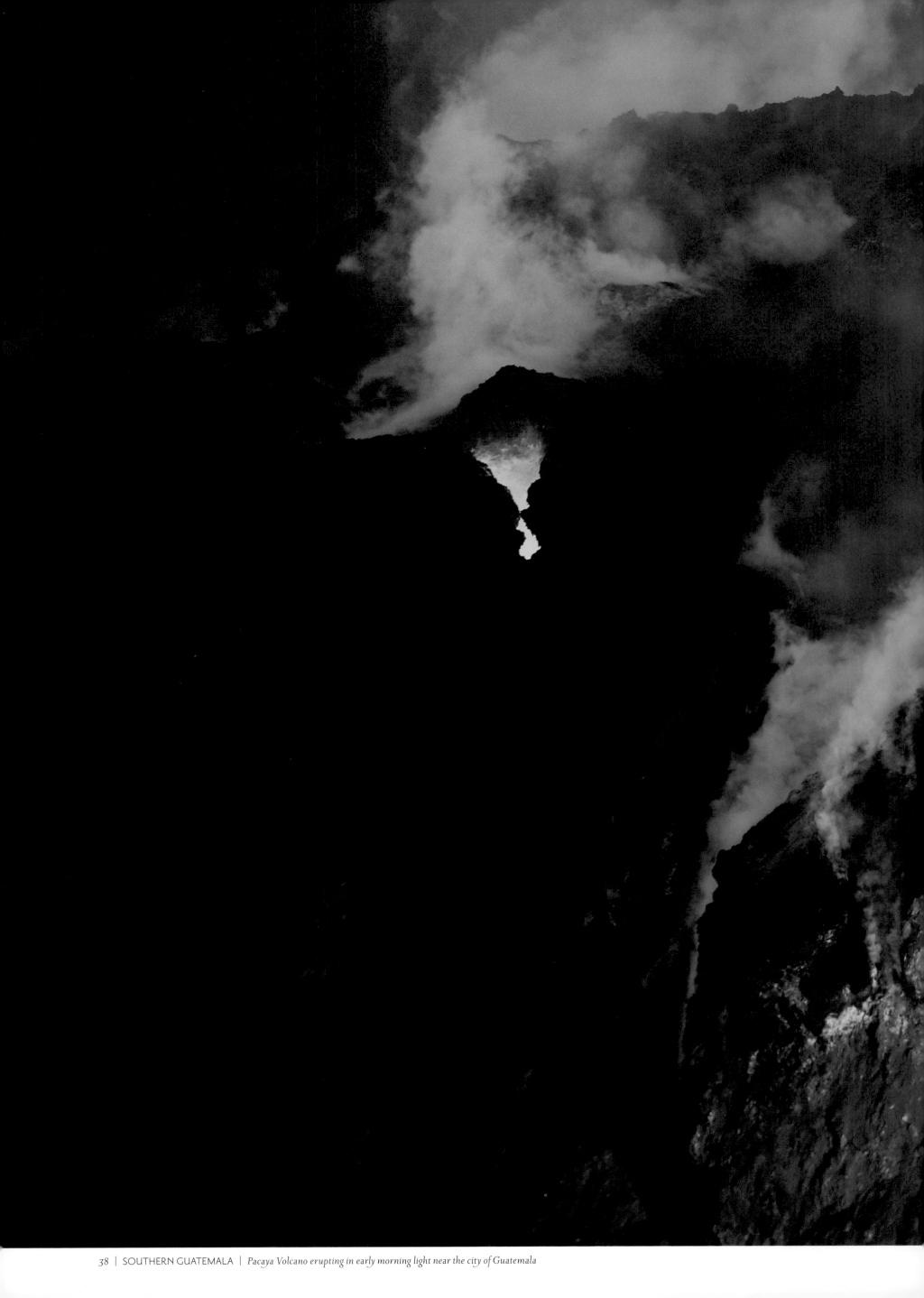

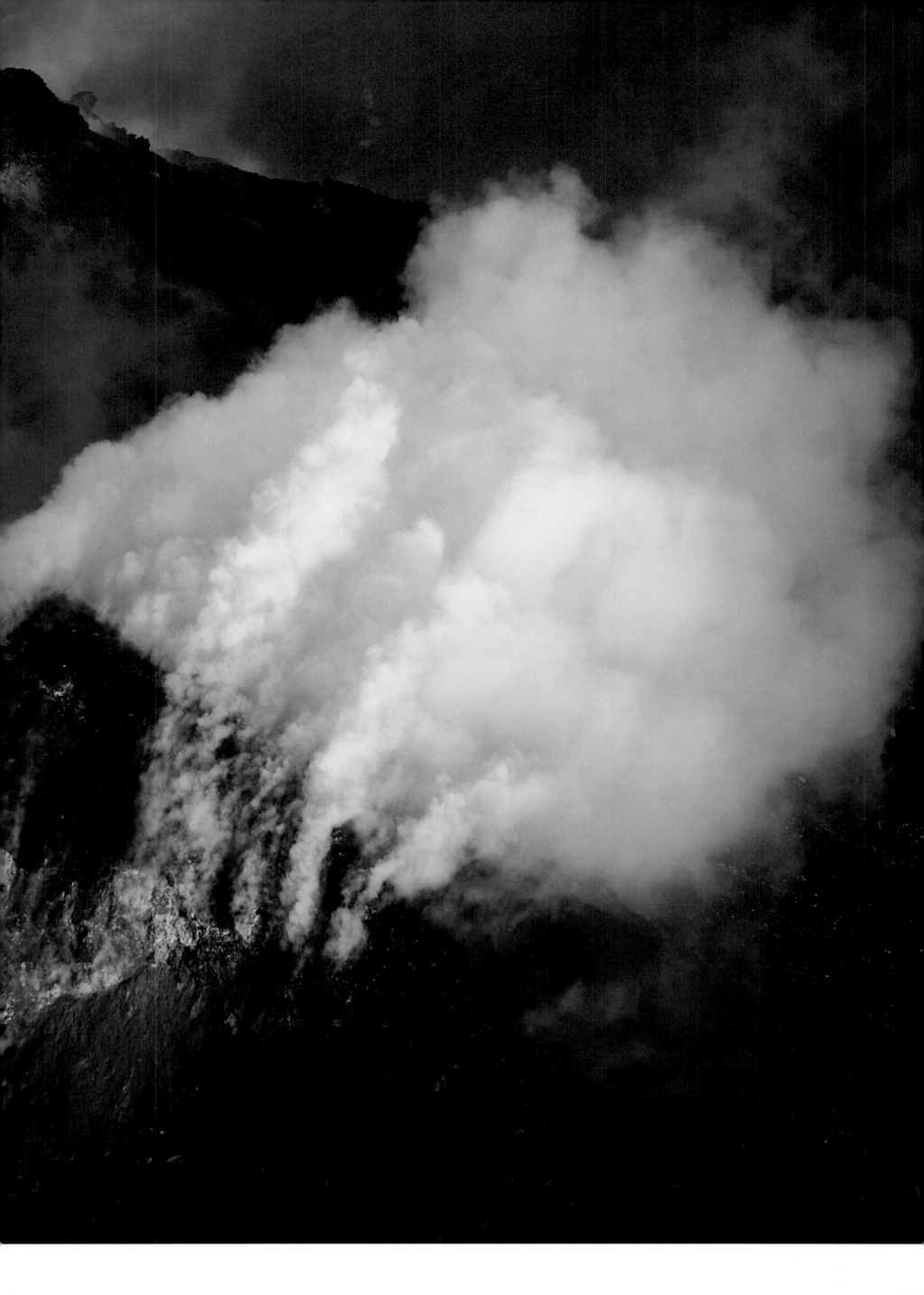

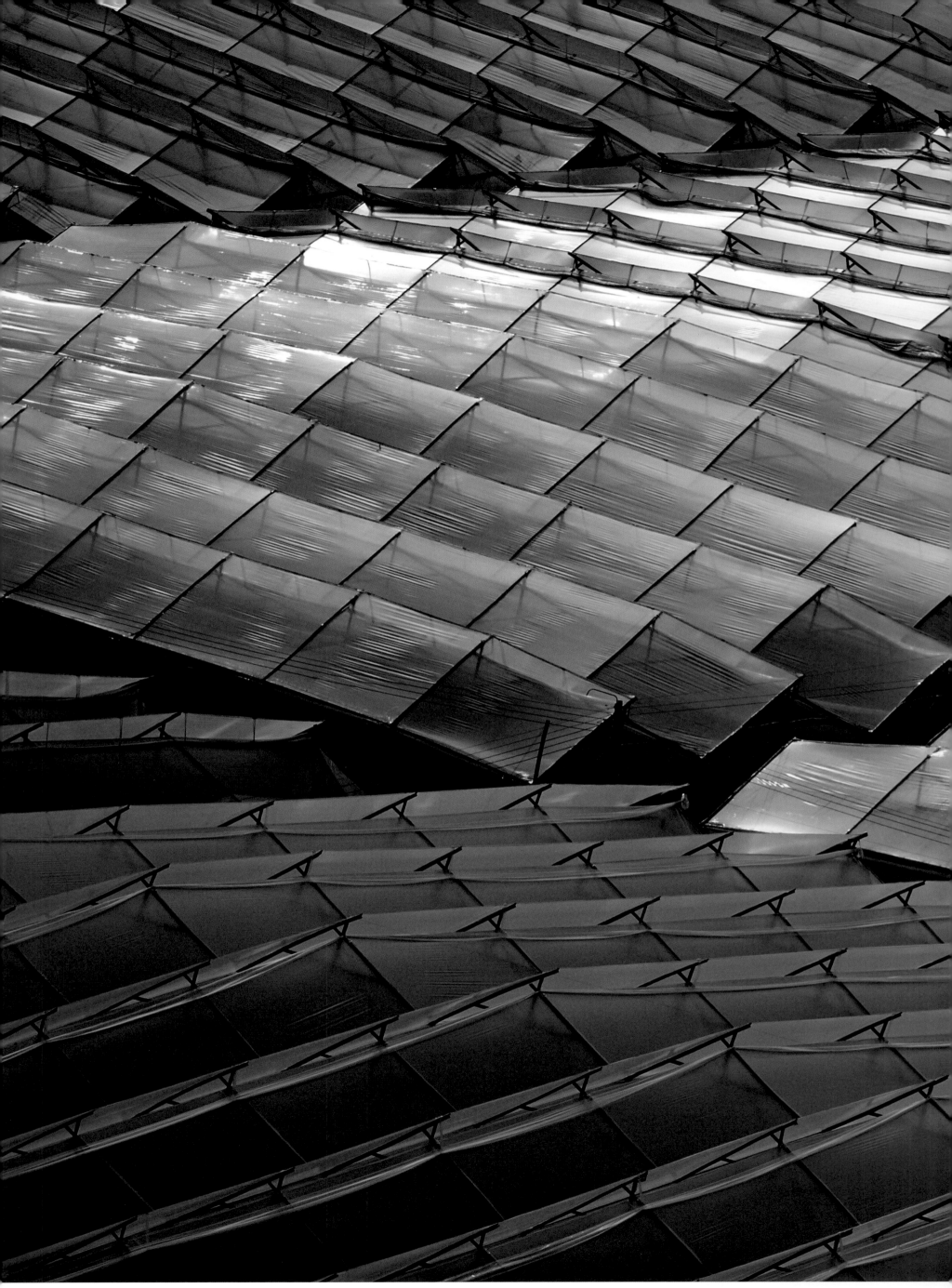

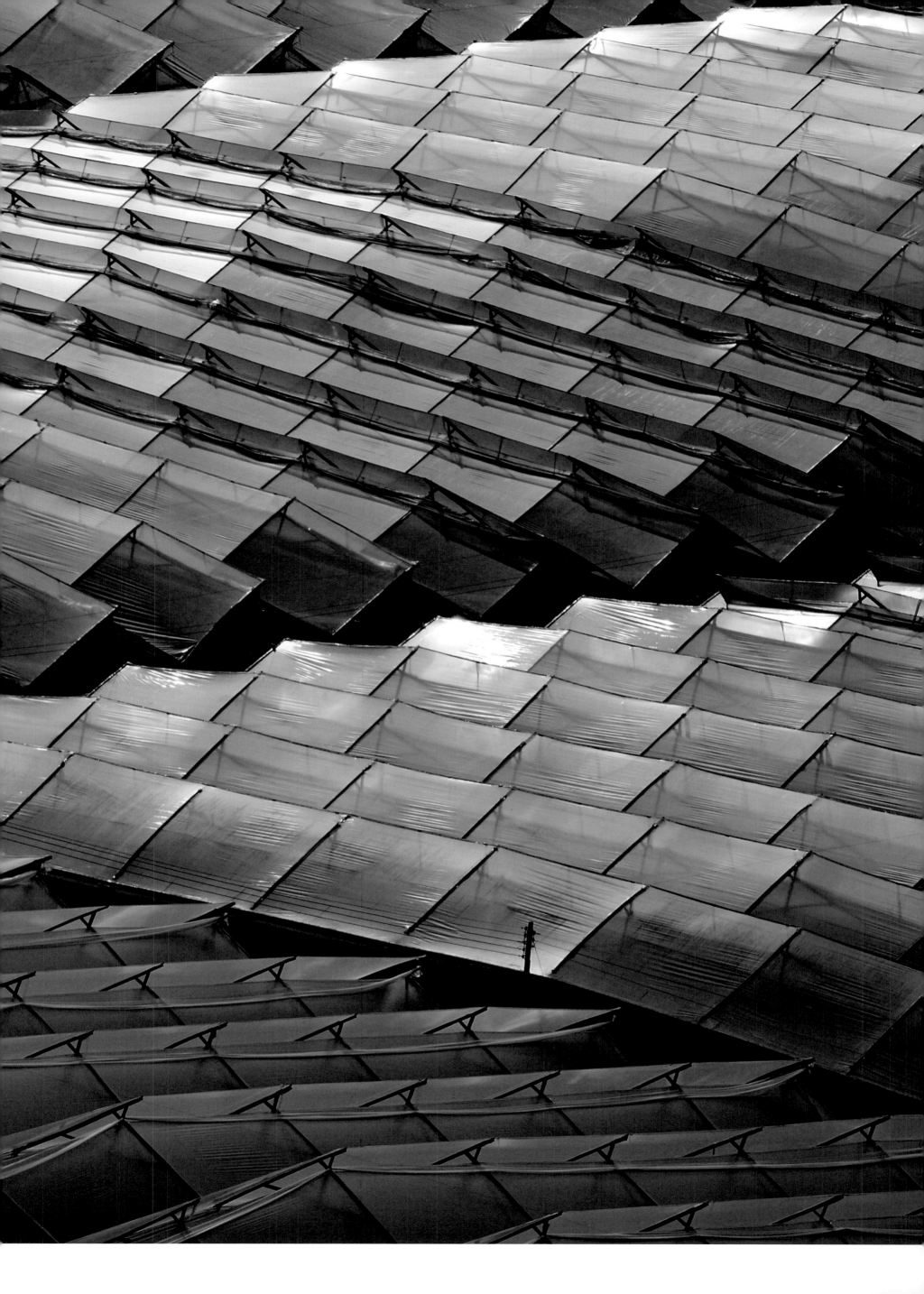

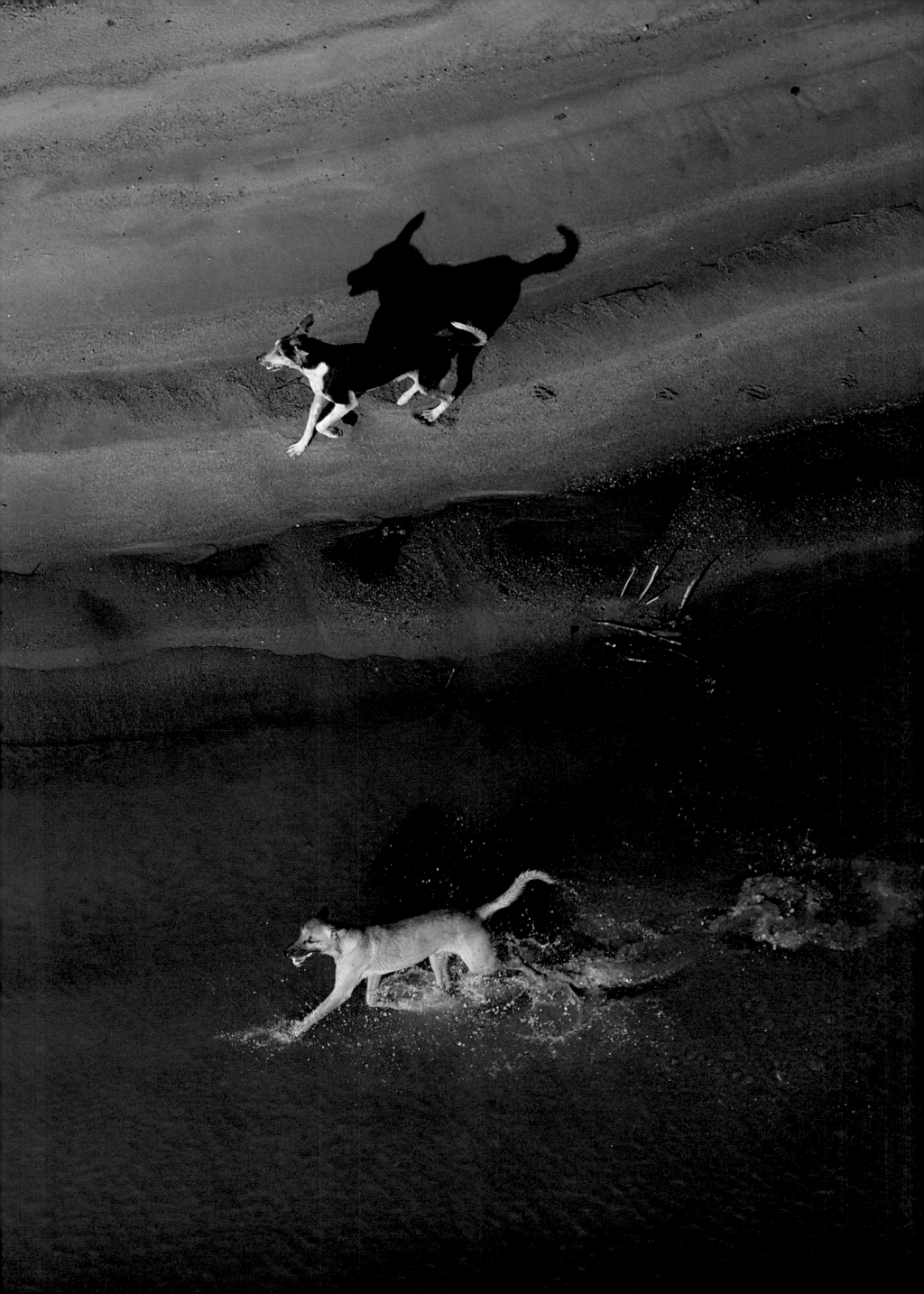

So Few Zebras in Brazil

THE ONLY REGRET I'VE HAD ABOUT MOVING ON TO LATIN AMERICA AND LEAVING MY WORK IN AFRICA BEHIND IS THE FACT that there are so few zebras in Brazil…and only a handful of cheetahs in Argentina…and just one or two herds of elephants in Chile. Actually, there are none, and I do miss those animals that spiced up my life and my photographs over the past ten years.

There is nothing quite like the epic battle that pits a herd of buffalo against a pride of lions. And what could possibly match the sprint for survival that unfolds between a cheetah and an impala, or the sensual movement of a predatory leopard at dusk? But it is not just the blood-pumping confrontation between the hunter and the hunted that I miss. Even the thought of more pastoral scenes, such as a collage of black-and-white stripes as a herd of zebras lopes across the plains, causes my eyes to glaze over in a wave of nostalgia.

The menagerie of creatures that populates Mexico and South and Central America is not nearly as iconic as that of Africa, but there have been moments along the way that have raised my blood pressure to Serengeti-like levels. A seemingly infinite cluster of brilliant Caribbean flamingos banking over the Yucatán or a platoon of 25 nurse sharks shimmering in the shallow blue waters off the coast of Belize—magical sightings that have induced just such a reaction. When that happens, I know the truth of what I have been told so often: In the throes of such moments, my face takes on a wholly different cast, flushed with downright boyish glee.

What I've come to realize over the past few years is that each continent has its own character—its own center of gravity—that beckons to travelers from near and far. For Africa, that force is the animals, a timeless magnet that distinguishes this place from any other on Earth. The dizzying variety of species and the sheer size of the herds harken back to a time when mankind in Africa came in only one shade of skin color, and national boundaries had not yet been drawn across its landscape.

For Latin America, that force is the land itself. It is a surface dominated by the Andes, a massive line that threads its way across the entire length of South America, separating east from west and harboring the source of the region's great rivers. In Latin America, you may search in vain for the million-strong herds of wildebeests that migrate around the Serengeti-Masai Mara rain dial…but in Africa you would search in vain for a mountain range that spawns both frigid glaciers and hot-blooded volcanoes.

As a photographer, I must reflect the essence of my subject matter, not the longings of years gone by. Here, my mission is to capture the soul of Latin America on its own terms, not seek in the Amazon what truly belongs to the Okavango Delta. The more I've come to realize this, the more I've discovered that the magic of each continent dazzles just as brilliantly as that of any other…each one just speaks in a different tongue. —*RBH*

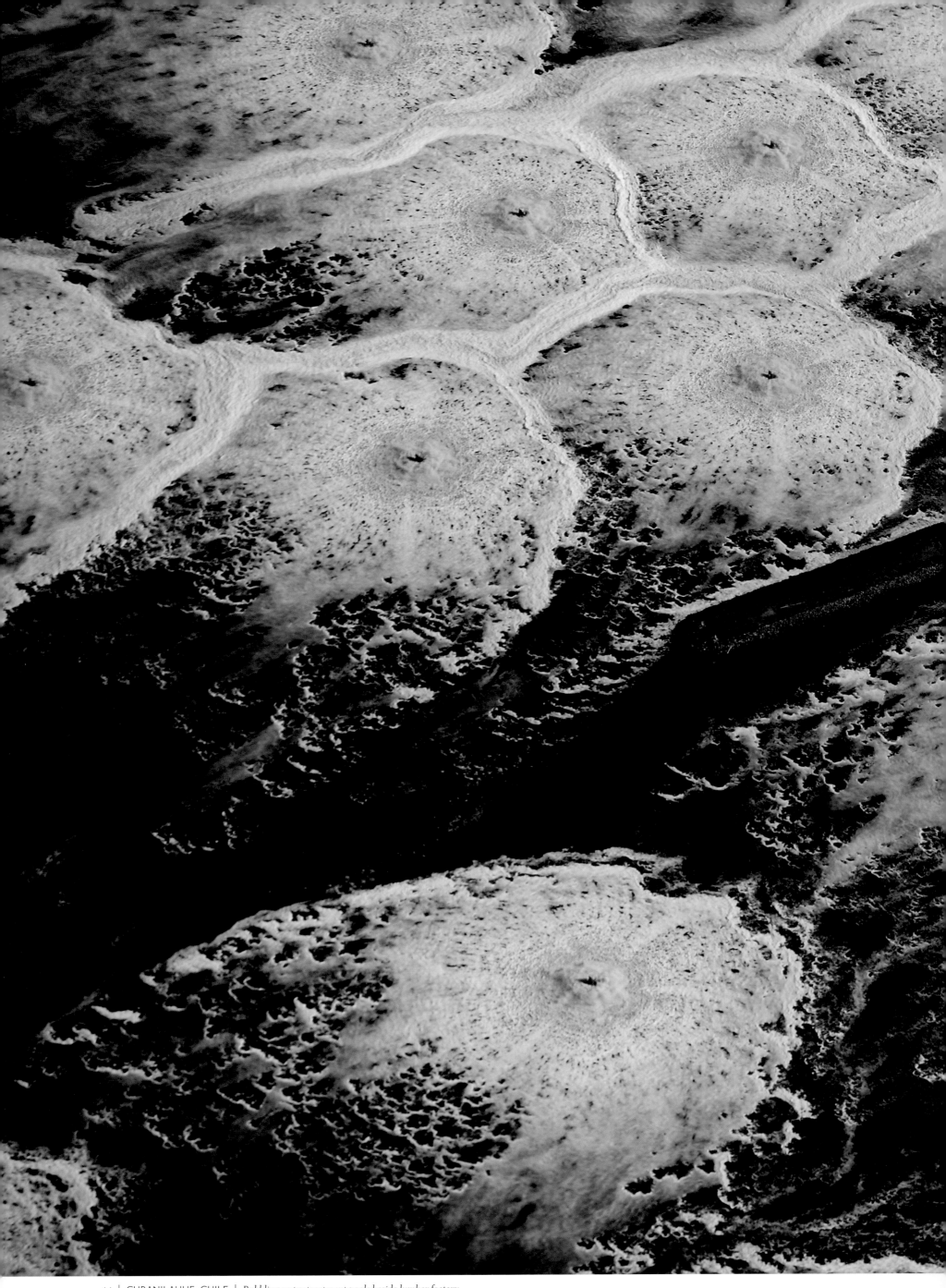

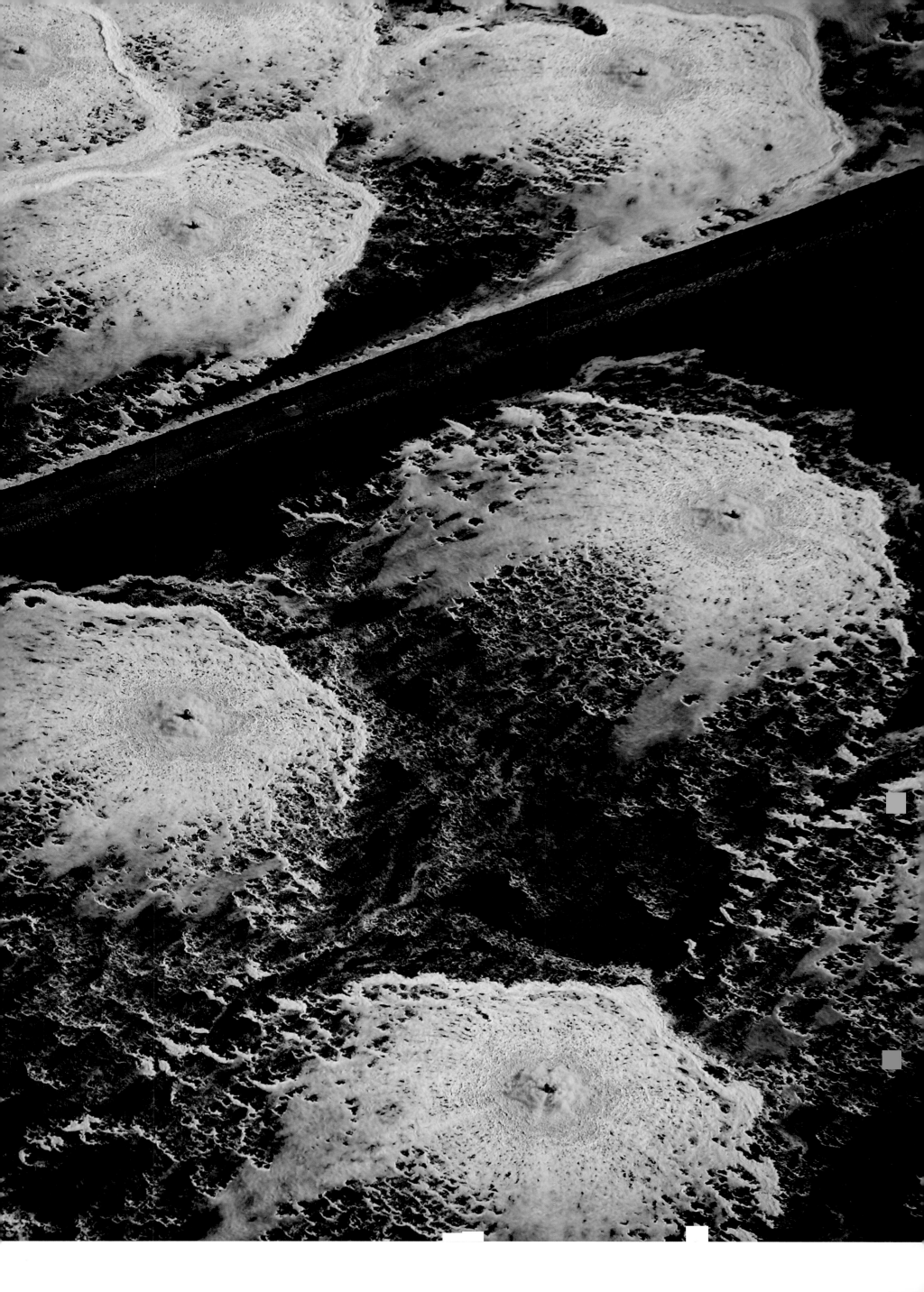

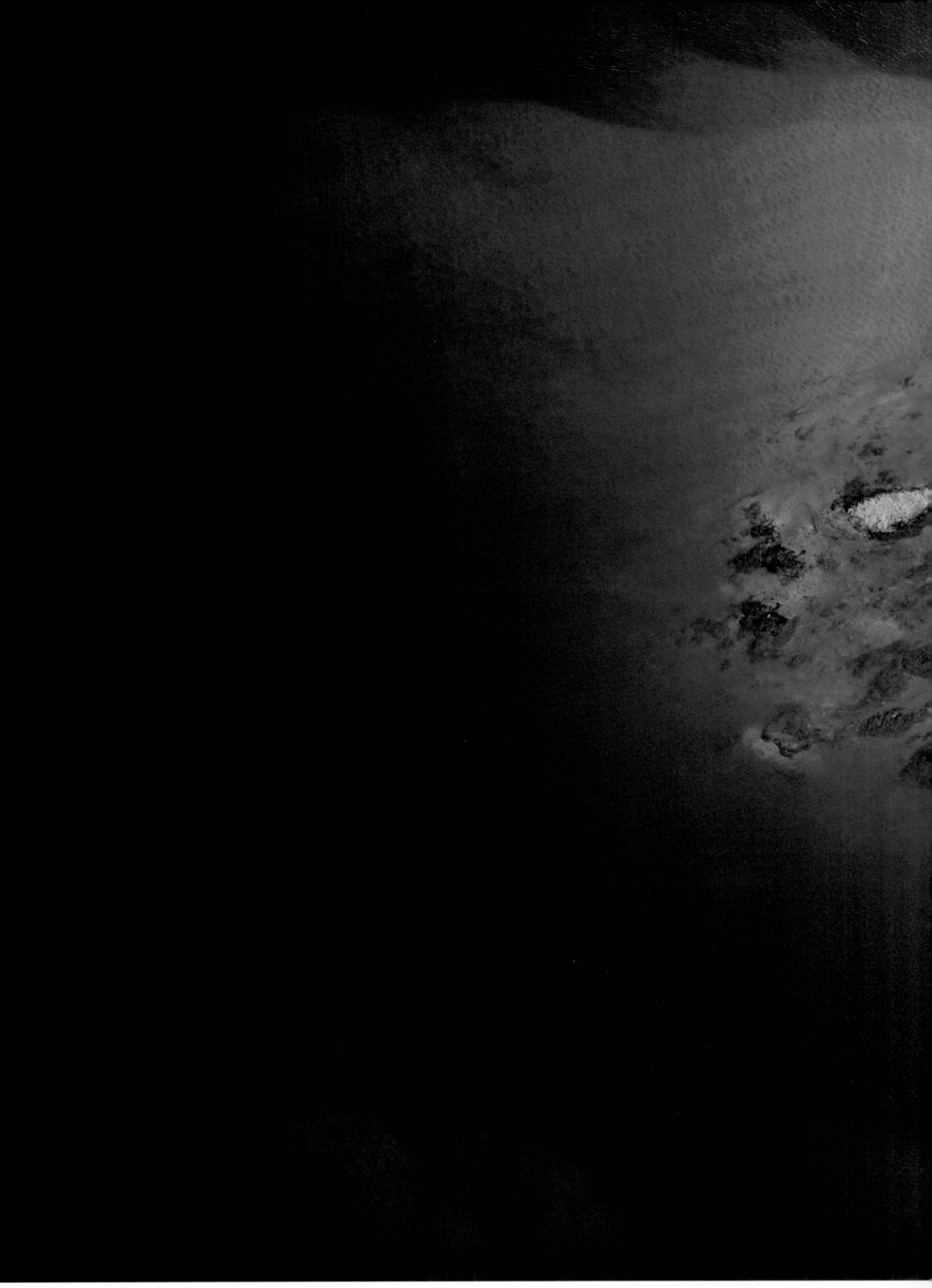

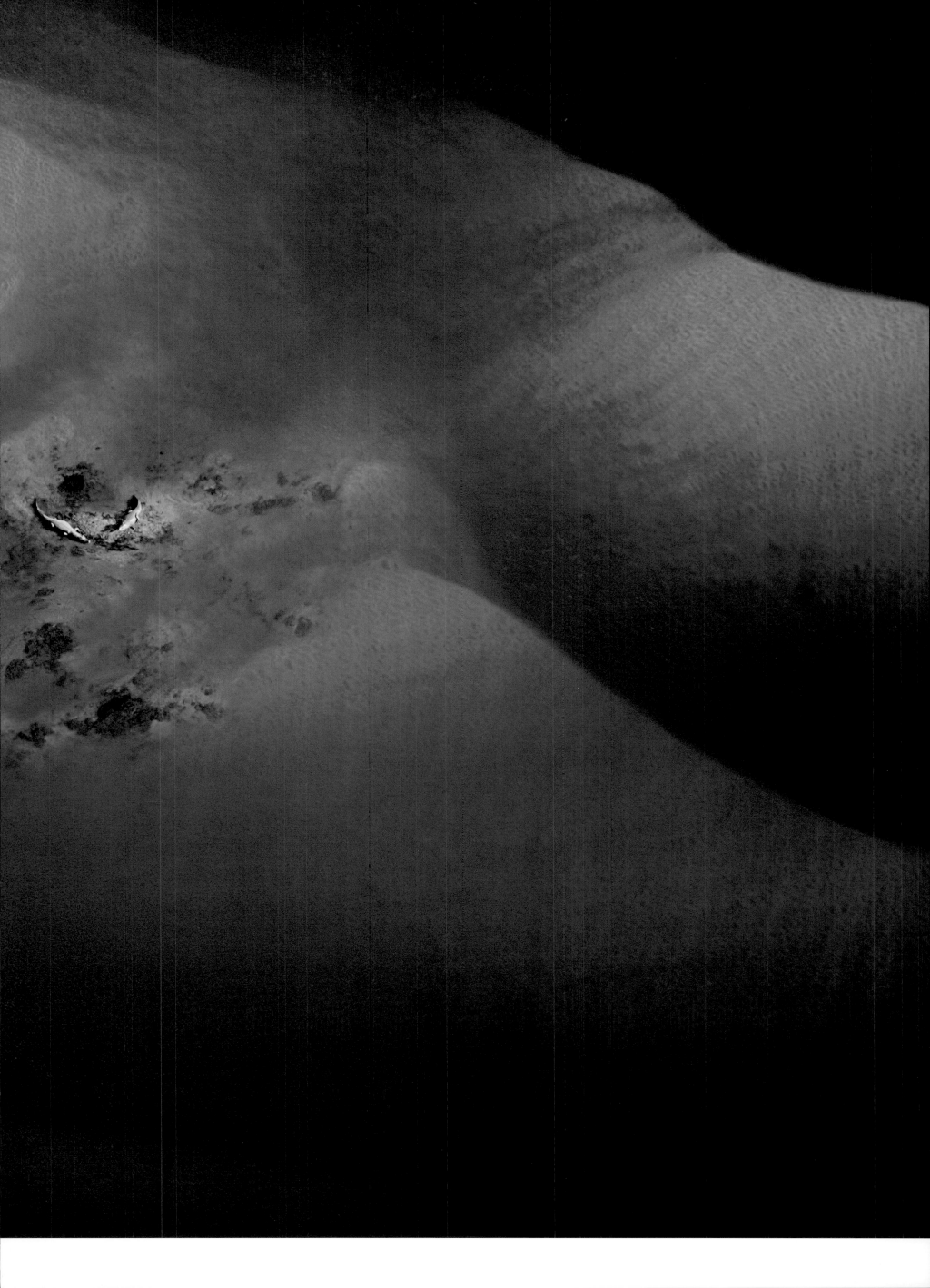

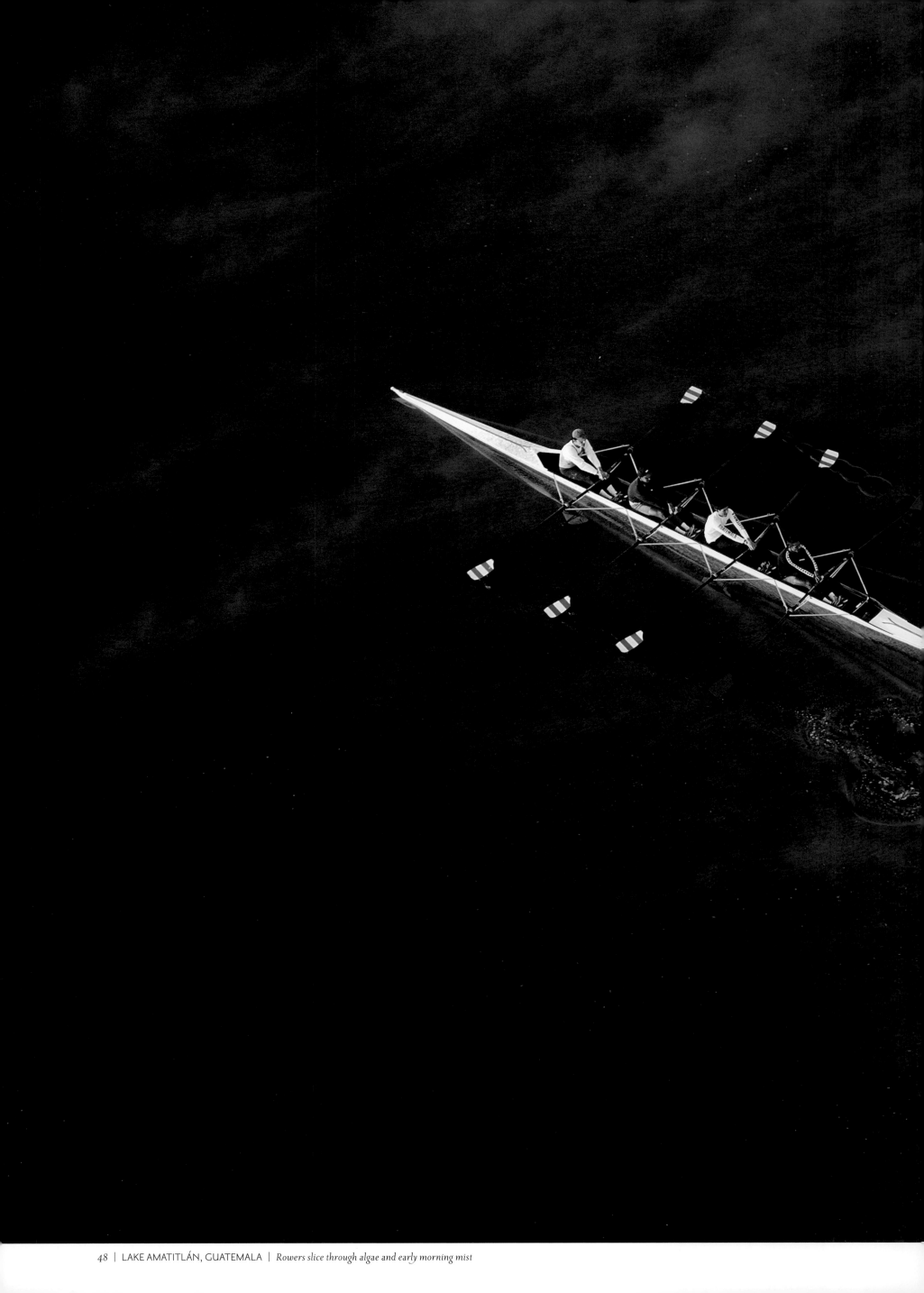

Rowers slice through algae and early morning mist

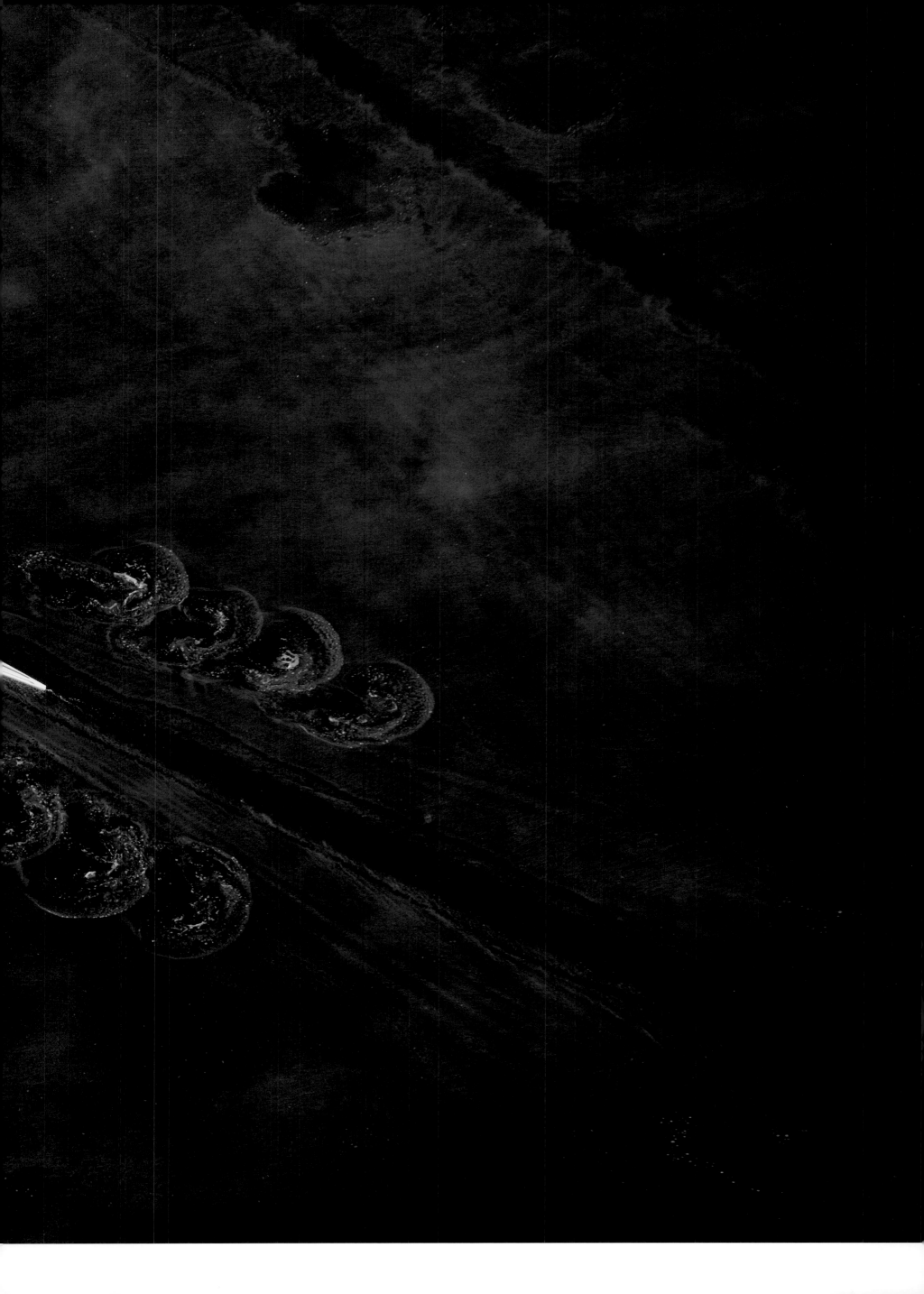

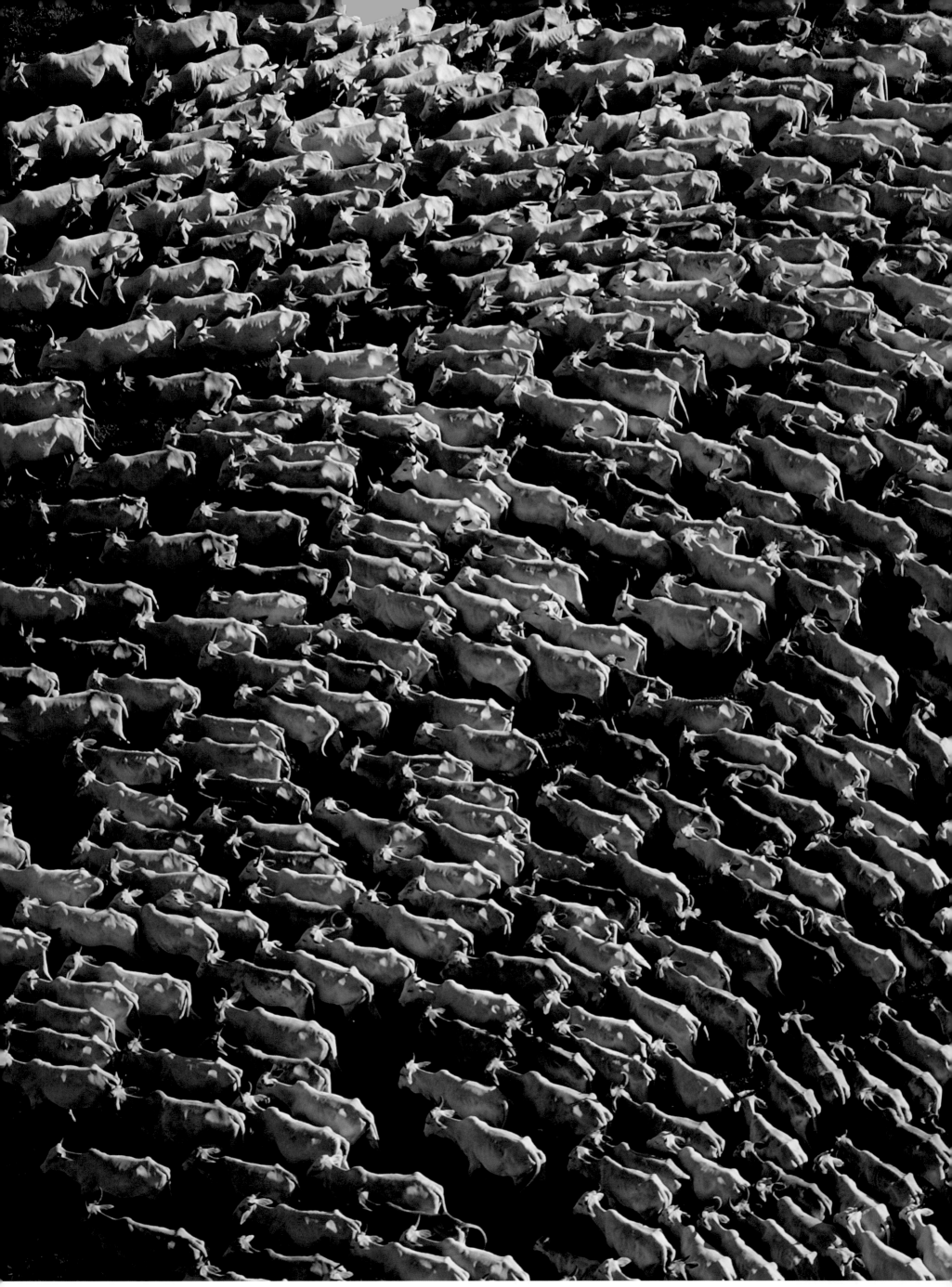

| MATO GROSSO DO SUL, BRAZIL | *Large herd of cattle being driven to richer grasslands in the southern Pantanal*

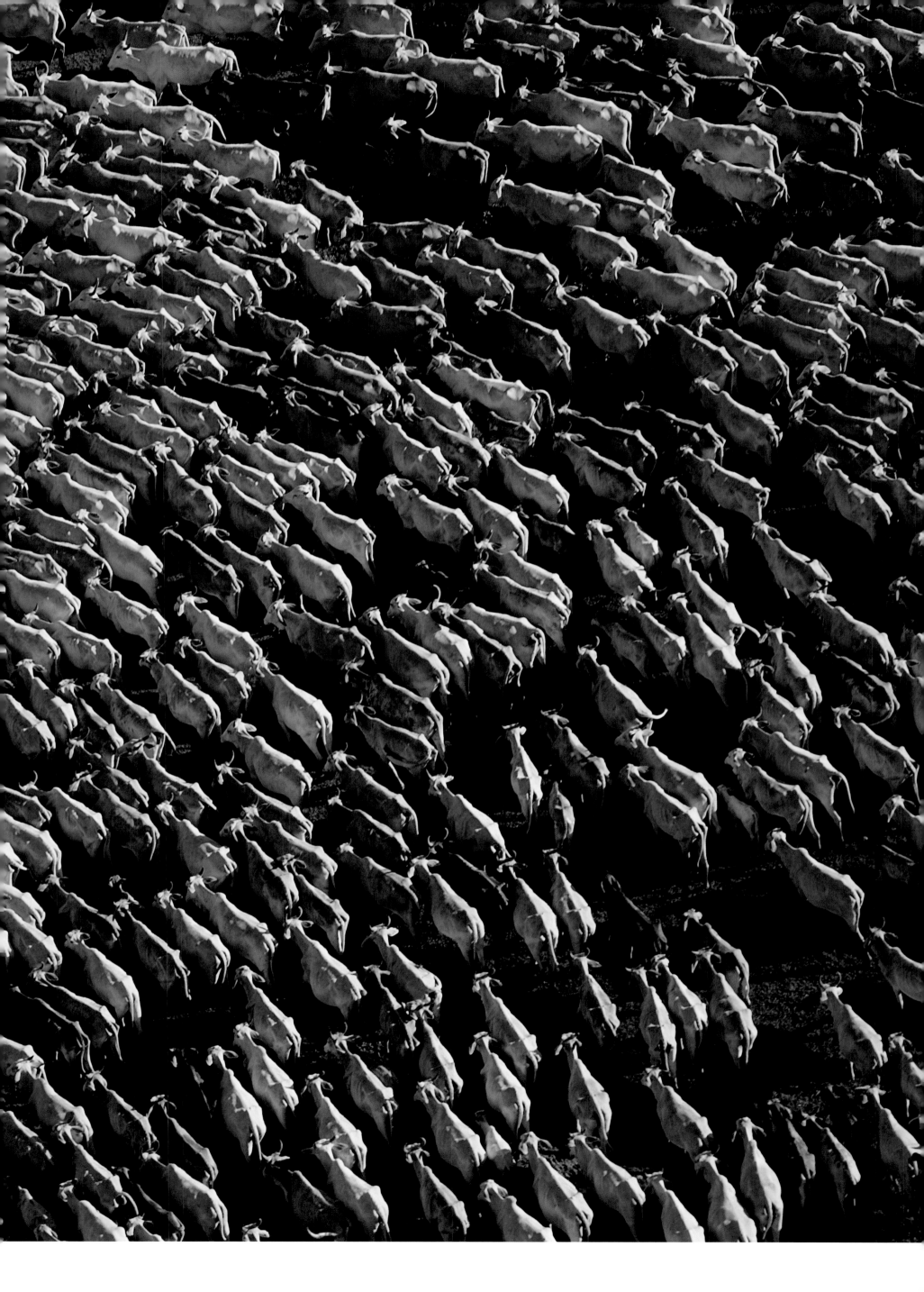

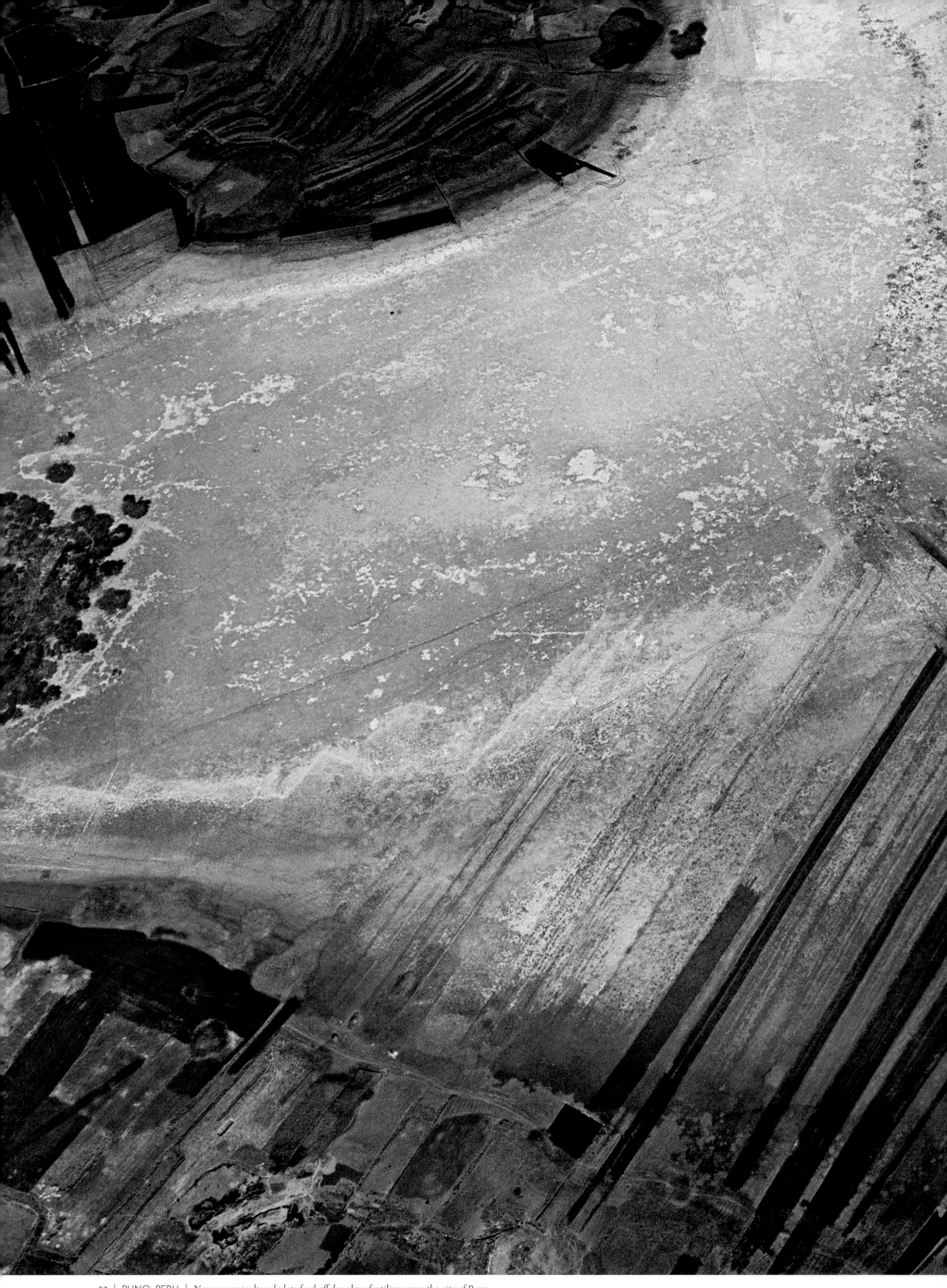

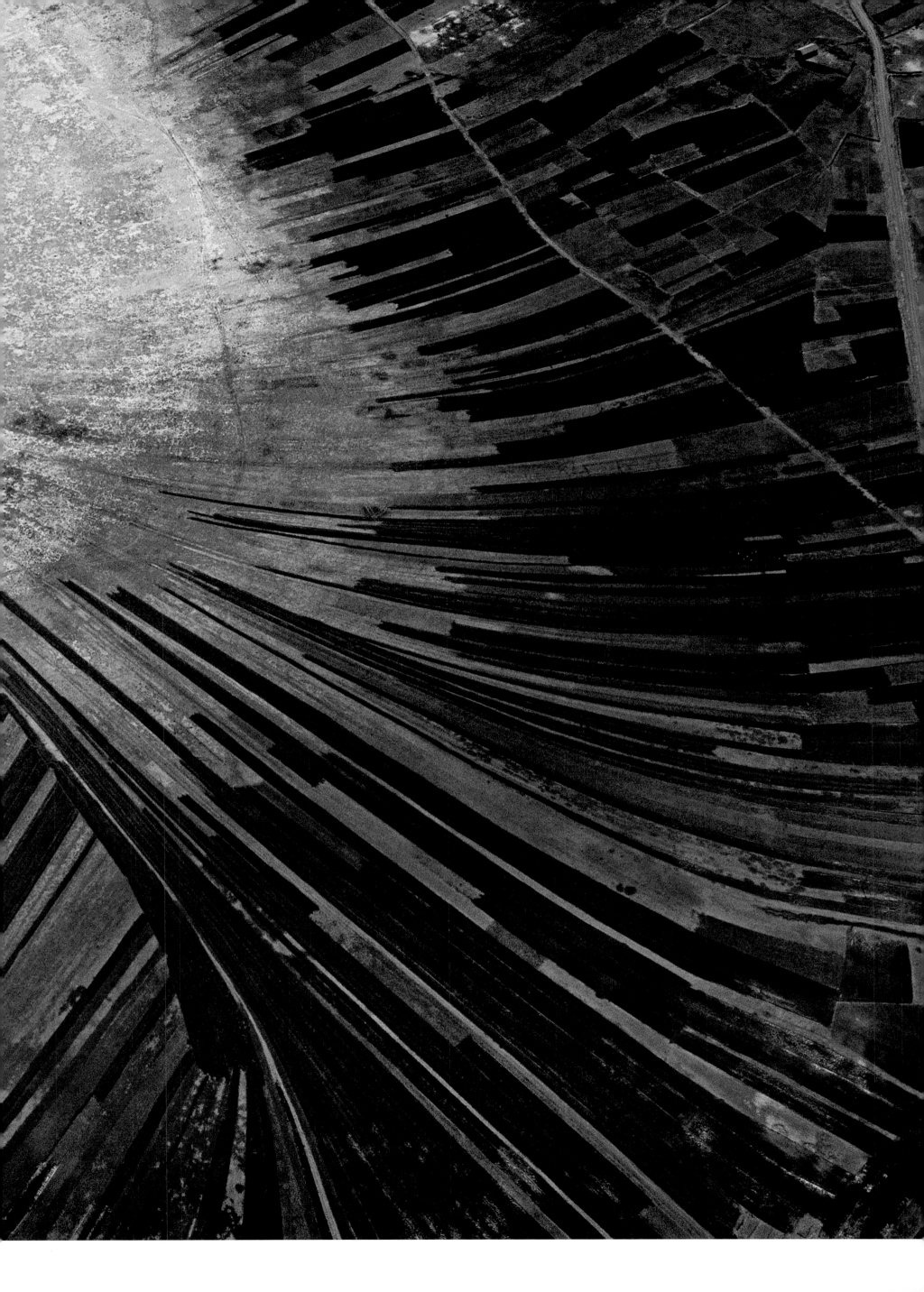

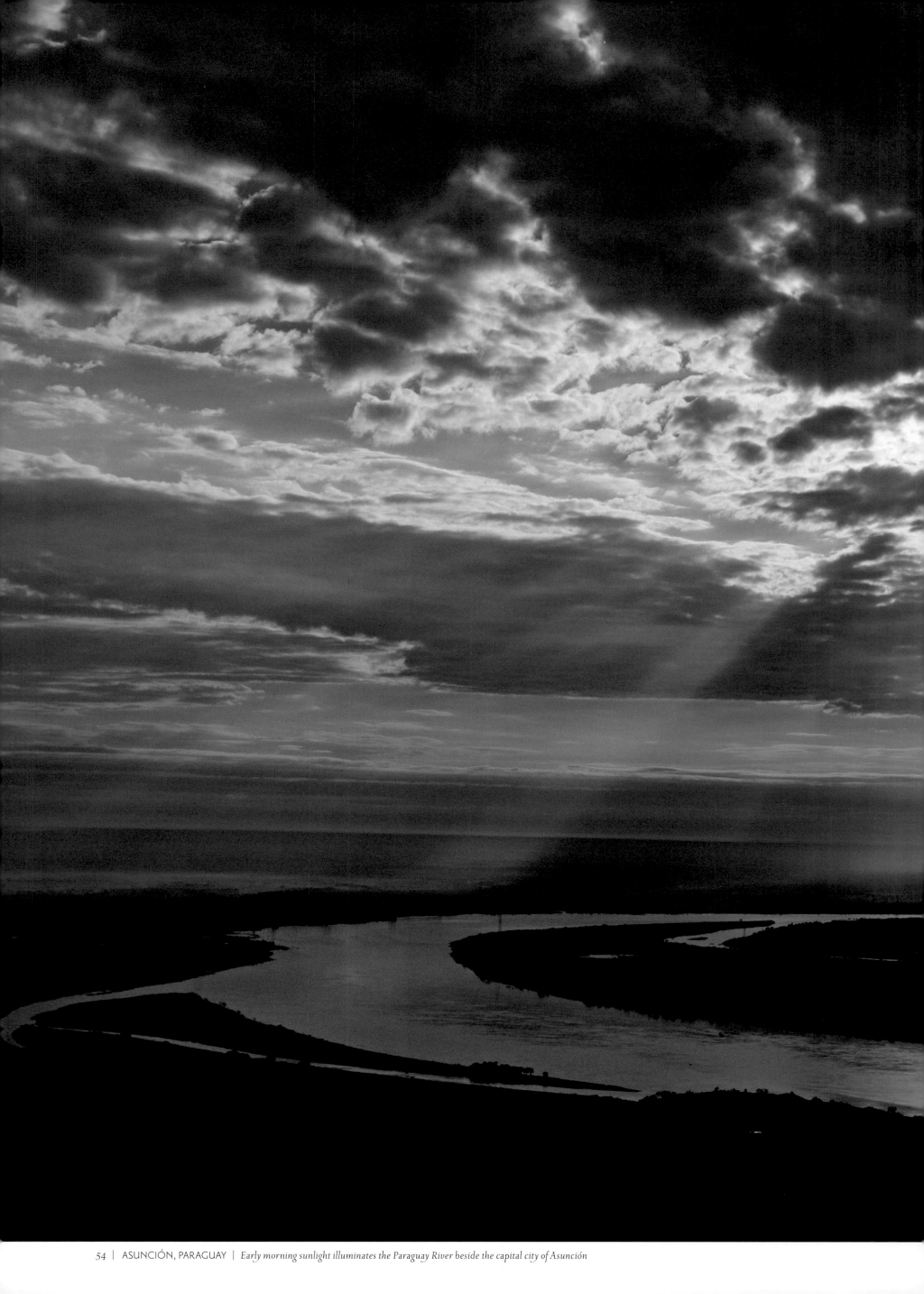

ASUNCIÓN, PARAGUAY | *Early morning sunlight illuminates the Paraguay River beside the capital city of Asunción*

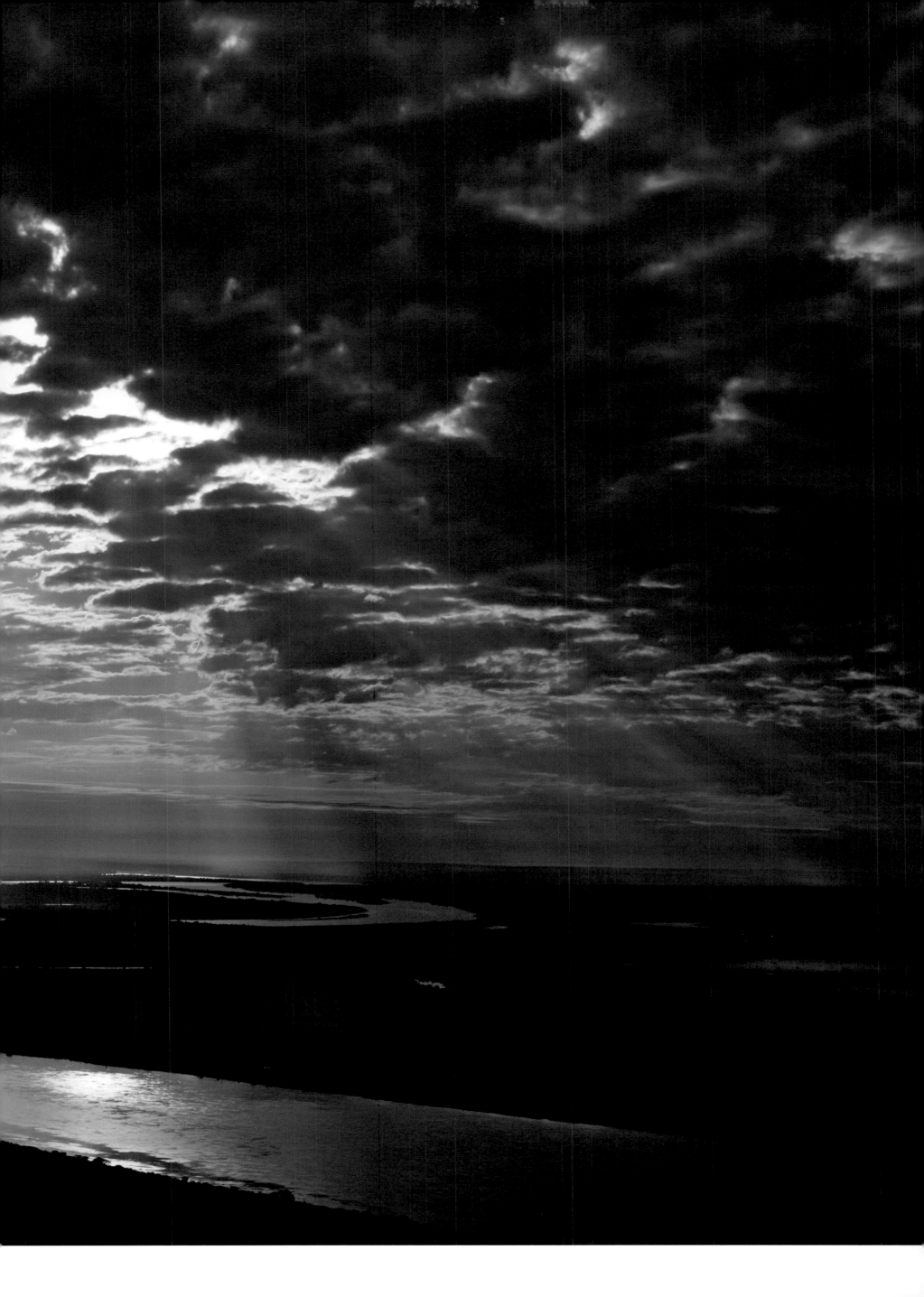

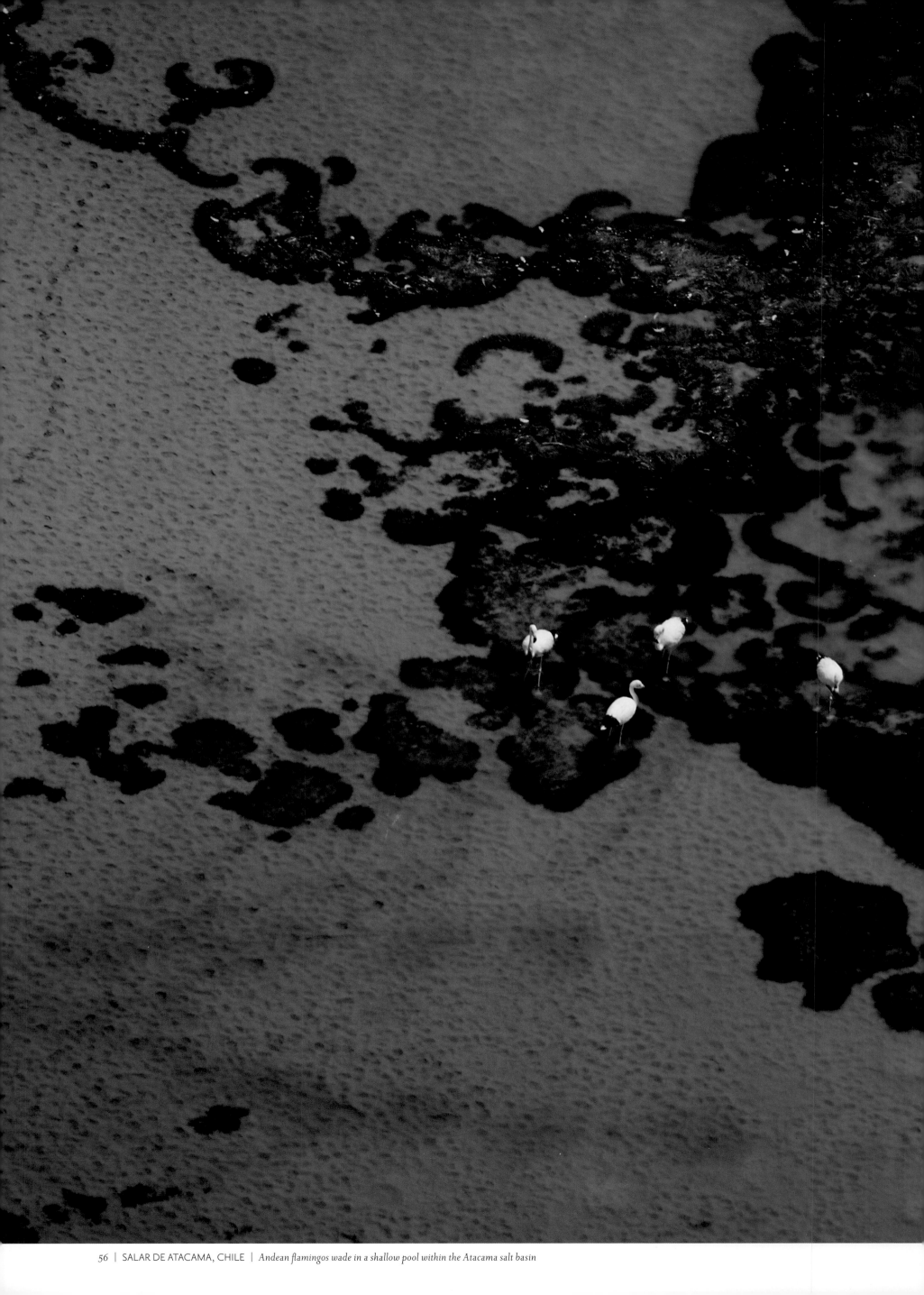

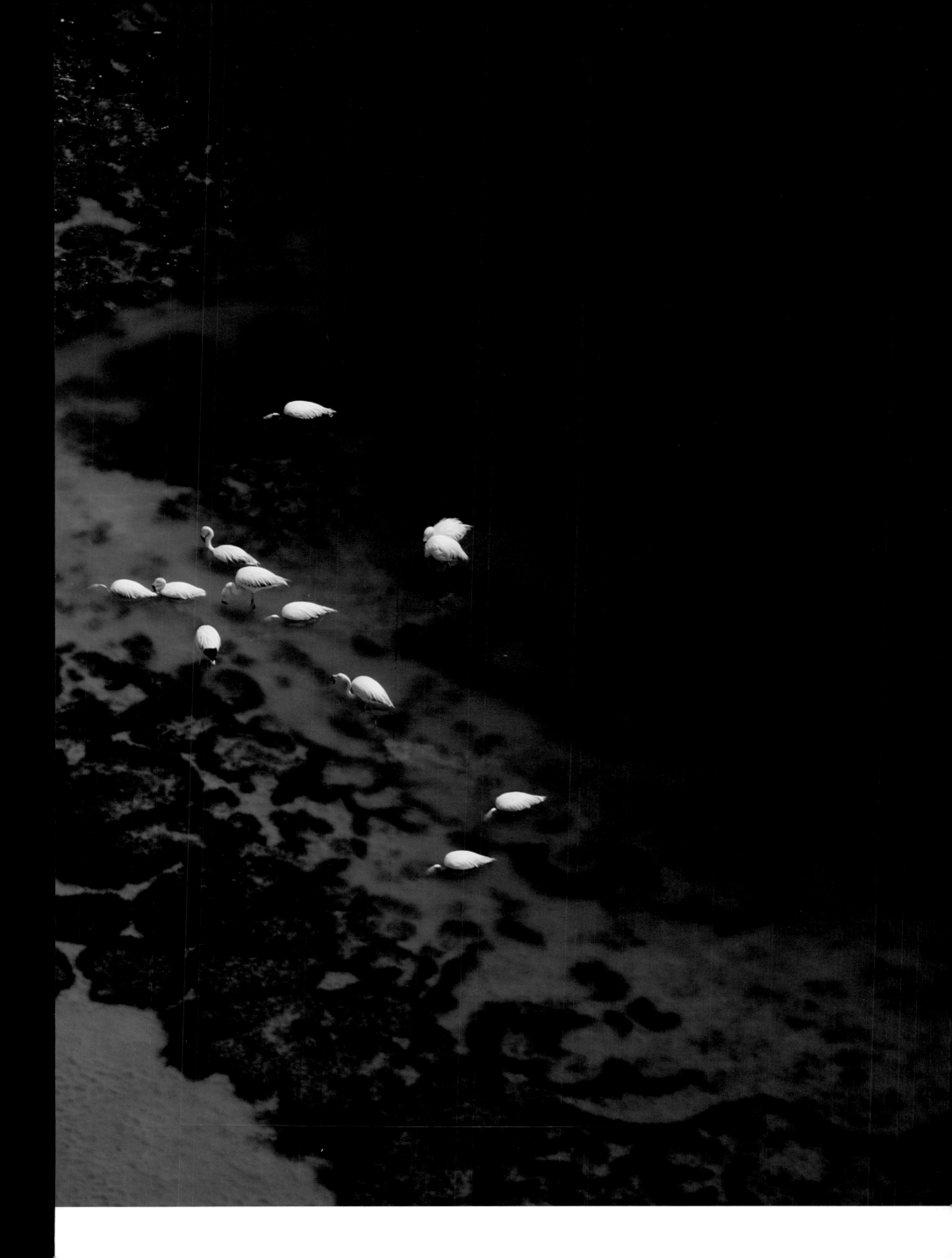

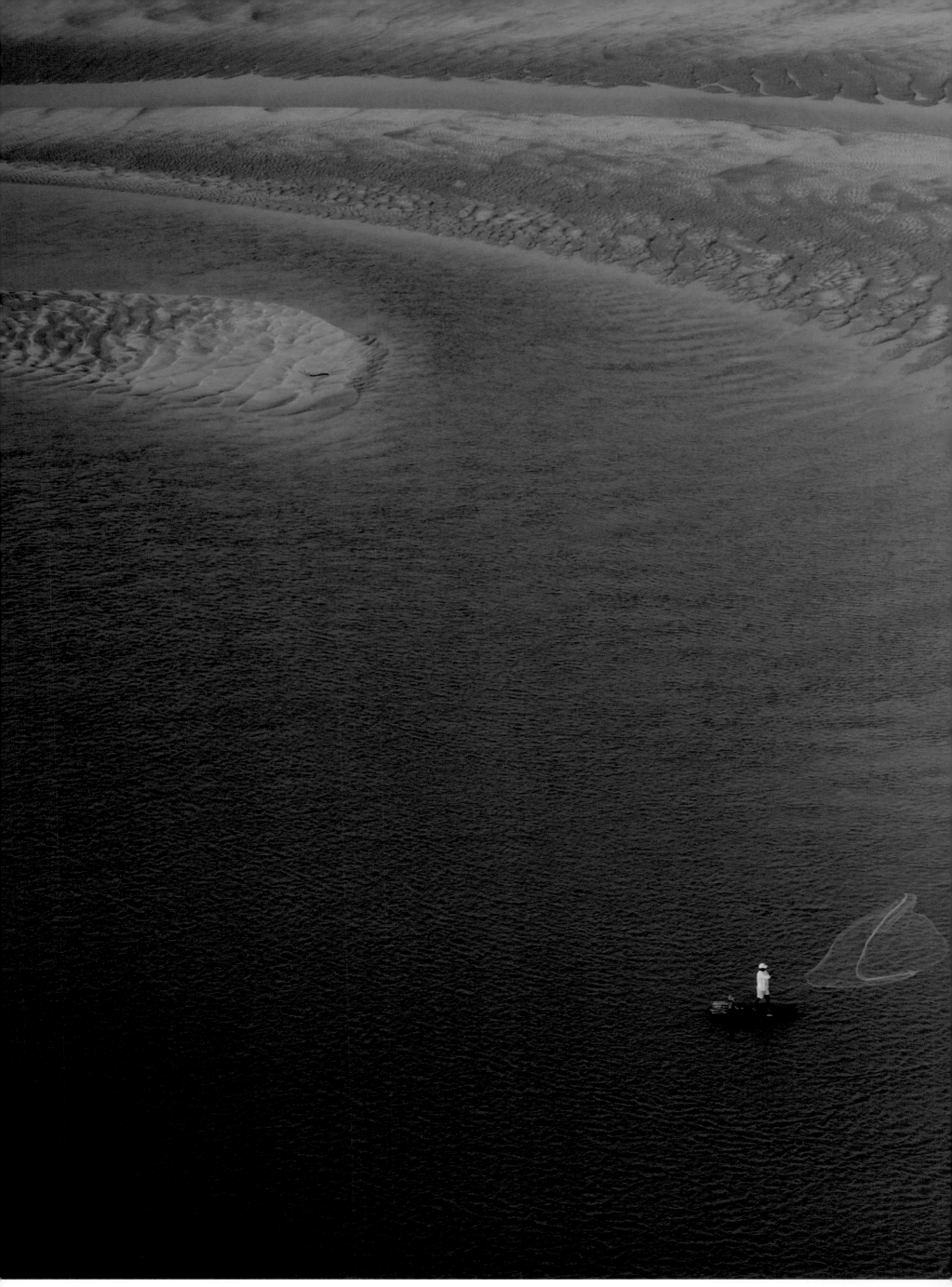

FORTALEZA, BRAZIL | *Fisherman casts his net into the shallow channels near Fortaleza*

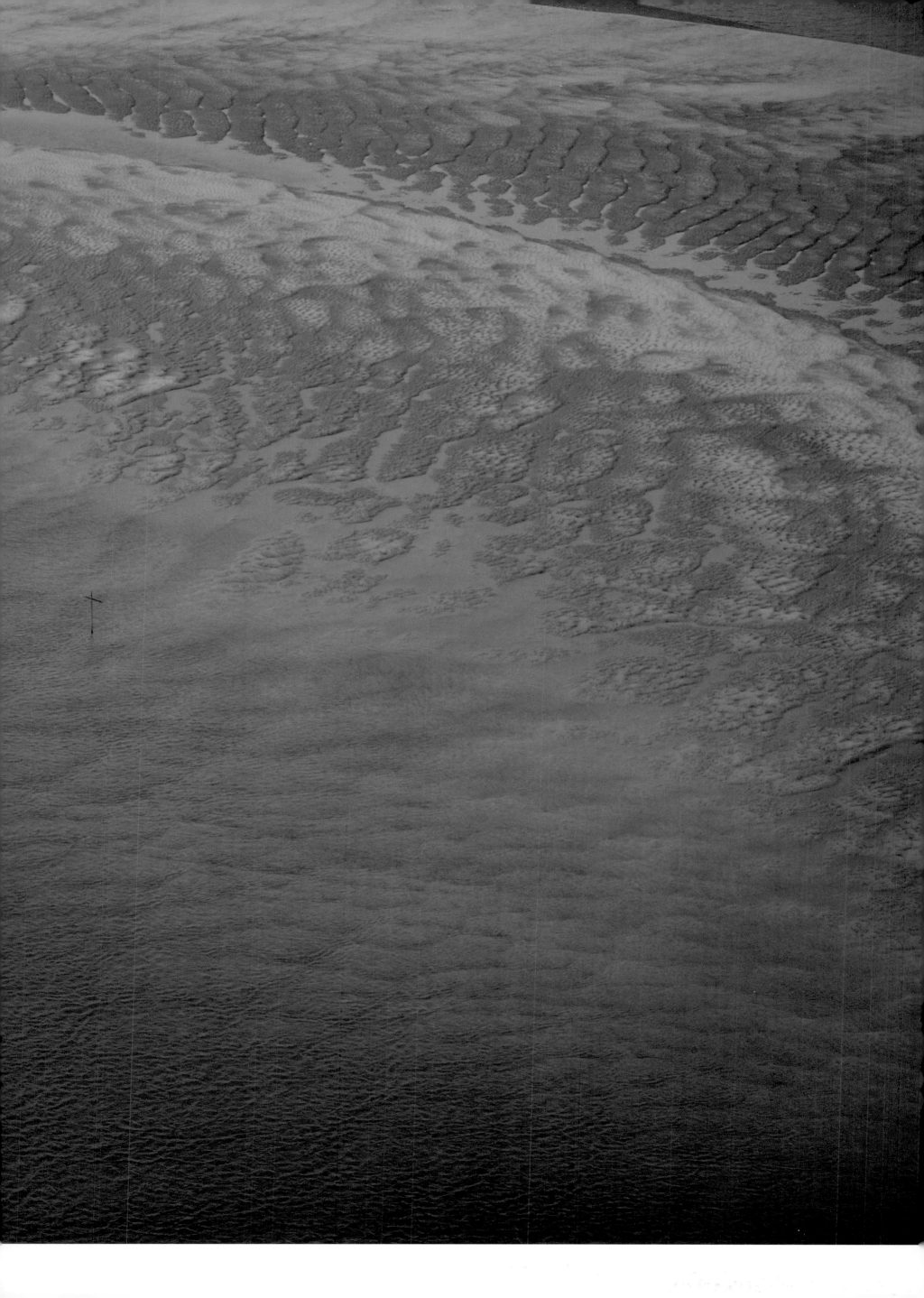

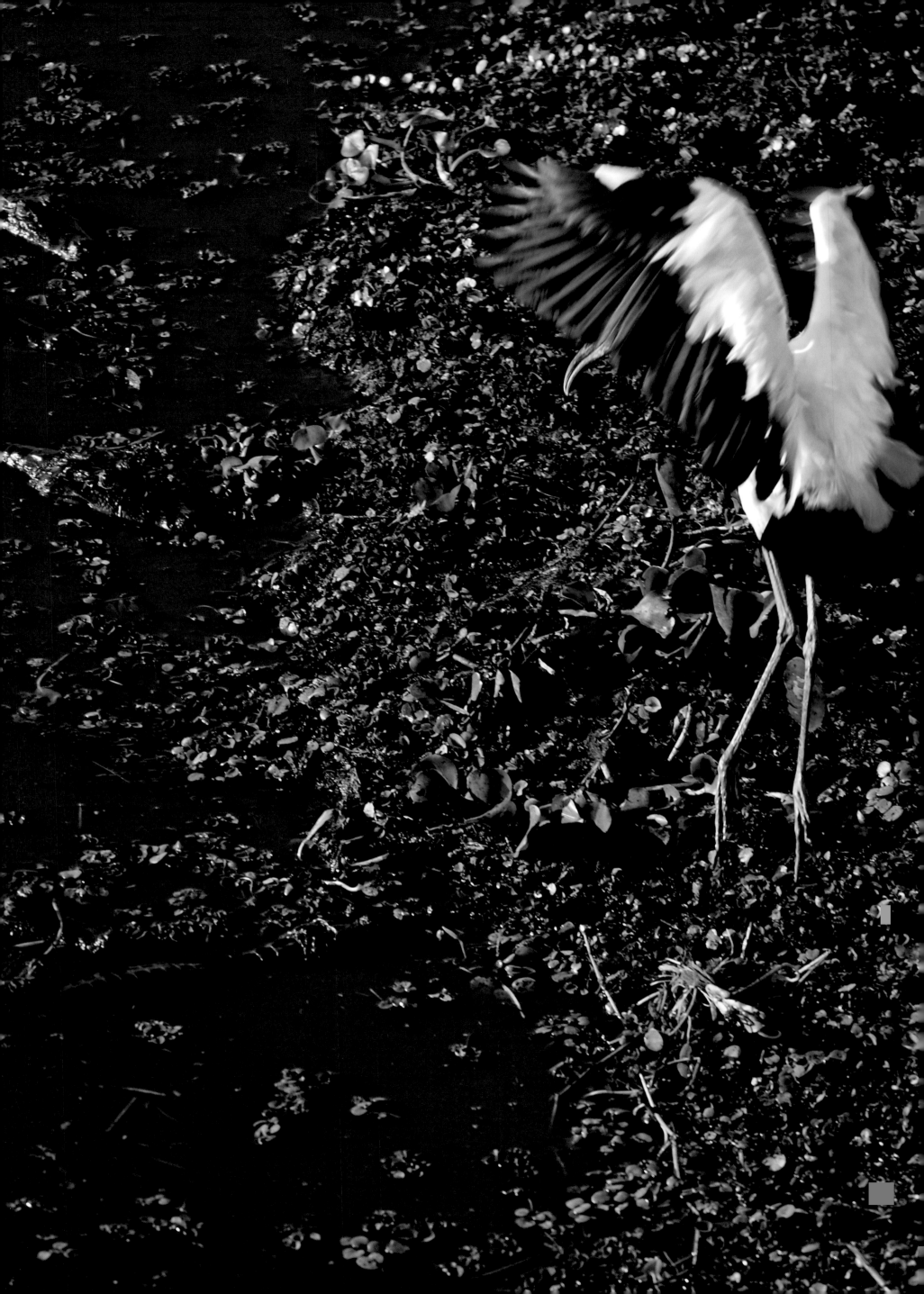

First-Day Jitters

I'M NOT SURE WHETHER OTHER PHOTOGRAPHERS EXPERIENCE THIS SYNDROME, BUT I ALMOST ALWAYS HAVE FIRST-DAY jitters at the start of any shoot. It's a creeping sense of unbelonging that washes over you as you meet, for the first time, your pilot and other locals who are visibly impressed that you are a "National Geographic photographer." You politely thank everyone for any compliments that come your way, but with silent misgivings about your right to be on the receiving end of such praise.

And then comes that initial encounter with the aircraft to which you will entrust your life over the next few weeks. Regardless of the type of vehicle, fixed-wing or helicopter, your first impression is almost always one of surprise at how impossibly small the inside of a Cessna 182 or Bell Jet Ranger actually is. You have trouble imagining how three or four adults plus an armload or two of camera gear plus oxygen tanks plus harnesses plus assorted other paraphernalia can possibly be shoehorned inside and still leave enough elbow room to maneuver.

Yesterday, after dumping all the photo gear and duffels at the hotel in Mendoza, our team inspected the four-passenger Cessna and debated a host of preflight issues: Should we remove just the window or the whole door for our first shoot over imposing Mount Aconcagua (the world's tallest peak outside Asia at a catch-your-breath height of over 22,000 feet)? Where do we cram the oxygen tank so that it's accessible but not in the way of the camera gear? How do we attach a second harness to the frame of the craft—my lifeline just in case I manage to accidentally hurl myself out into the frigid air? Eventually, everyone cocks their head in my direction for a decision and I can hardly say, "I don't know...I'm just the photographer."

Then the crew starts to discuss the best routes for covering the first day's targets: mountain ranges, volcanoes, vineyards, lagoons, and so forth. Your unspoken impulse is to implore your crew to search out the most novel shots first, ones that you do not already have. But you say nothing for fear of having no clear answer to the question, "Like what?" So you just listen to the debate of where to go first, often in Spanish, which at least provides a linguistic reason for your silence. Eventually your instincts creep in—a bit like morning consciousness after your first strong cup of coffee—and you begin to exert the leadership that is unquestionably your role to play. Satisfied at last with your decisions, you retreat to your hotel room and just stare at that camera case where the instruments of your craft wait to be prepped for your first shoot.

You still have those first-day jitters and that recurring anxiety that perhaps you have shot your proverbial "last great shot"...but then you touch the cold rugged sides of your camera bodies and the sturdy barrels of your lenses, companions that have never let you down before. It is the physical act of handling those high-powered tools that somehow imparts a distinct sense of belonging. The simple routine of adjusting those familiar switches and dials immediately restores your confidence. At last, you are actually doing something photographic, and you realize that you are not an imposter after all. *—RBH*

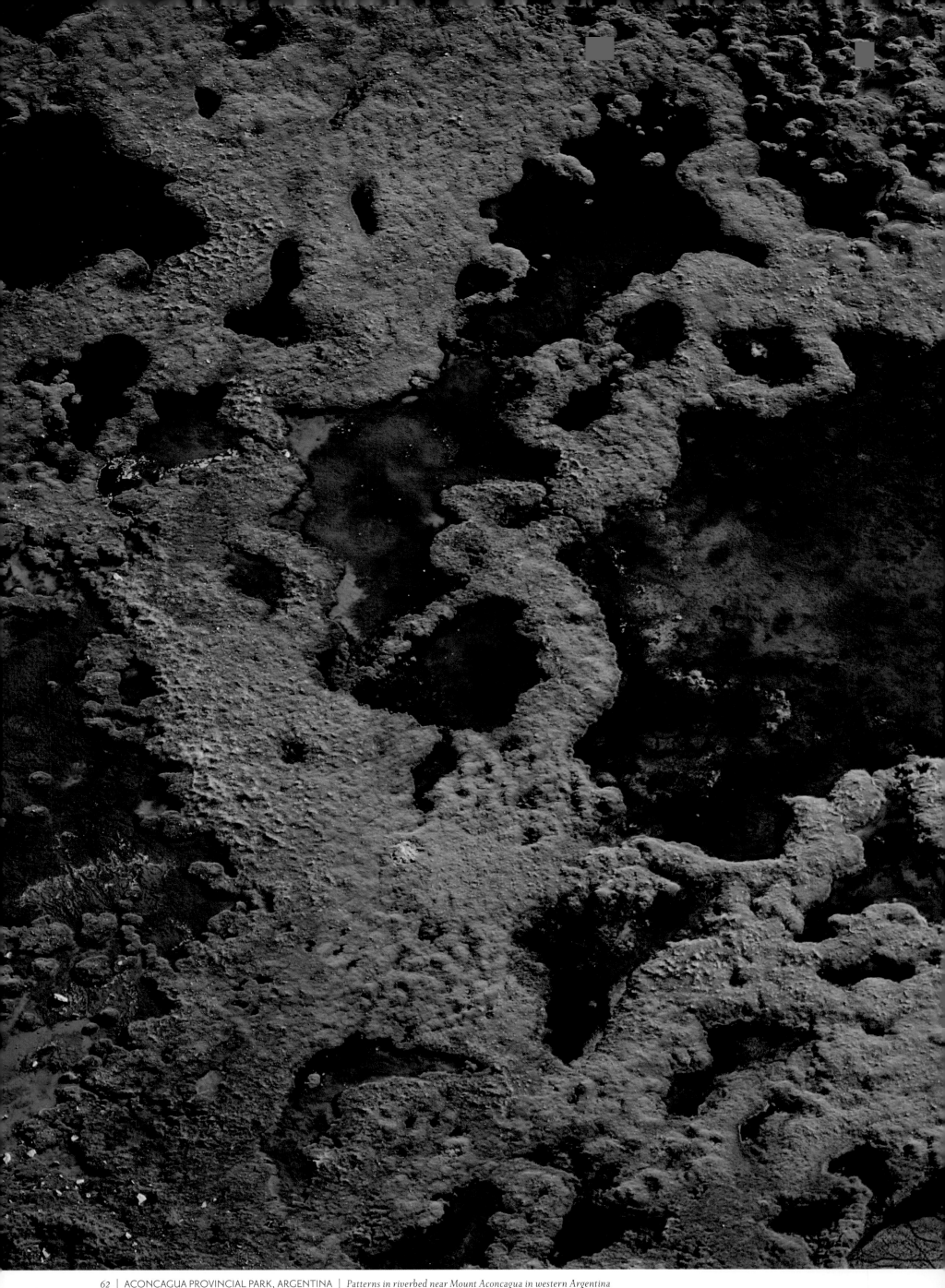

Patterns in riverbed near Mount Aconcagua in western Argentina

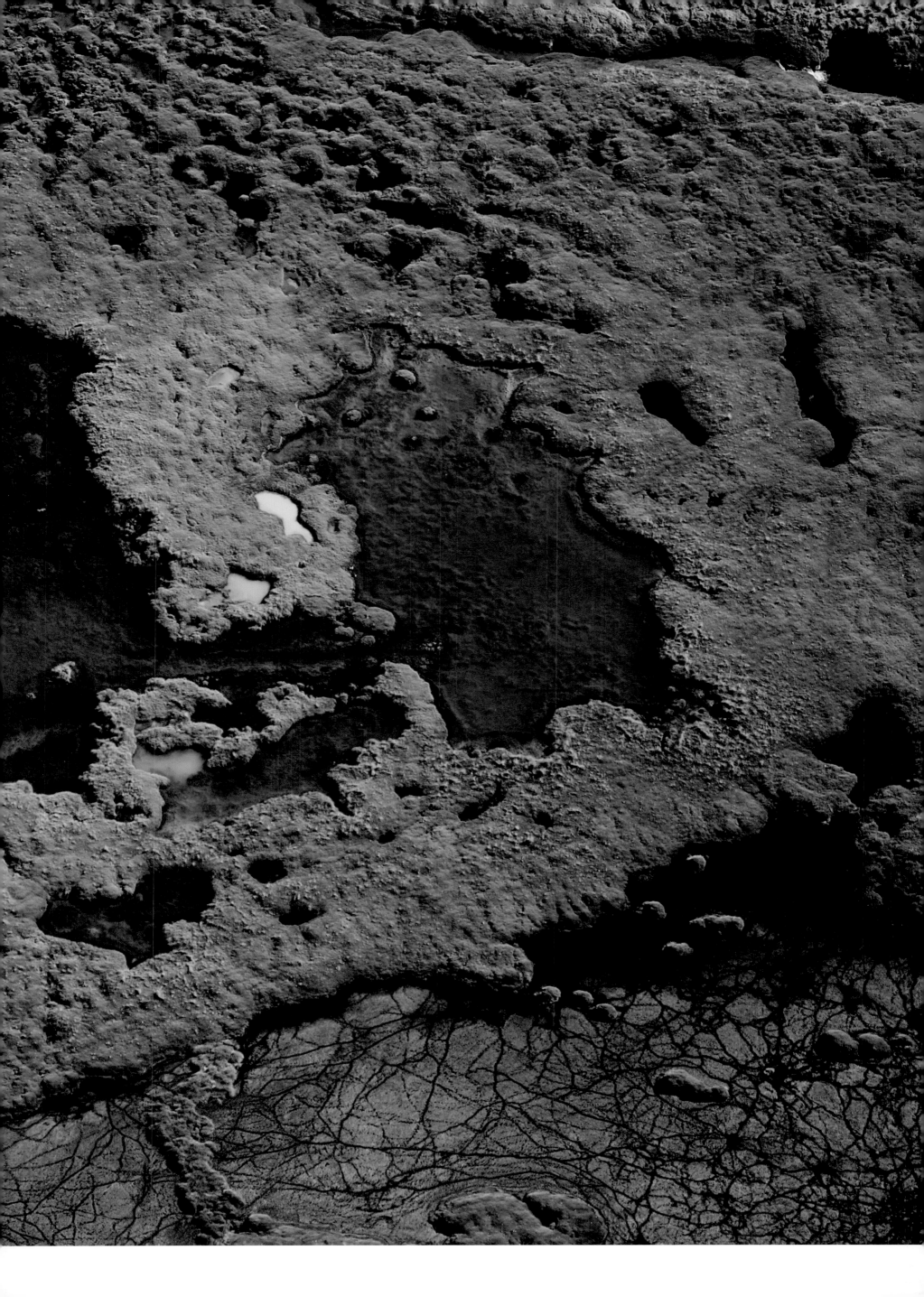

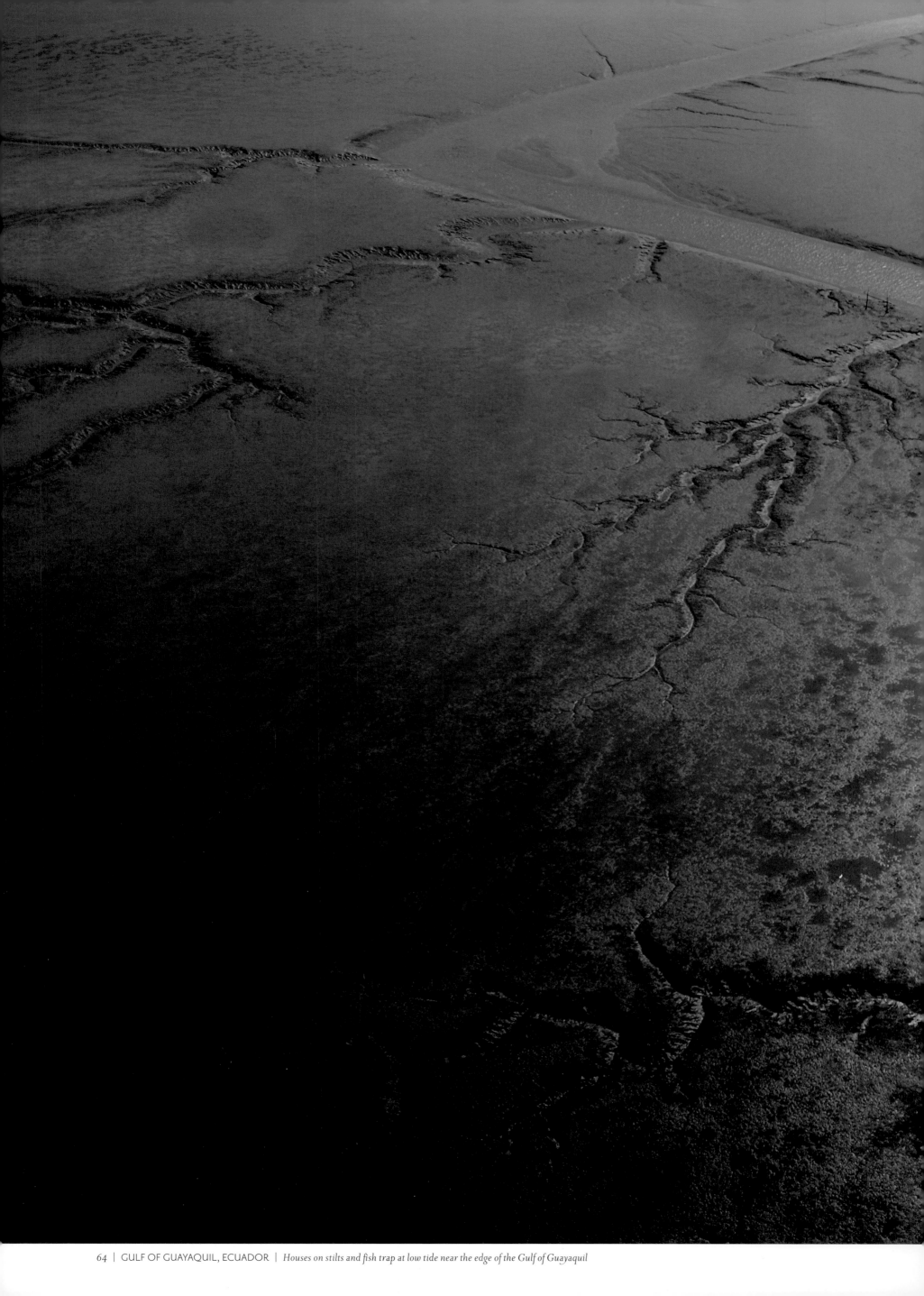

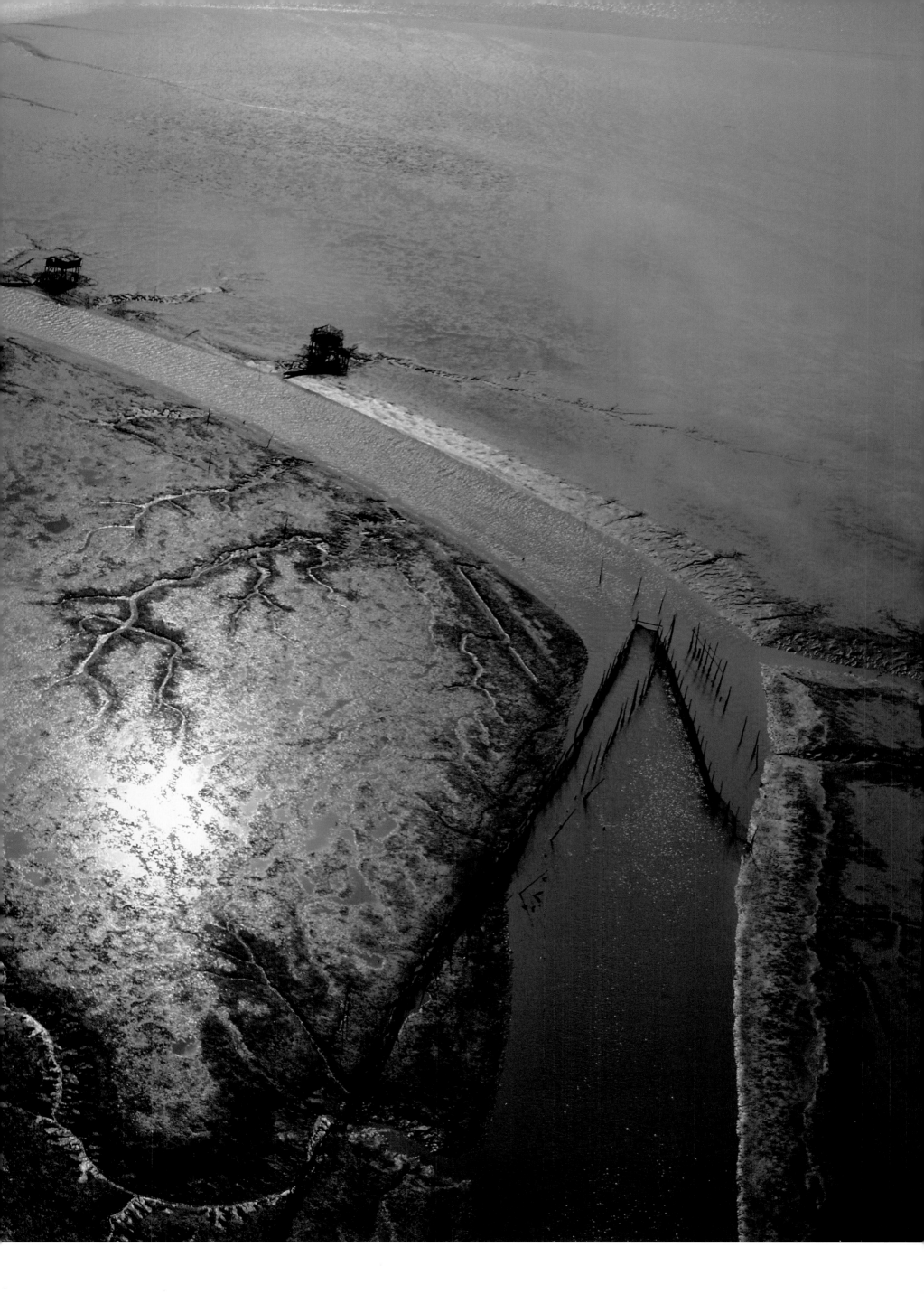

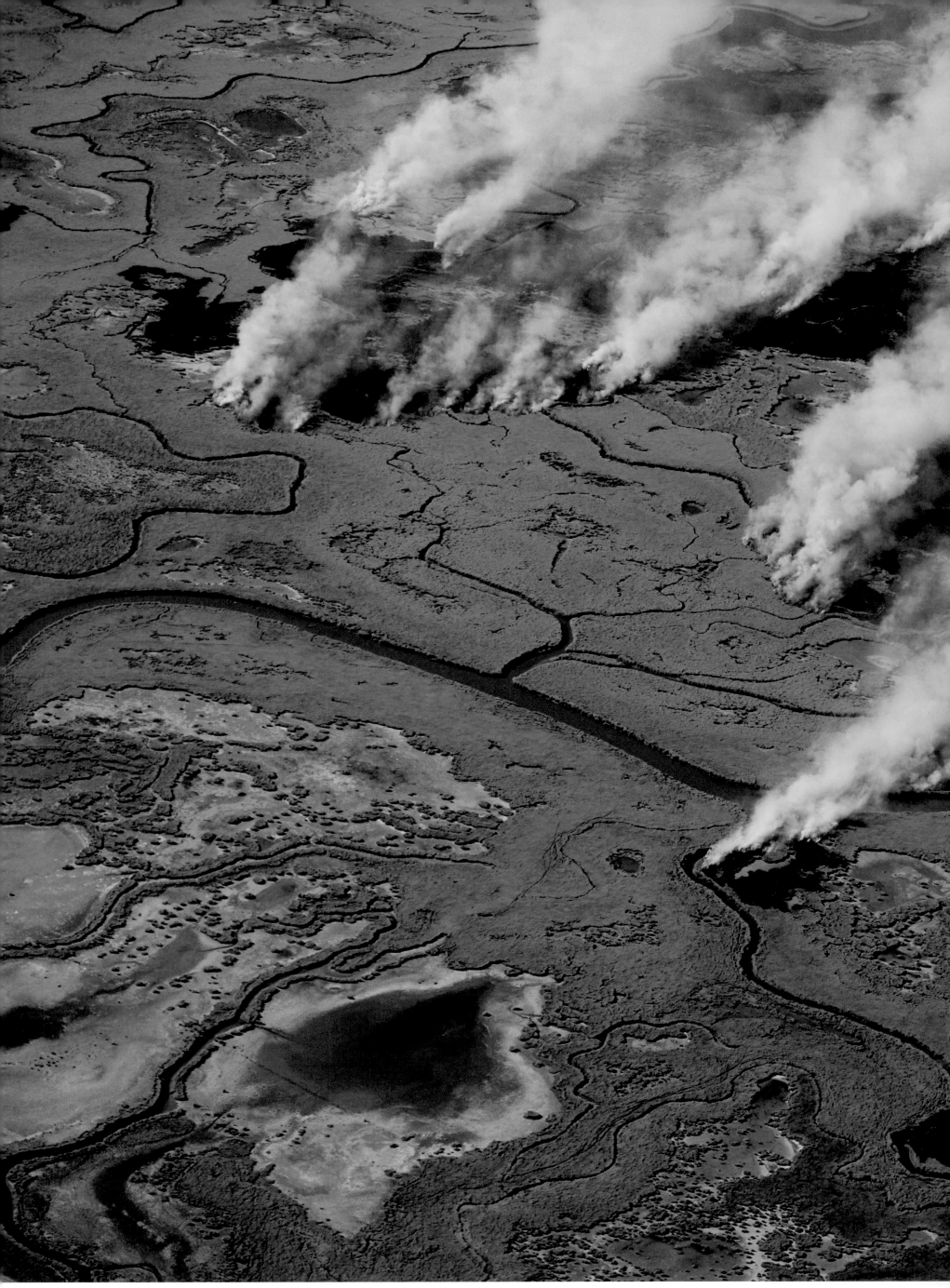

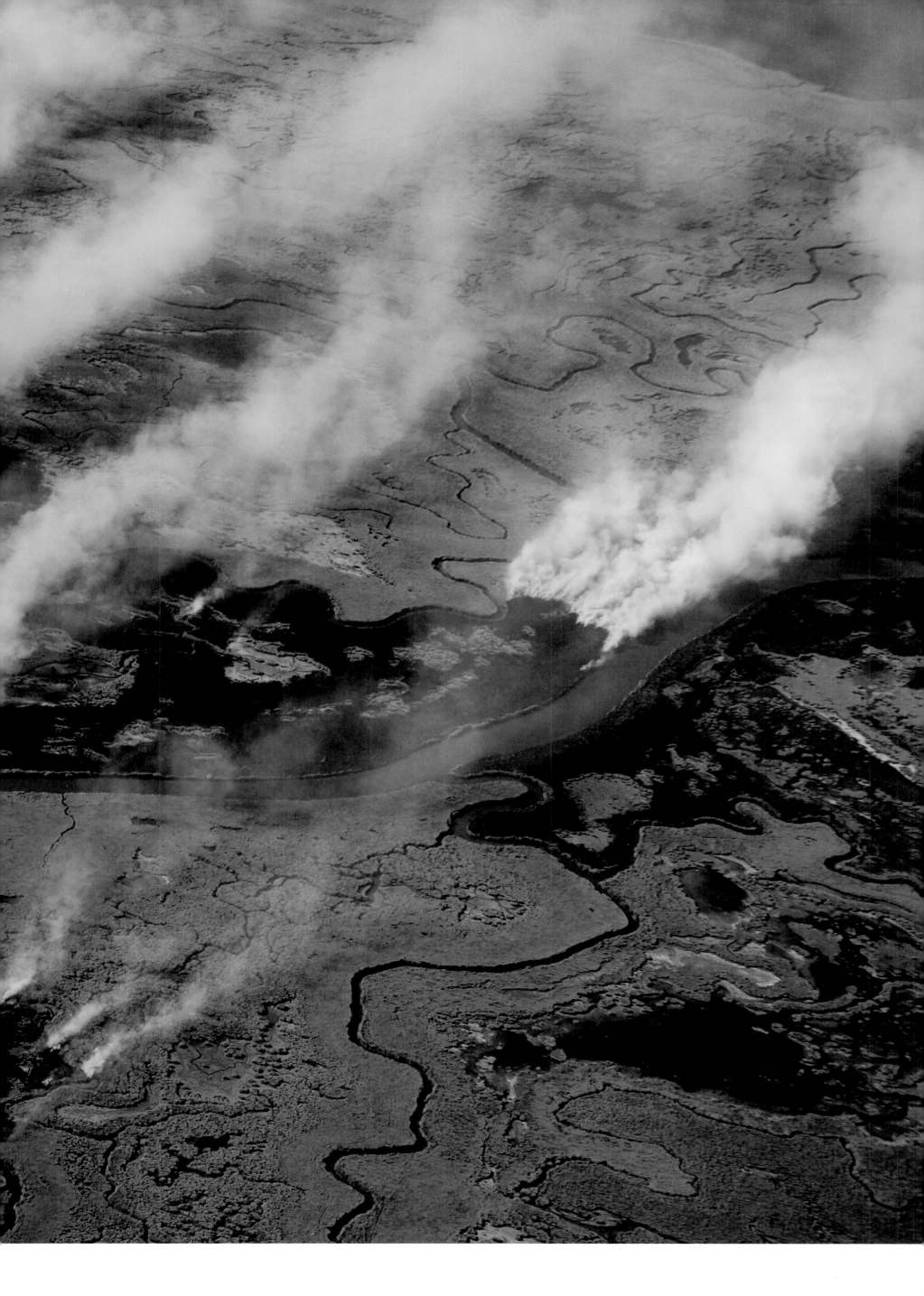

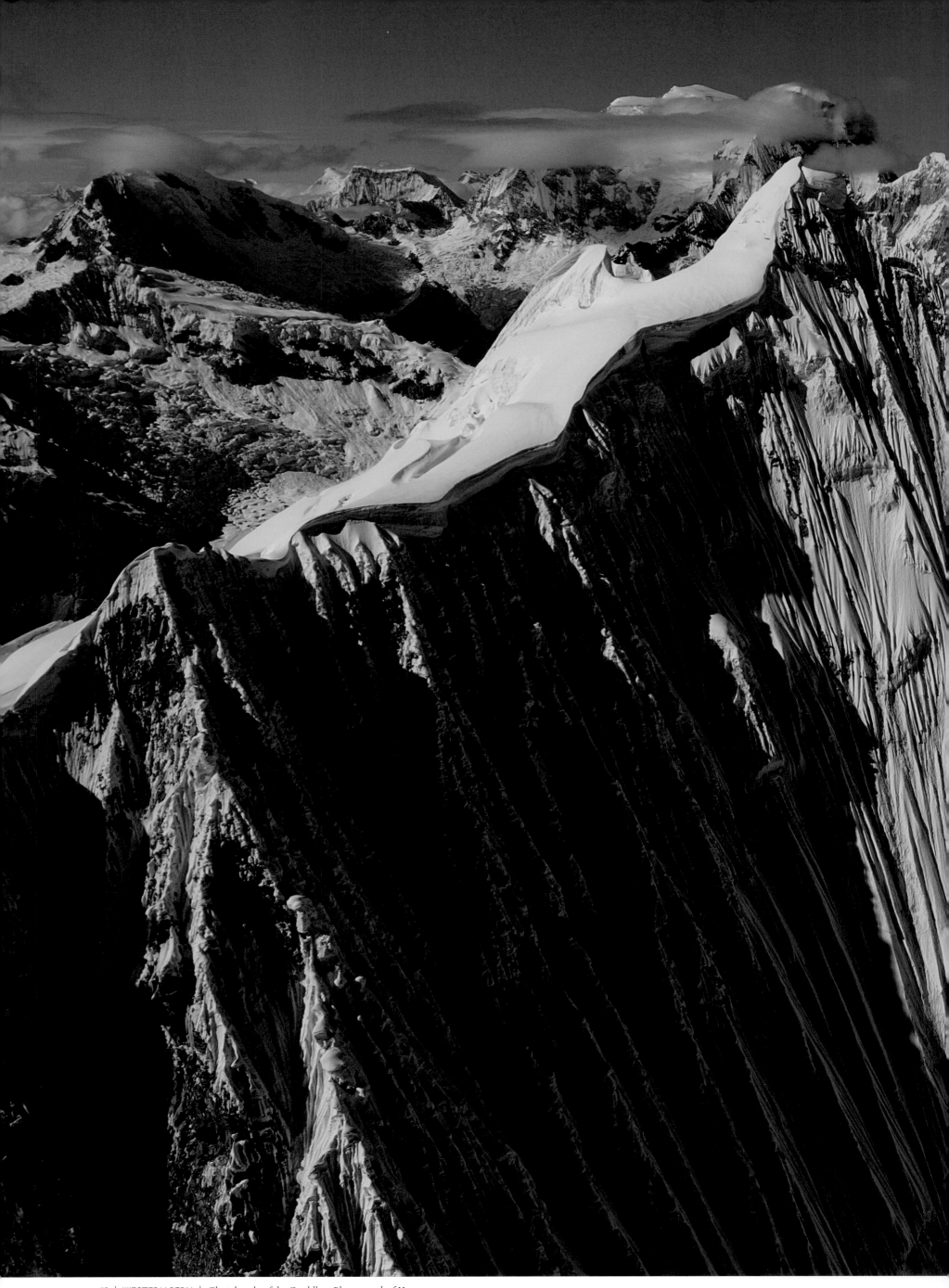

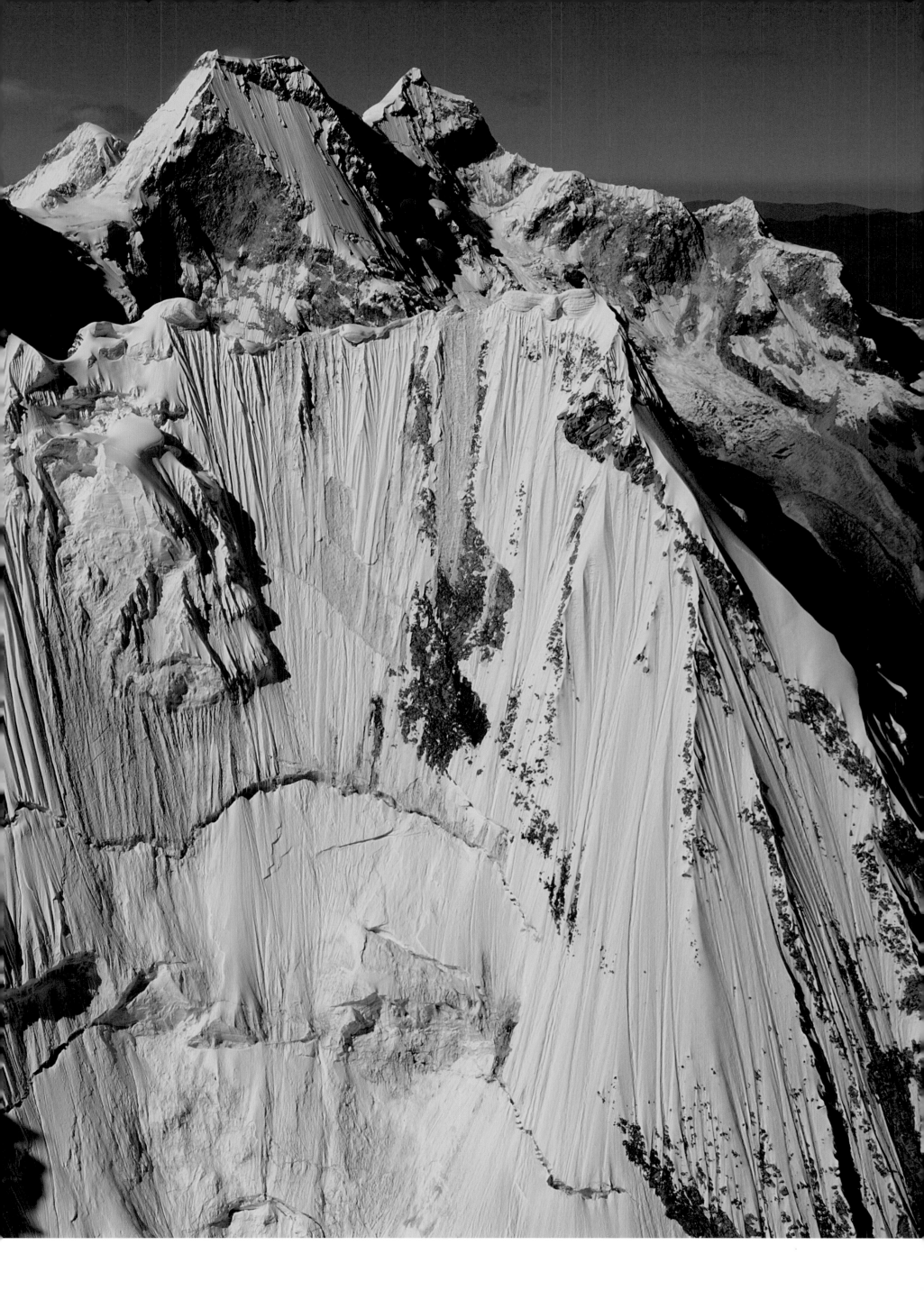

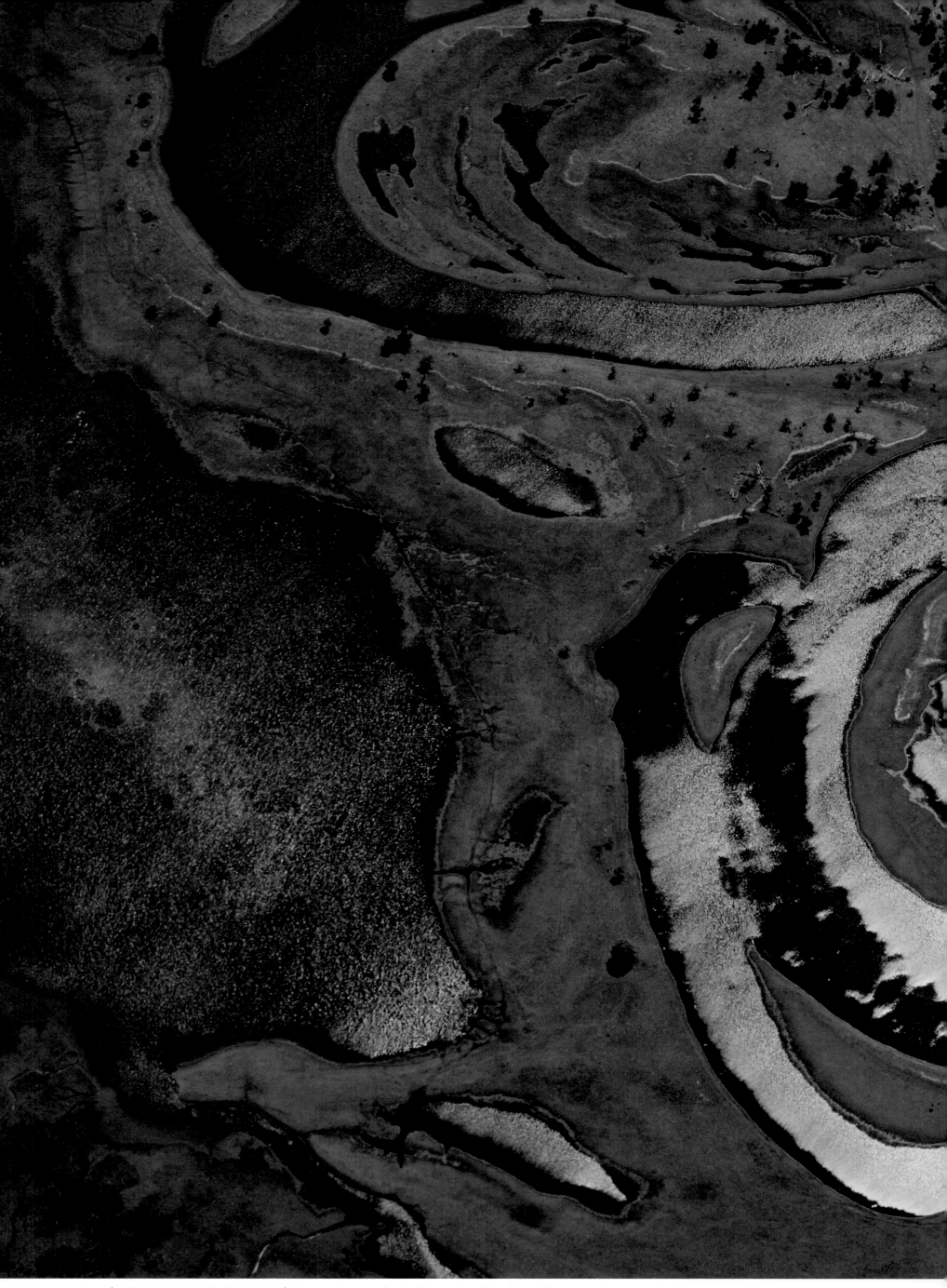

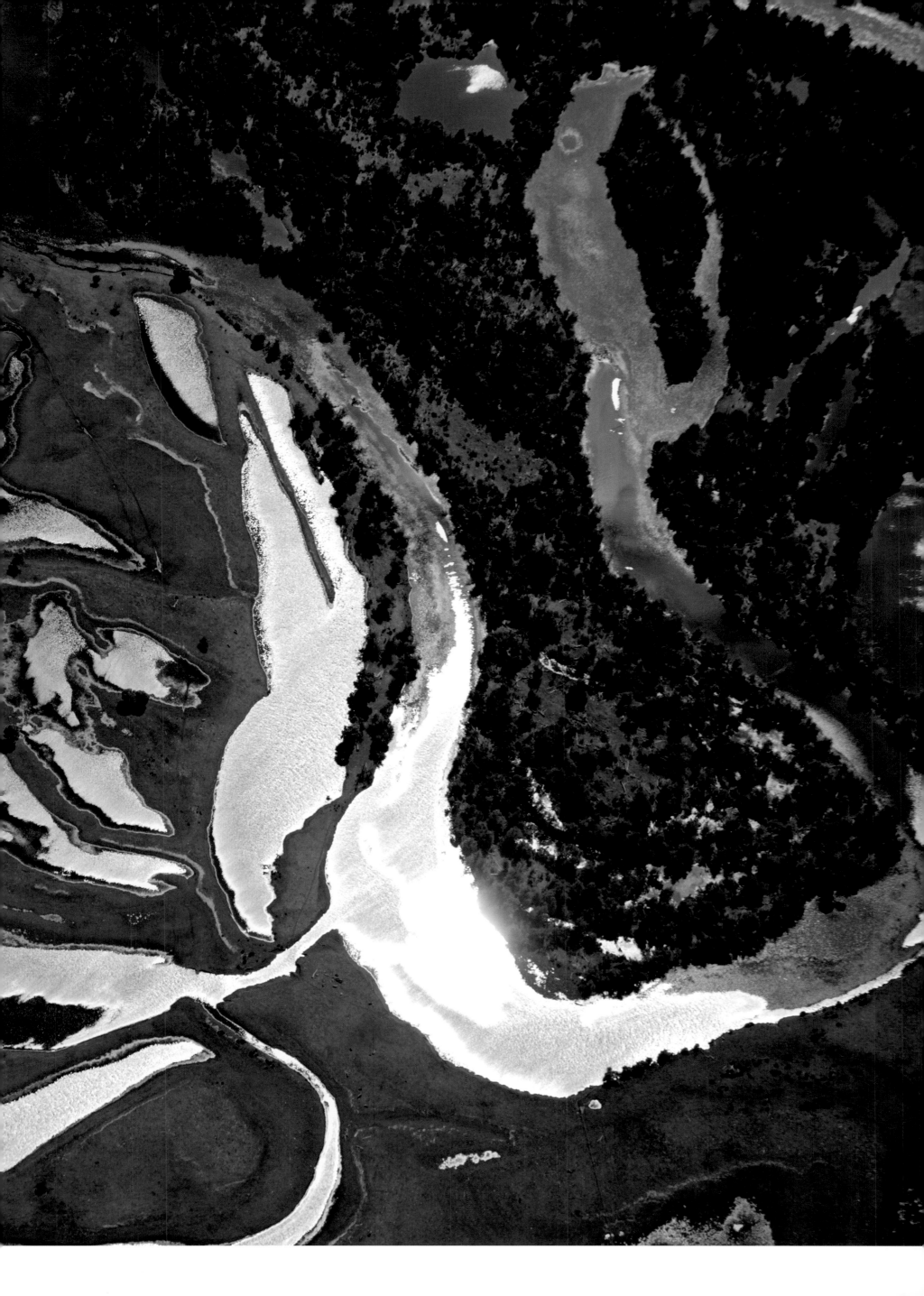

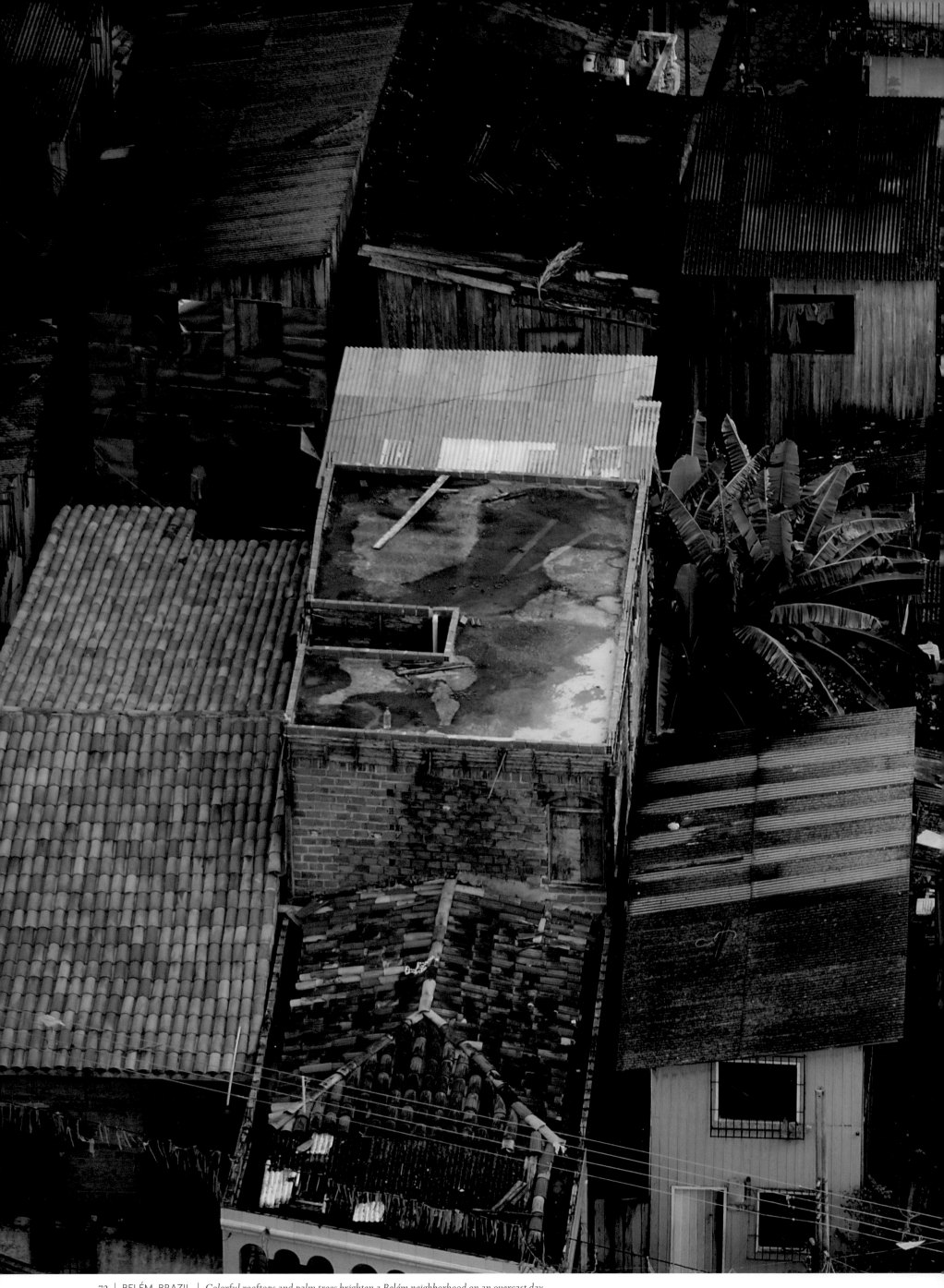

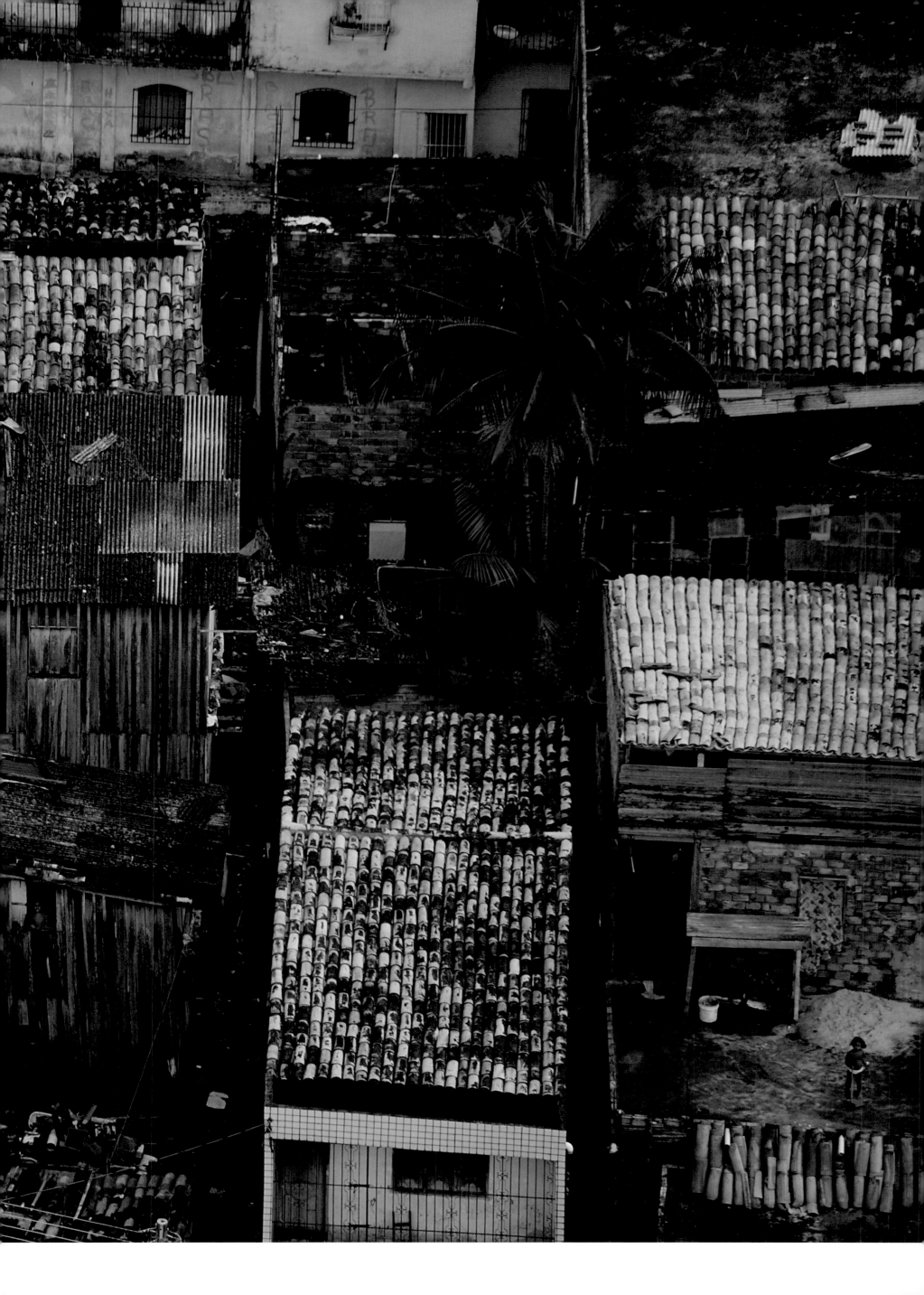

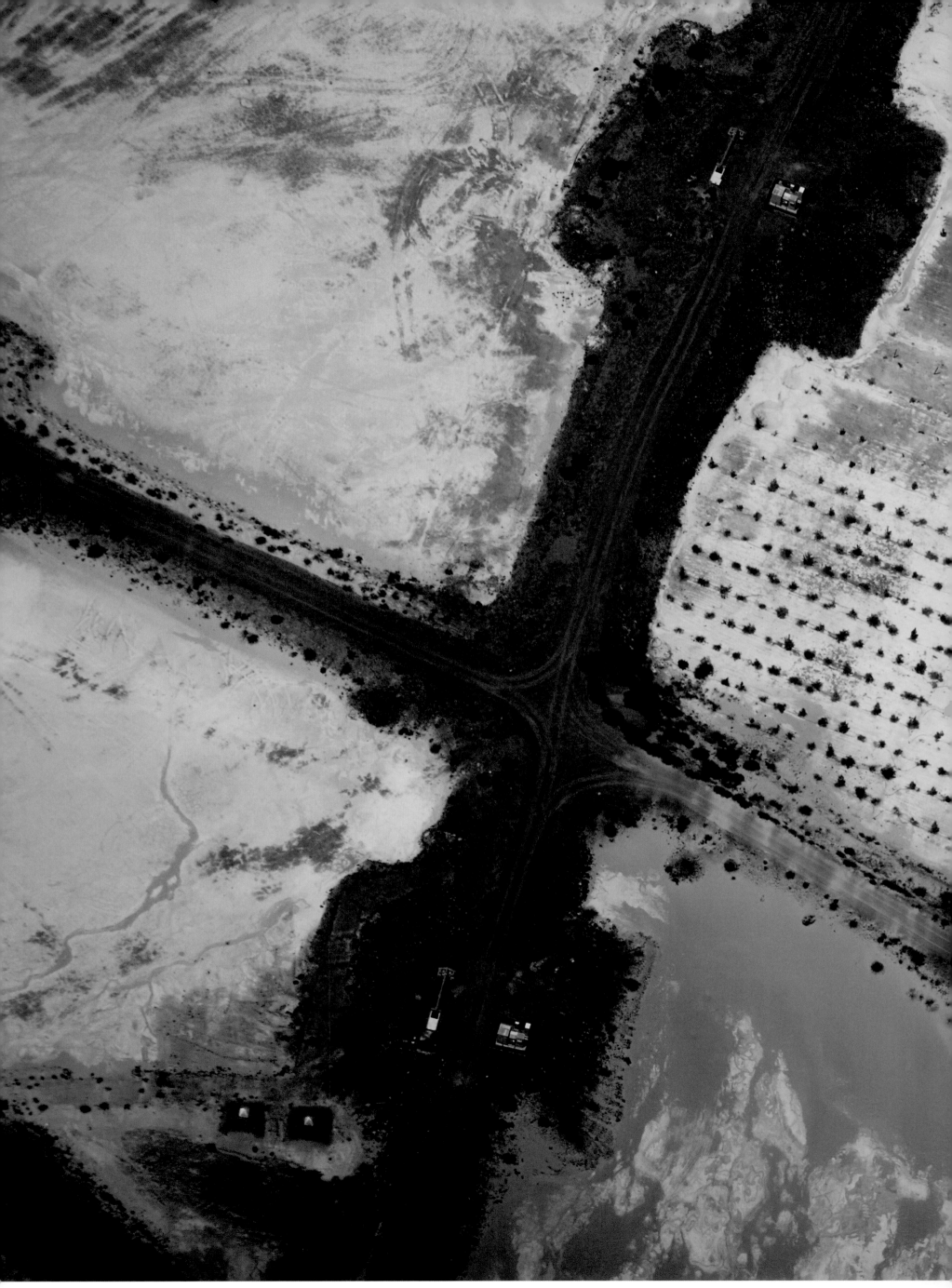

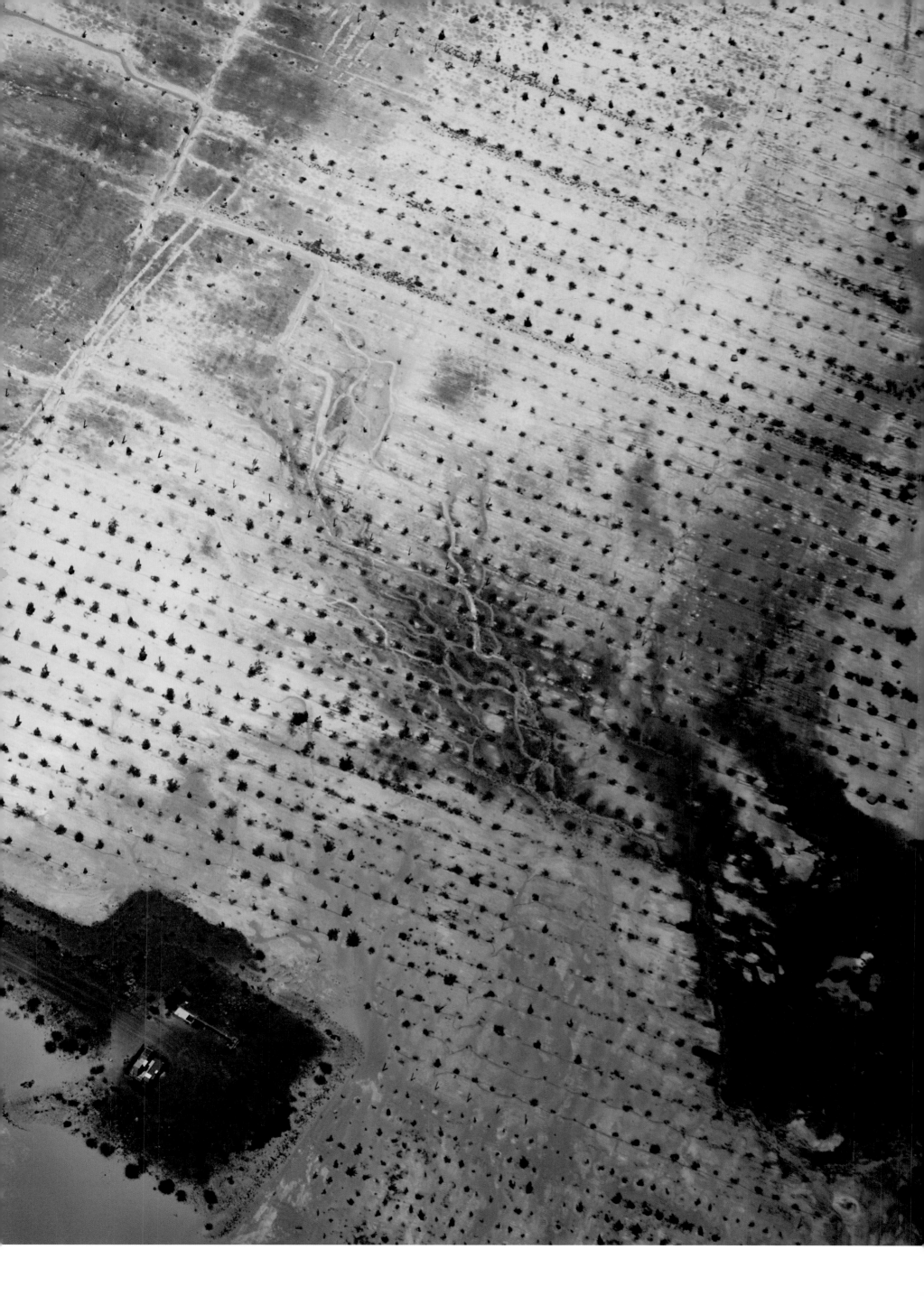

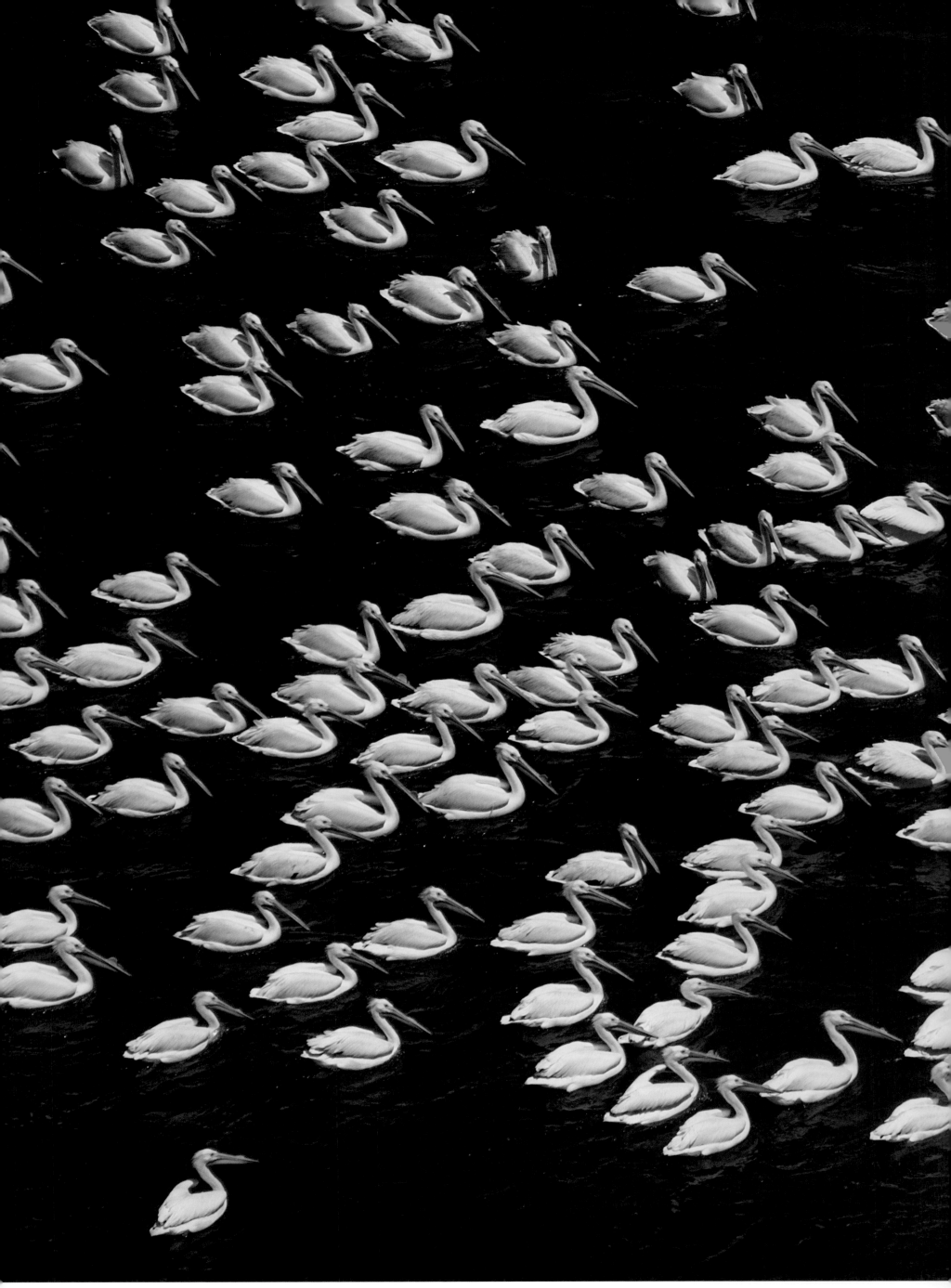

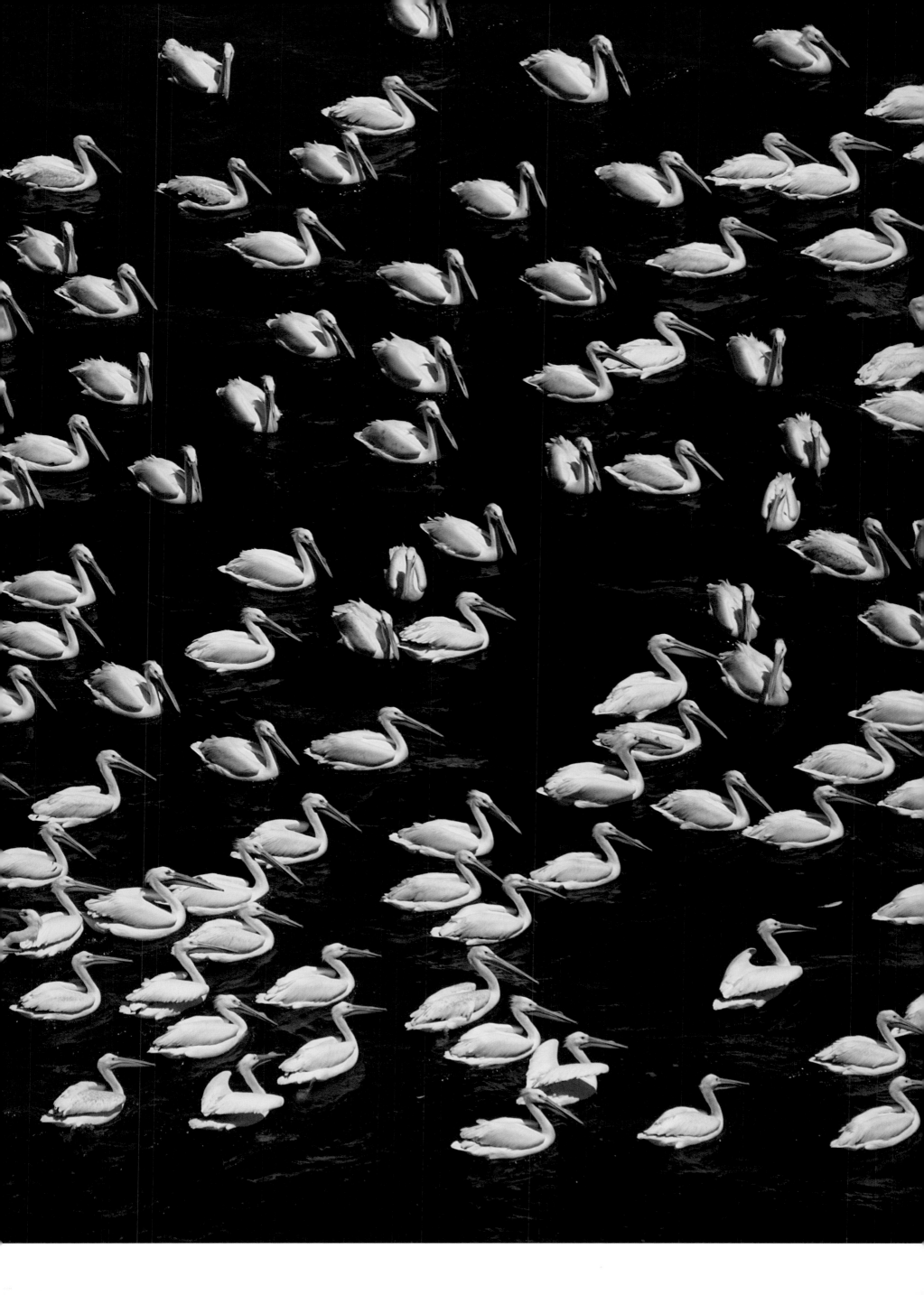

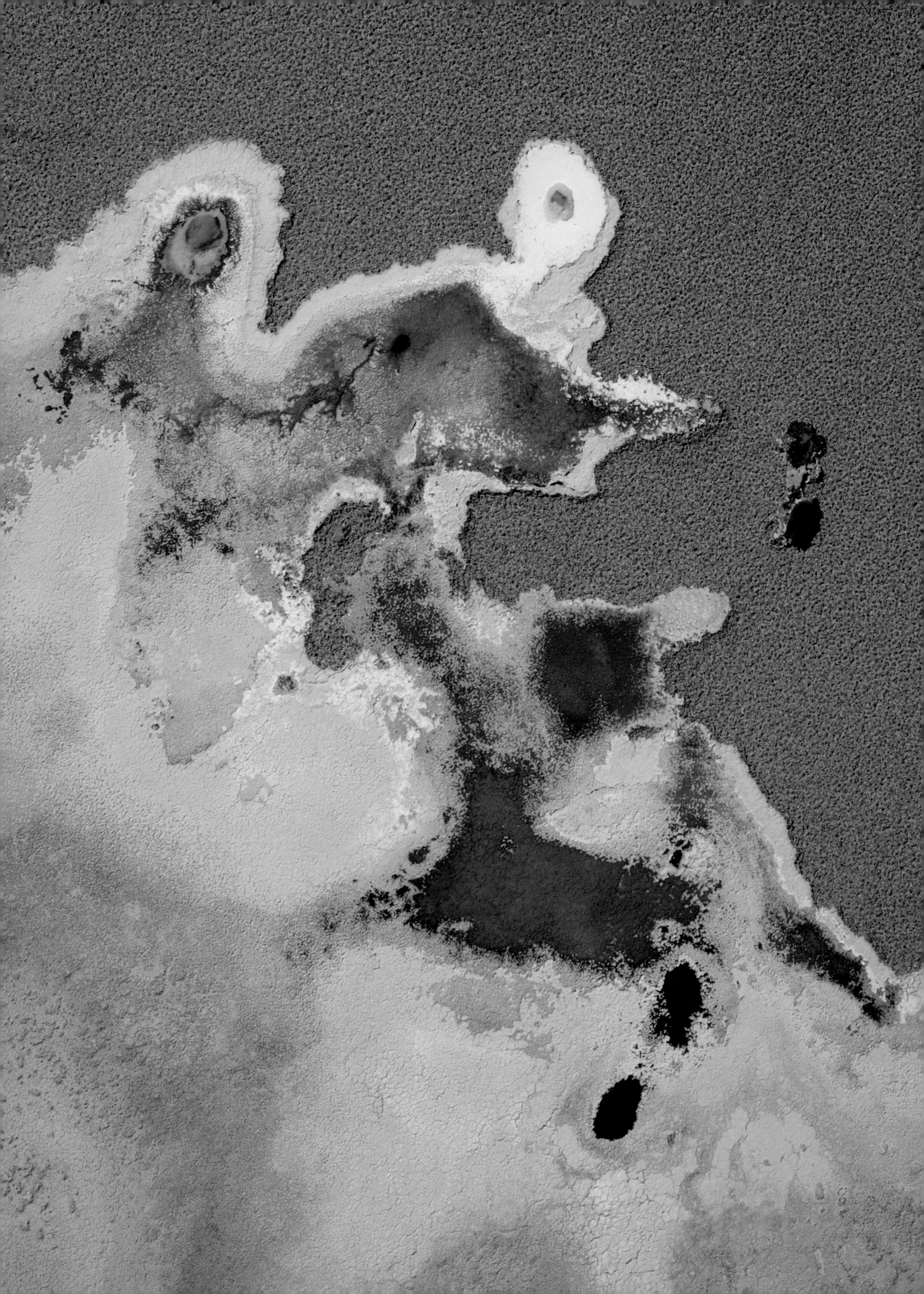

No Man's Land

SOMETIMES A WORD OR PHRASE EXQUISITELY EXPRESSES ITS OWN MEANING, BUT THAT MEANING HAS BEEN MUTED BY decades of either use or neglect. For example, although rarely used today, the phrase "ne'er-do-well," describing a scoundrel or rowdy, is reduced to its raw meaning by the literal translation "never does well." And so it is with our casual use of the phrase "no-man's-land," which the dictionary lists as having a variety of meanings in common parlance: an unoccupied area between opposing armies; an anomalous, ambiguous, or indefinite area especially of operation, application, or jurisdiction.

But quite literally, it means a land that does not belong to man…and that is a more poignant description of venues such as the Atacama Desert of northern Chile, where I am right now awaiting the first breach of sunlight over the Andes before my crew and I lift off in our chopper. Other words simply cannot do justice to the most remote reaches of the Atacama: lunar…foreboding…bizarre…primeval. Each one is certainly accurate as far as it goes, just as each piece of a puzzle fits in its own cardboard slot, but none of them approach the impact of the more complete message, "This land does not belong to you…it is no man's land."

The parched air is so devoid of moisture and oxygen that our nostrils and lungs feel incapable of performing their natural function. In large portions of the Atacama, rainfall is every bit as much a stranger as man might be were it not for the intrusion of artificial oases. Only the fact that the hills and valleys have offered up a bounty of copper and other minerals has served as an invitation to settle in this foreign land in order to extract what has value elsewhere, but not here. As we scan the desert floor that blends seamlessly into the hazy horizon, we notice the incongruous, fading swirls of large tire tracks across the crusty earth, witness to both the presence and the absence of man.

We have stuck our labels on the map of this region—Salar de Atacama, Valle de la Luna, Reserva los Flamencos— as if doing so would impart dominion over that which cannot be dominated. In such places, we are somewhere between trespassers and momentary visitors. In a few days or a few years, we wear out our welcome and cede our place to those who are next in line.

Beneath the surface of this volcano-ridden Chilean landscape are scores upon scores of cauldrons mixing up molten brews that surface every once in a while and leave us with an eerie sense that we are passing through a minefield with its own secret timer. Just another reminder that a large chunk of this place is indeed a land where nature rules… it is no man's land. —RBH

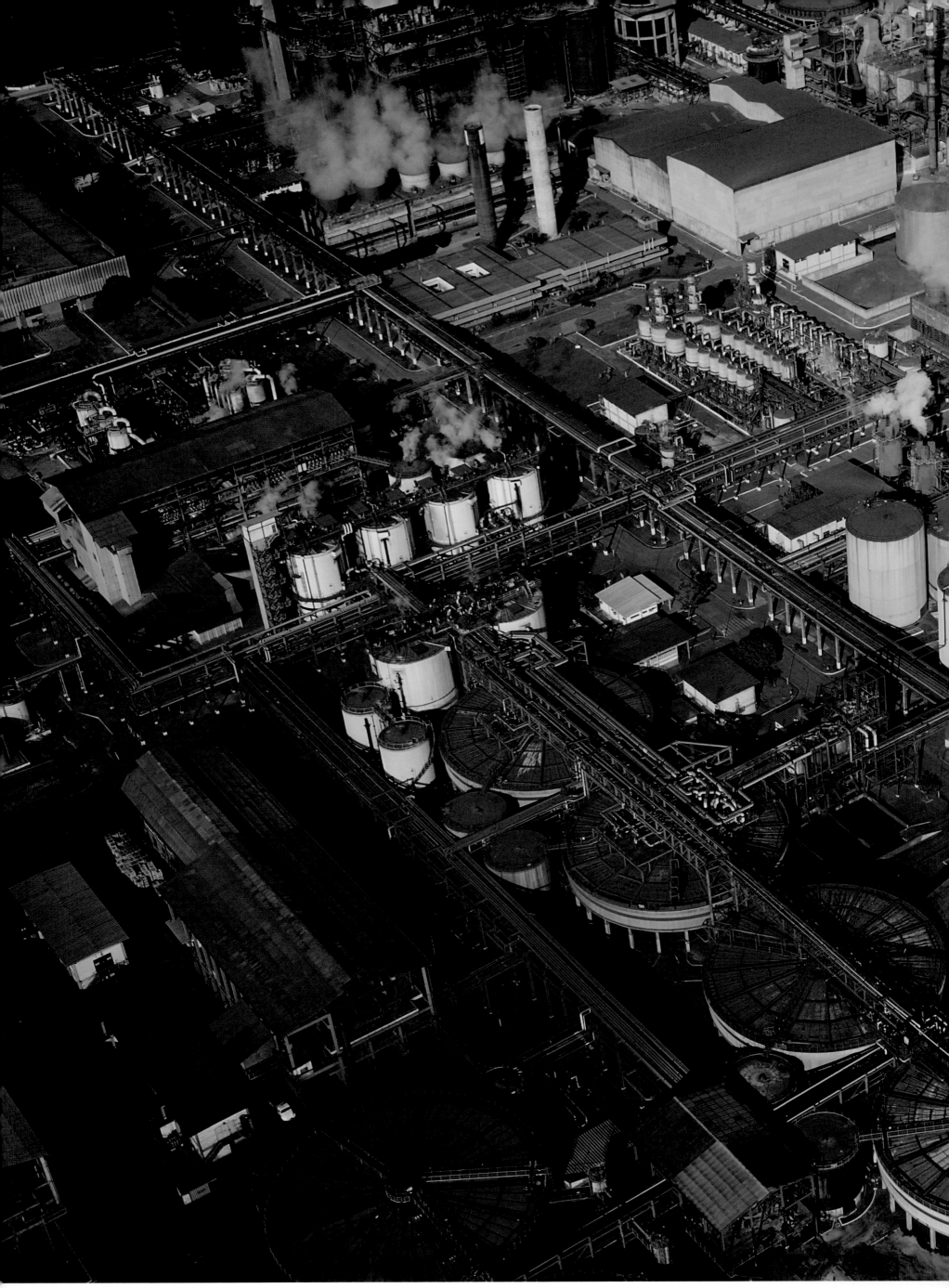

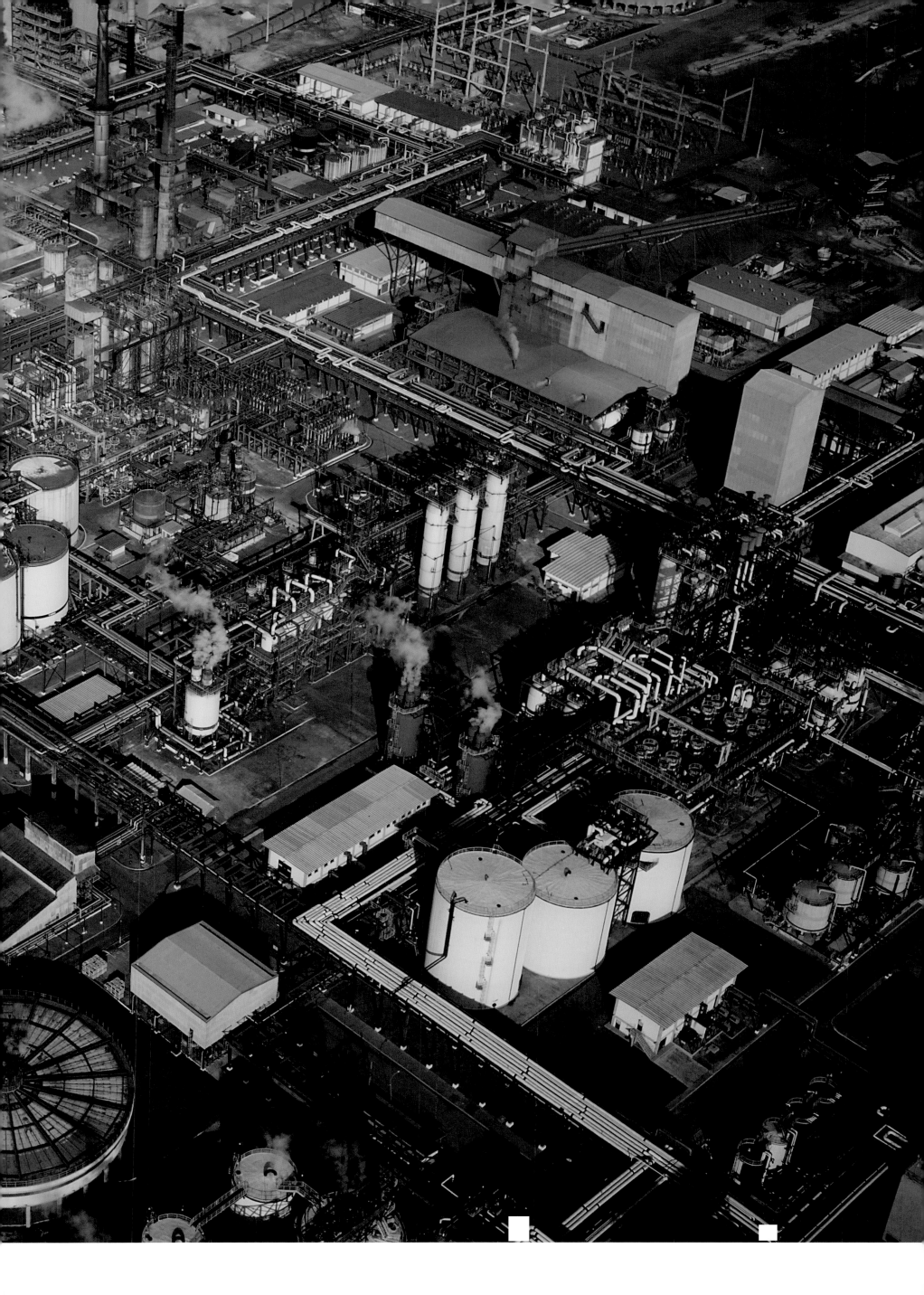

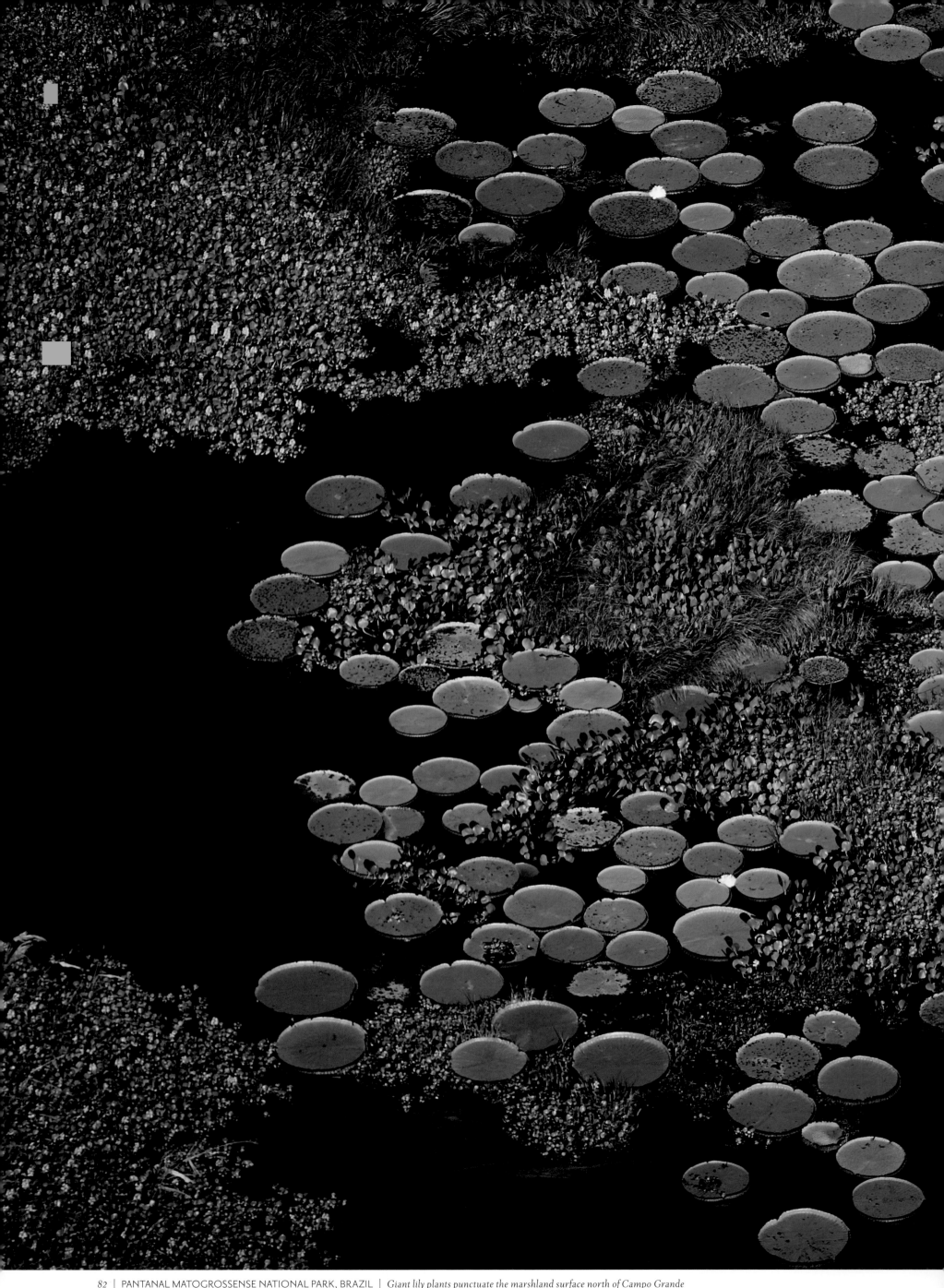

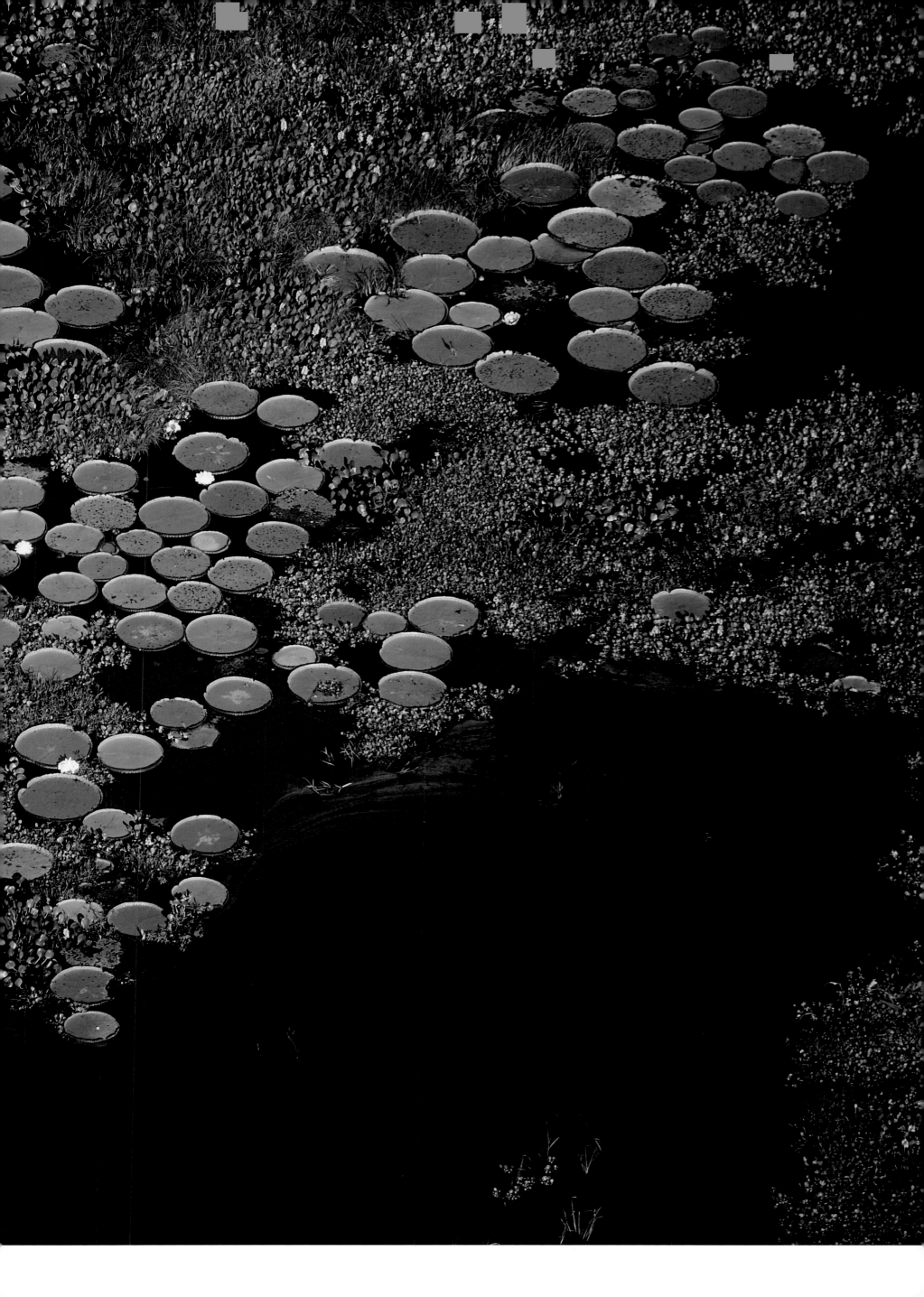

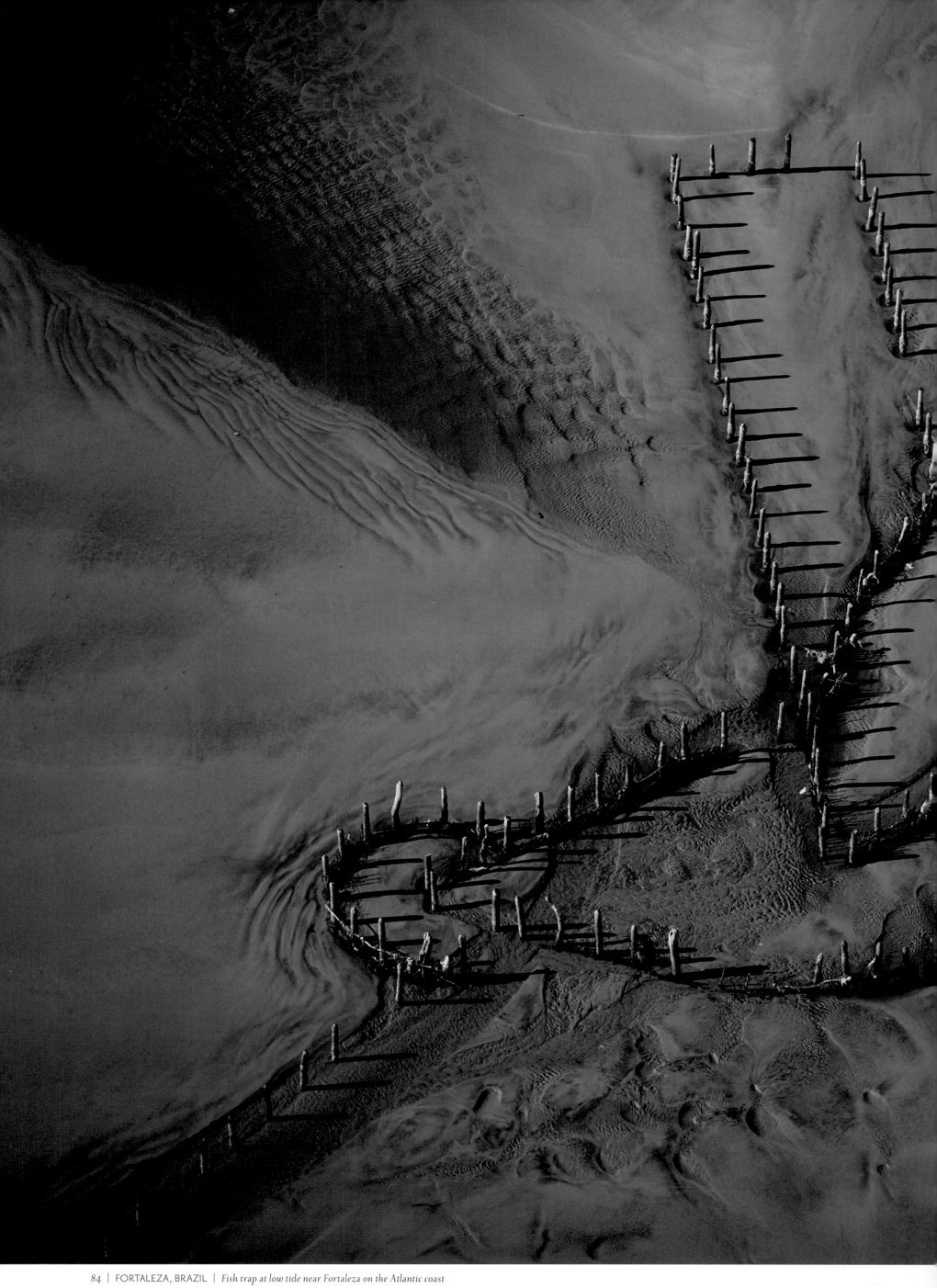

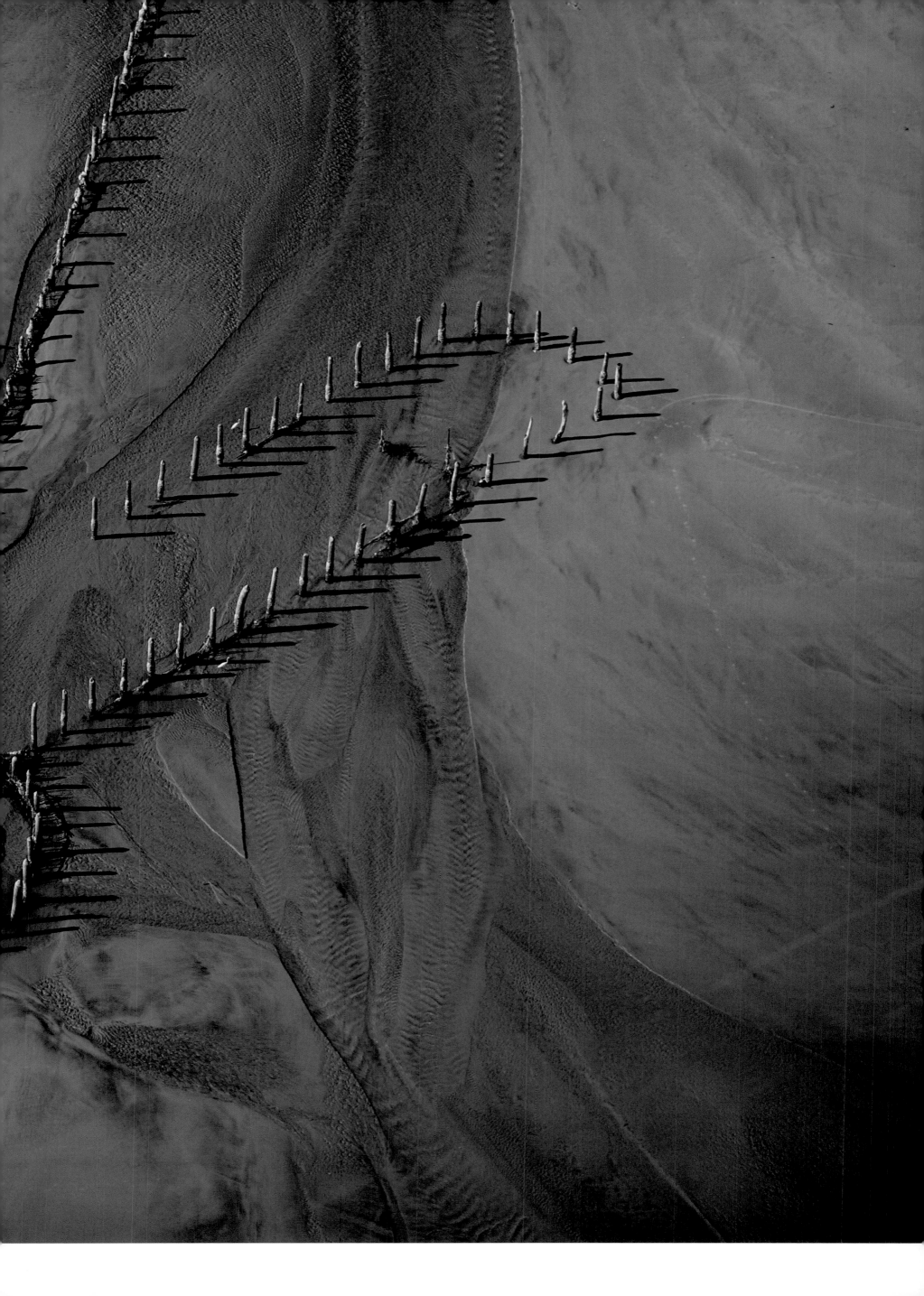

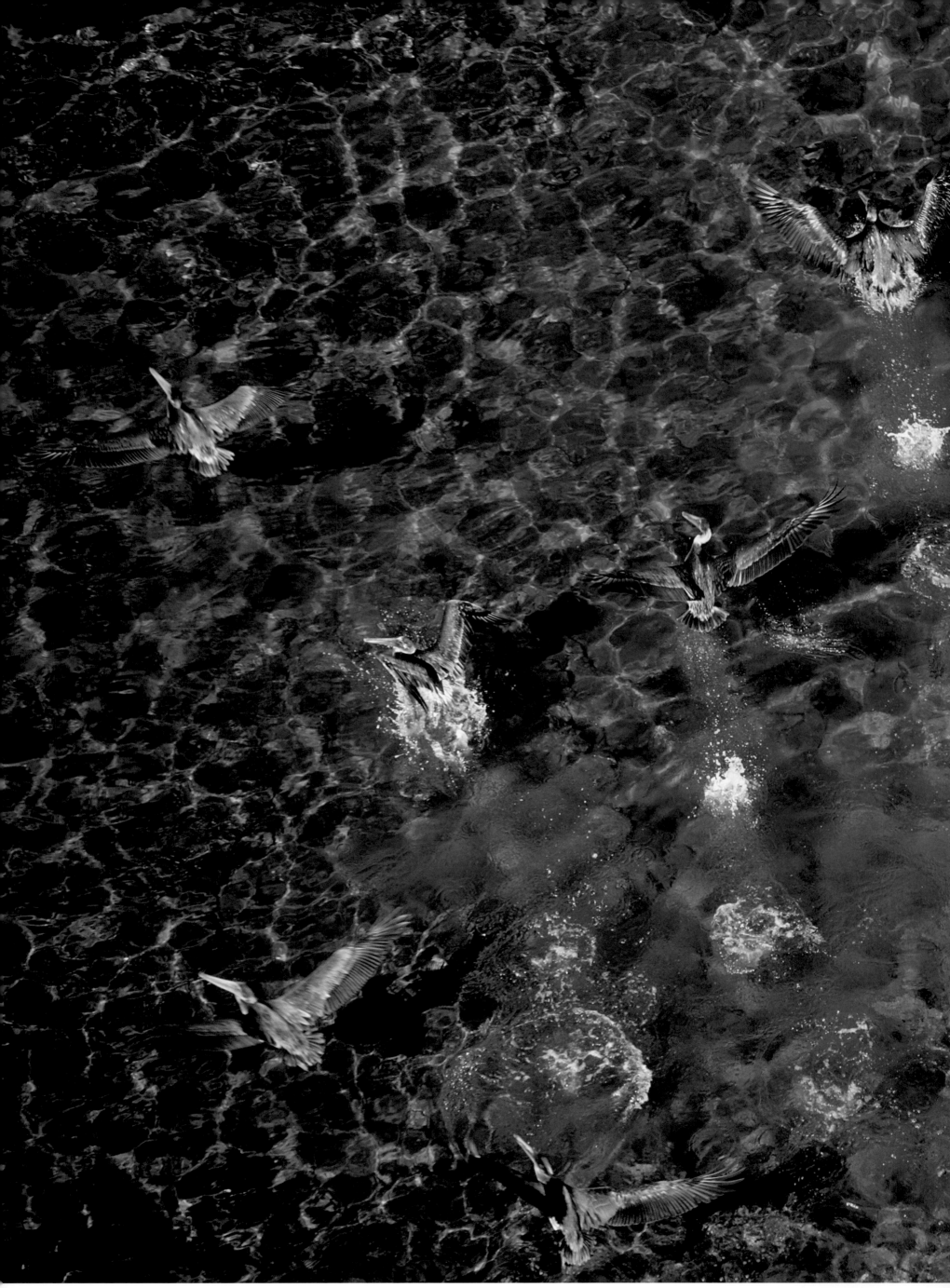

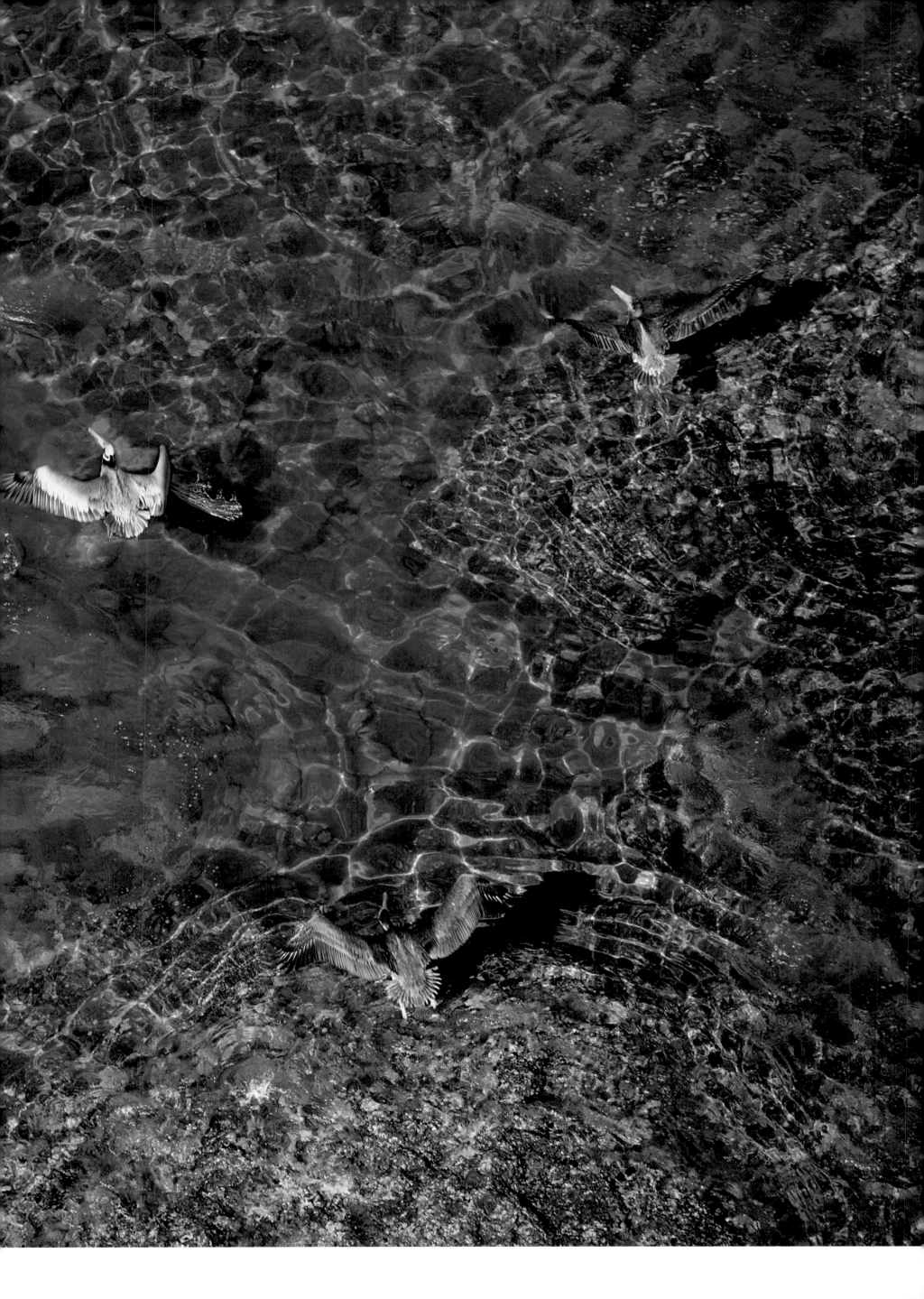

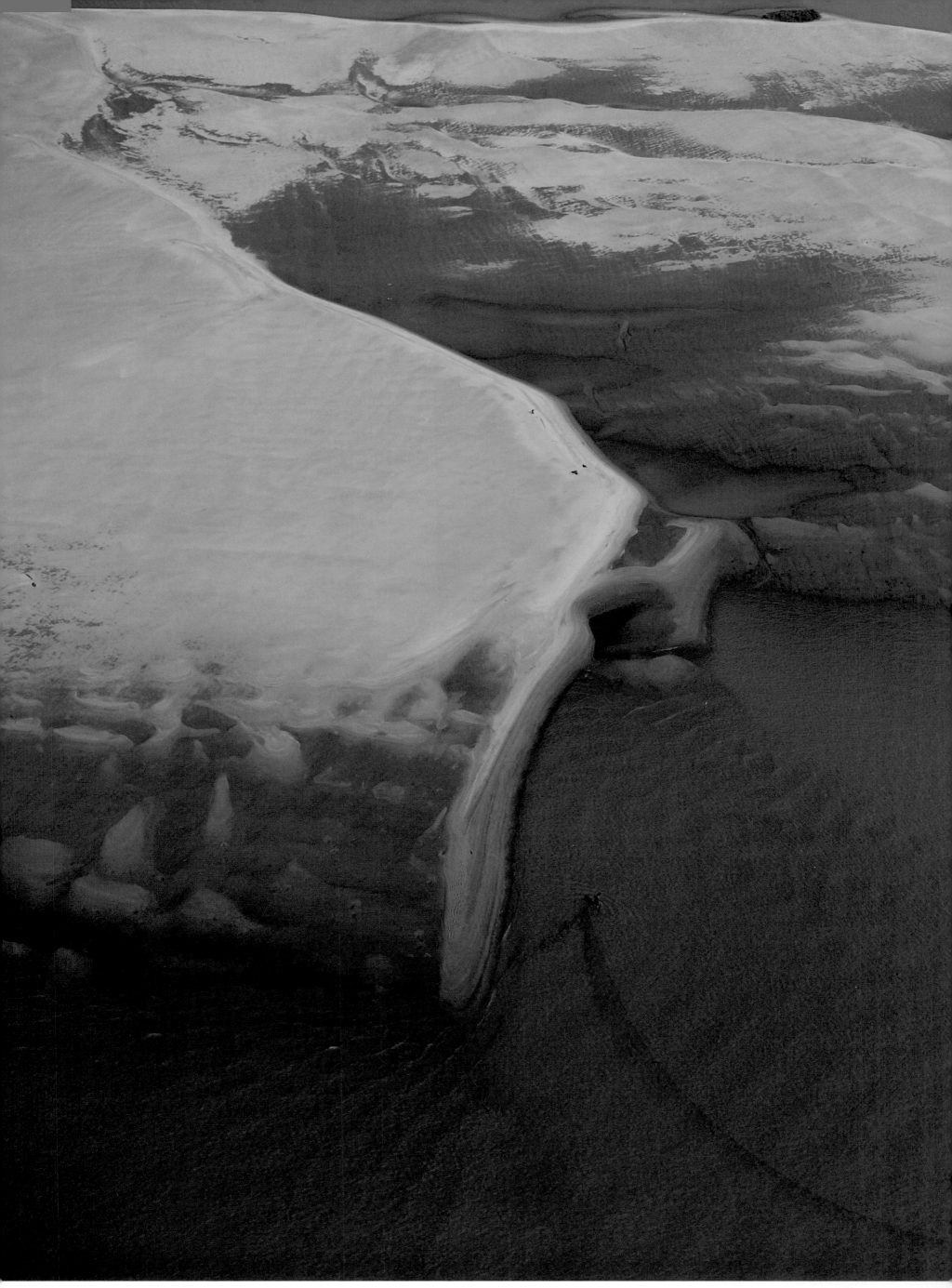

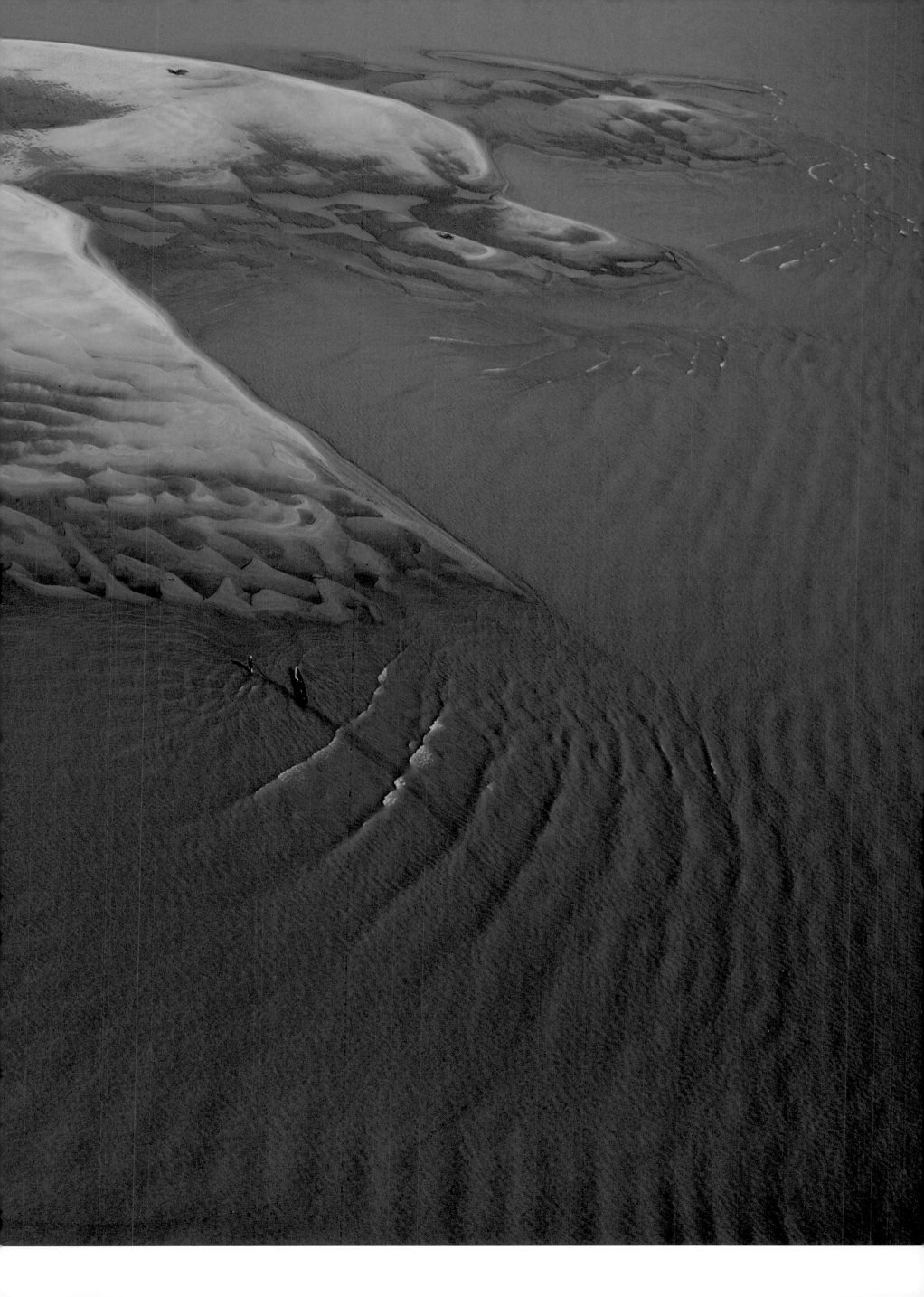

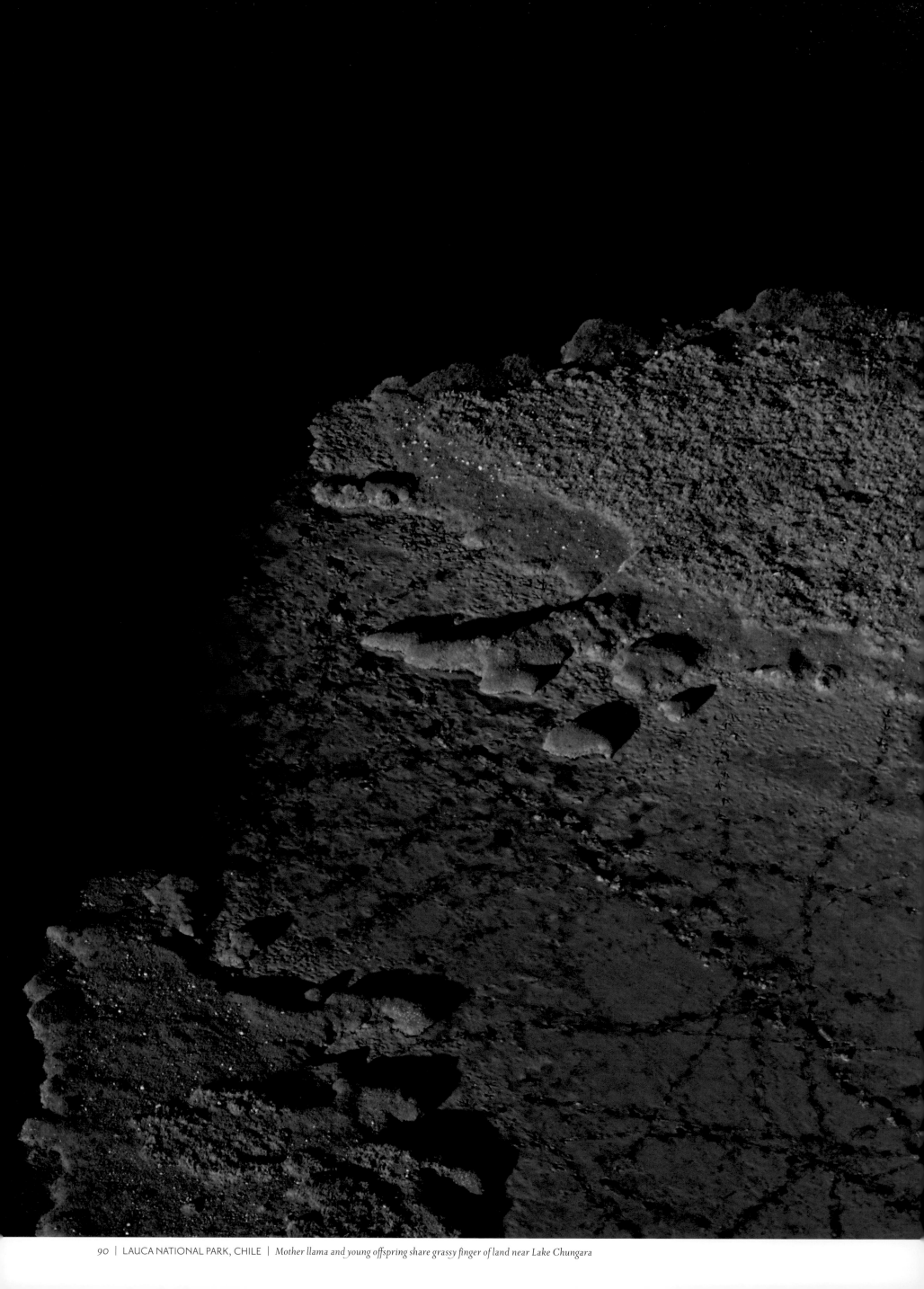

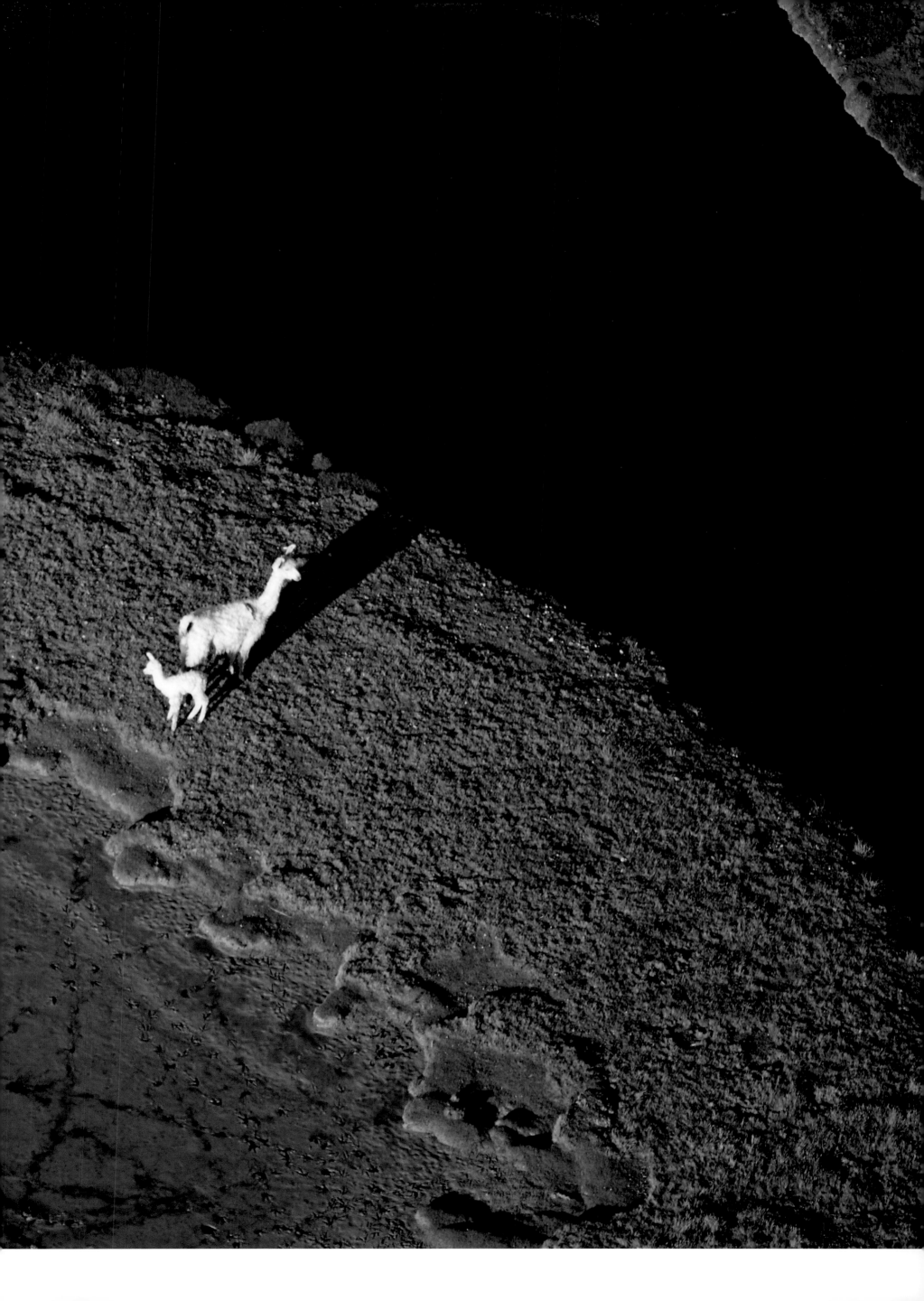

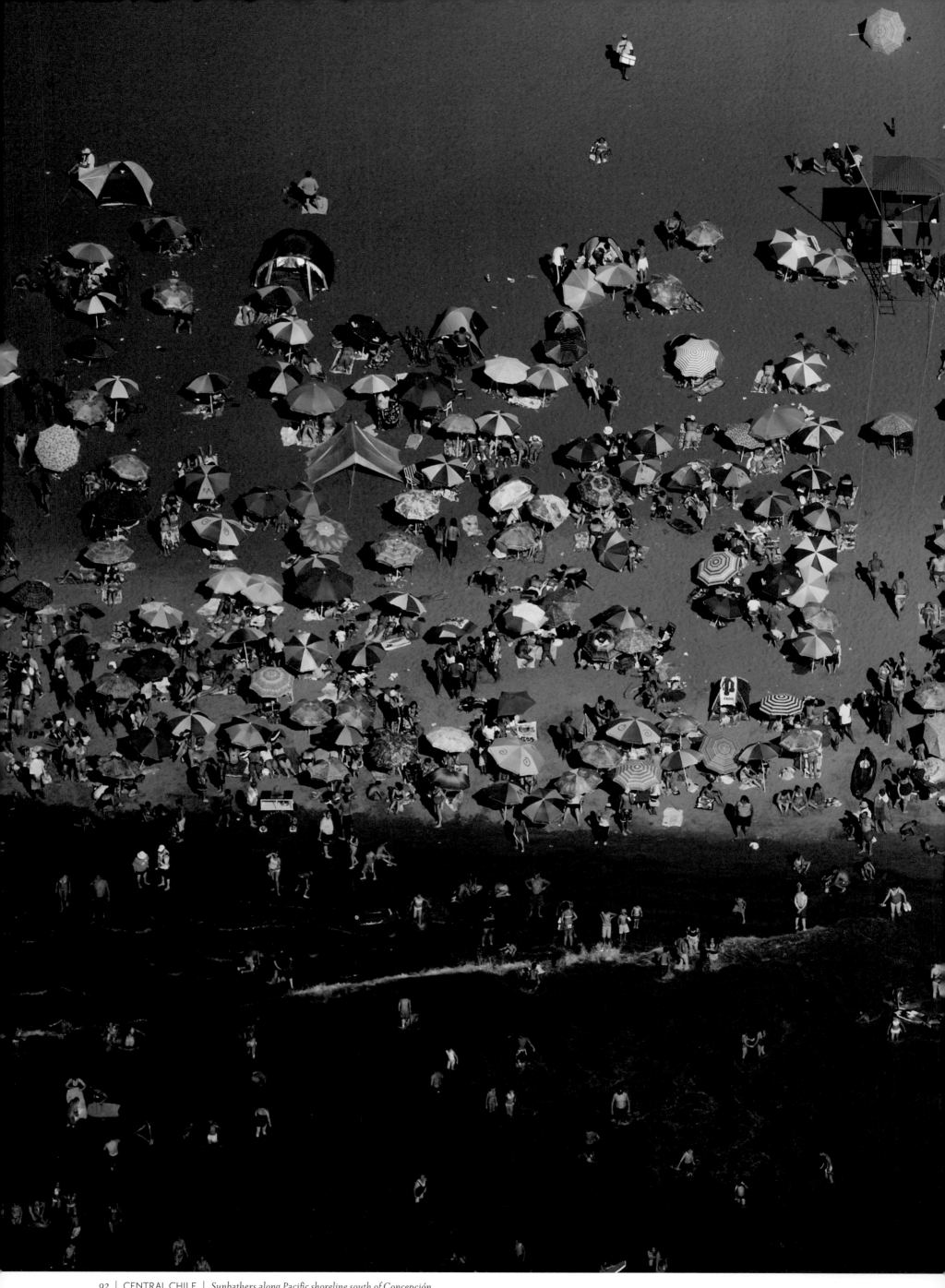

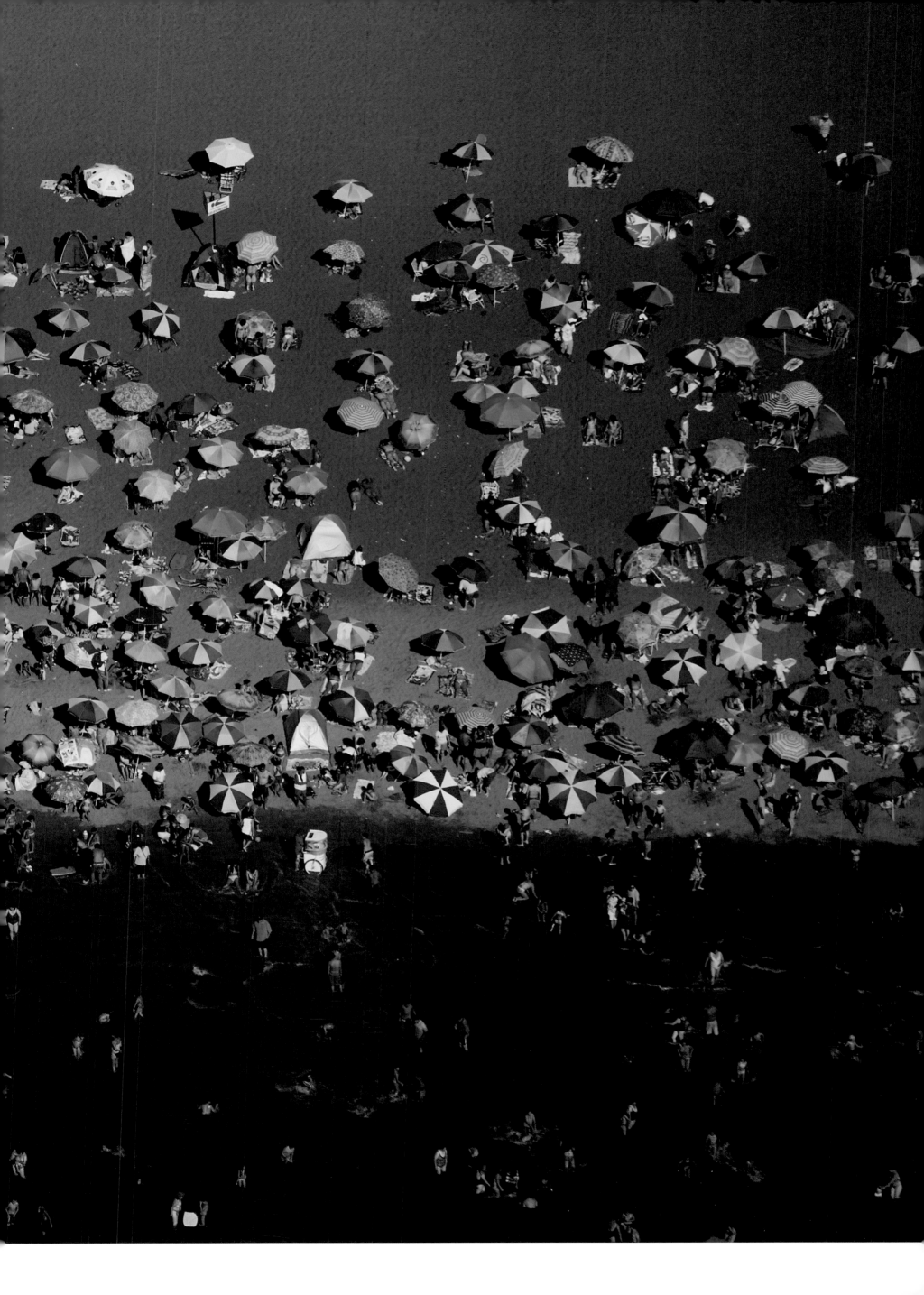

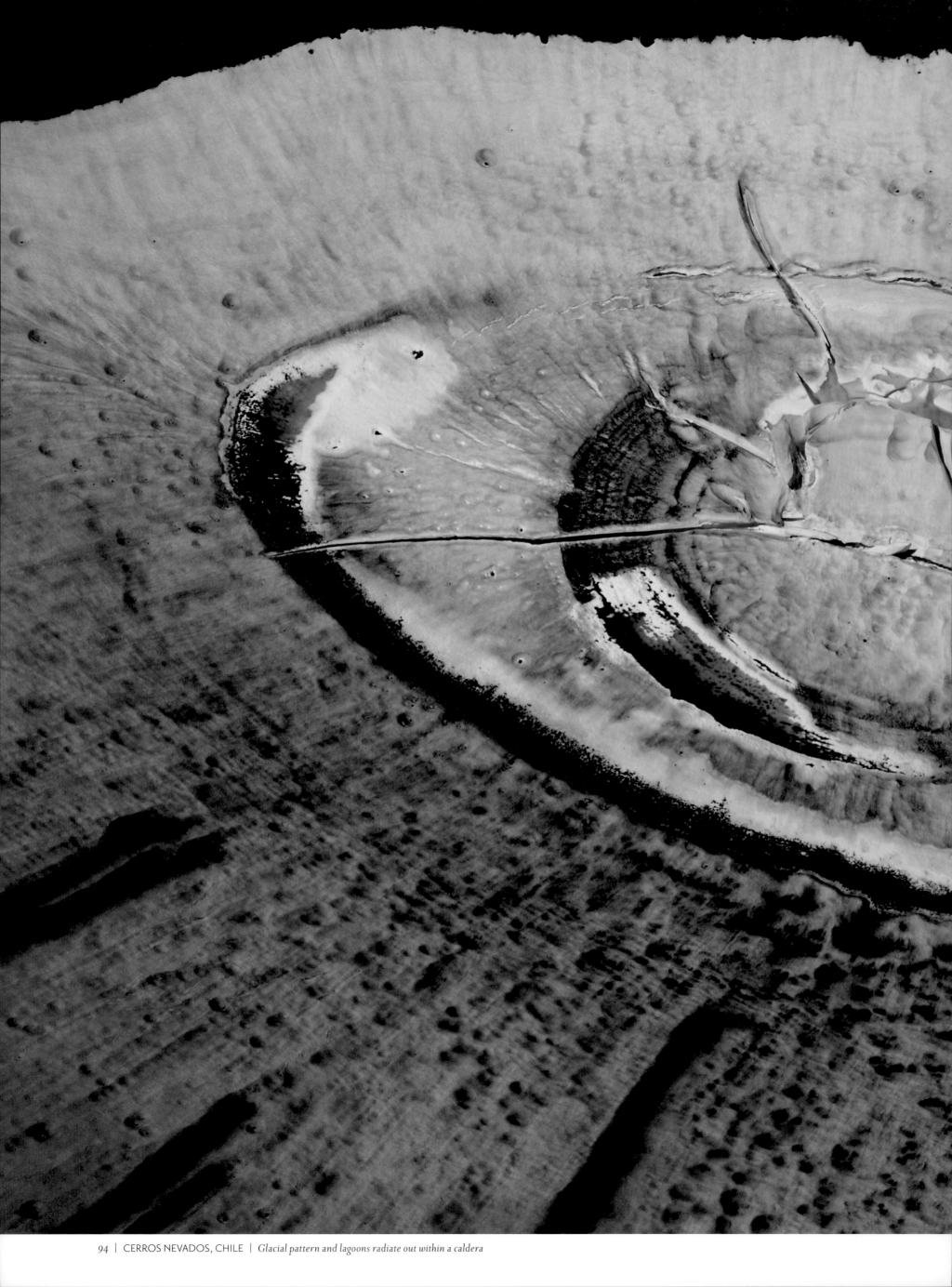

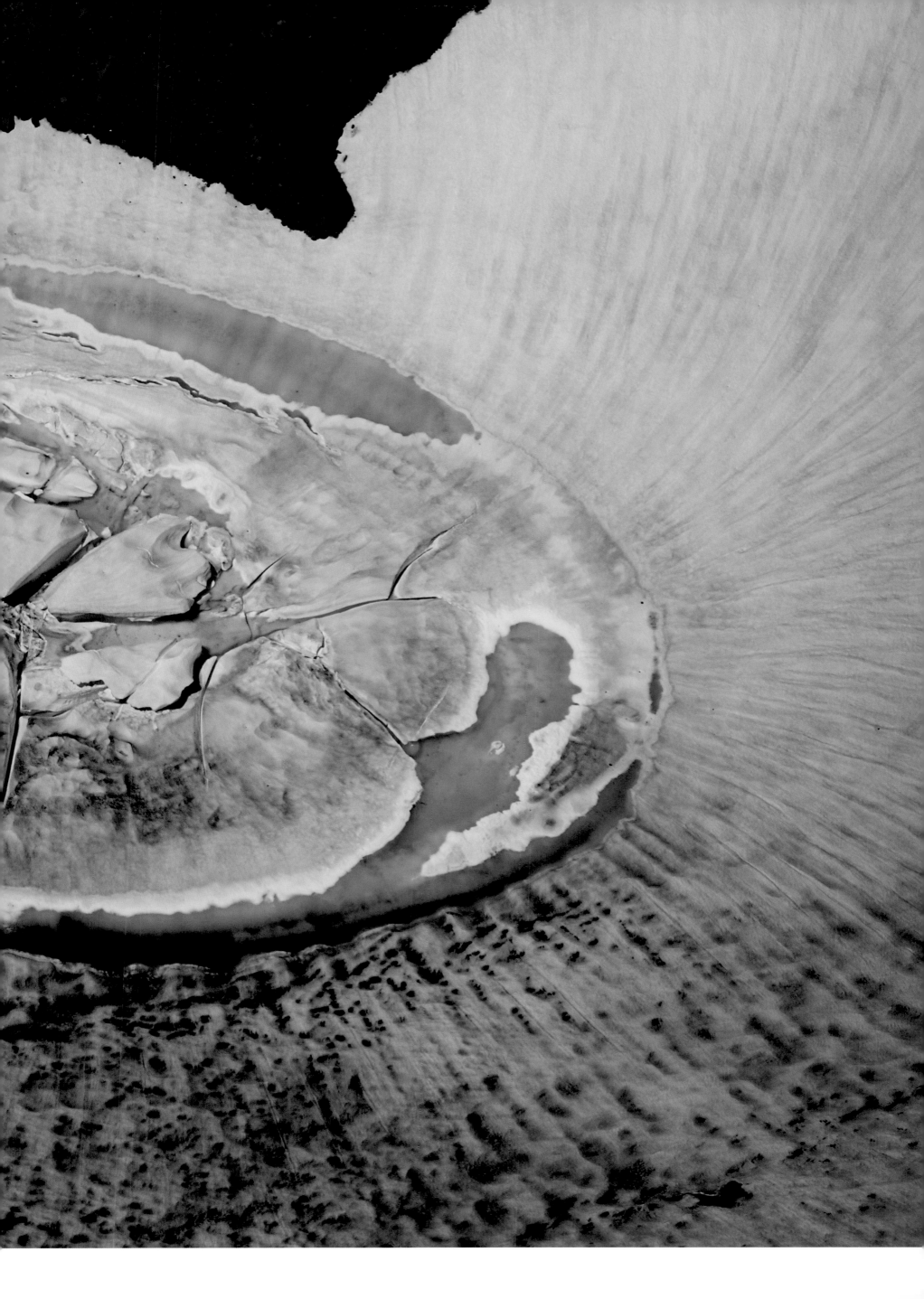

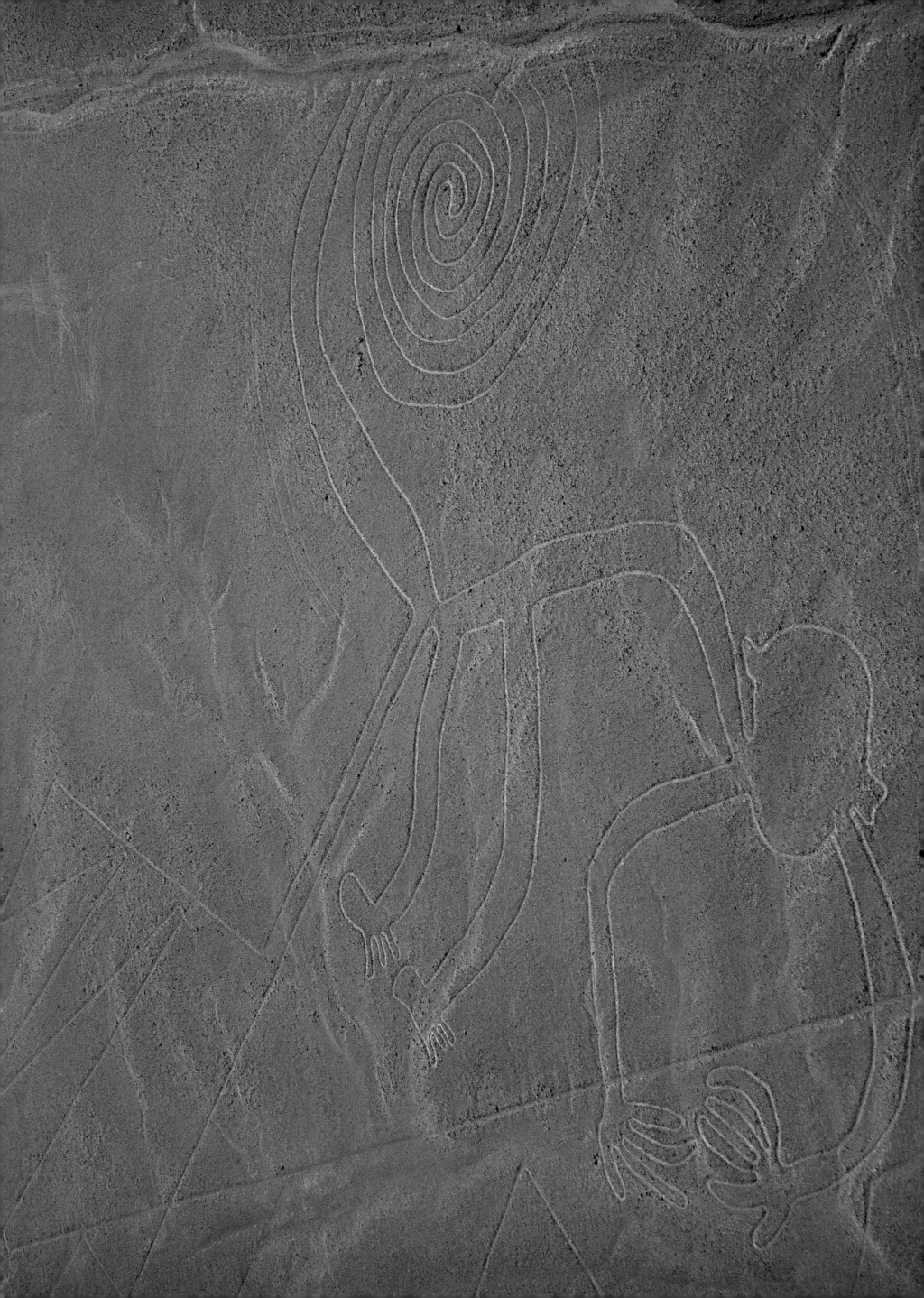

Dogfight Over the Desert

ONE OF THE MOST FASCINATING SIGHTS IN ALL OF SOUTH AMERICA—THE FAMOUS NASCA LINES—SHOULD BE AN AERIAL photographer's delight, if only because the artisans who etched this series of gargantuan portraits of animals, birds, geometric shapes, and fantasy figures in the hardened crust of the Ica Desert undoubtedly intended their handiwork to be viewed from above. In the pampa north of the Peruvian settlement of Nasca, a civilization dating back two millennia decided that this arid and desolate landscape offered the perfect canvas for depicting a complex set of shapes that bear a remarkable resemblance to the subjects of their artistry (including the condor, spider, hummingbird, monkey, lizard, and heron)…even though the craftsmen could never step back and assess their handiwork.

But what should have been a natural for an aerial photographer turned into a free-for-all. Until we actually arrived at the small airport in Nasca, I assumed we would be free to roam across the desert at will and feast our eyes on the etchings that decorate this 30-square-mile museum, first discovered in 1939 by North American scientist Paul Kosok. To my utter surprise, I was greeted by an airport scene that would have rivaled O'Hare in its intensity—a squadron of single-engine aircraft lifted off, one at a time, literally every few minutes. Each pilot had in his clutches a permit that required him to follow exactly the same route as his brethren, skittering from one etching to another at a brisk pace that kept each craft only a few minutes ahead of the next one in this aerial caravan. The flight rules allowed only two brief semi-circles around each formation. Hustling along at a cadence approaching 100 knots, we were not permitted to ad lib or go out of sequence.

This was the closest I've ever come to being in a drive-by shooting…I was obliged to shoot with virtually no regard for how closely the craft should position itself to the target, which angle would be best, or whether frontlit or backlit would be preferable. A lazy 360° circle around a target of particular interest was a luxury totally at odds with this orchestrated regimen. At times, I failed to spot a figure (all beige lines against a pale desert floor) until we had actually passed it by and the pilot or guide was pointing frantically but rather hopelessly at what was no longer in photographic range. The skies were so crowded with single-engine aircraft that I felt like a bit player in a Cecil B. deMille extravaganza entitled *Dogfight Over the Desert*.

At the end of the day, I counted close to 30 rolls of film, all burned with the most suspect accuracy. If within those 1,000 images just one were to survive the editing process, I would be content. As we trudged back to camp, I could not help but imagine the ghosts of the original Nasca artisans watching this aerial extravaganza and wandering off into the Ica Desert, shaking their heads in collective disbelief. —*RBH*

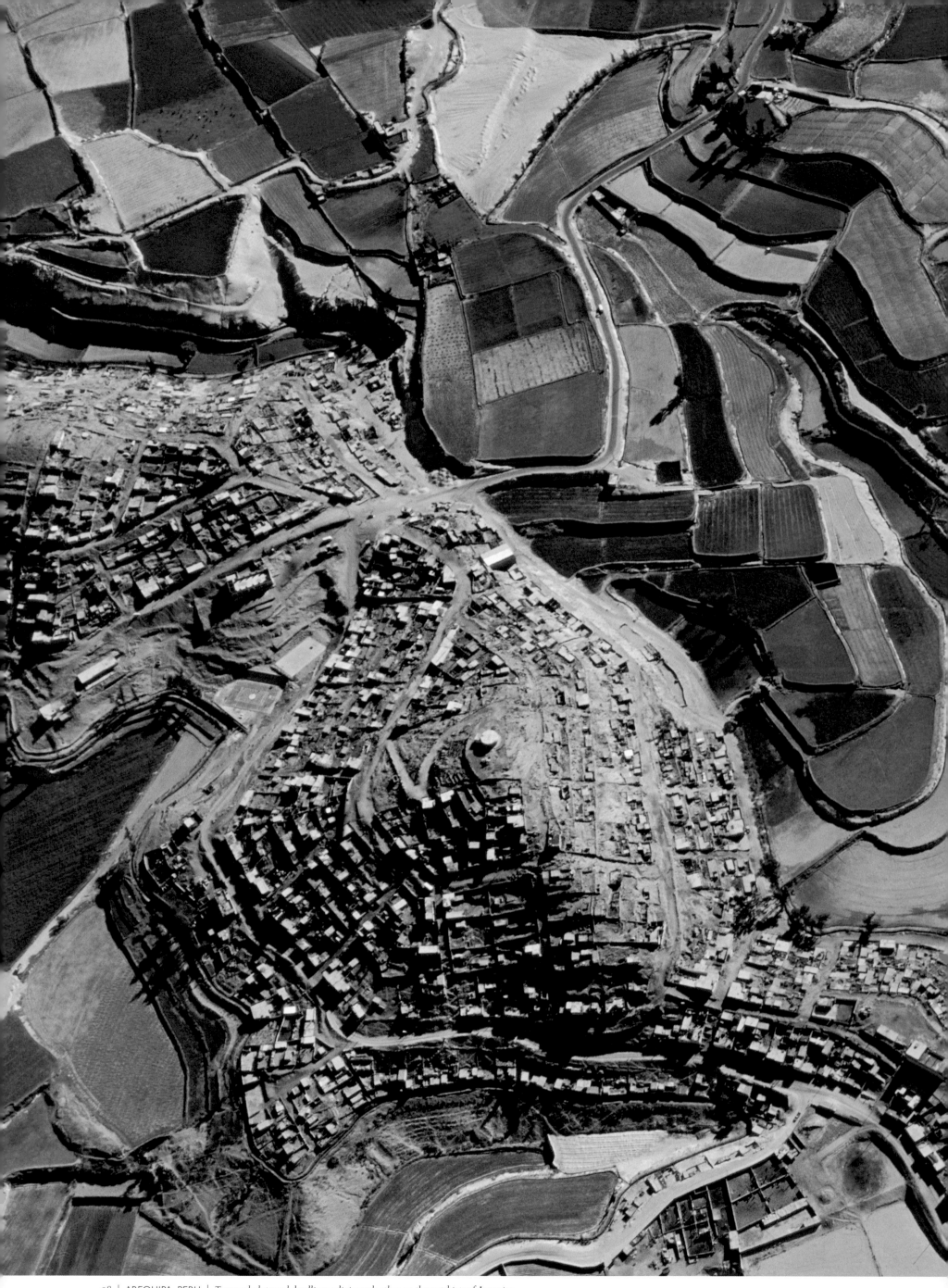

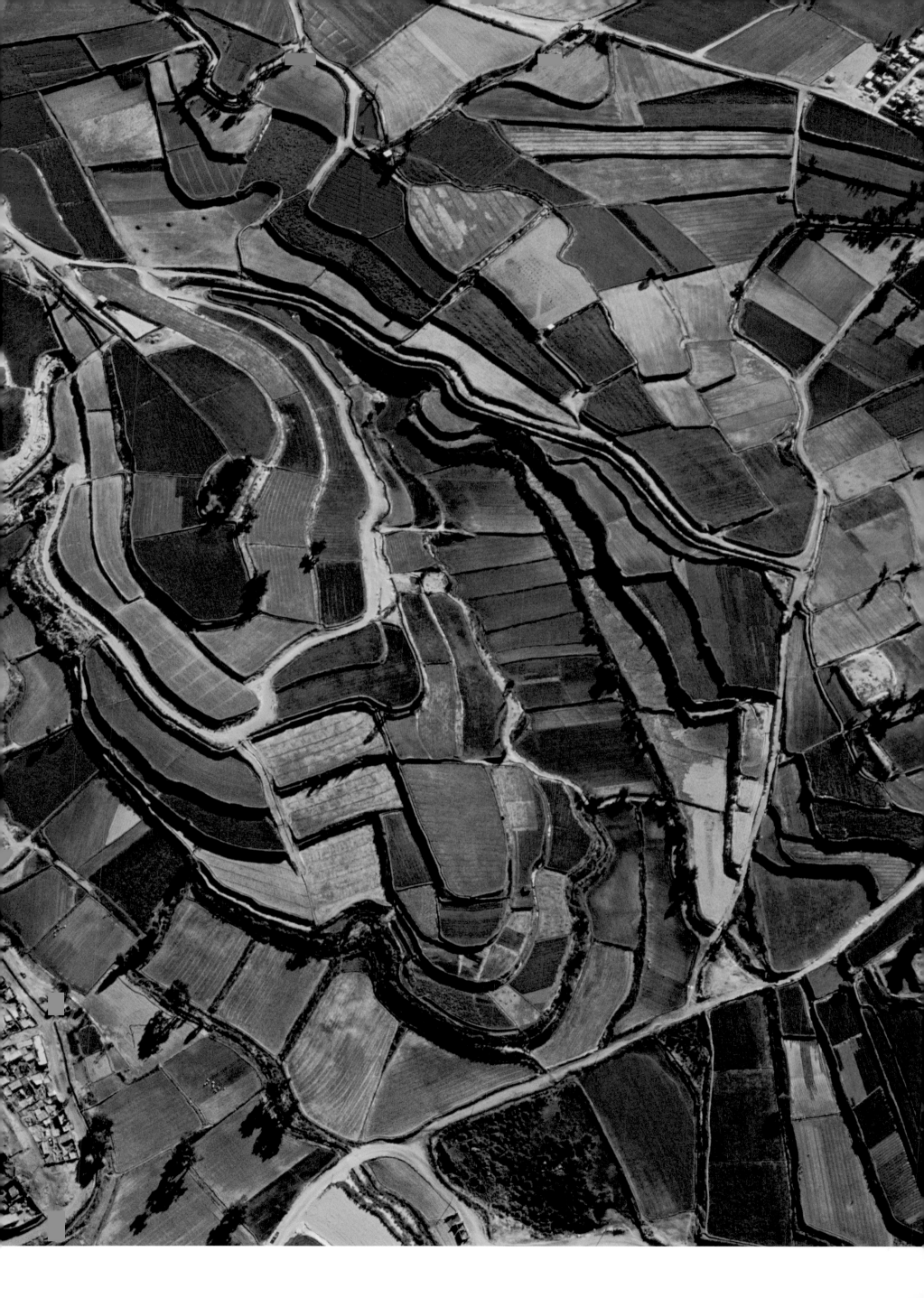

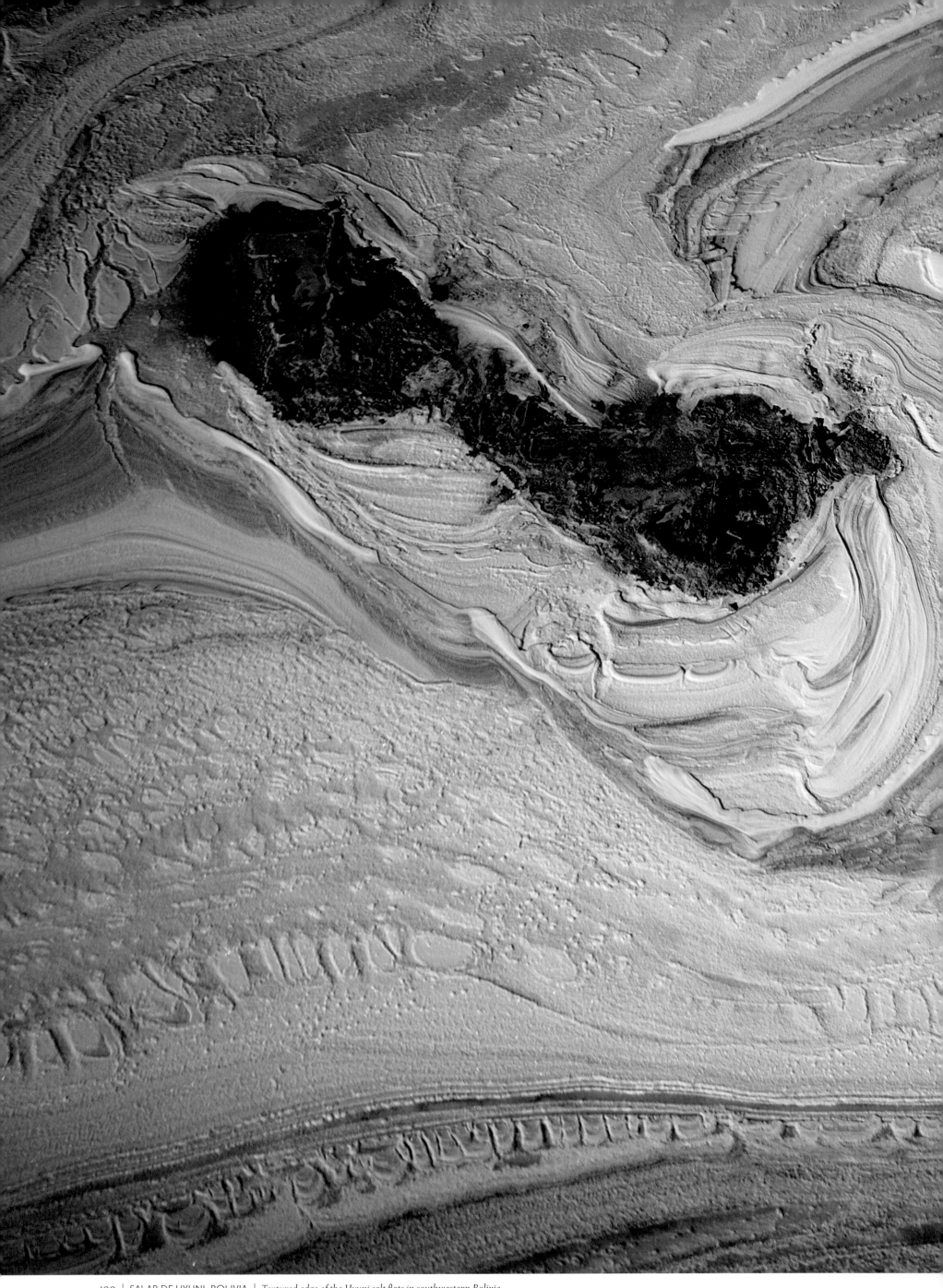

| SALAR DE UYUNI, BOLIVIA | *Textured edge of the Uyuni salt flats in southwestern Bolivia*

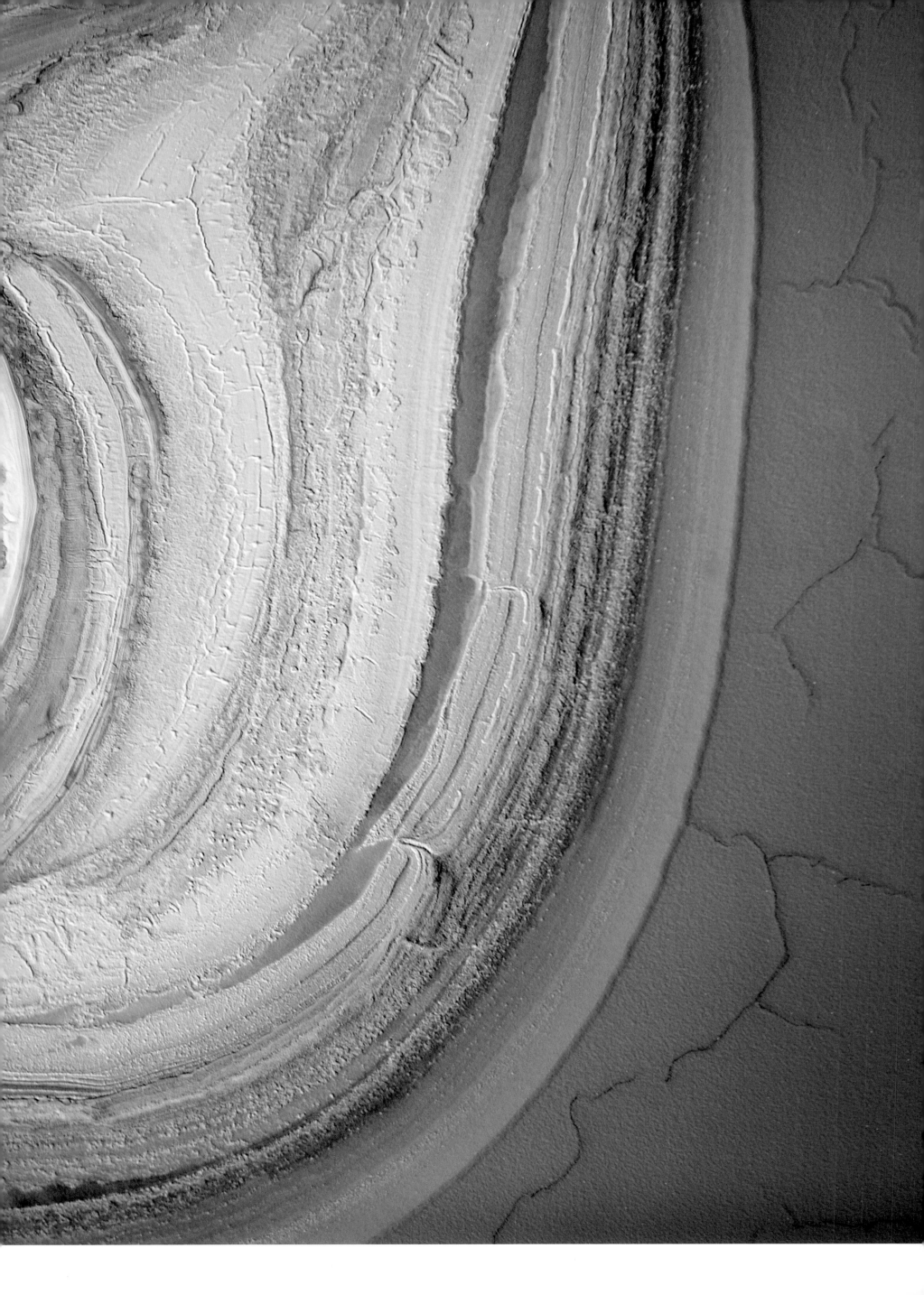

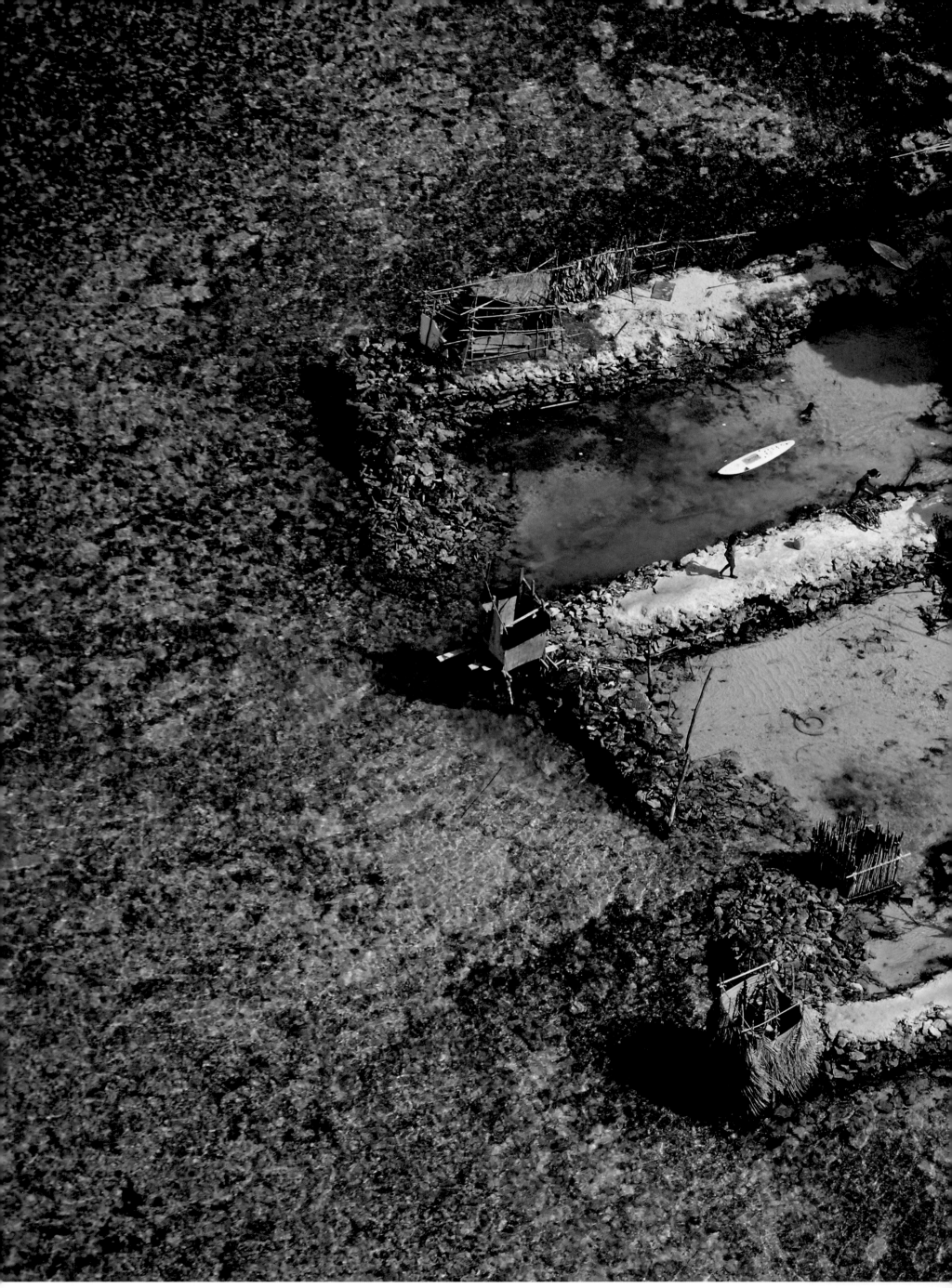

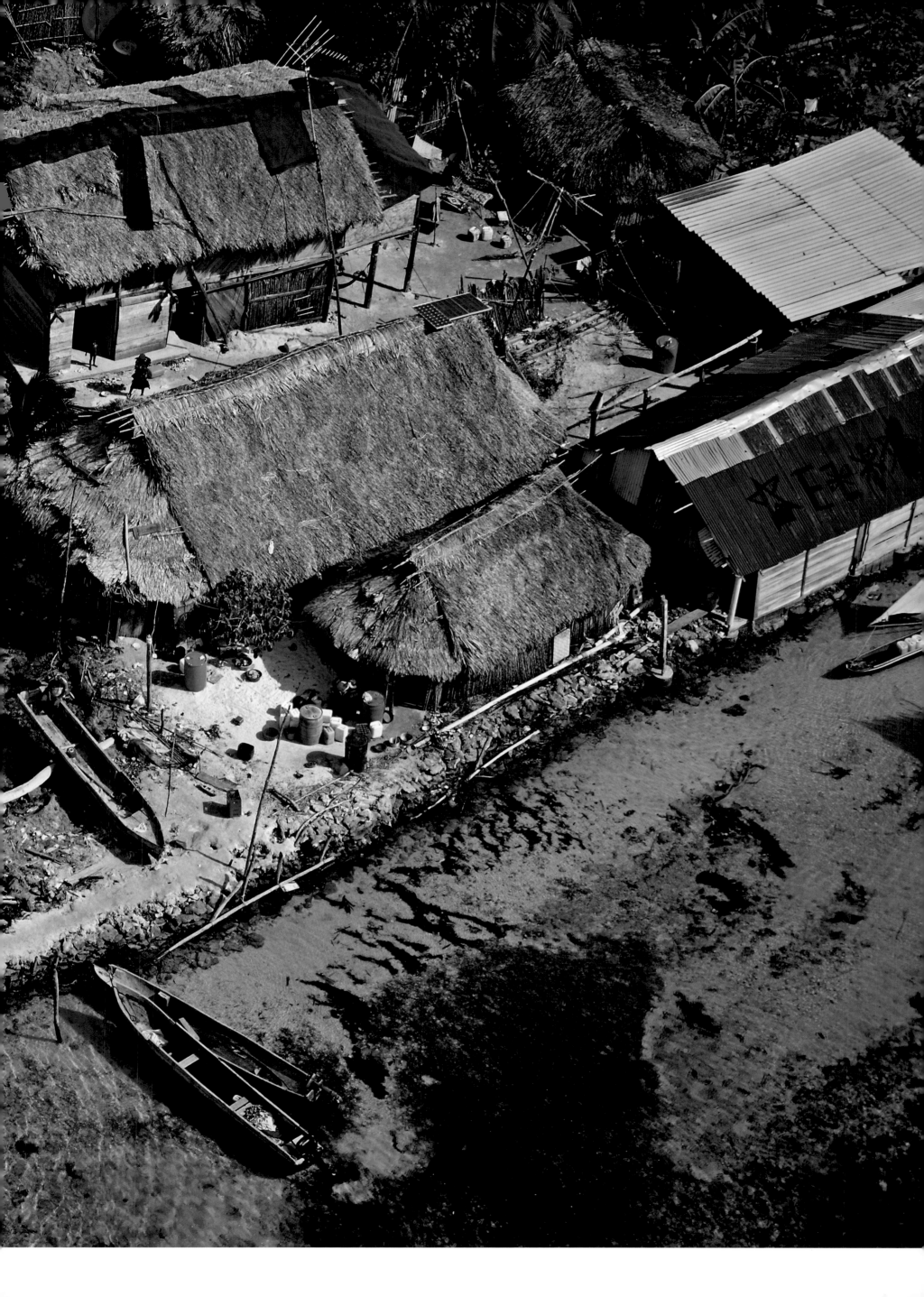

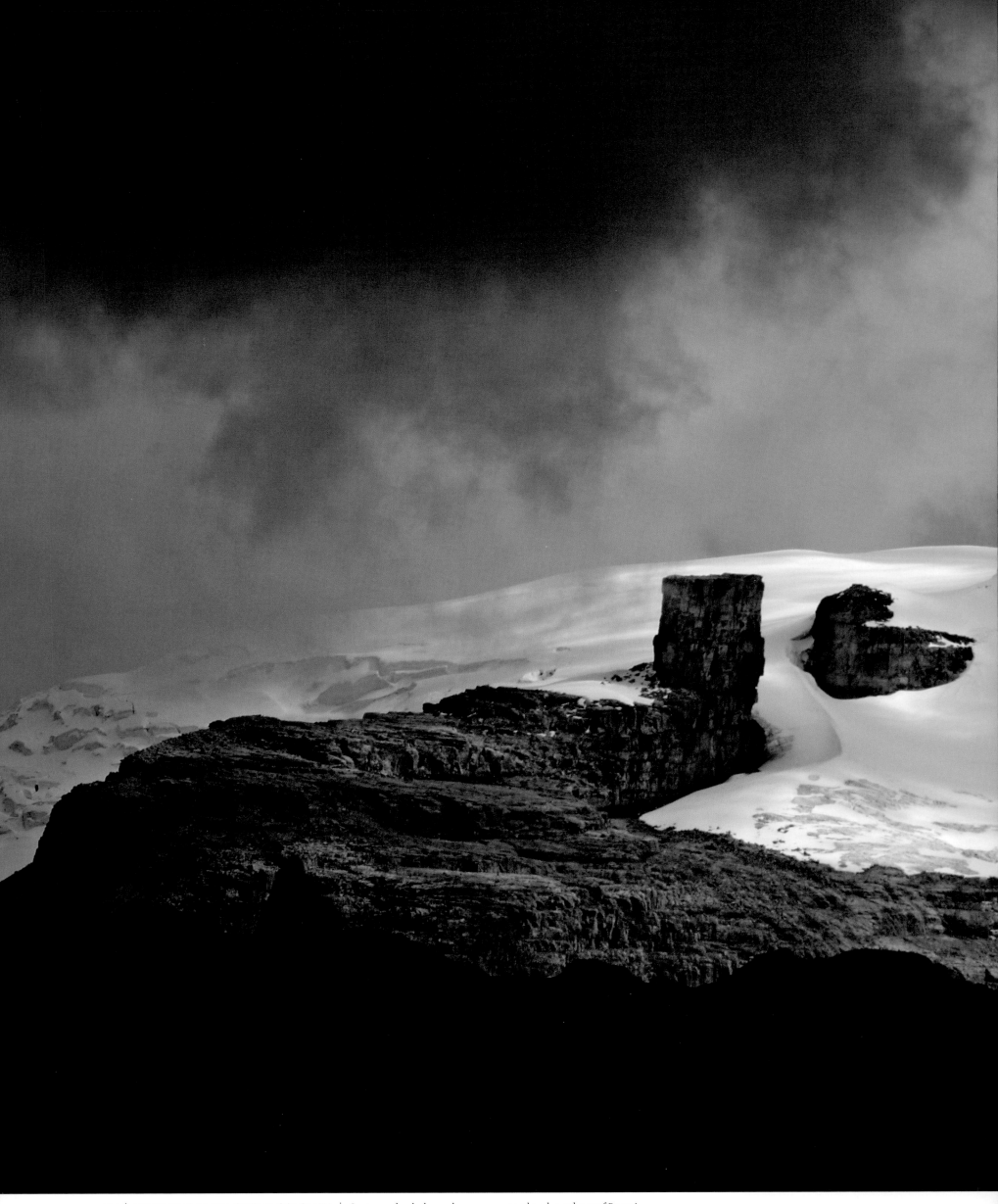

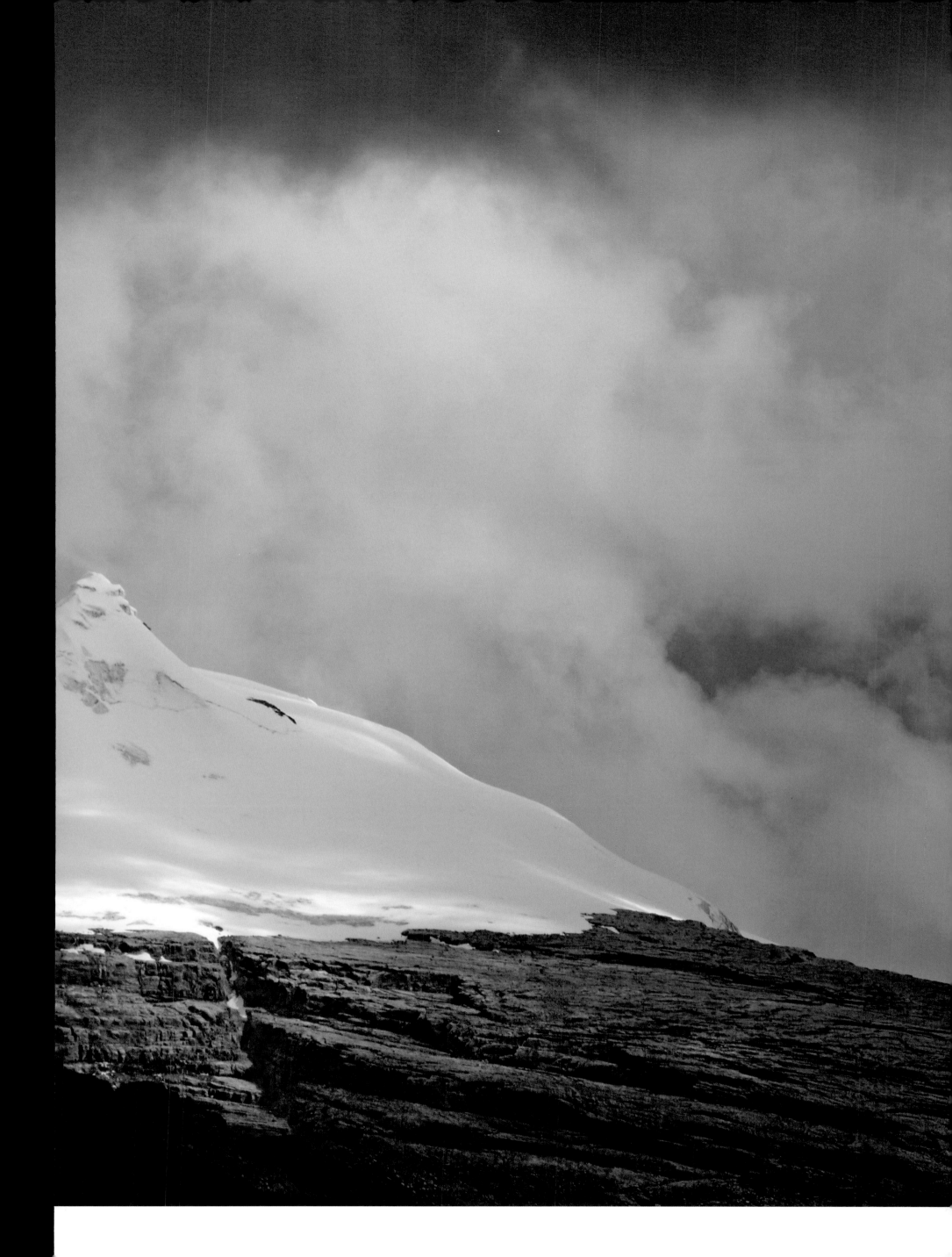

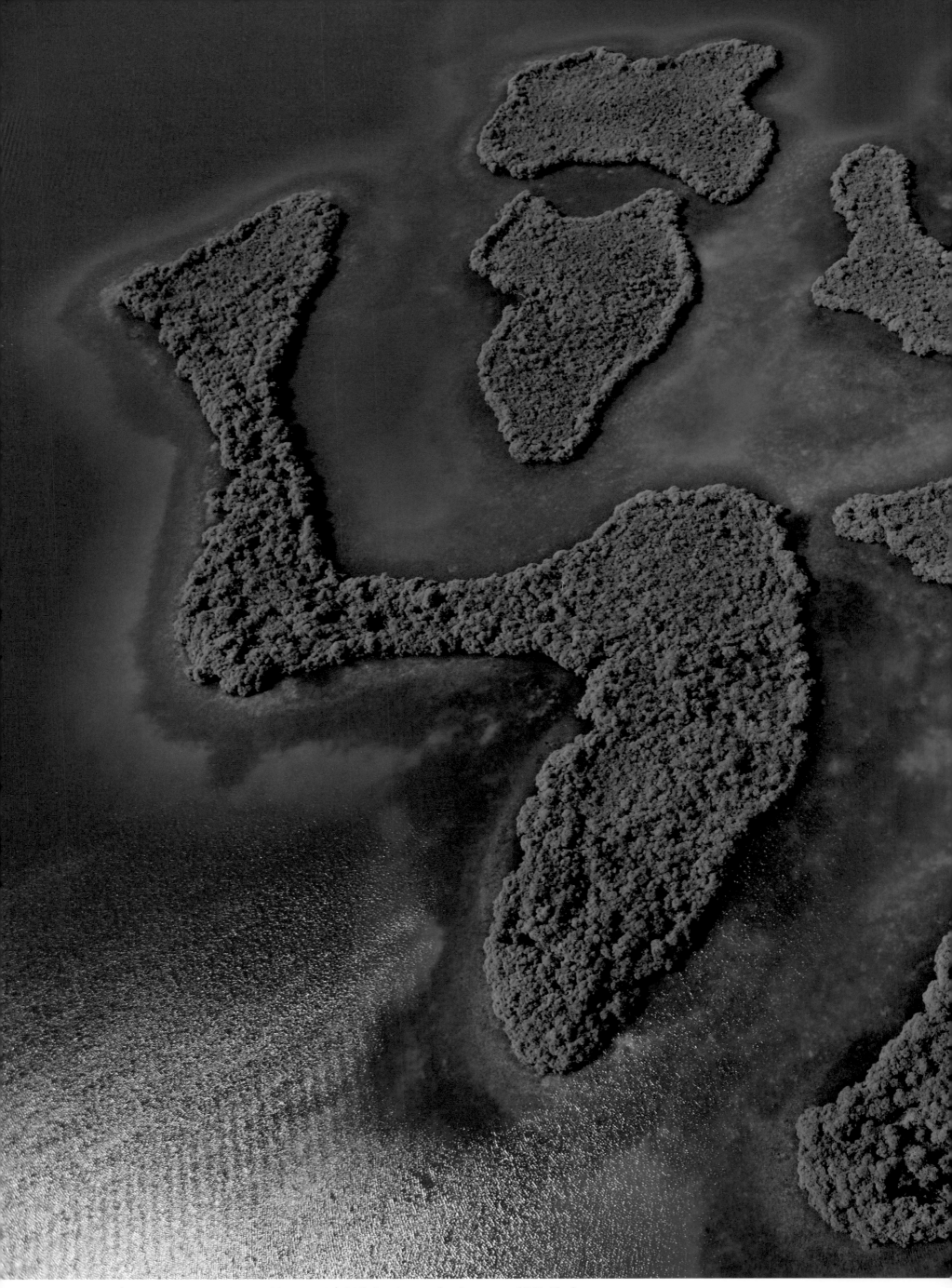

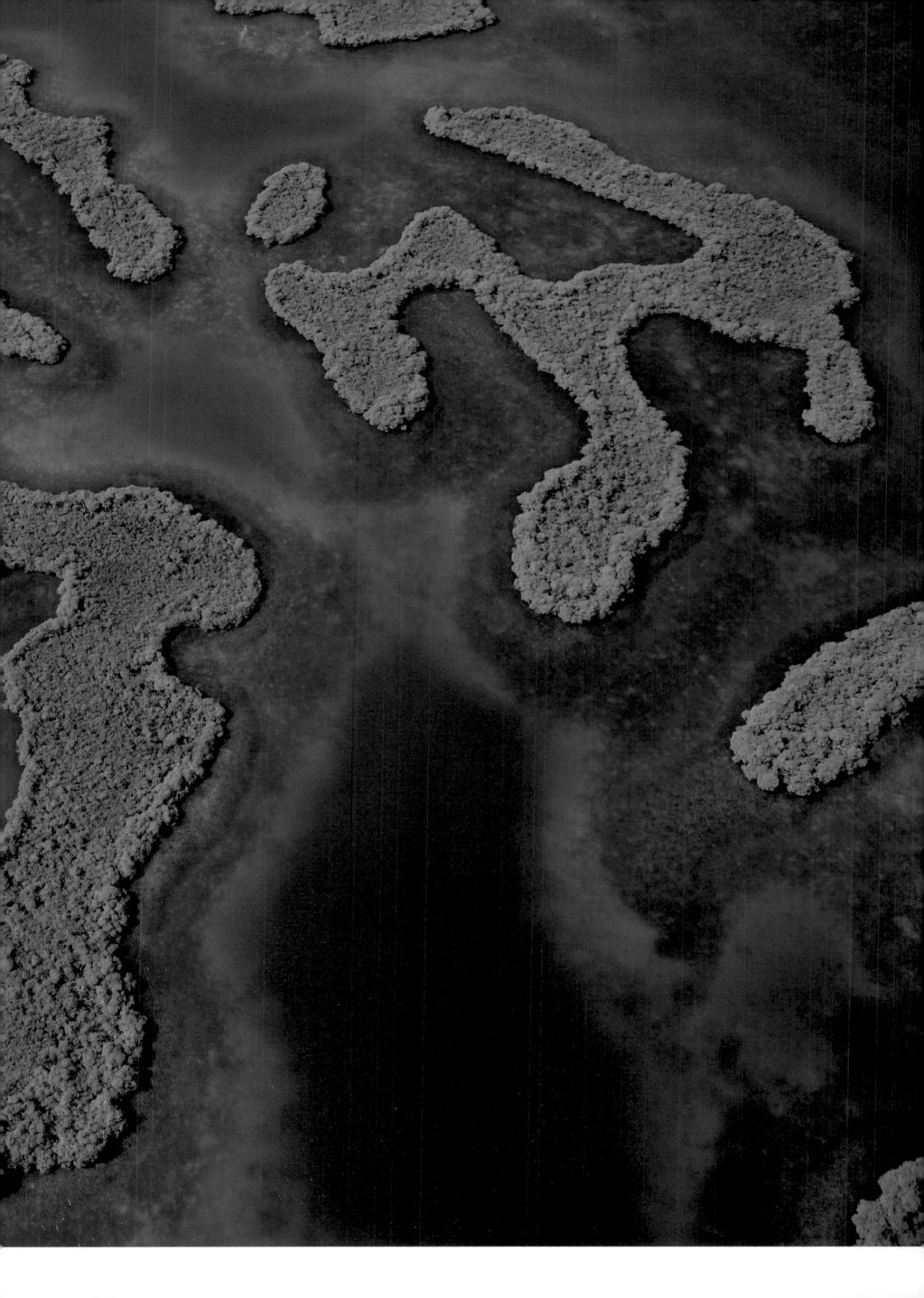

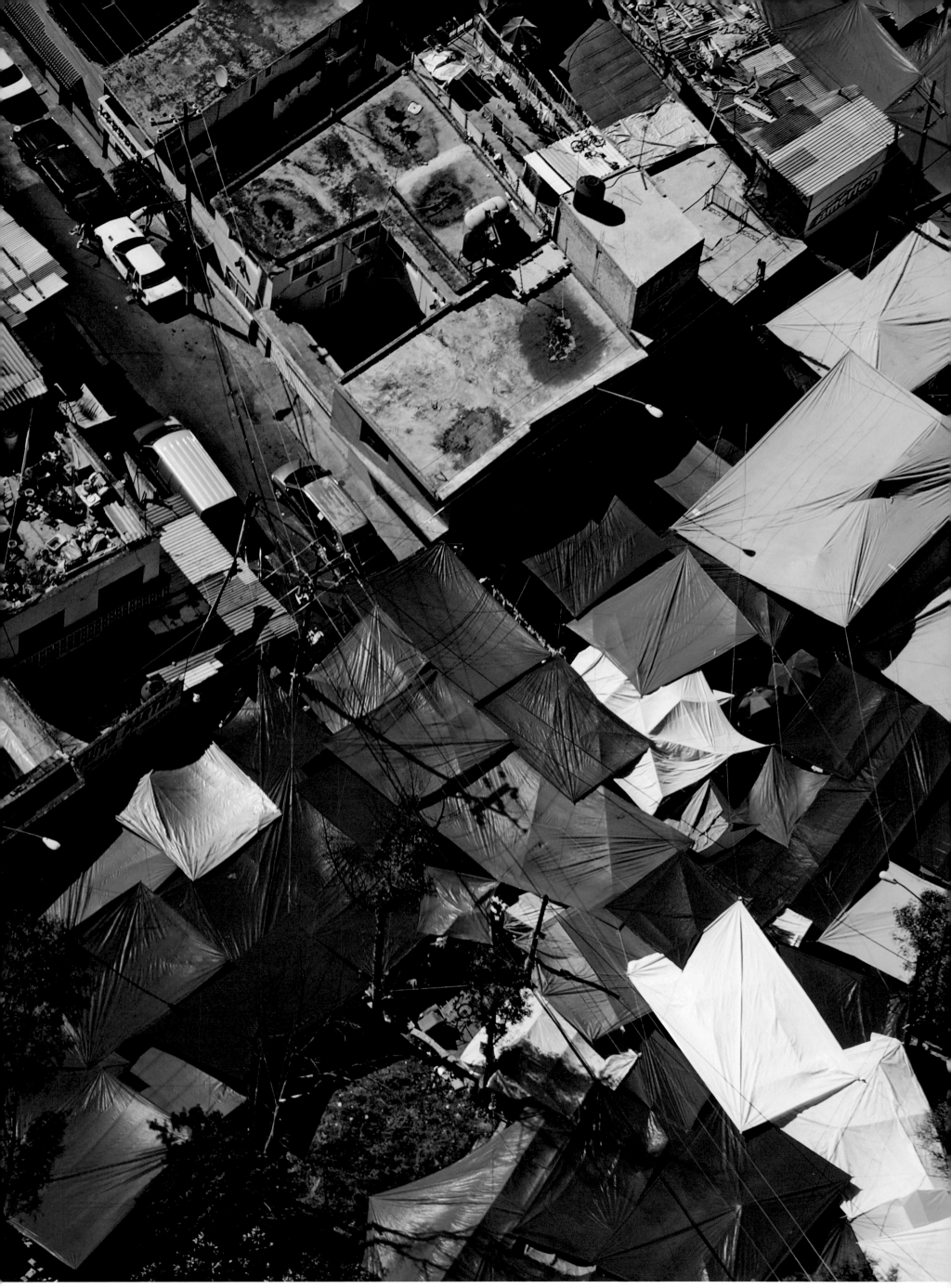

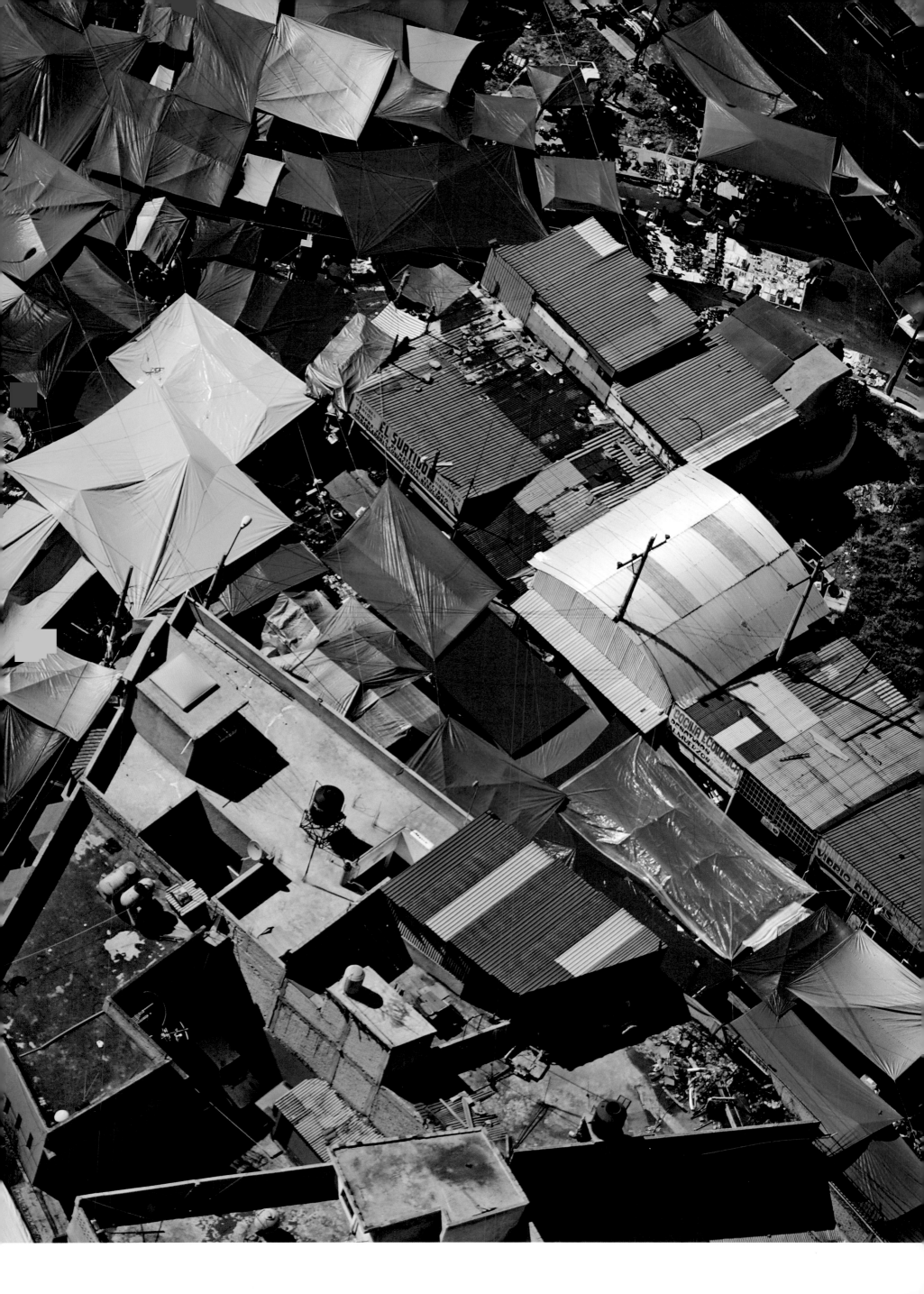

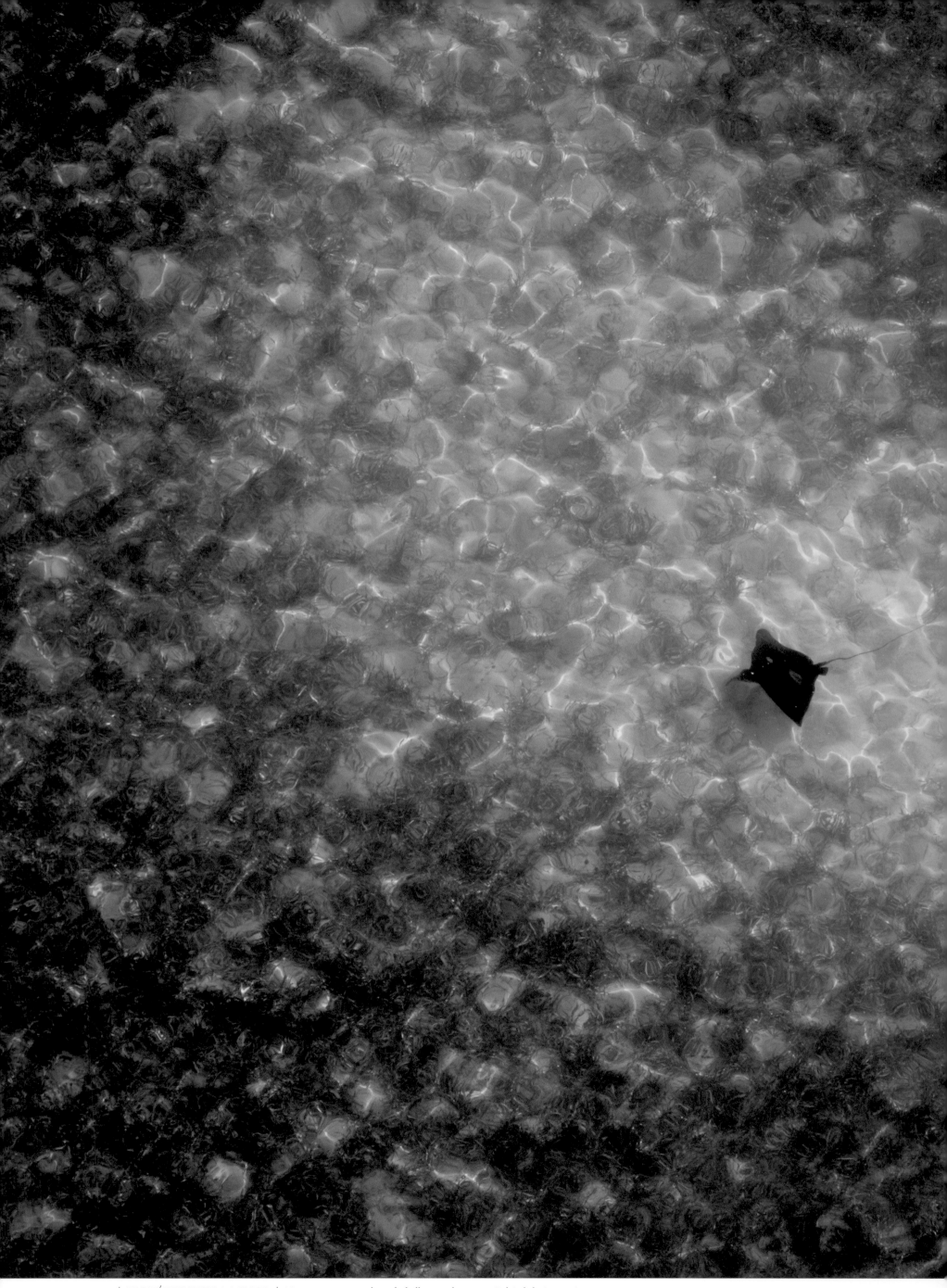

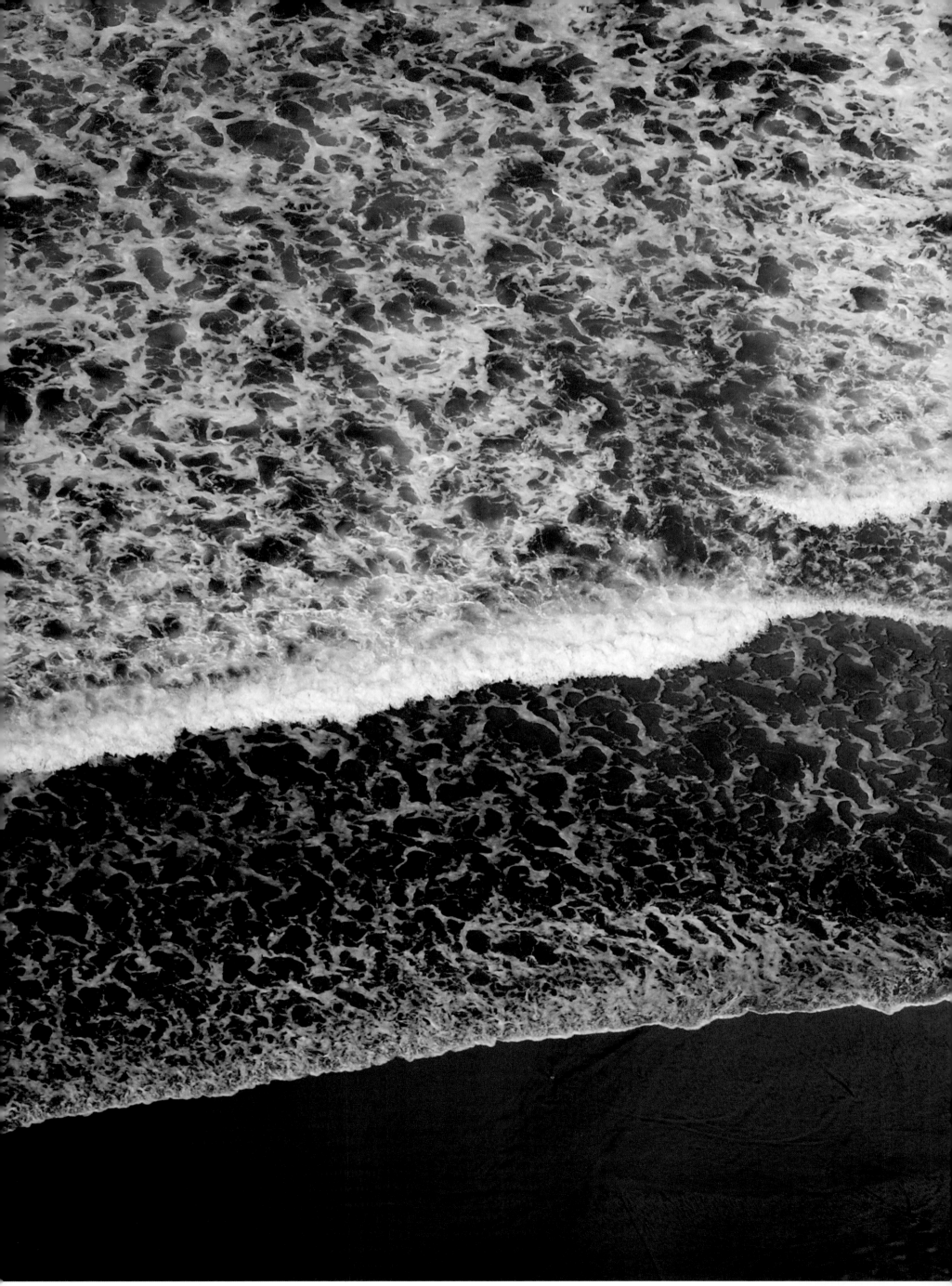

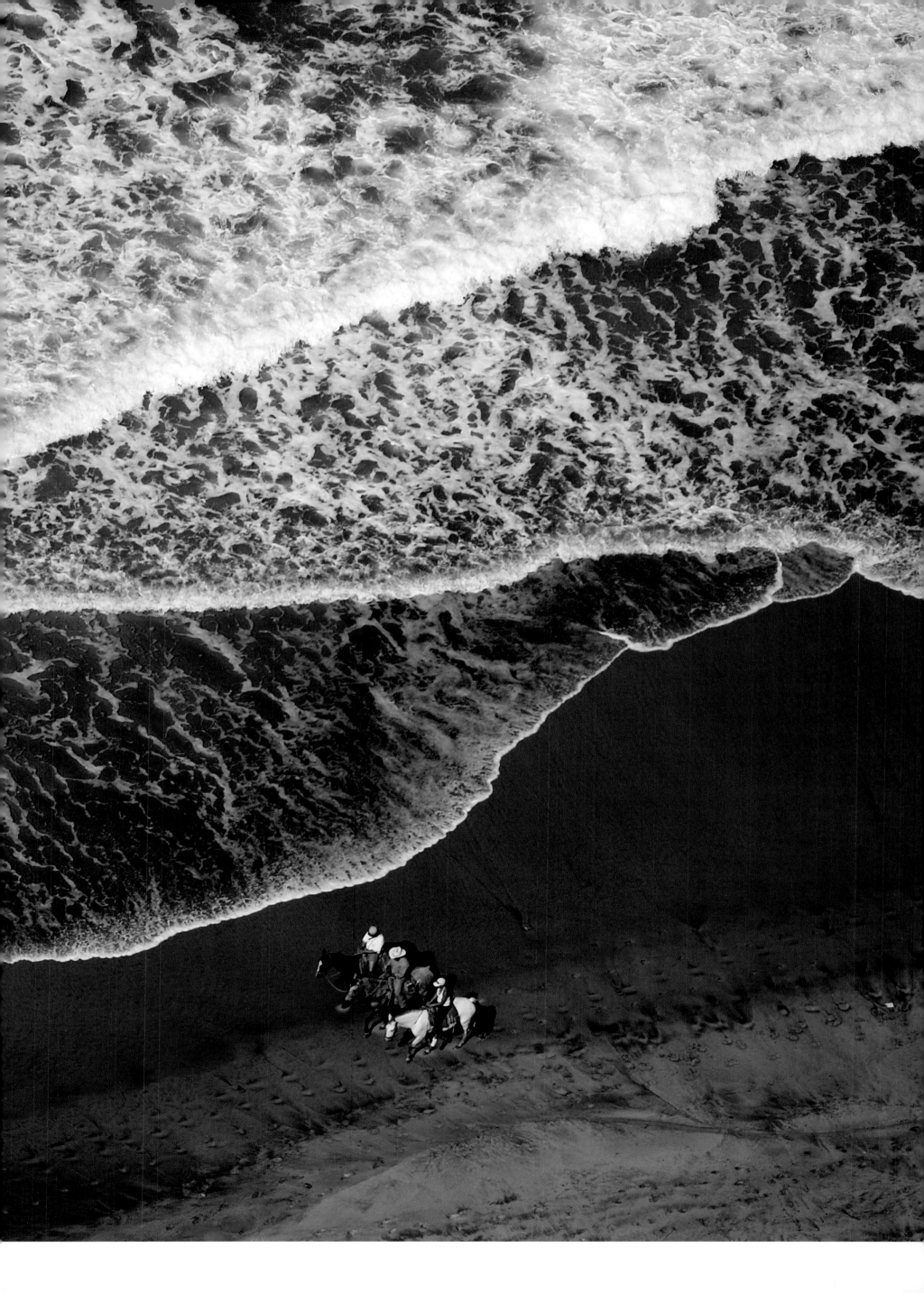

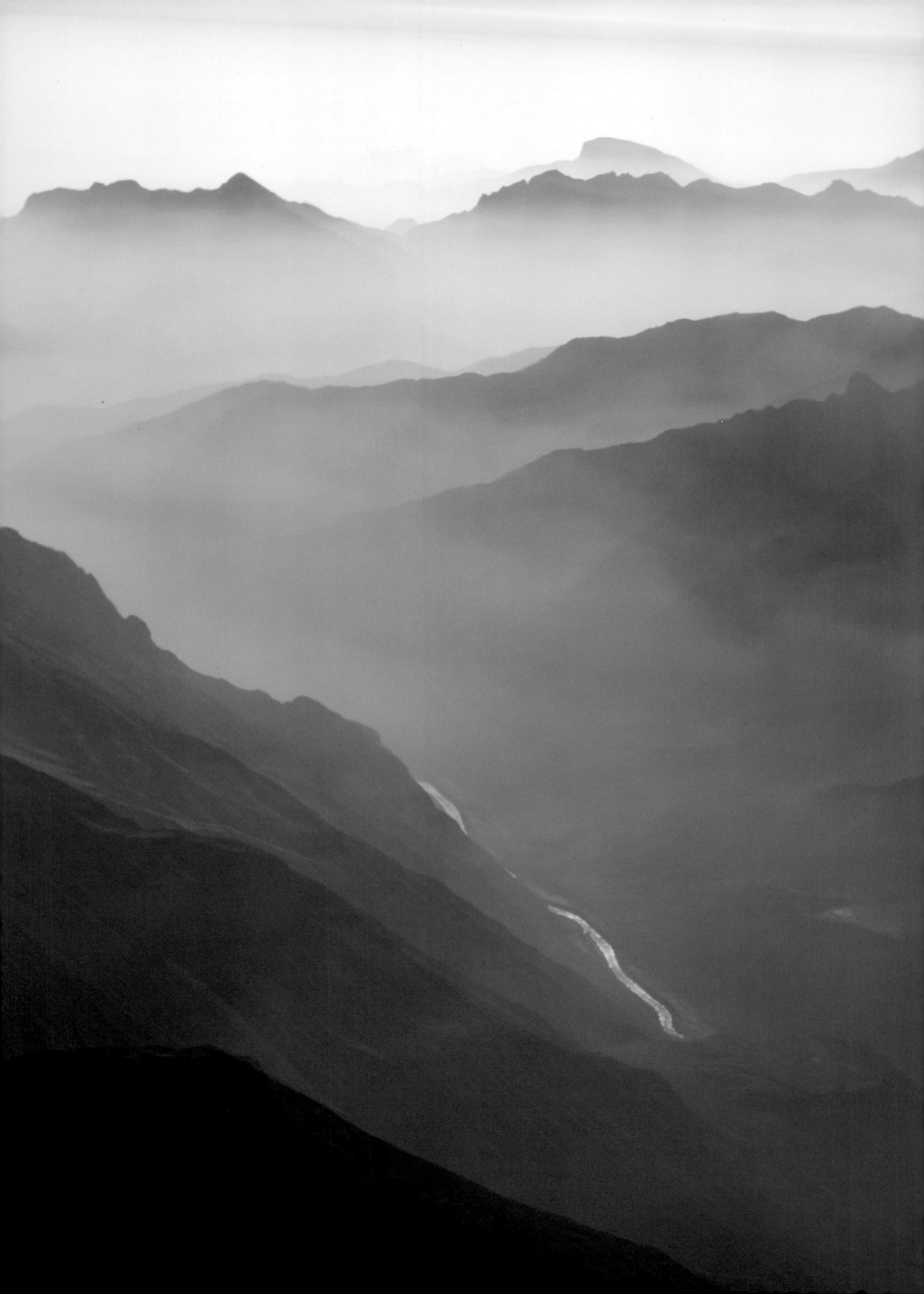

MACHU PICCHU, PERU

Sanctuary at Machu Picchu

THE NAME OF THE LODGE IS "THE SANCTUARY AT MACHU PICCHU," BUT IT IS HARDLY THAT. DURING THE DAYLIGHT HOURS the Sanctuary is a beehive of activity, with an endless succession of buses disgorging wave after wave of *turistas* who invade this mountain retreat as relentlessly as the conquistadores imposed their European will upon the Inca 500 years ago. In a twist of irony, Machu Picchu, perhaps the most iconic landmark of an intensely dignified Inca civilization, now faces daily invasions by a never ending procession of smoke-belching tour buses...*Field of Dreams* meets Yankee Stadium.

Wandering around the ruins at Machu Picchu, I detect a palpable sense of genius and achievement, but also the poignant melancholy that attaches to a scene overrun with visitors but utterly devoid of ancient life.

Unable to sleep past 4 a.m. on my second day at Machu Picchu, I wander downstairs and nurse a Peruvian-strong cup of coffee in my chilled hands. And in the predawn void, Machu Picchu seems to stir as well. A distinct spirituality fills the air...the Inca are awake now for just a while longer. In the solitude of a sanctuary still asleep with its 21st-century visitors, I sense the mountains are also alone in their collective dignity. At this early hour, the scene eerily resembles a more distant era. There are no backpacks, water bottles, or designer vests to dispel the Inca spirits. The footprints left in the dust of the mountain terraces by Nike footwear do not yet spoil the ancient rhythm with an anachronistic note.

I wander around the dining hall and gaze at a series of large black-and-white photographs taken by Hiram Bingham. The acknowledged "discoverer" of Machu Picchu, Bingham led the National Geographic-Yale Expedition of 1912 that unveiled this "lost city of the Inca" to a world that had lived in ignorance of its existence for half a millennium. The photographs prove, once again, that black-and-white photography sometimes offers a range of emotional octaves that chromatic film can only hint at. The images depicted in the expedition scenes of 95 years ago are every bit as alive as the characters in the photos are not.

But predawn never lasts forever...it only lasts until dawn. And as daylight approaches, a crowd collects itself on the opposite side of the lodge to witness the sun cresting over the mountain peaks. A waiter asks if I would care to join the group on the other side, but I decline, preferring to sit alone amid the 1912 photographs and the ancient spirits which will recede as surely as the sun will rise. —*RBH*

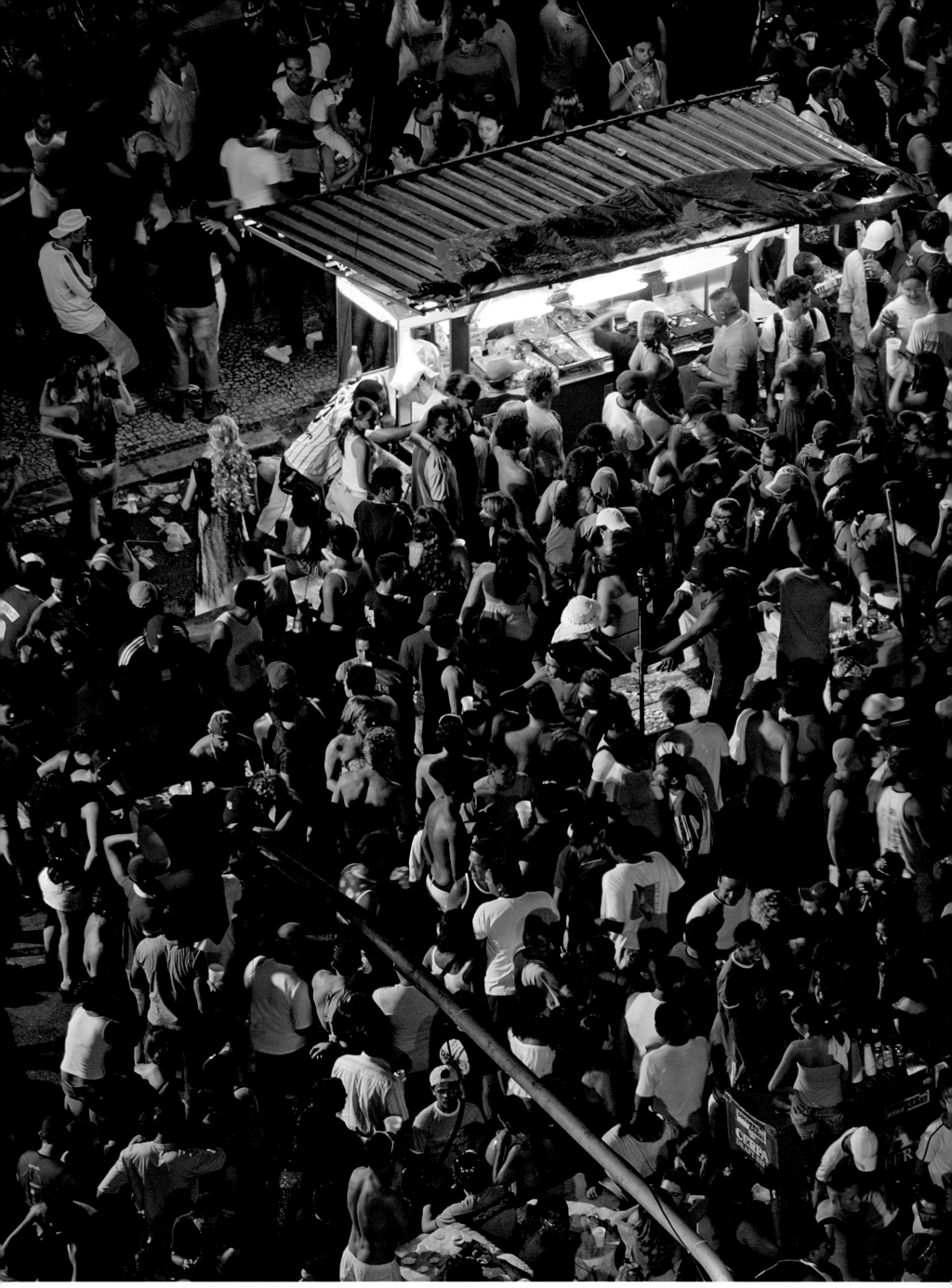

Revelers at a street festival and rock concert densely pack the Praça da República in Belém

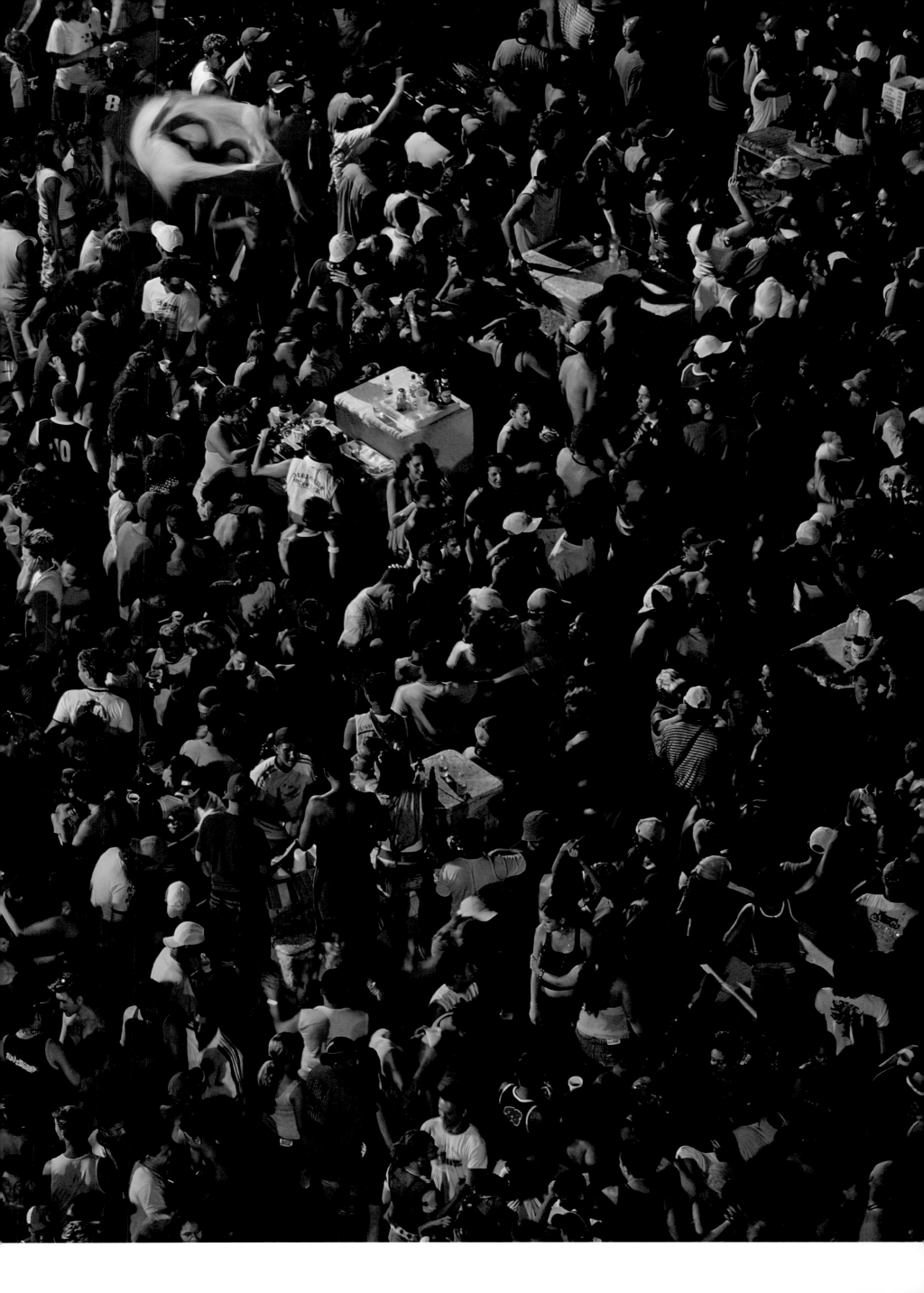

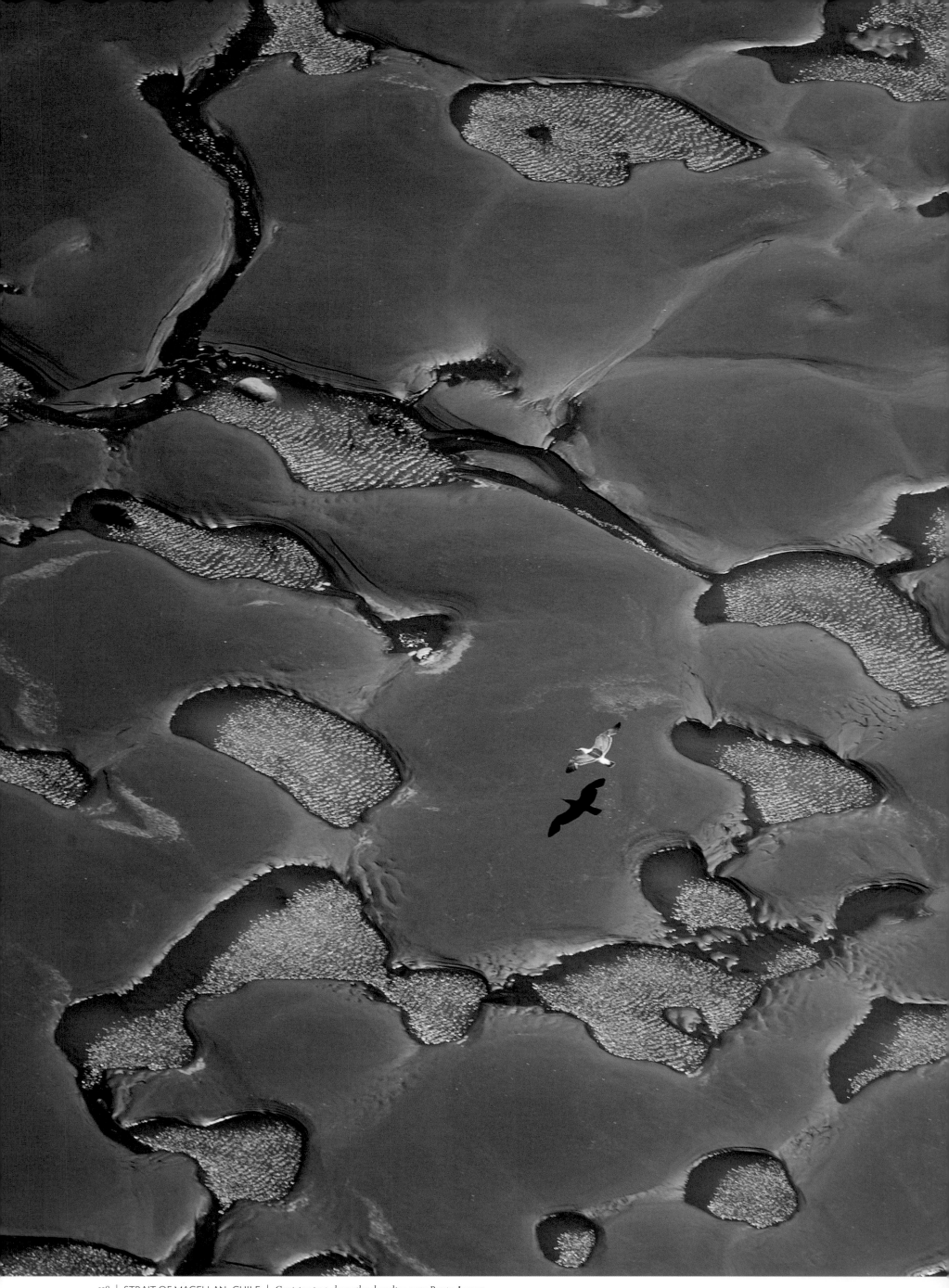

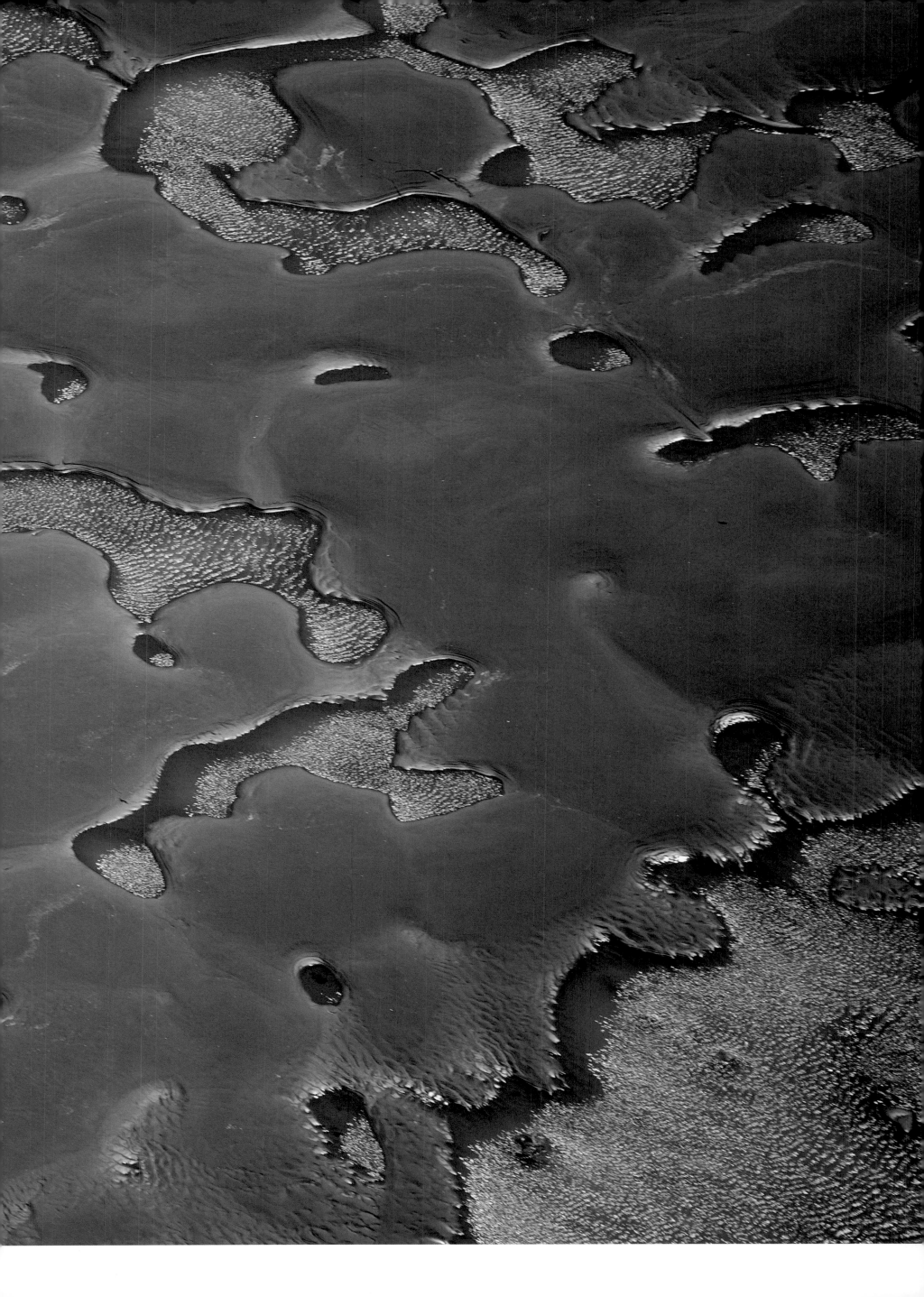

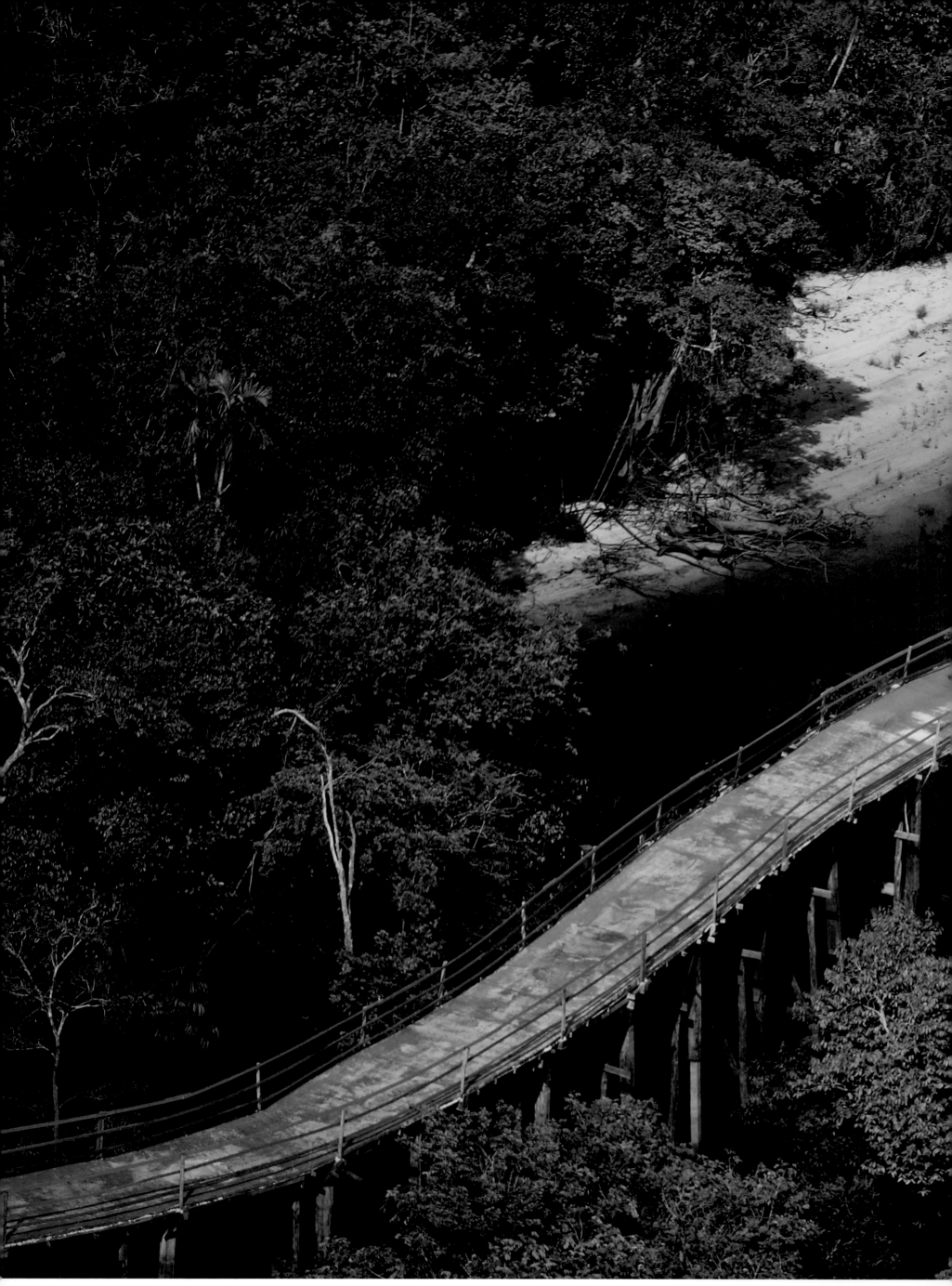

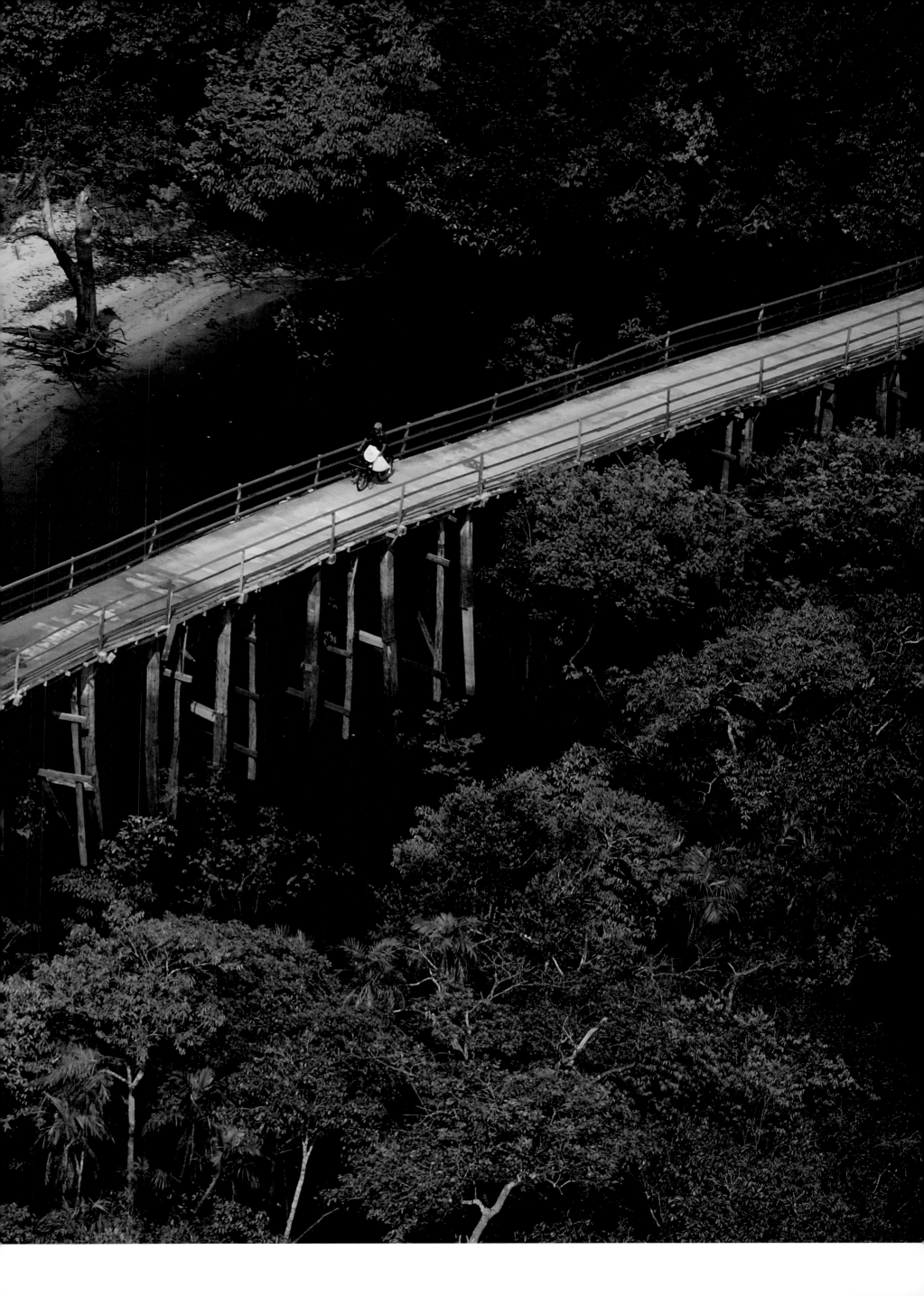

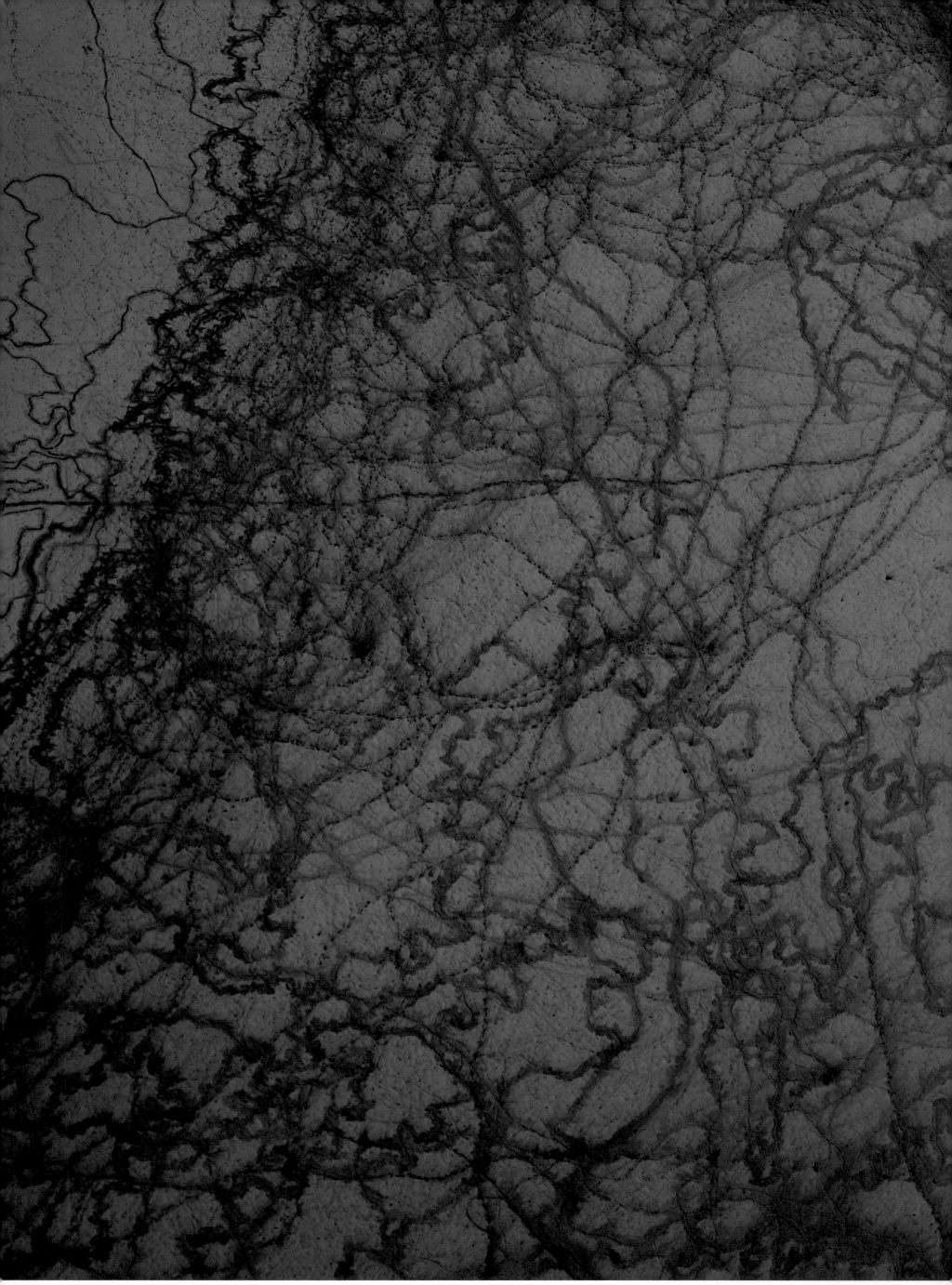

| LAUCA NATIONAL PARK, CHILE | *Single Andean flamingo wanders among a labyrinth of tracks*

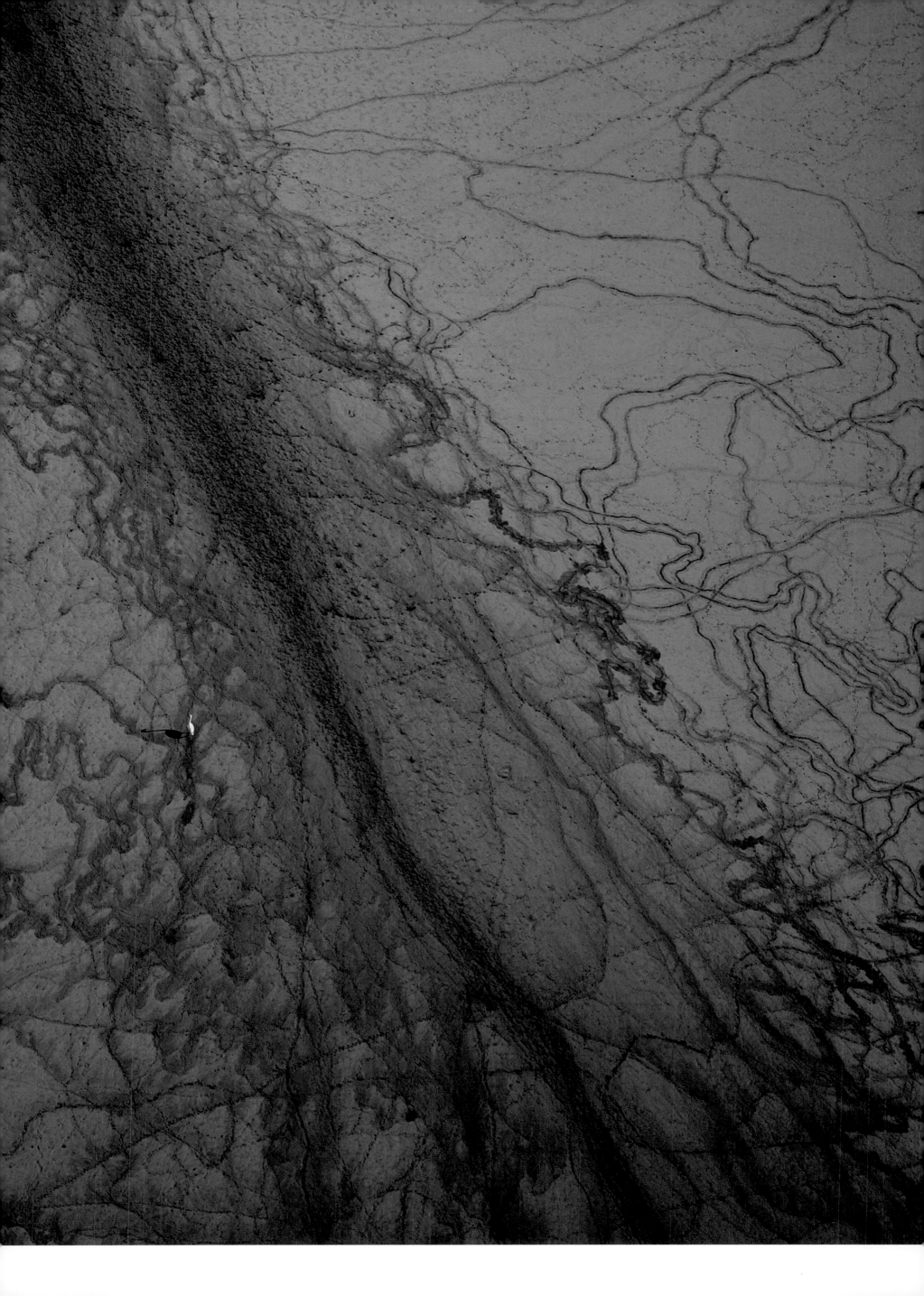

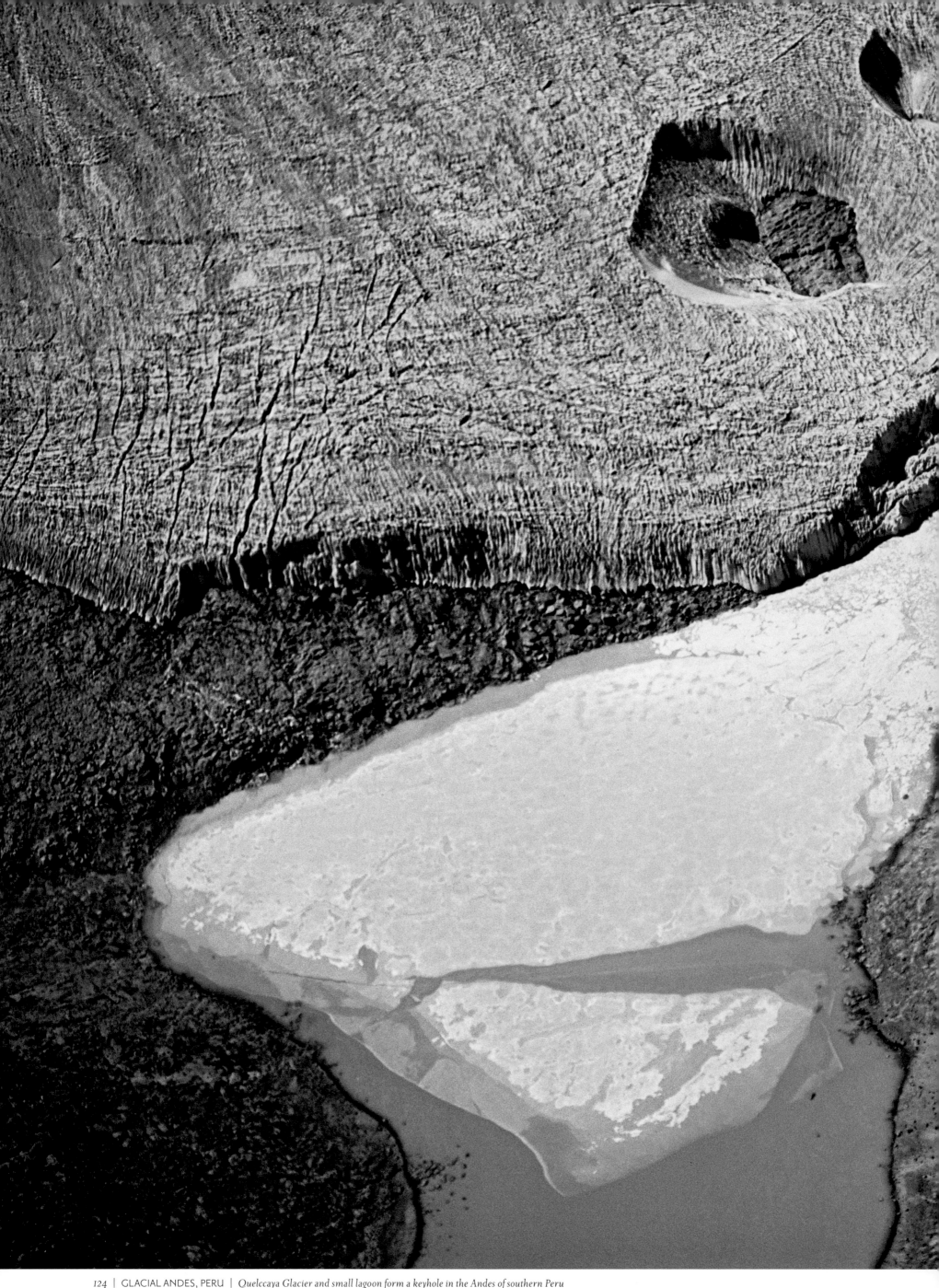

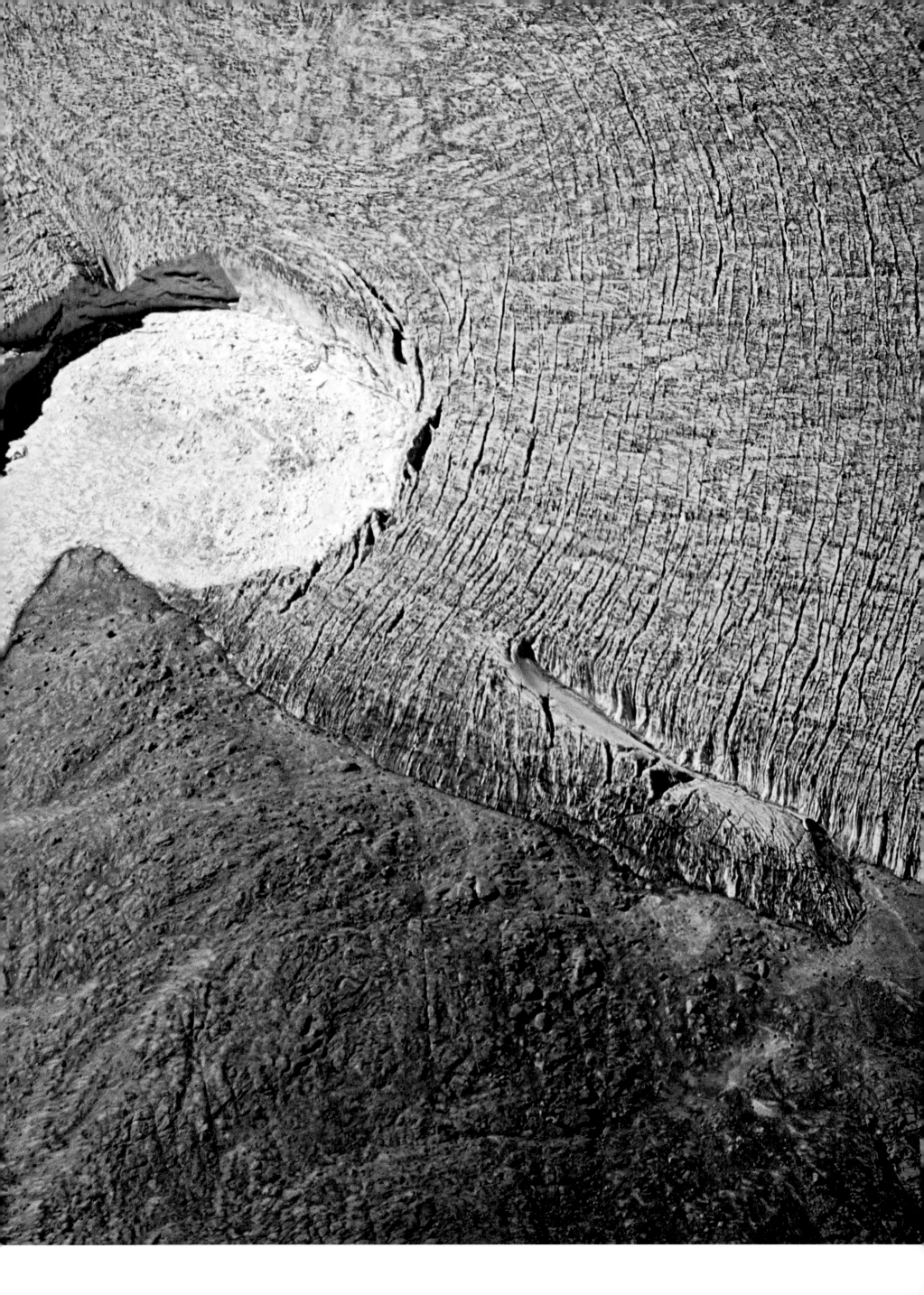

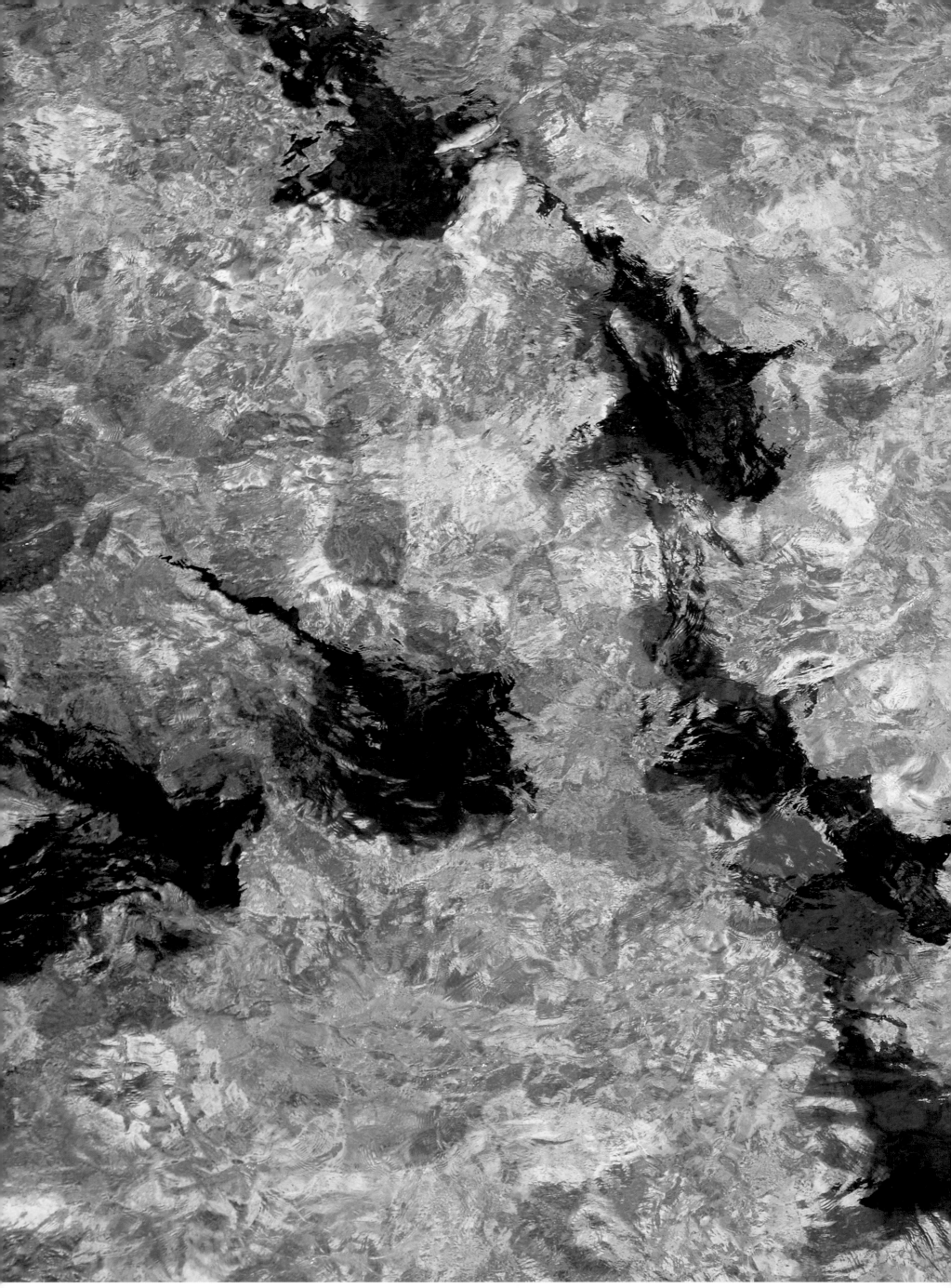

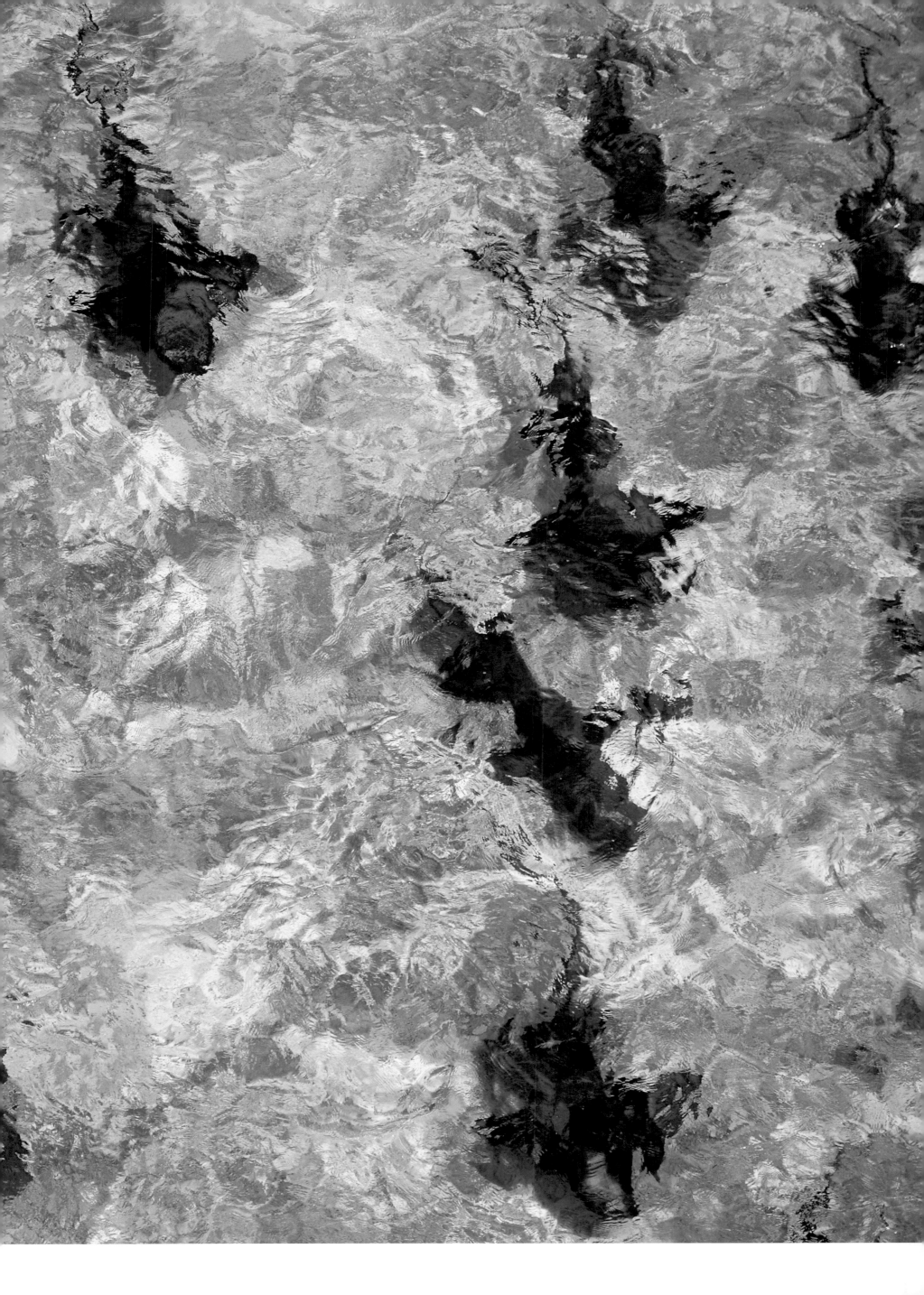

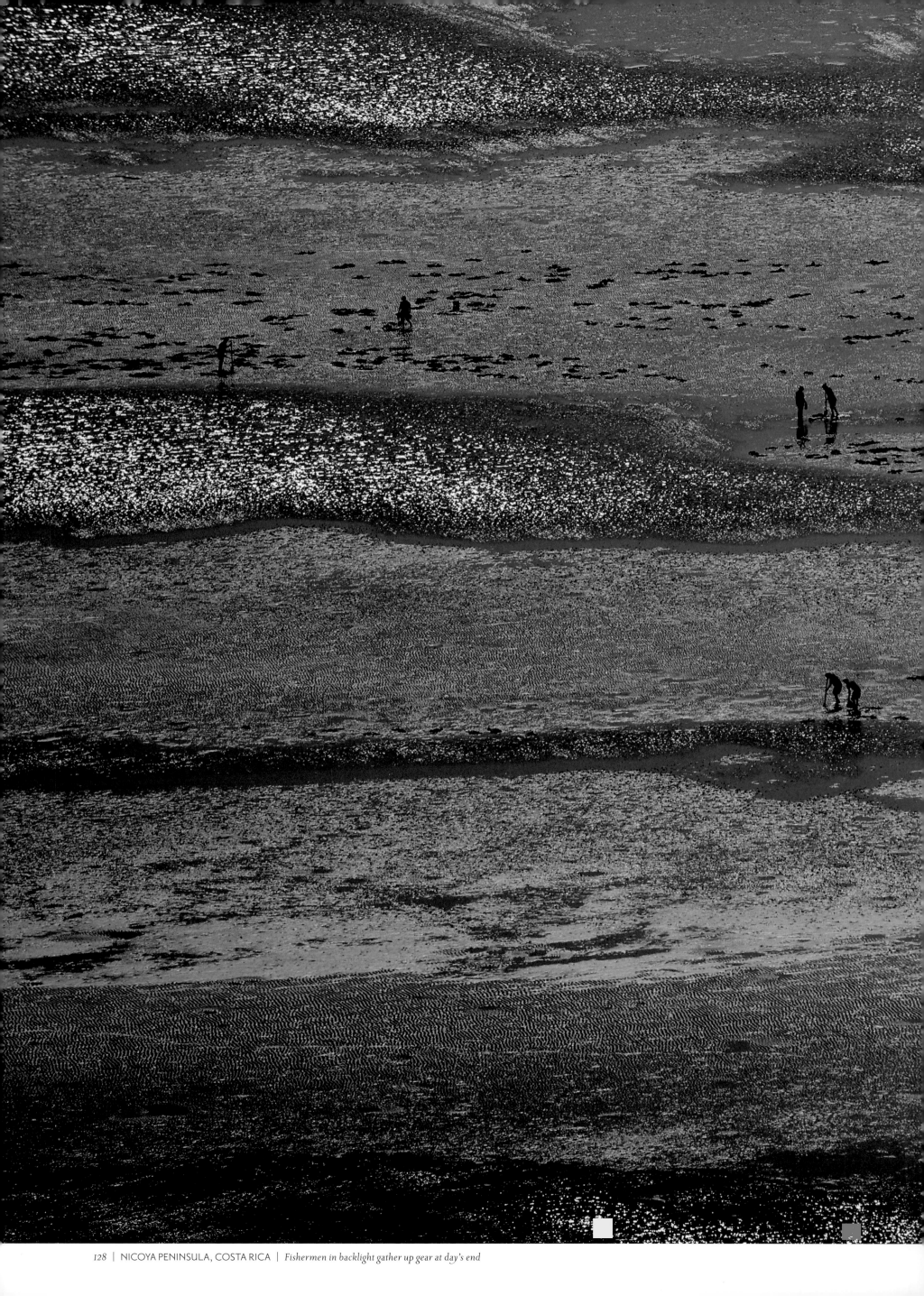

NICOYA PENINSULA, COSTA RICA | *Fishermen in backlight gather up gear at day's end*

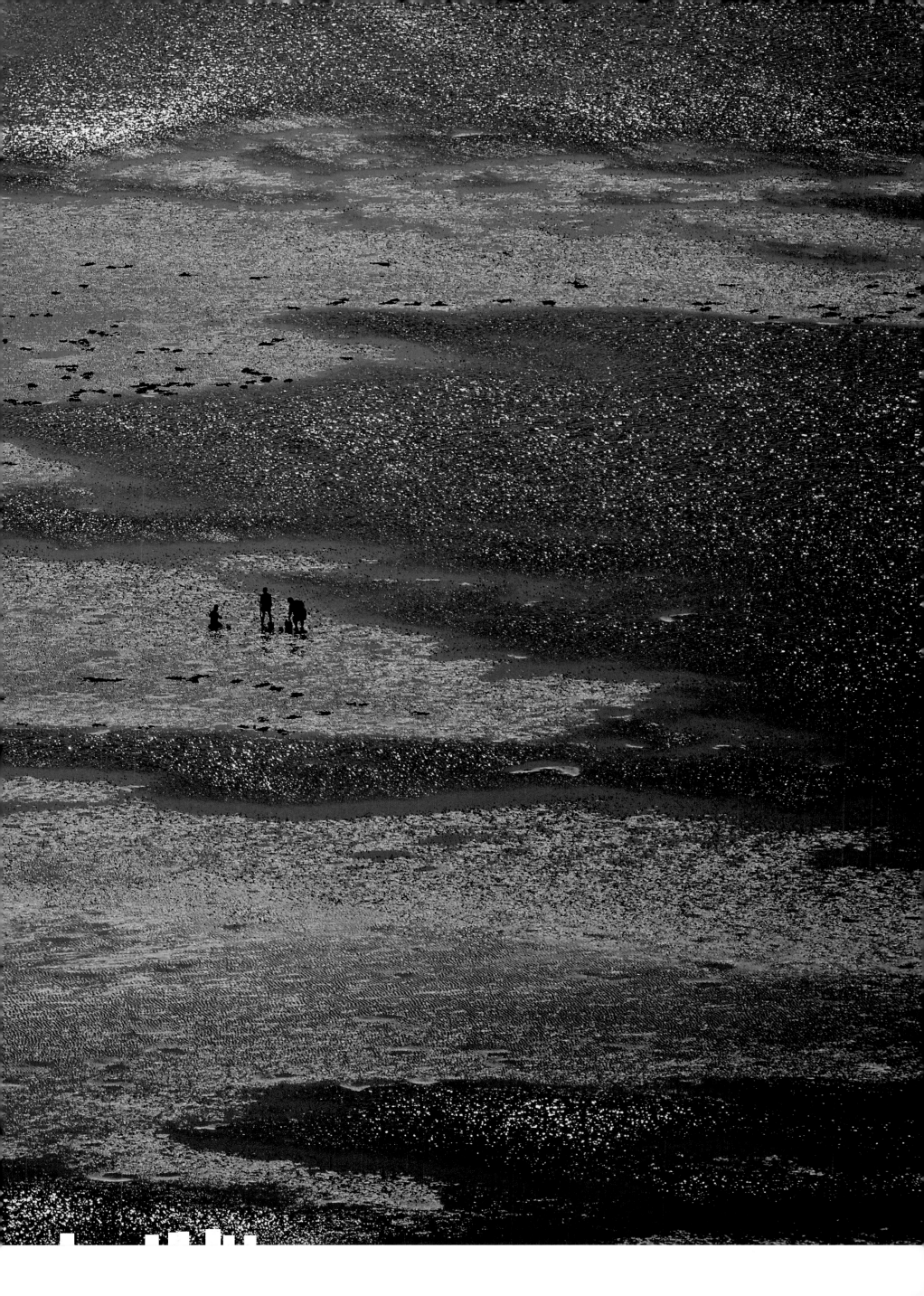

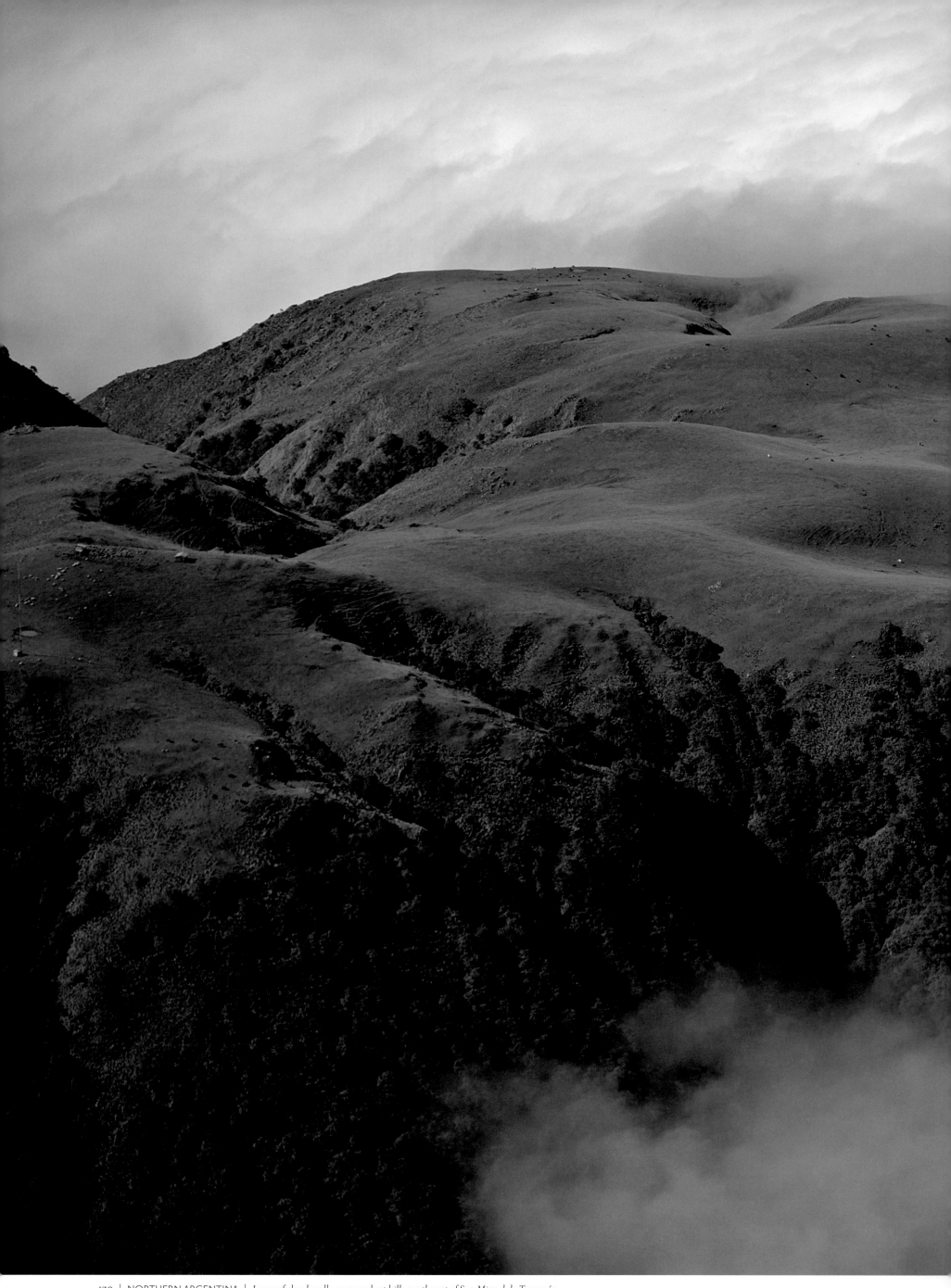

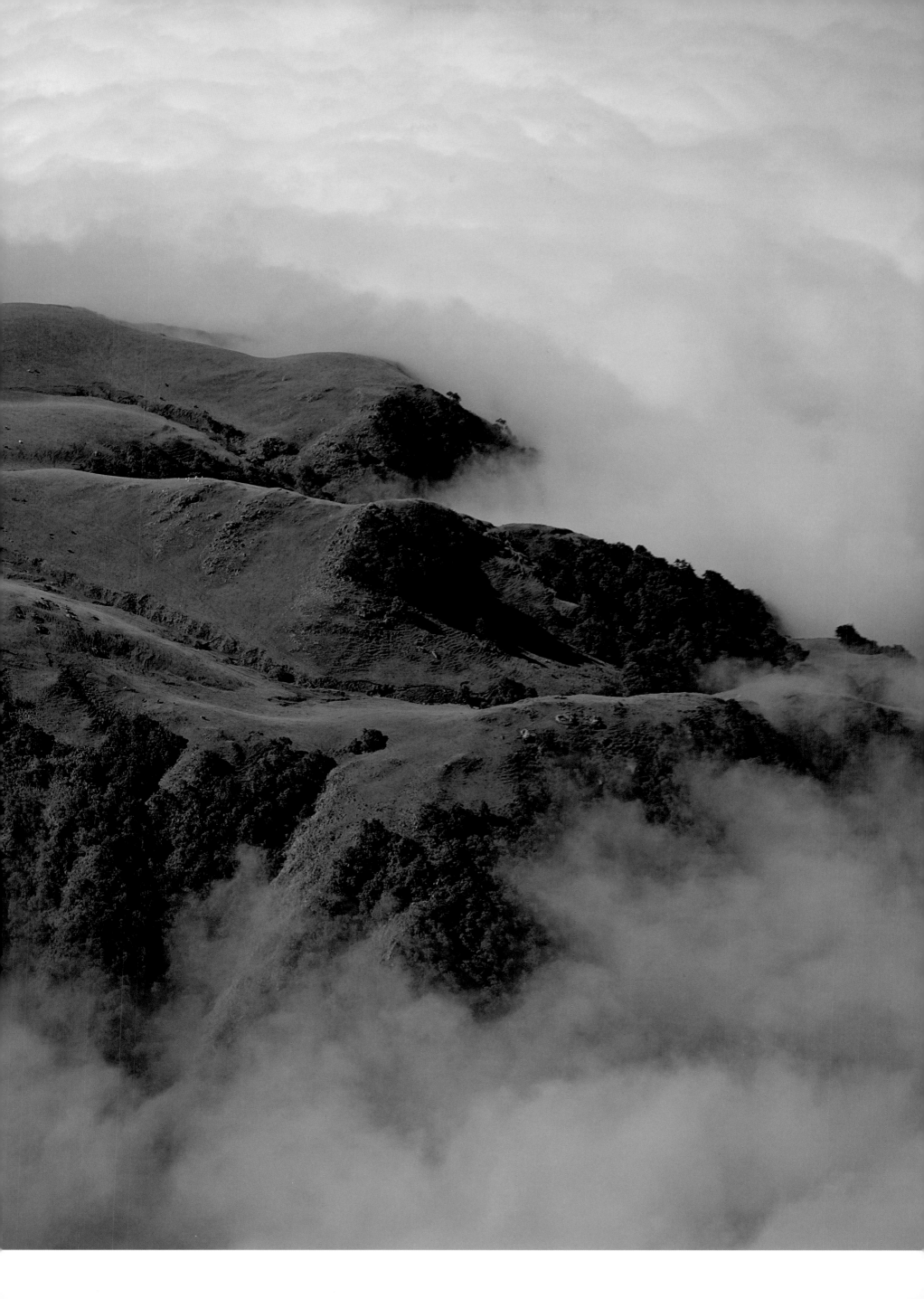

Recharging Batteries

IT IS A RELATIVELY WELL-KNOWN MAXIM OF COLD-WEATHER PHOTOGRAPHY THAT CAMERA BATTERIES WILL DRAIN AT A rather brisk pace in frigid temperatures, but given a chance to recover inside the warmth of an insulated camera bag, the batteries will regenerate enough to power another round of action. That maxim will certainly be put to the test over the next week when we venture far south to Ushuaia, Argentina (the self-proclaimed southernmost city in the world, on the very doorstep of Antarctica), and then on to its neighbor to the west, Punta Arenas in the extreme south of Chile. Shooting from the doorless confines of a helicopter, man and machine must endure extremes of cold and wind in places where summer is just a convenient notation on the calendar not always observed in practice. This year, the balmy days of summer are still many degrees and a fistful of knots of wind away.

The rectangular batteries that slide down the shaft of my Canon Mark II are not the only source of energy in need of recharging. When we learned this morning that the winds over El Calafate were far in excess of the limits for our single-engine Cessna, I must confess that I was actually somewhat relieved. The last few days in the Patagonian steppe have been a rather tart blend of energy-sapping logistical challenges and energizing photographic results. In the last two days alone, the hours devoted to four-wheel drives across the rugged steppe have outnumbered our hours of photography by a ratio of four to one. To my great relief, the camera's tiny LCD monitor has provided just enough assurance that there are images on the memory cards that will outlast the aftershock of those bone-rattling drives.

But the excessive winds have called a halt to our artistic pursuits. Right before this official time-out on the field, we did manage to hit each of the targeted areas around El Calafate in the crevices of light we were given: from the brilliant lagoons in the north, to the bizarre petrified forest and banded sierras, to the imposing glacier of Perito Moreno. With those images securely in my camera bag, I find it possible to bridge the gulf between my obsessive-compulsive nature and the patience needed to endure a weather-imposed halt in the action.

Mechanical batteries are not the only ones in need of recharging…your eye, your creativity, and your zest to overcome the obstacles that lie in the way of the next publishable image all profit from a day deep inside a personal cocoon of reading, writing, and trail rides. The biting winds and teeth-chattering cold of Ushuaia and Punta Arenas are waiting just around the corner. —RBH

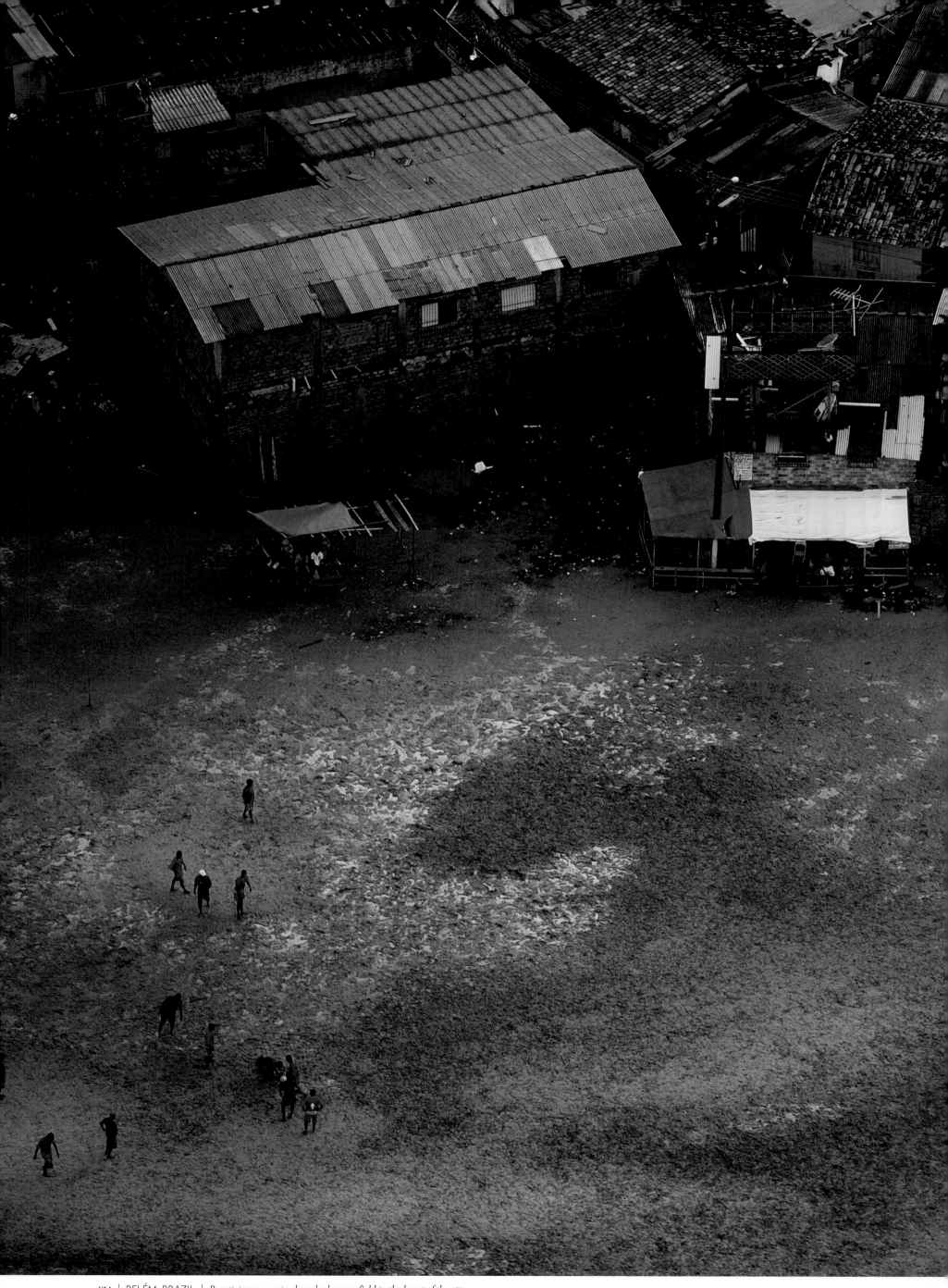

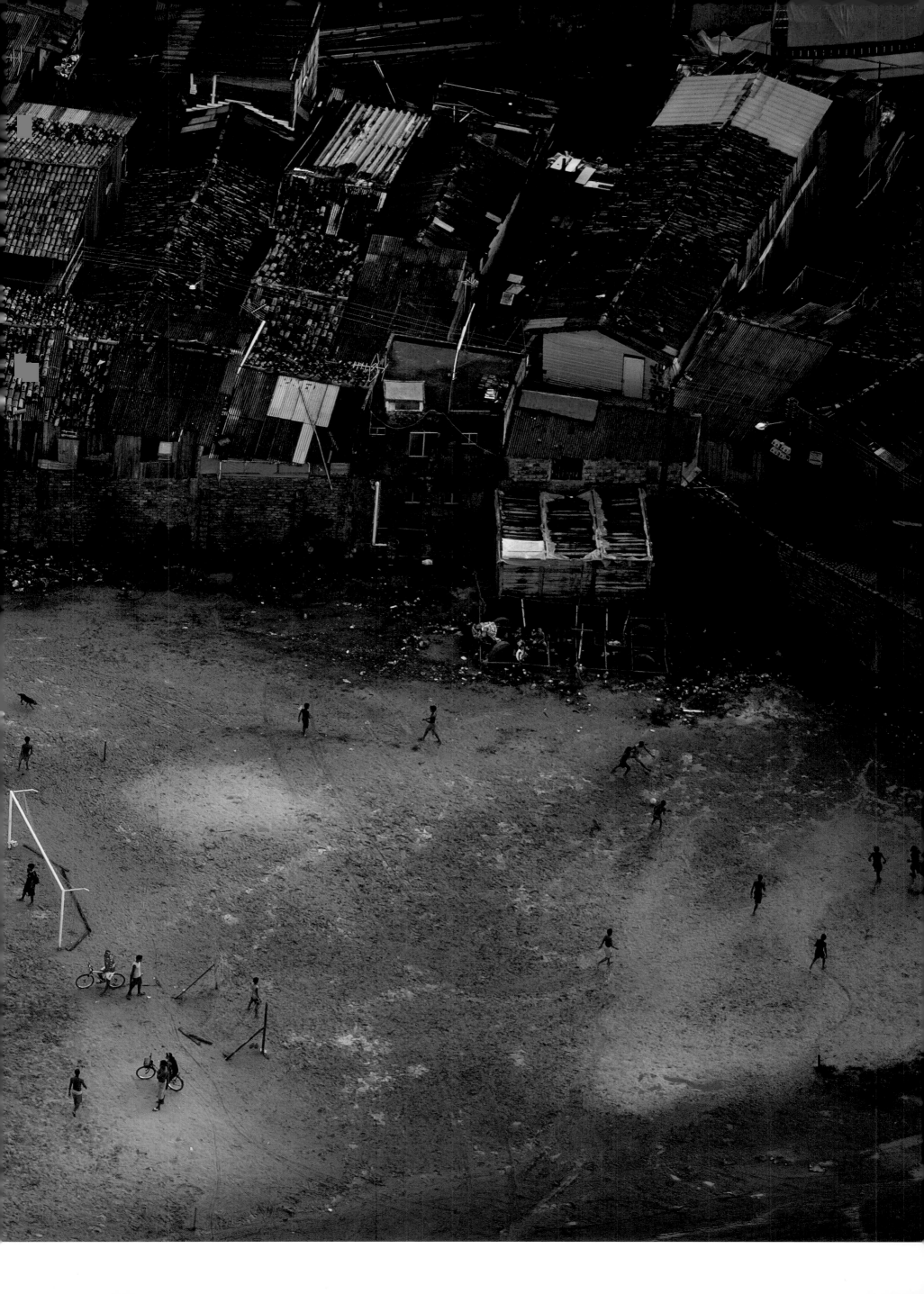

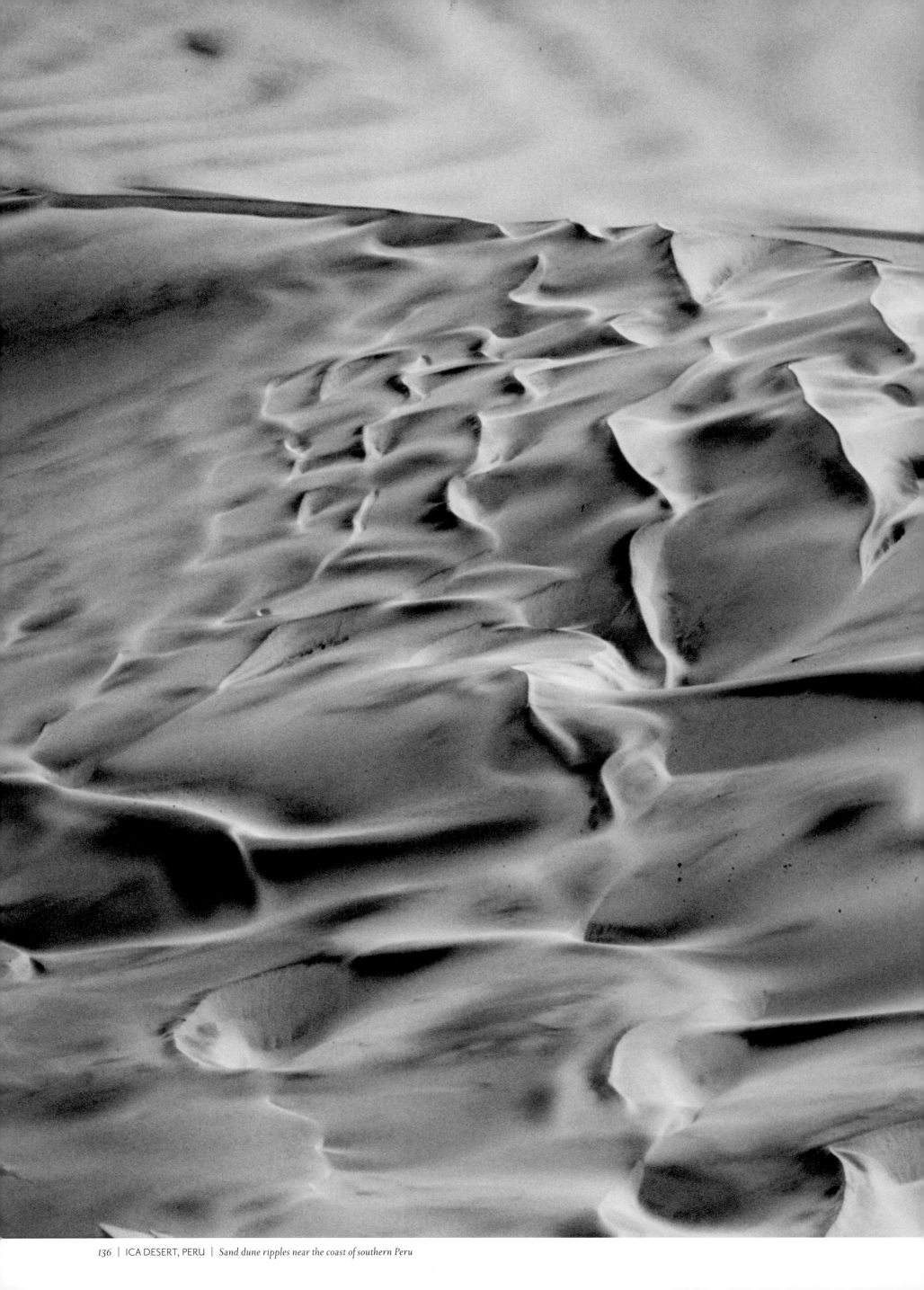

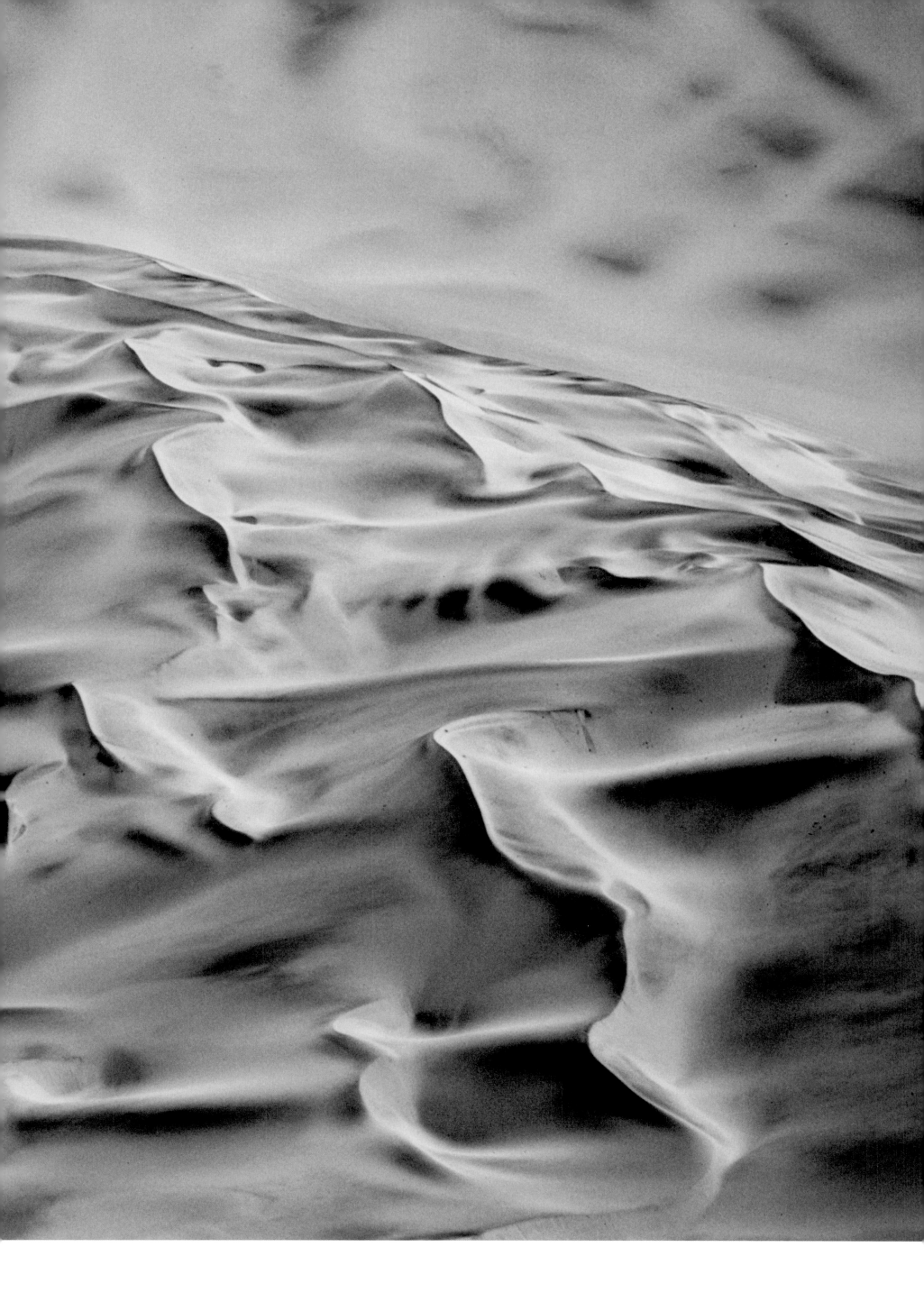

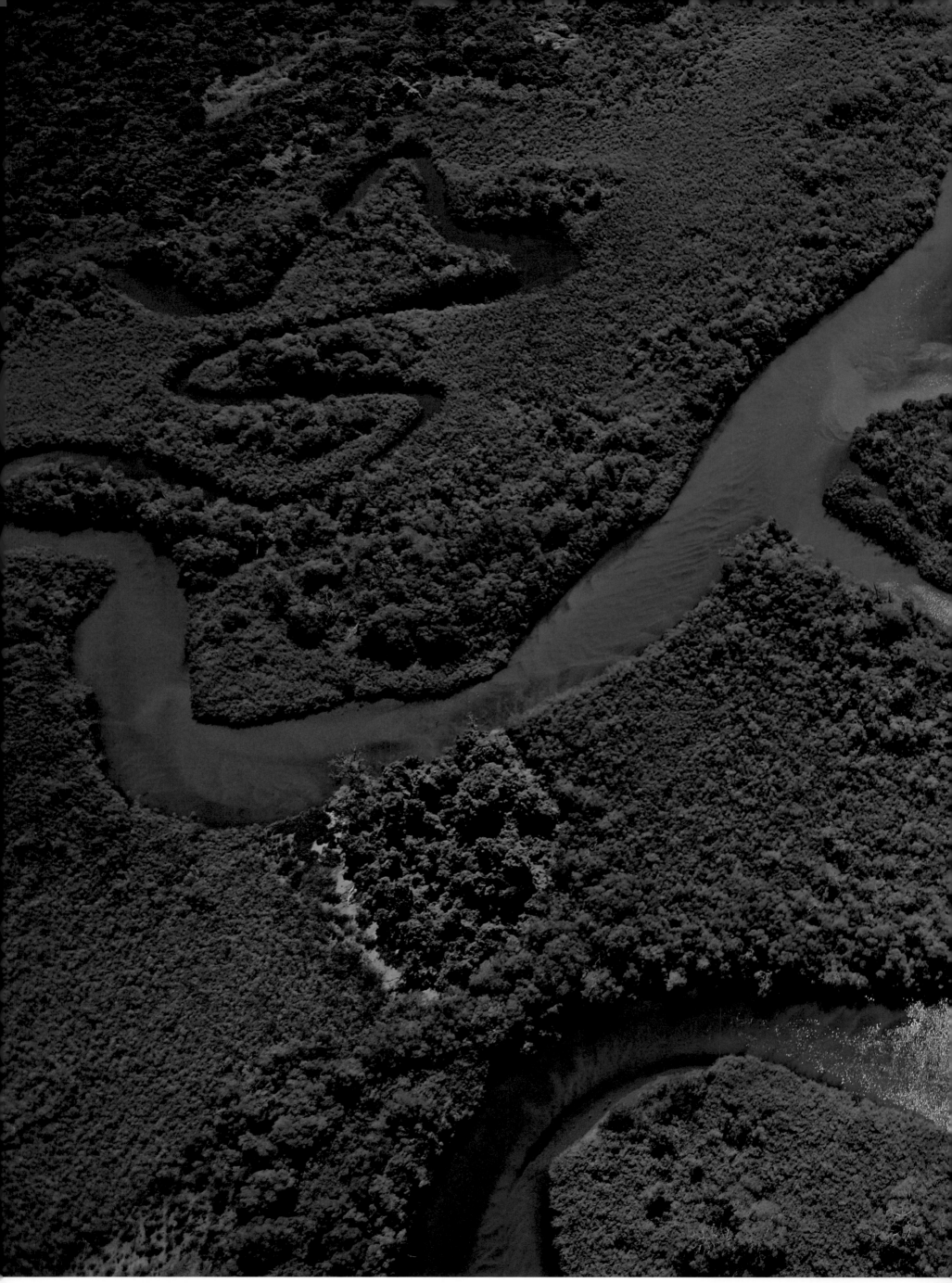

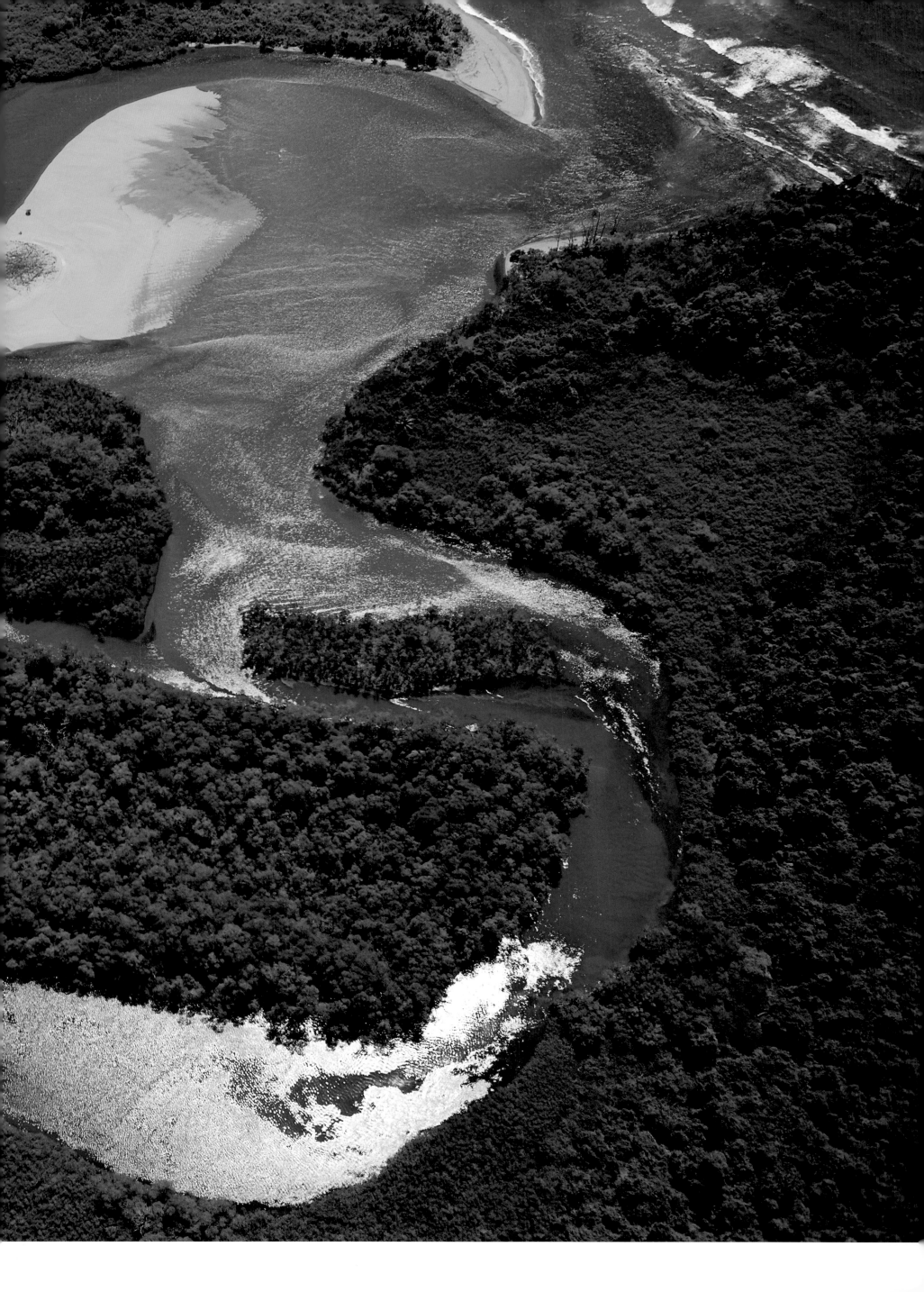

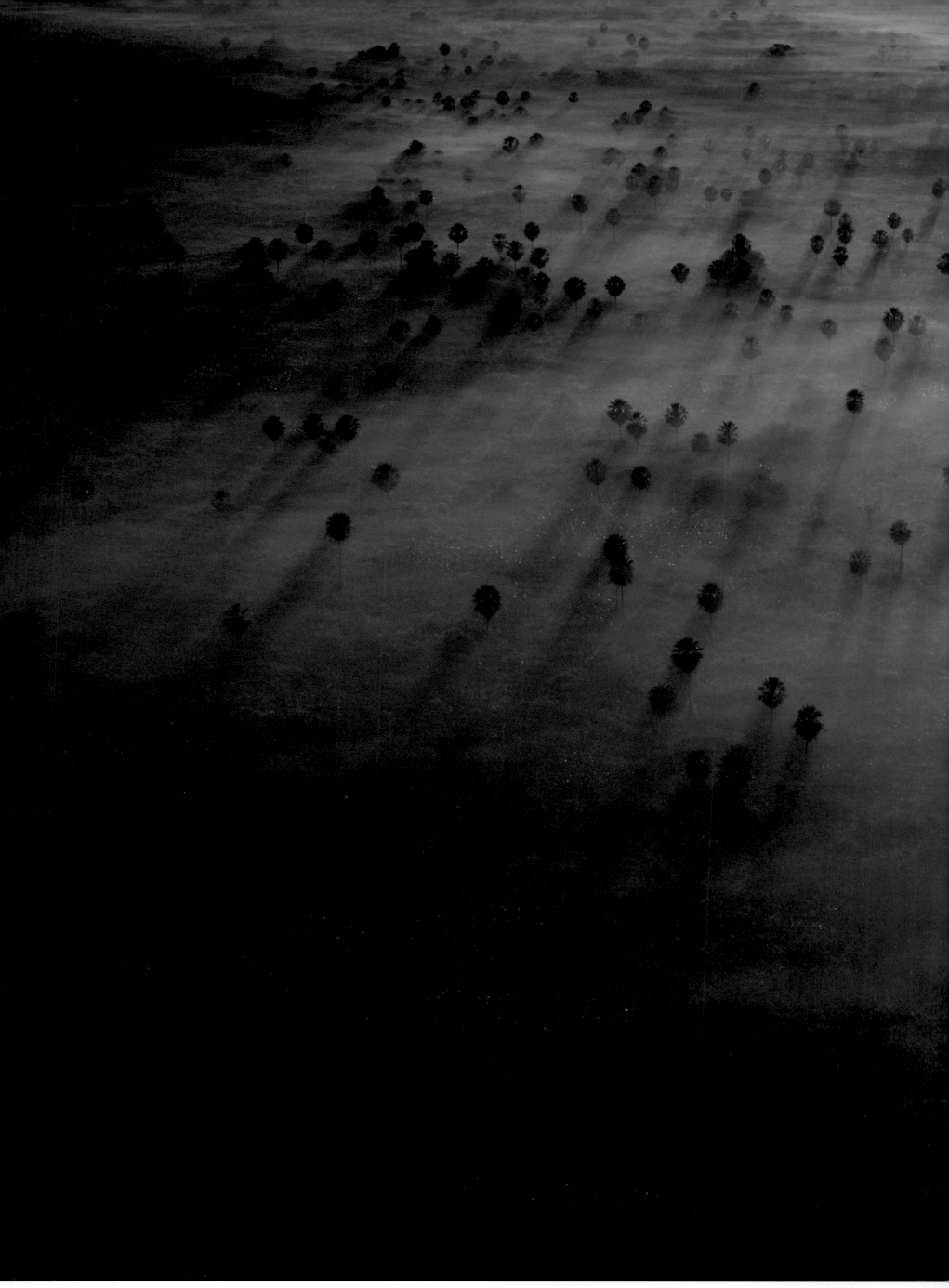

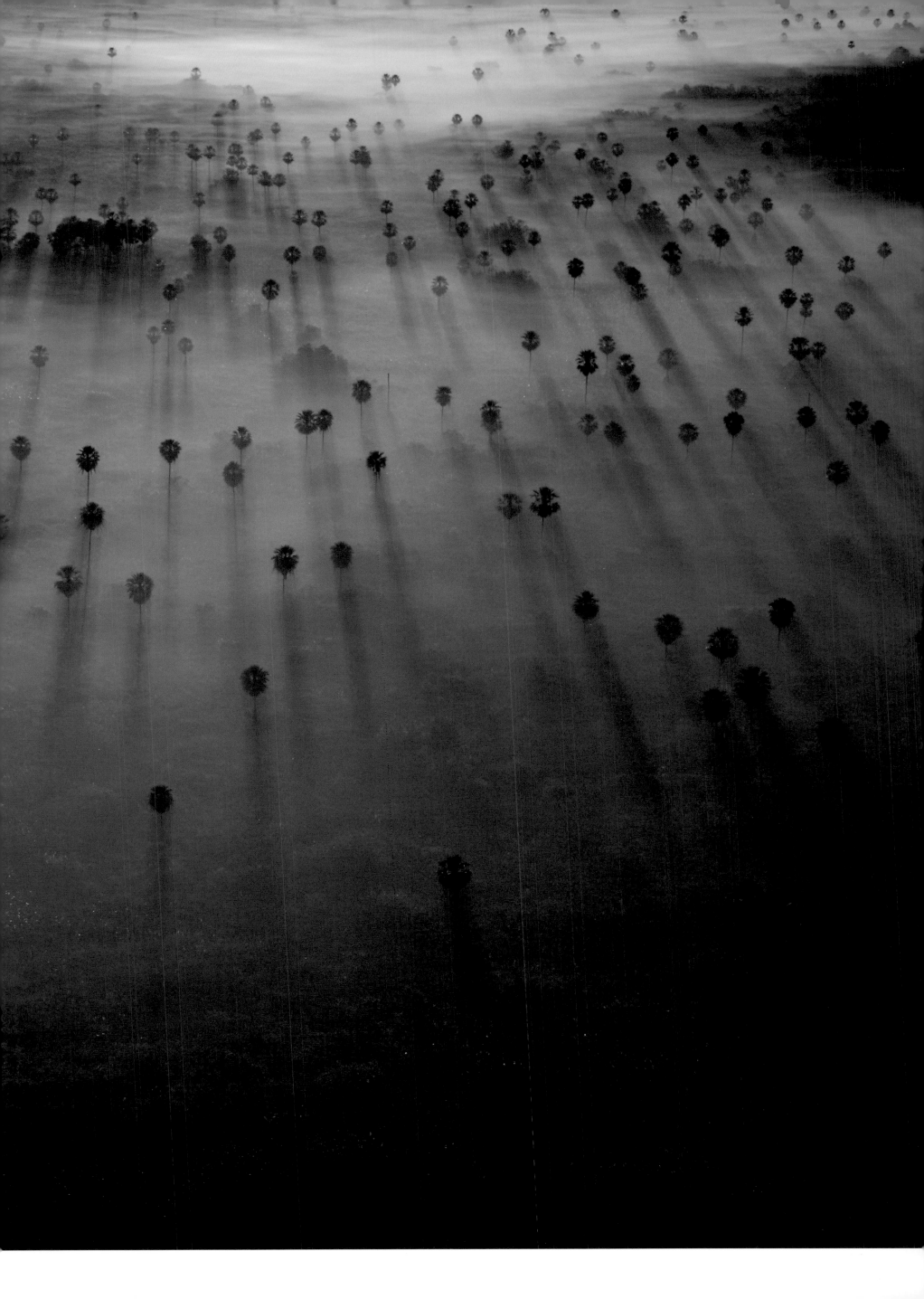

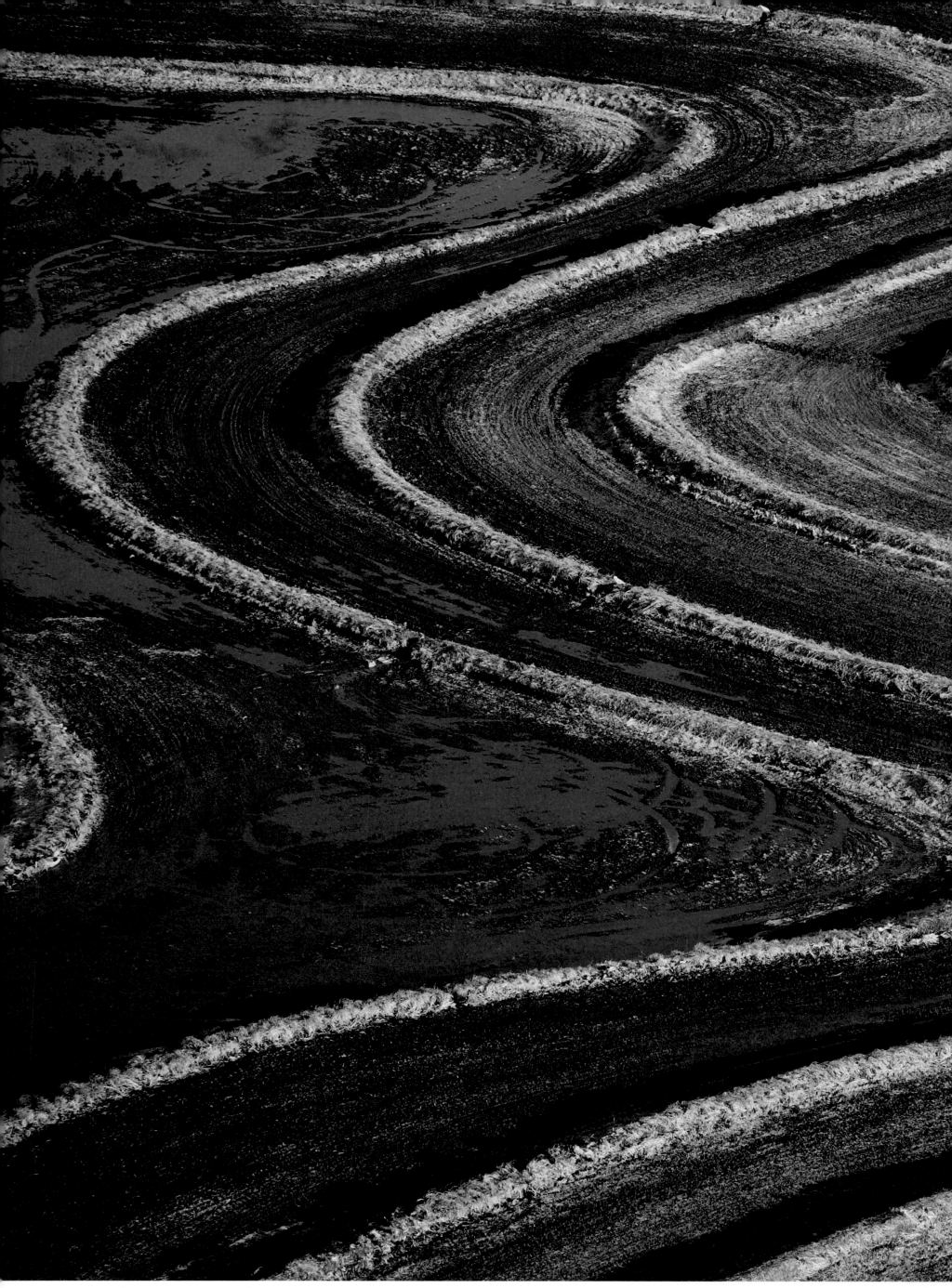

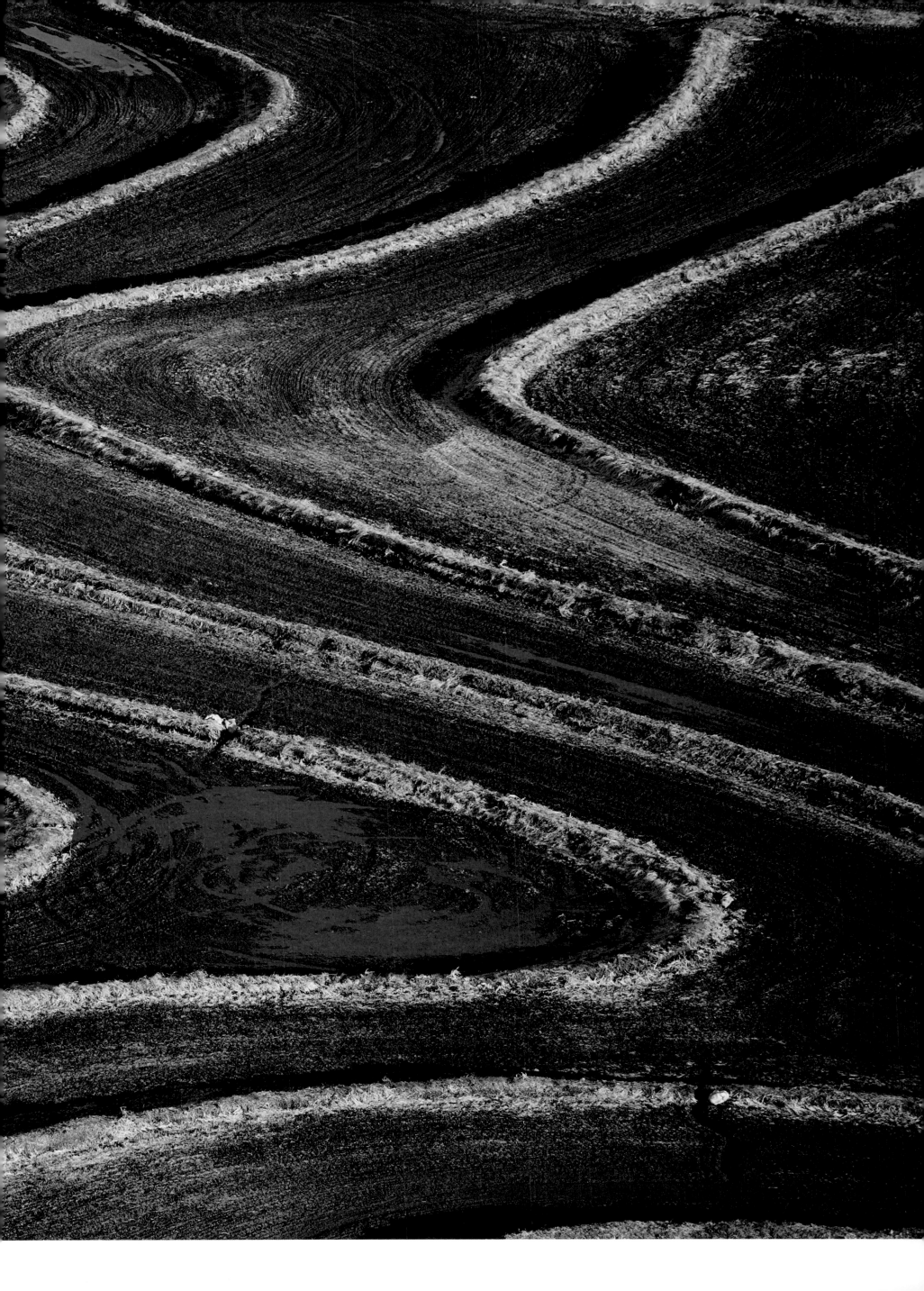

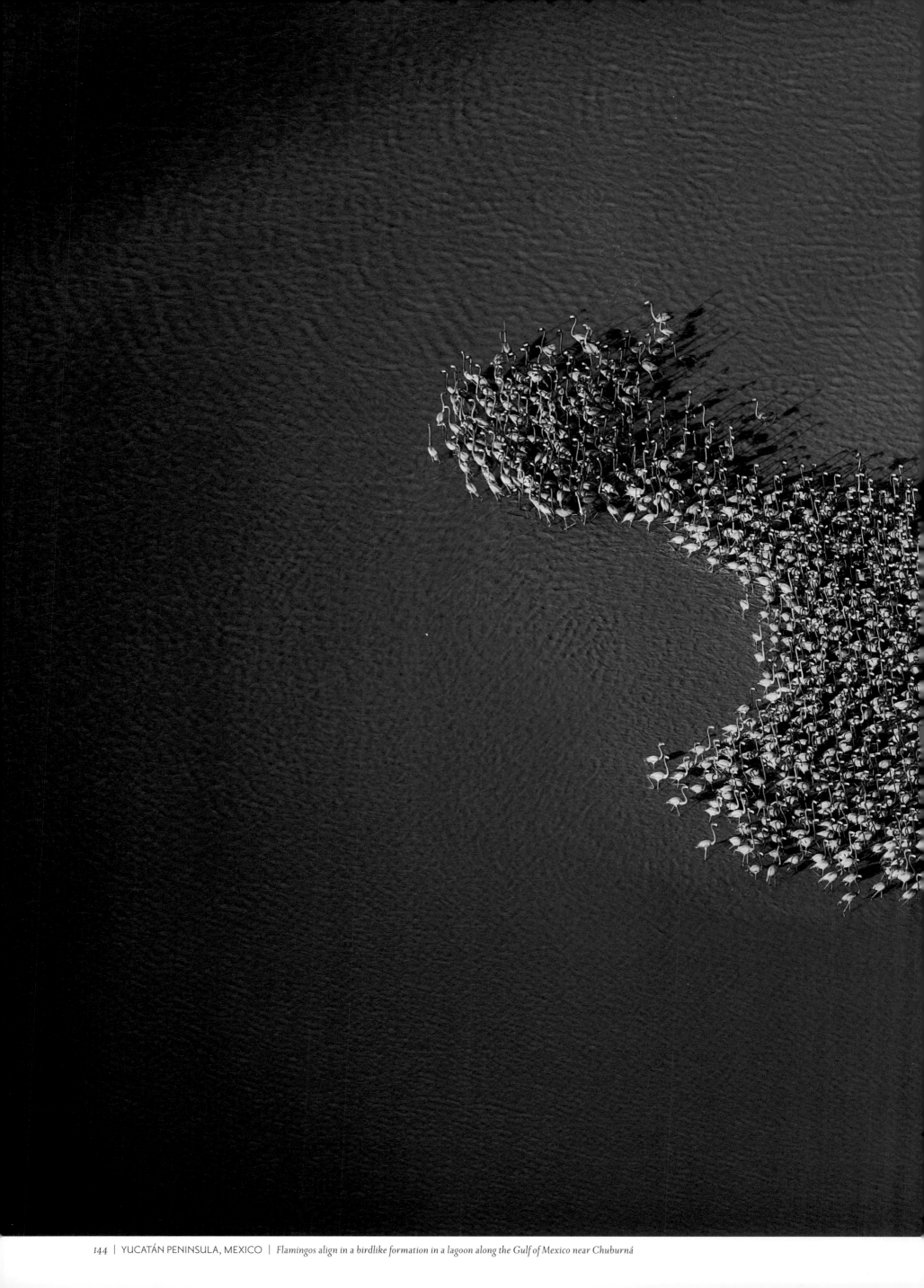

Flamingos align in a birdlike formation in a lagoon along the Gulf of Mexico near Chuburná

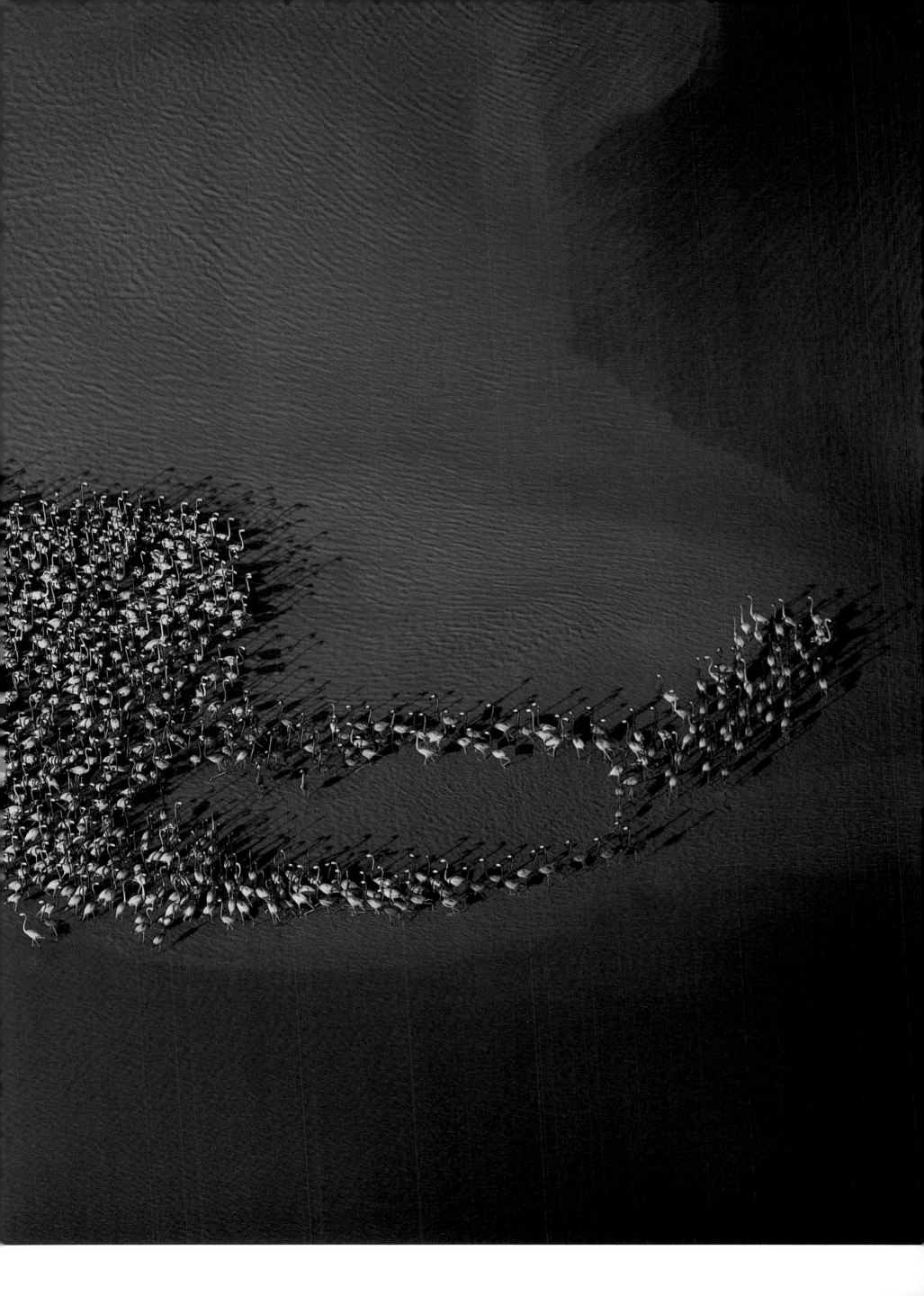

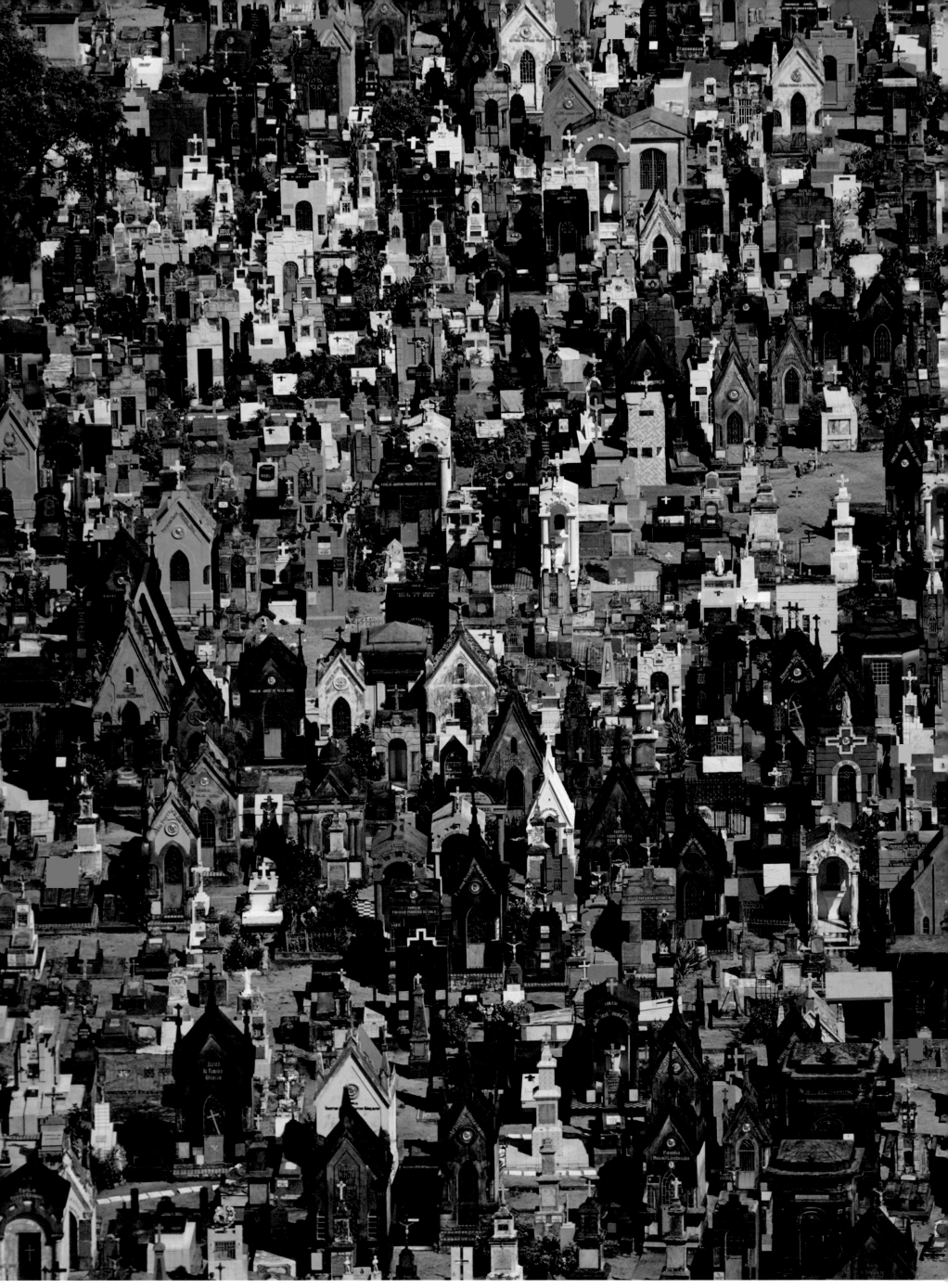

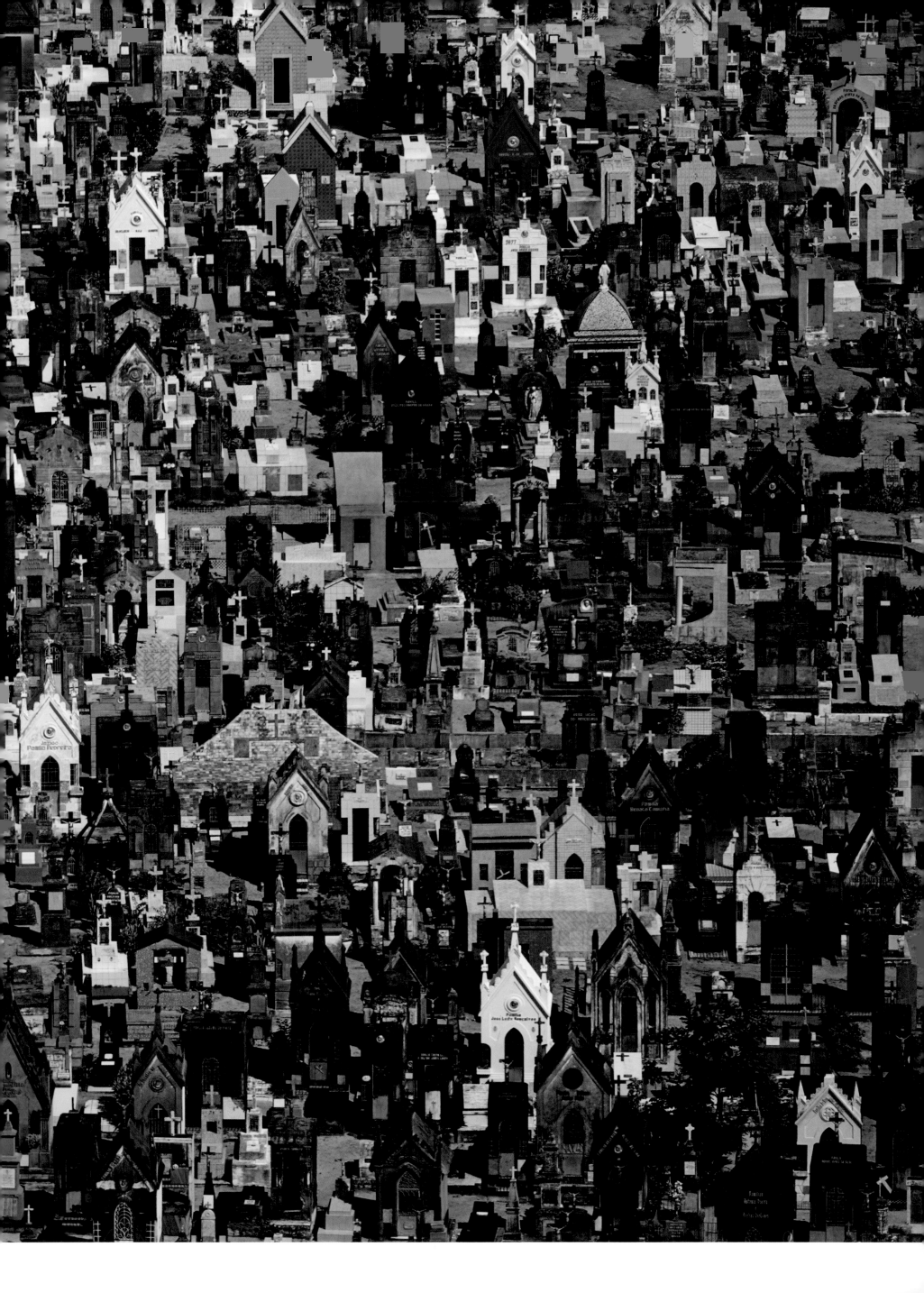

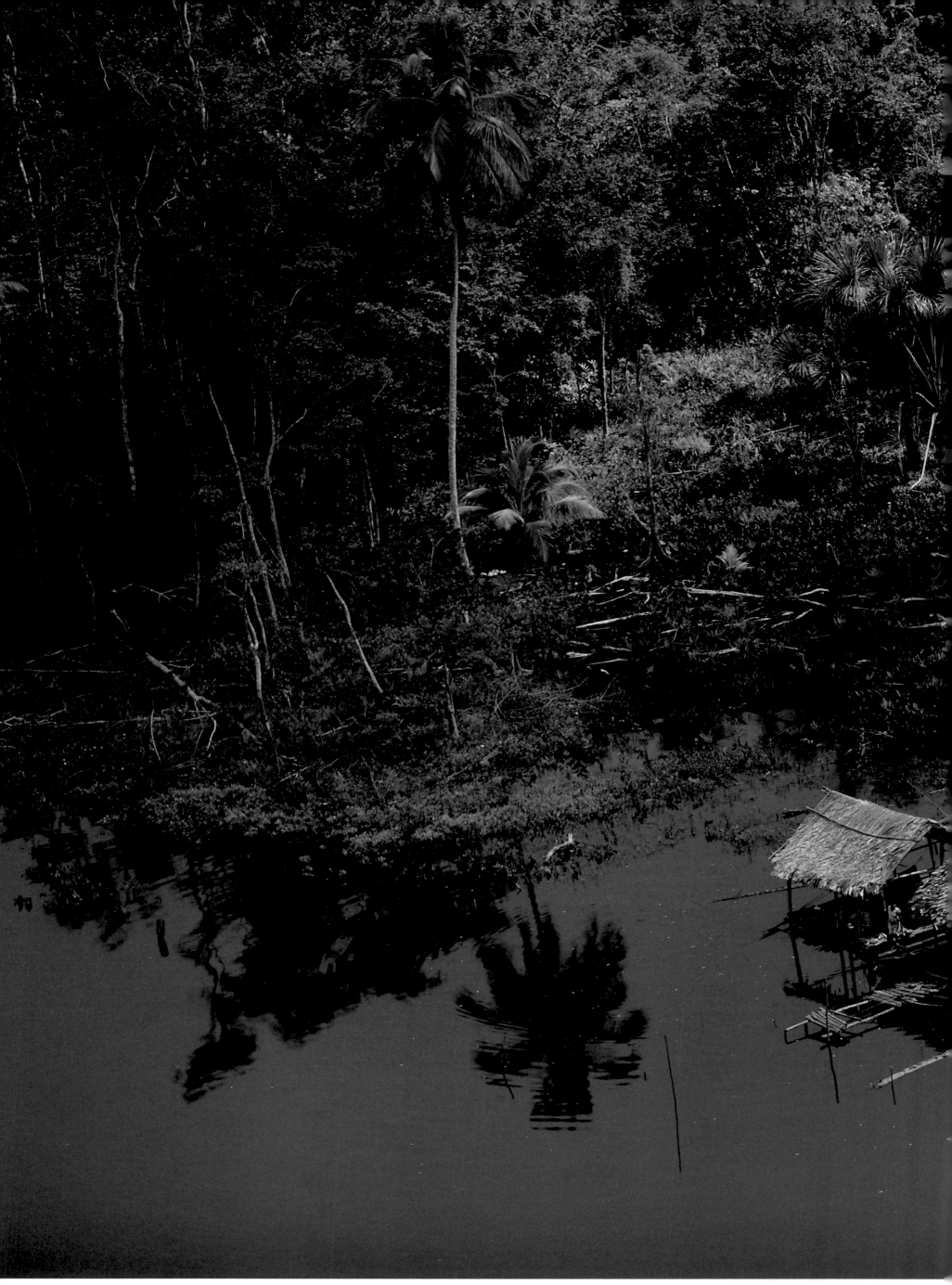

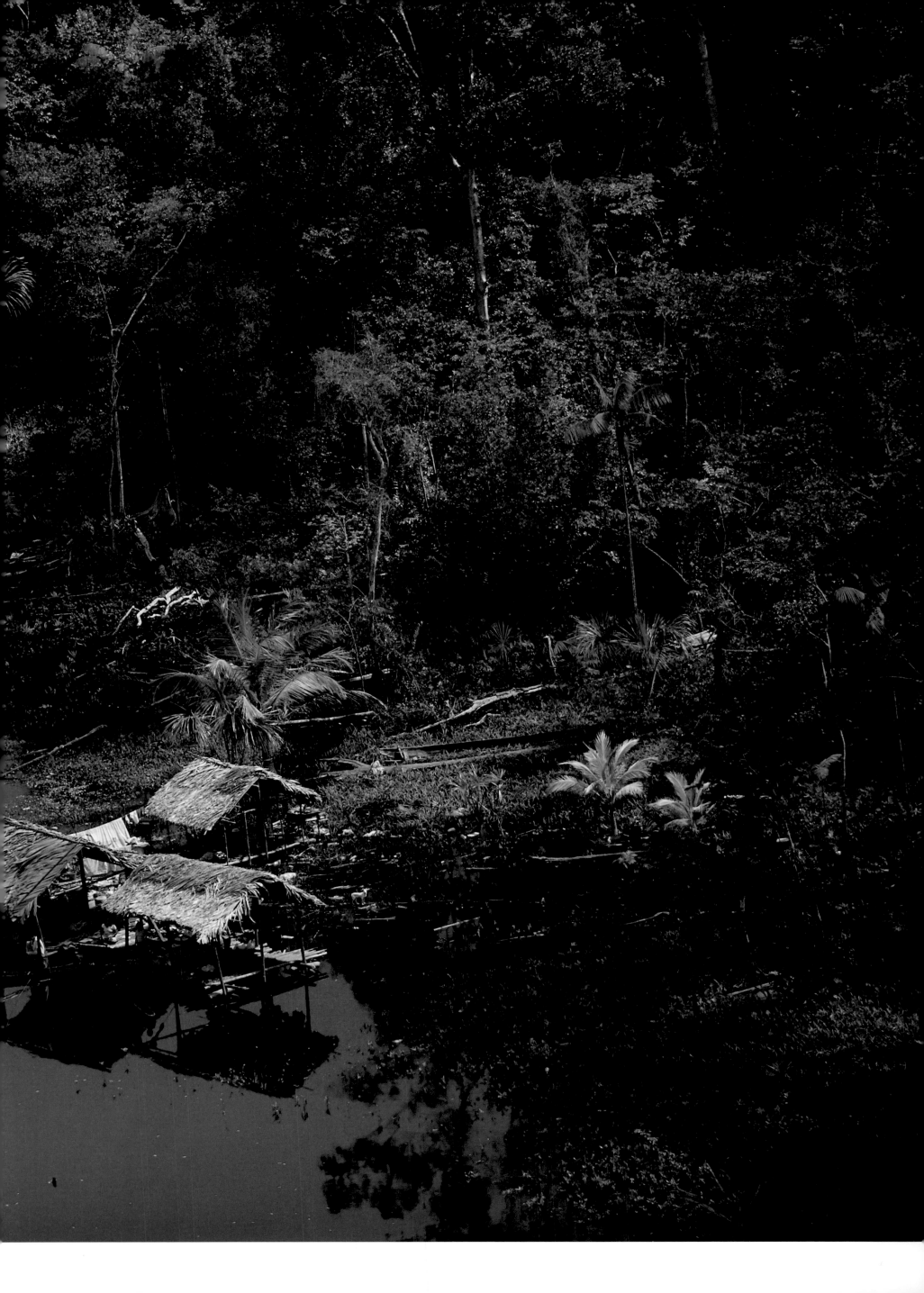

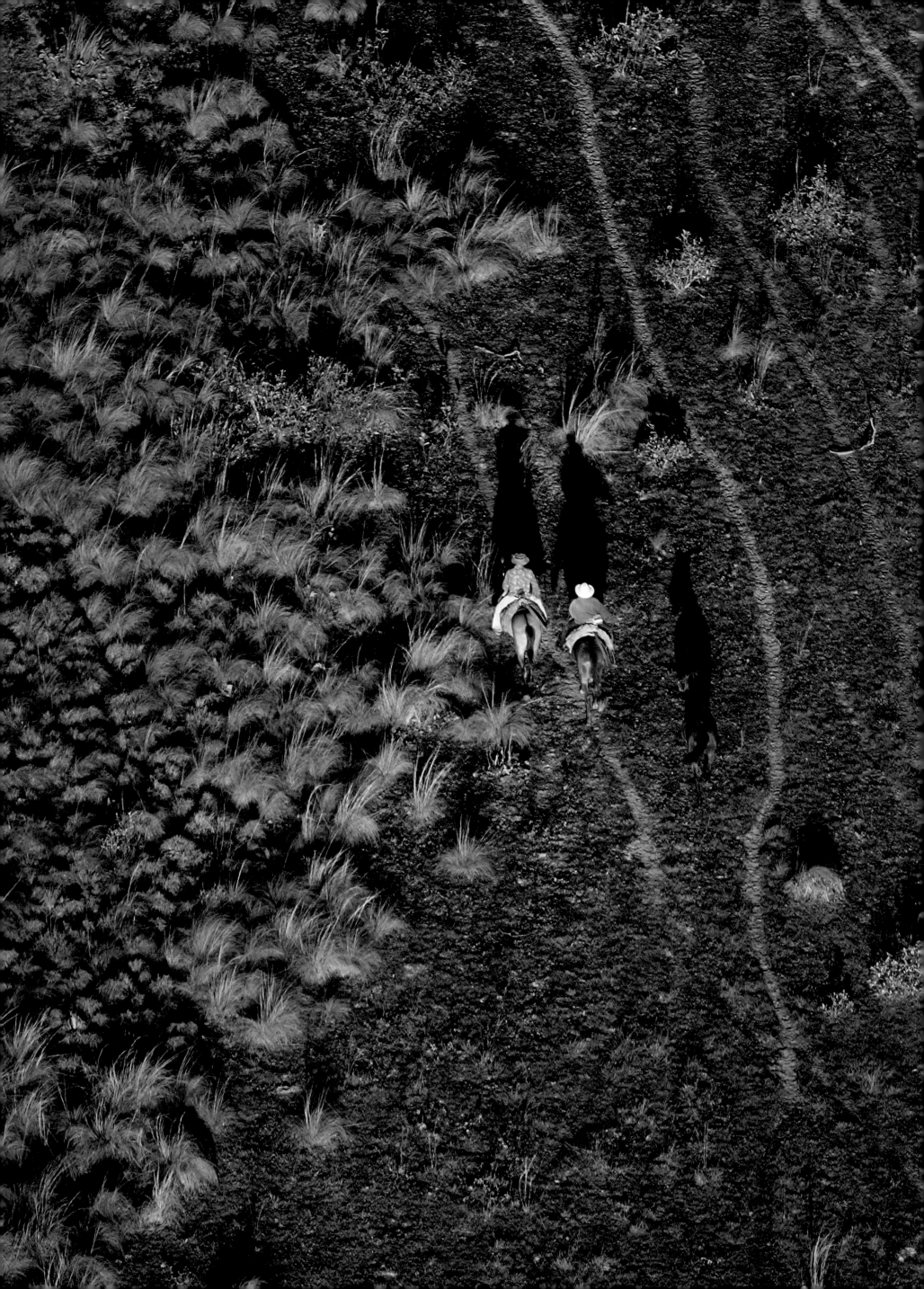

Mr. Ambassador

AFTER COLLECTING MY BAGS AT THE AIRPORT IN ASUNCIÓN, I AM WHISKED AWAY BY OUR LOCAL GUIDE RODRIGO PAST THE serpentine immigration lines and into an empty one marked "Diplomatic Personnel Only." Rodrigo waves me forward with the words, "Right this way, Mr. Ambassador." Apparently, in advance of my arrival, Rodrigo has had the presence of mind to explain to the Paraguayan authorities that the ambassador from the sovereign state of Morocco will be arriving shortly, and, wishing to remain incognito, will have no bodyguards or other support personnel in attendance.

I find Morocco an interesting choice for several reasons, not least of which are my U.S. passport and the fact that I would undoubtedly be the first Jewish ambassador from Morocco in modern times. Not to mention that I had once been placed under "temporary" arrest at the Marrakech airport during a previous aerial shoot. But once I see firsthand just what instant respect this diplomatic status bestows, I ask my photo assistant to please refer to me only as "Mr. Ambassador" or "His Excellency" while we are in the company of strangers.

The diplomatic treatment continues after we arrive at our hotel (with the misnomer Paraguay Yacht and Golf Club, given that the only boat in sight is dredging the Paraguay River). Possibly forewarned that the Moroccan ambassador is on his way over, the staff has upgraded me to the Presidential Suite, which could easily be converted to a full-length soccer field should the need arise. The accommodations are embarrassingly luxurious, but we have gone too far at this point to reverse course and confess that I am just a photographer from the States. I feel somewhat less ambassadorial when I decide to go for a walk at 5 a.m. the next morning and notice that one of the stray dogs that are in abundance everywhere has defecated on the red carpet just outside the patio entrance to my suite. Apparently, the canine community of Asunción is not as easily duped as one might expect.

But all good things must come to an end...and so too my ambassadorship, which lasts only three days. Even for South American politics, that is on the brief side. We bid farewell to Paraguay and move on to the Pantanal of Brazil, where the prospect of the continent's premier wildlife refuge beckons.

At our first base near Campo Grande, I check in to the considerably more rustic Caiman Ecological Reserve. No more Presidential Suites...my bungalow is exactly twelve feet by twelve feet with two single beds, an overhead fan, and a bathroom that does not quite deserve the moniker "petite." A sign over the commode issues the curious warning, "Please don't throw toilet paper in the toilet." It is a place with solid home-cooked meals, coffee as thick as motor oil, and things crawling around on the floor that haven't been given scientific names yet.

But this bungalow feels good. The spartan motif is more in keeping with my mission, restoring a feeling of oneness with the primitive and timeless marshland that surrounds us in all directions. With no regrets, I surrender my diplomatic status and go forth in search of the noble four-legged citizens of the Pantanal. —RBH

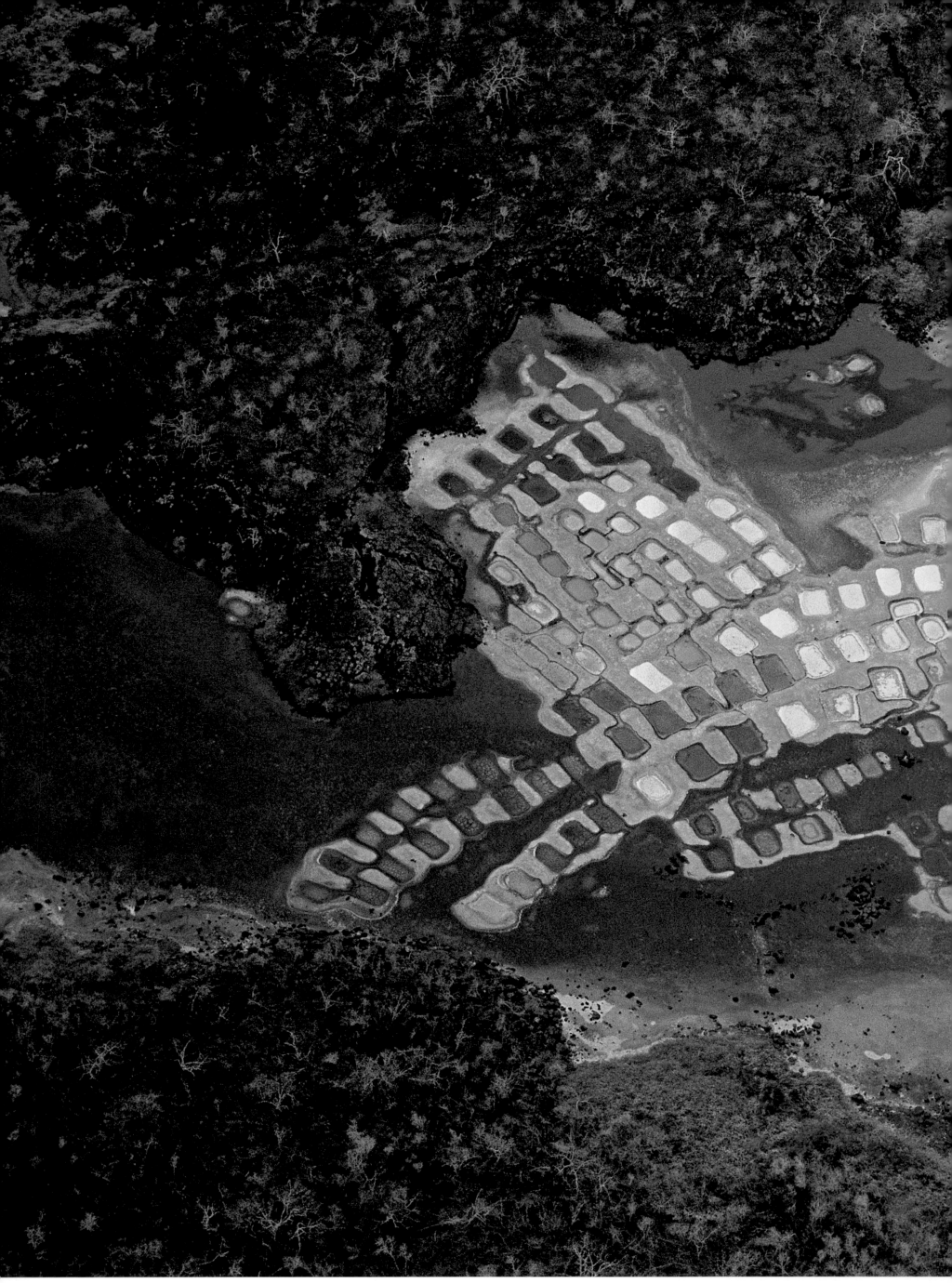

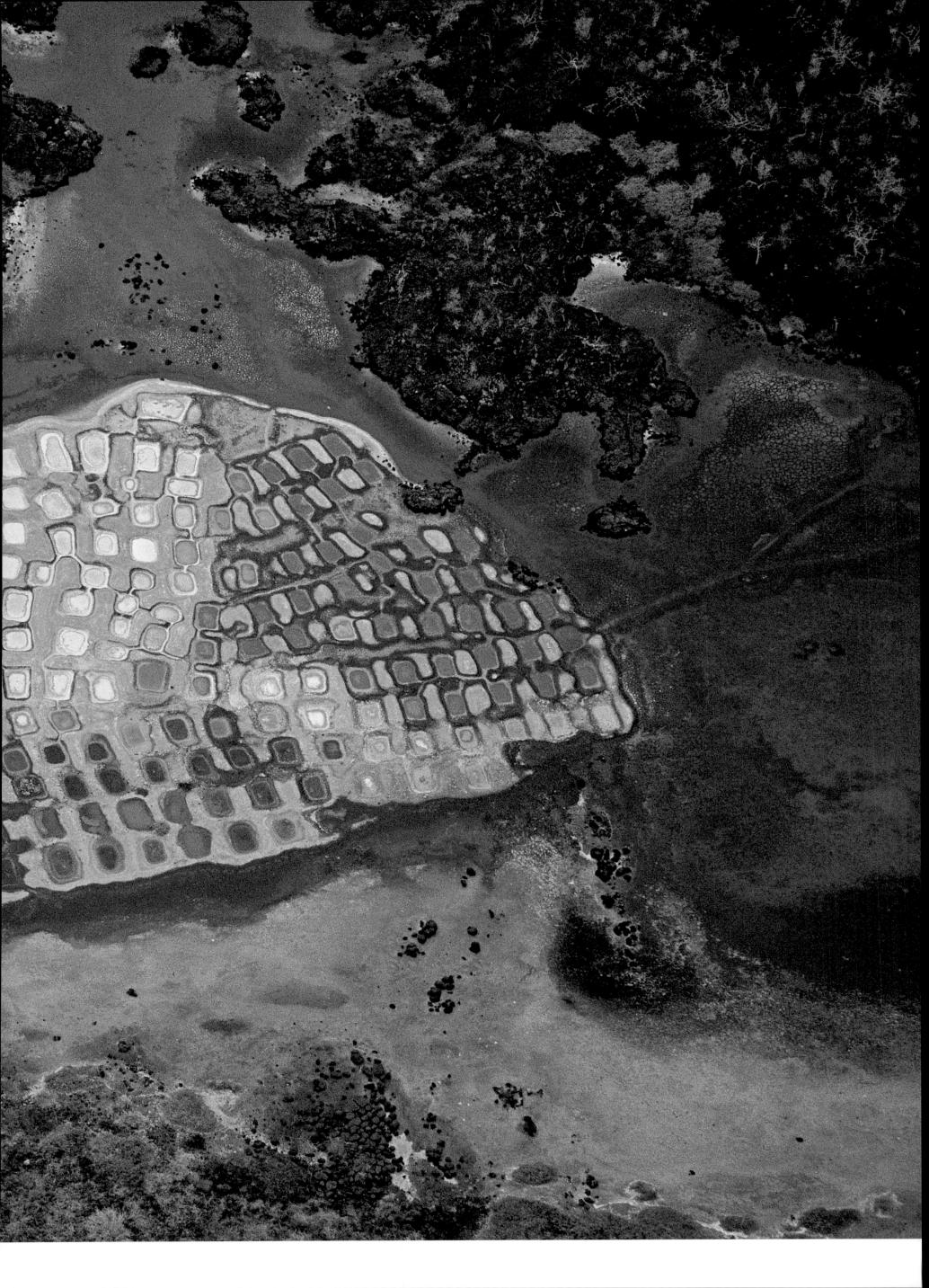

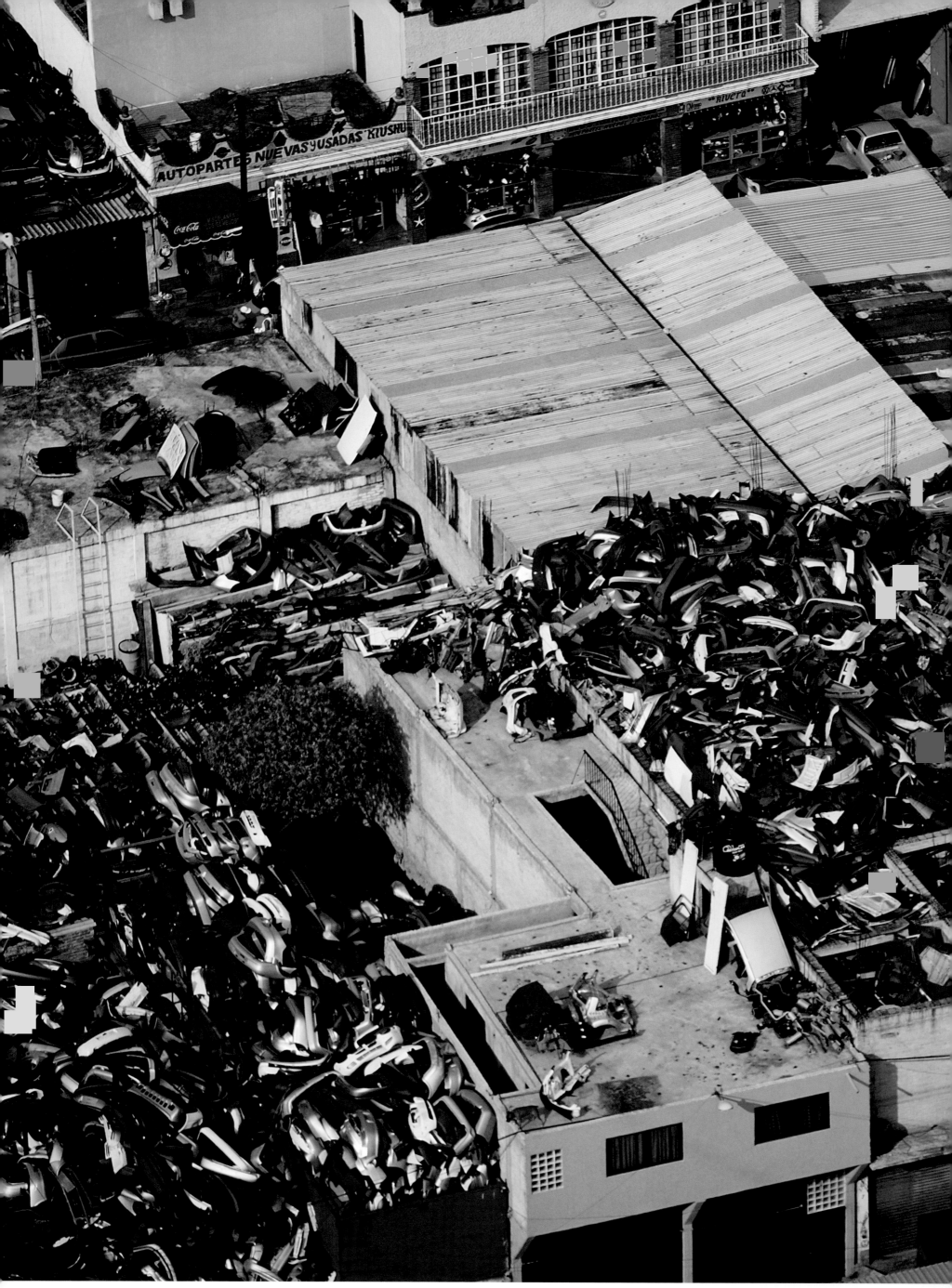

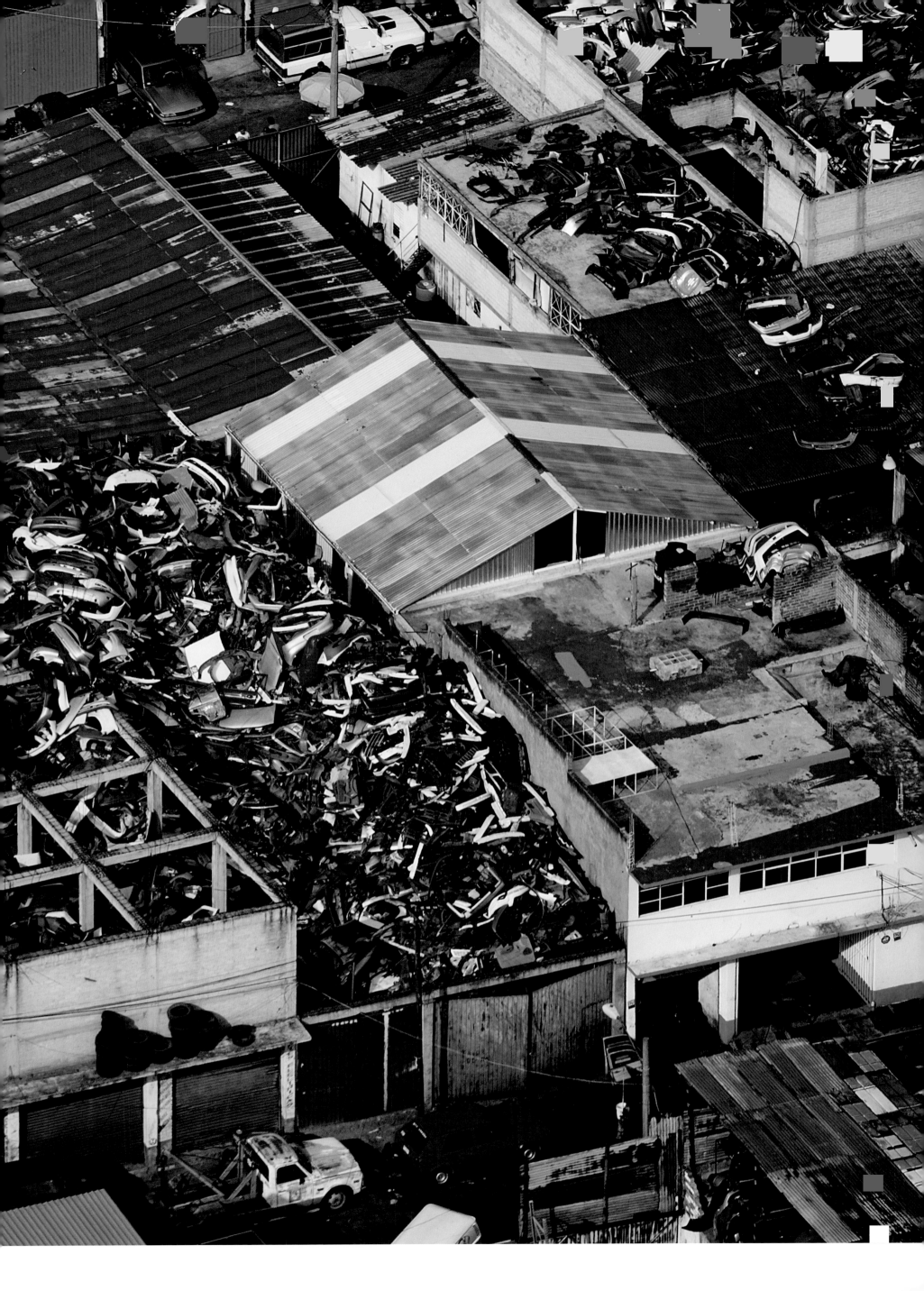

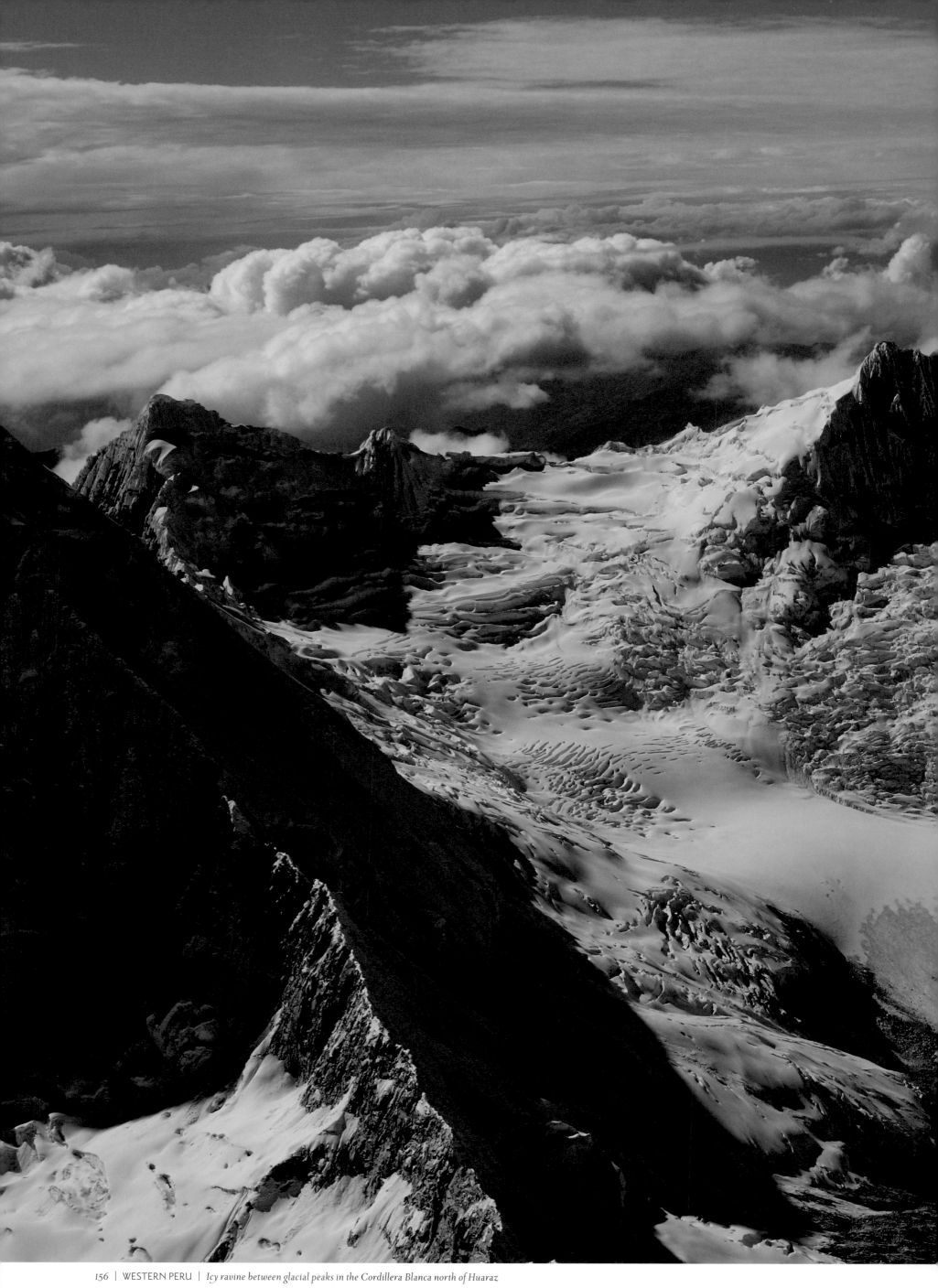

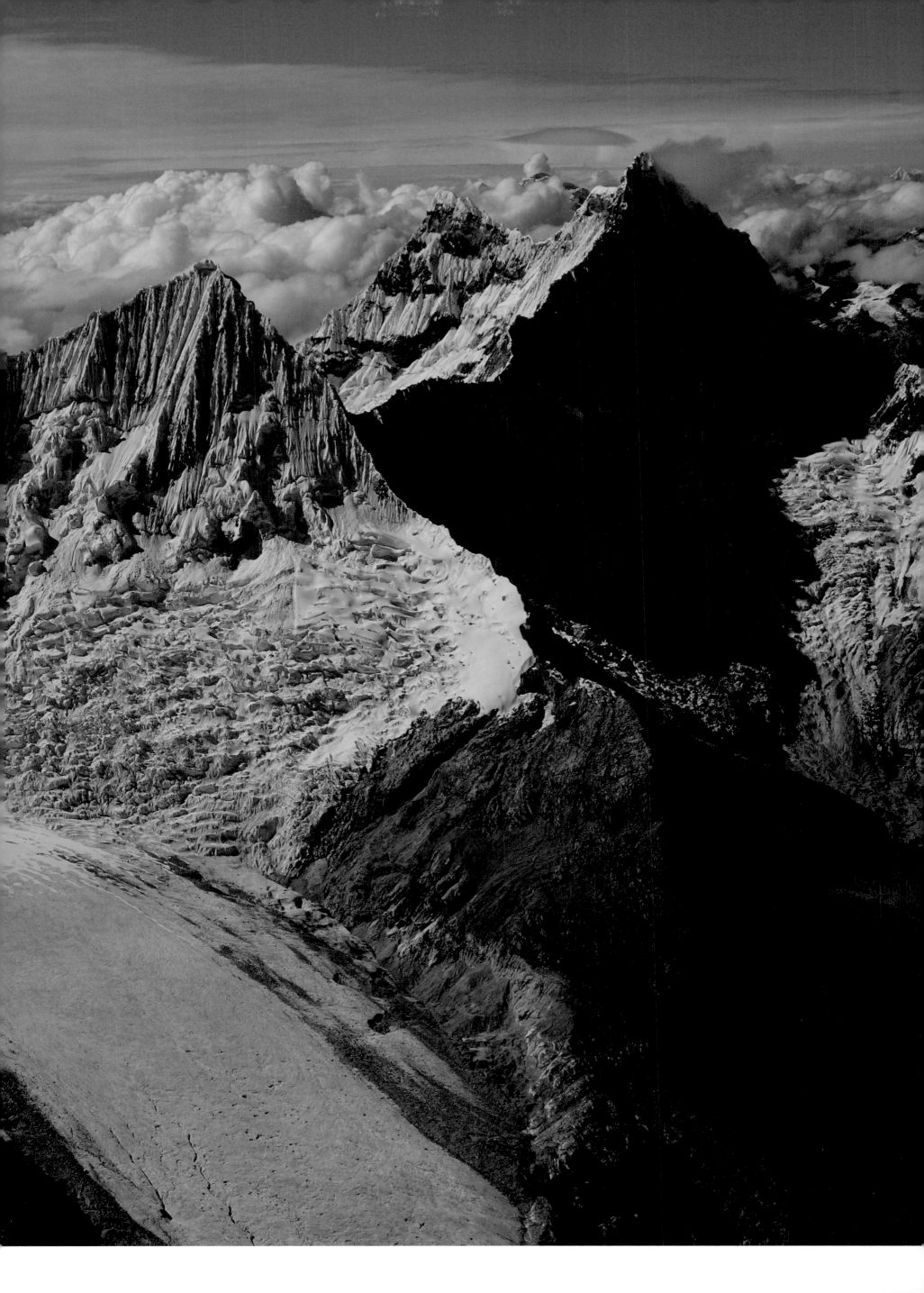

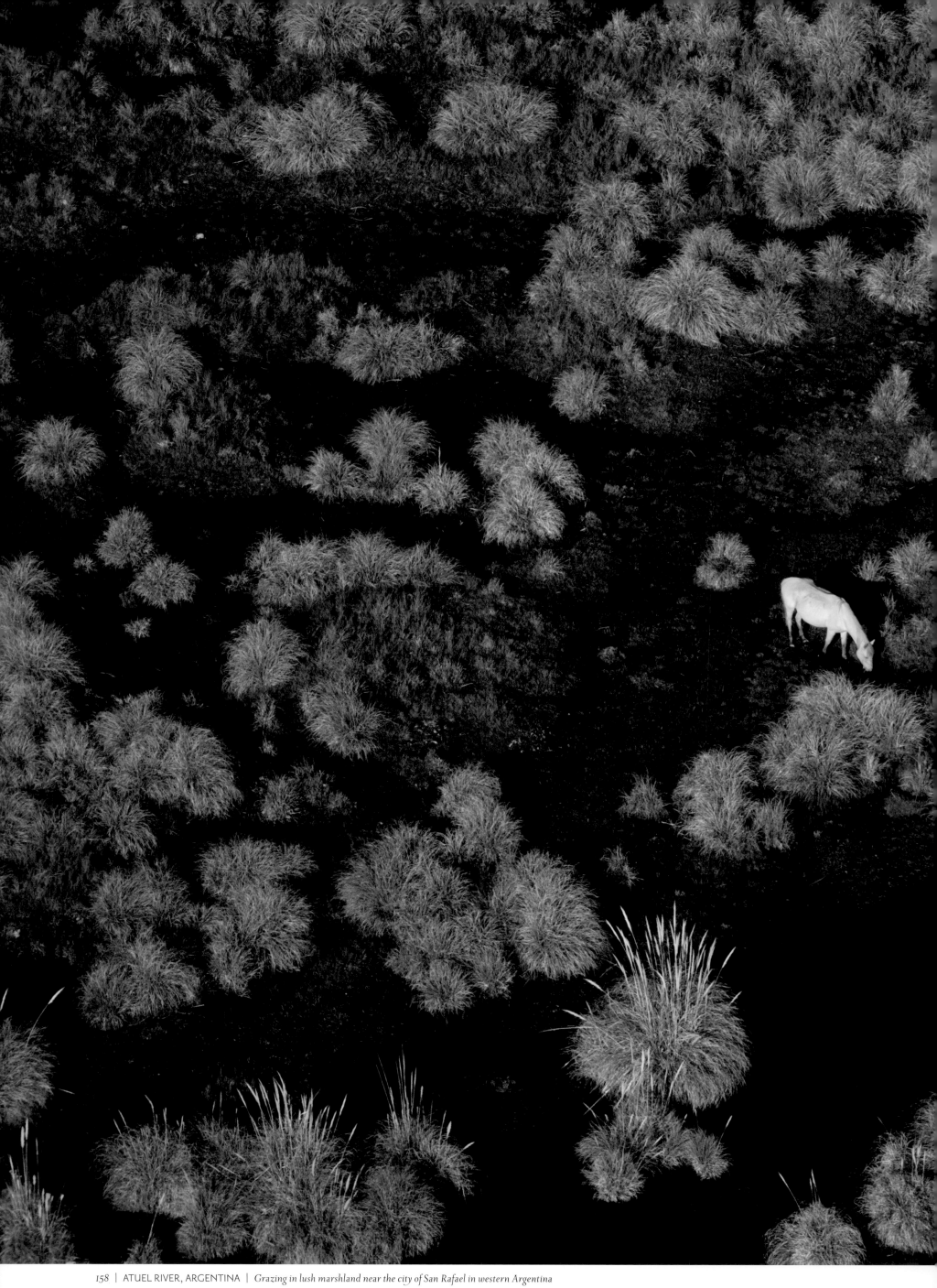

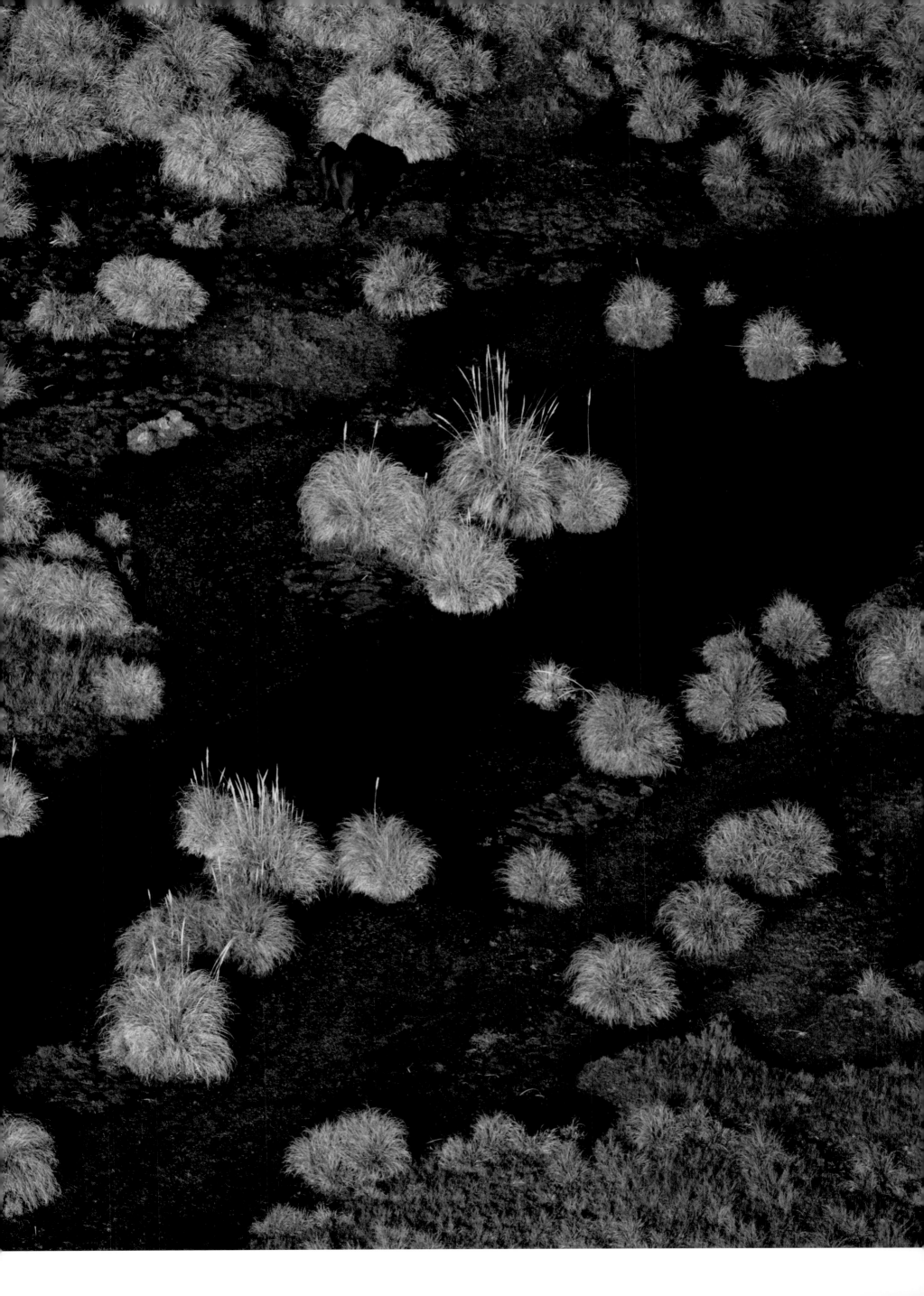

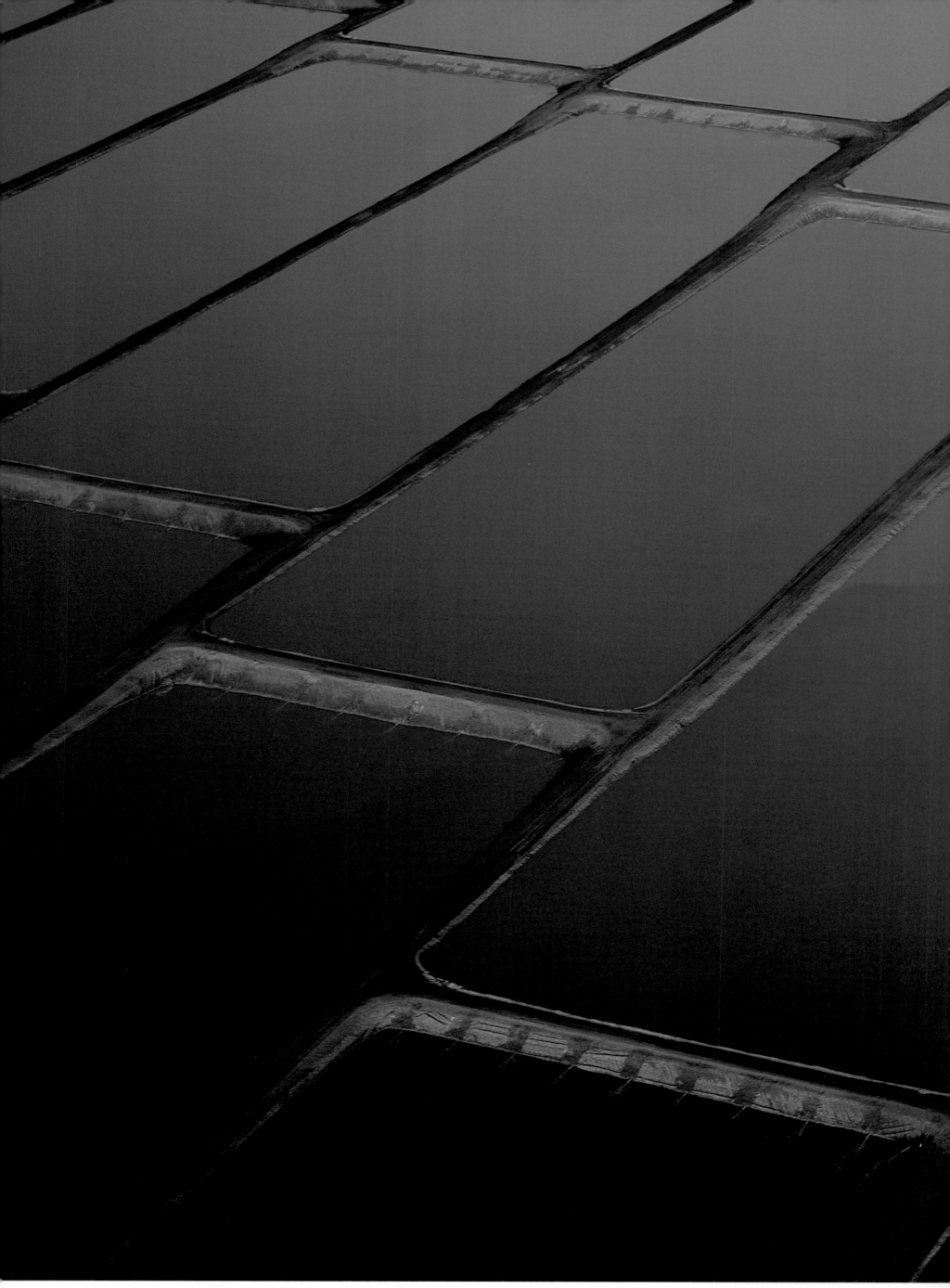

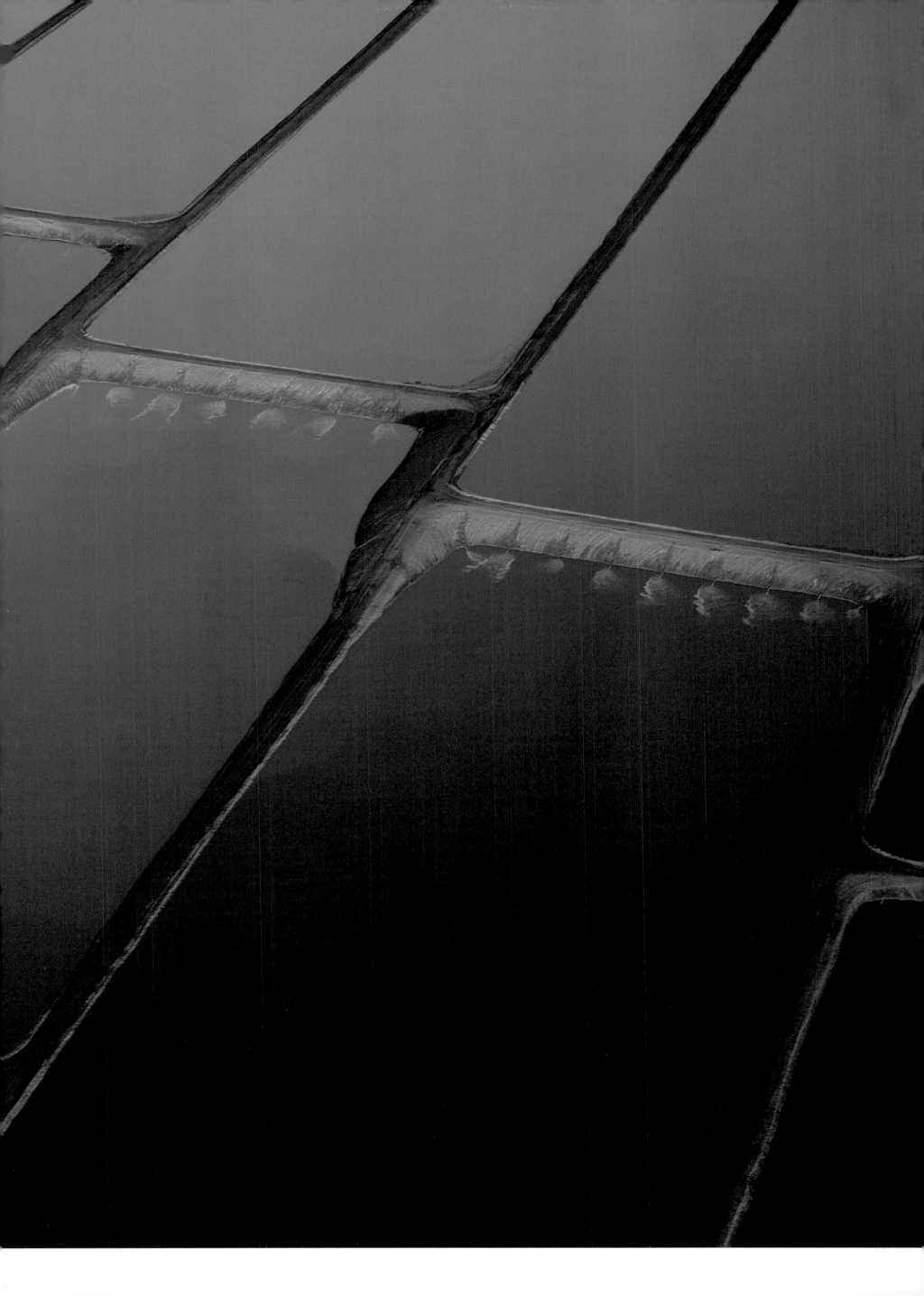

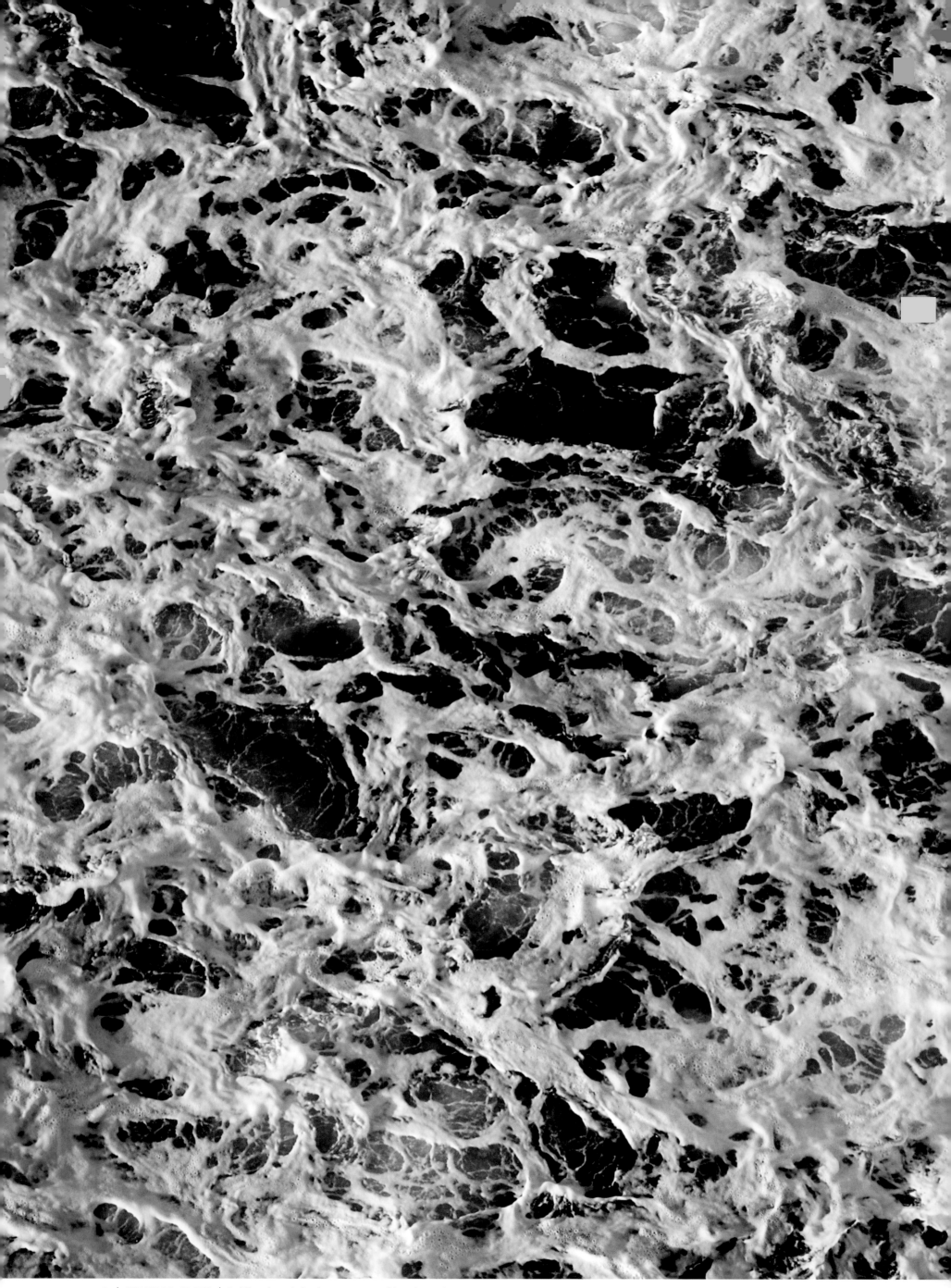

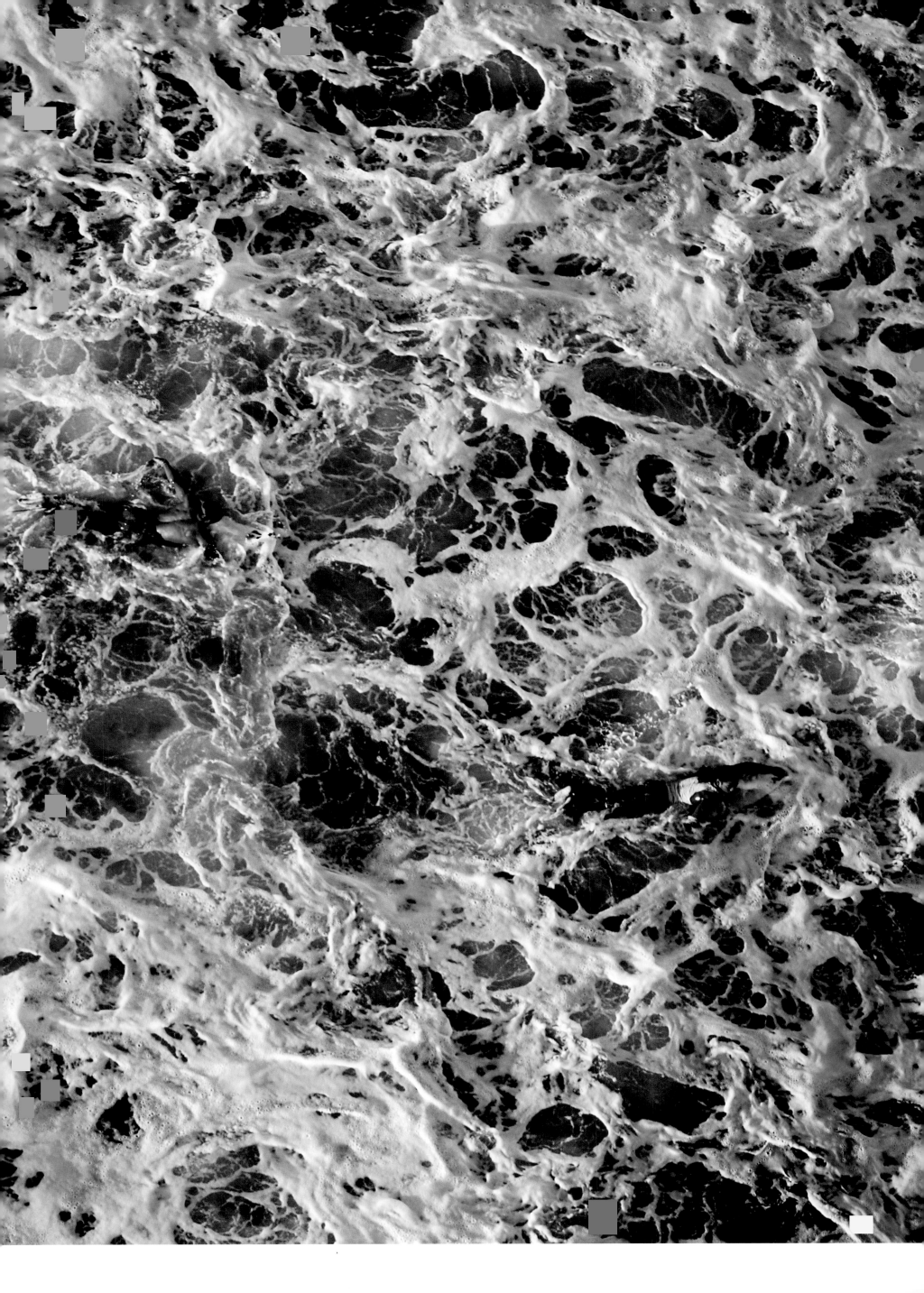

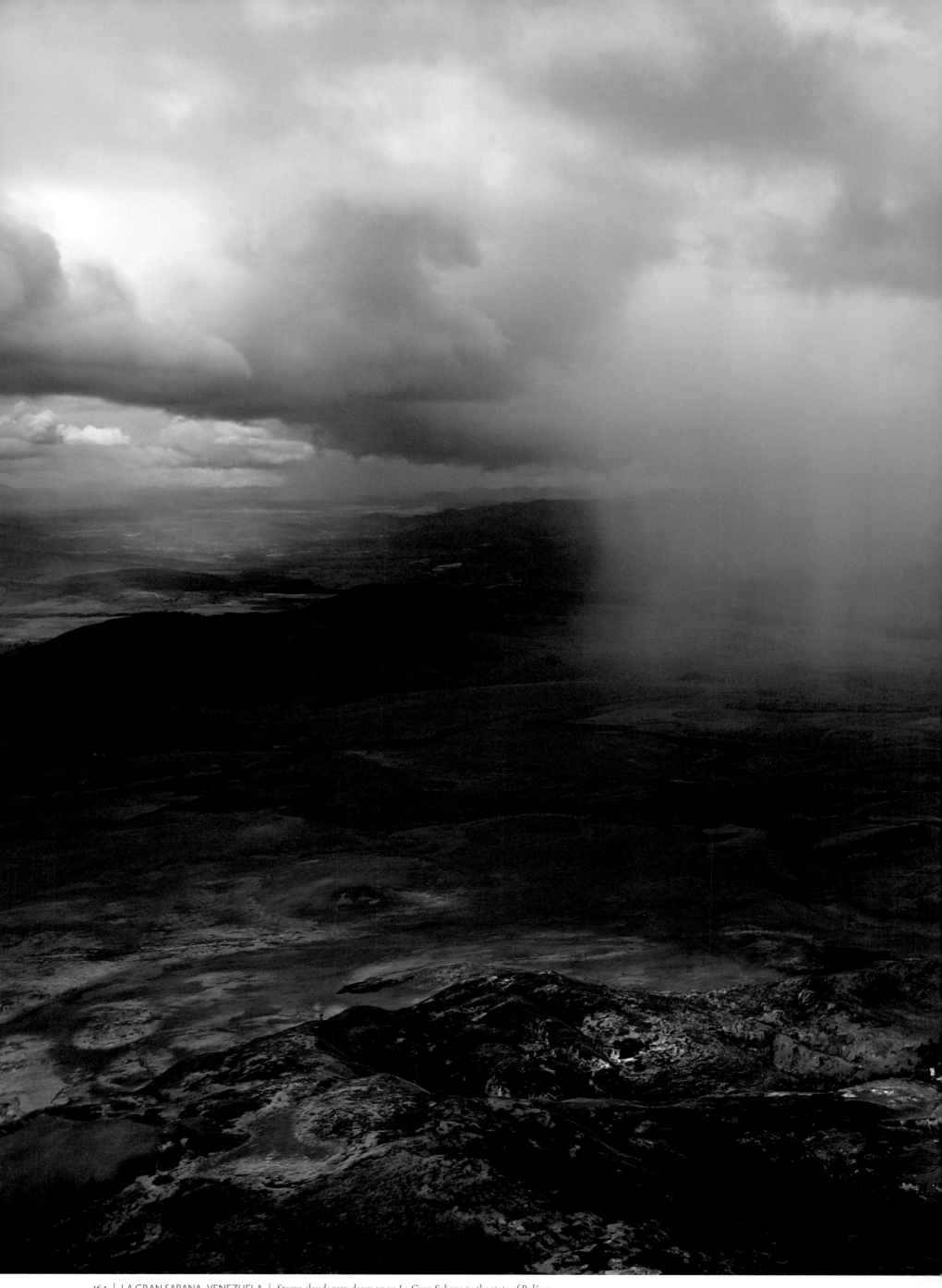

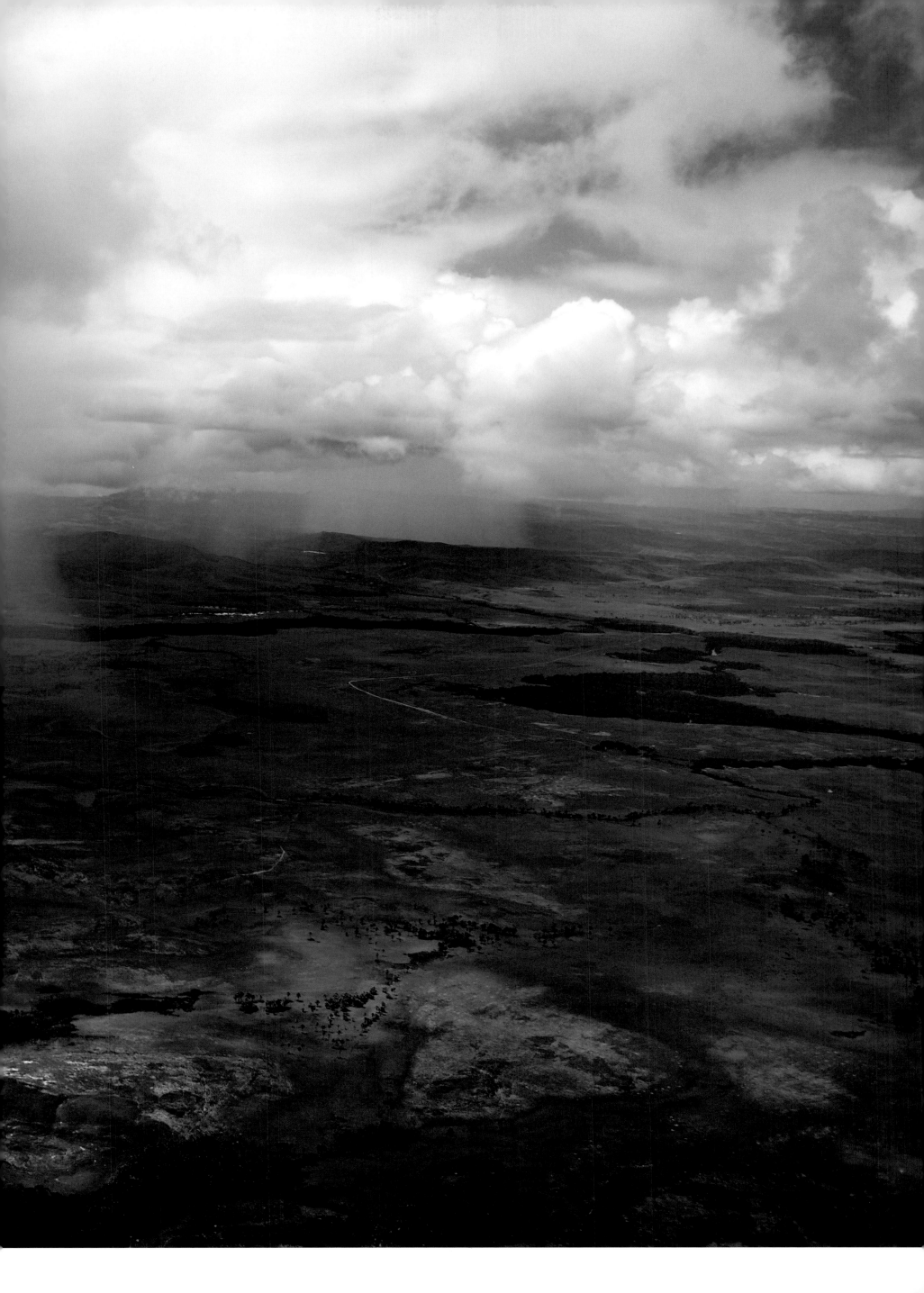

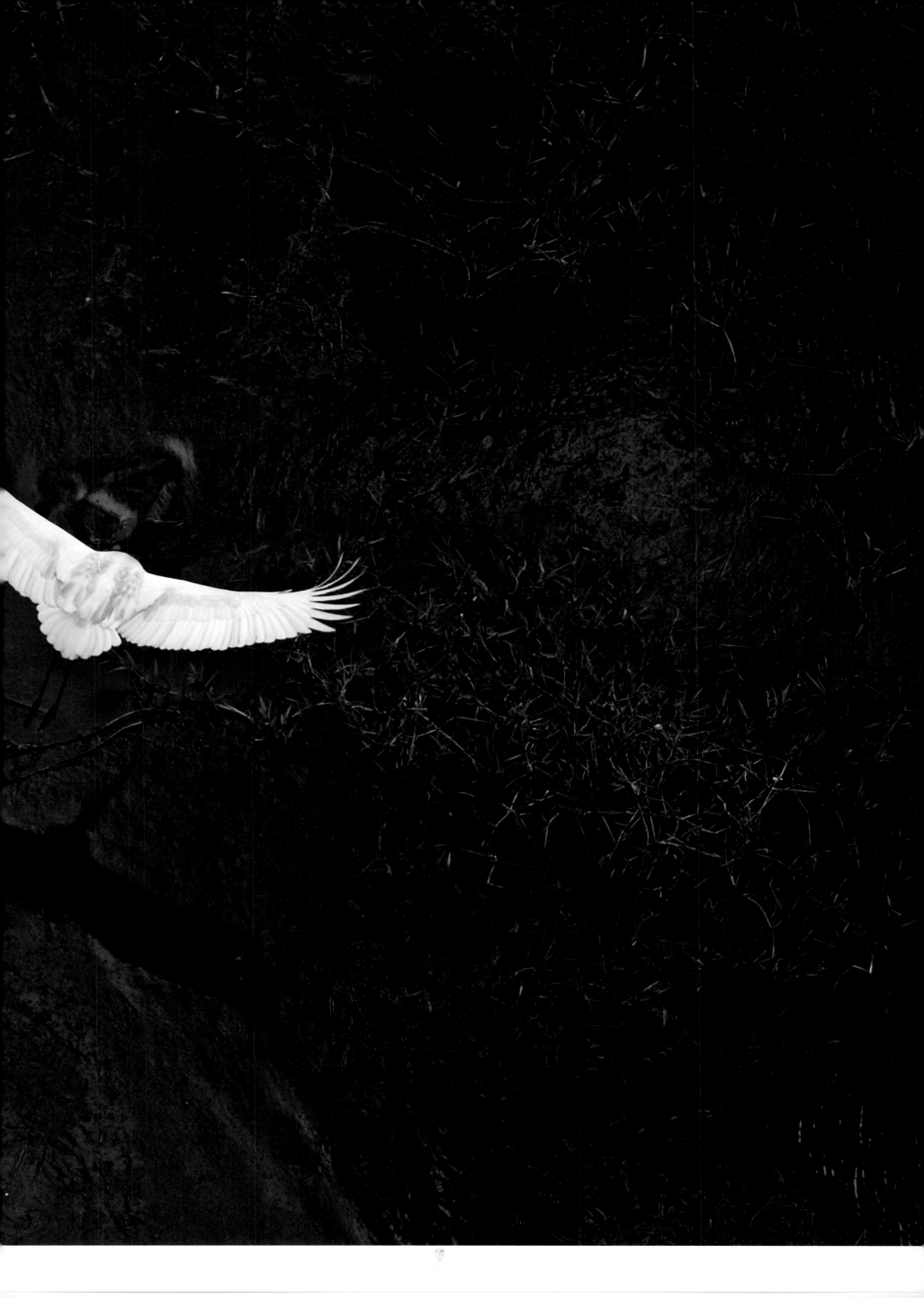

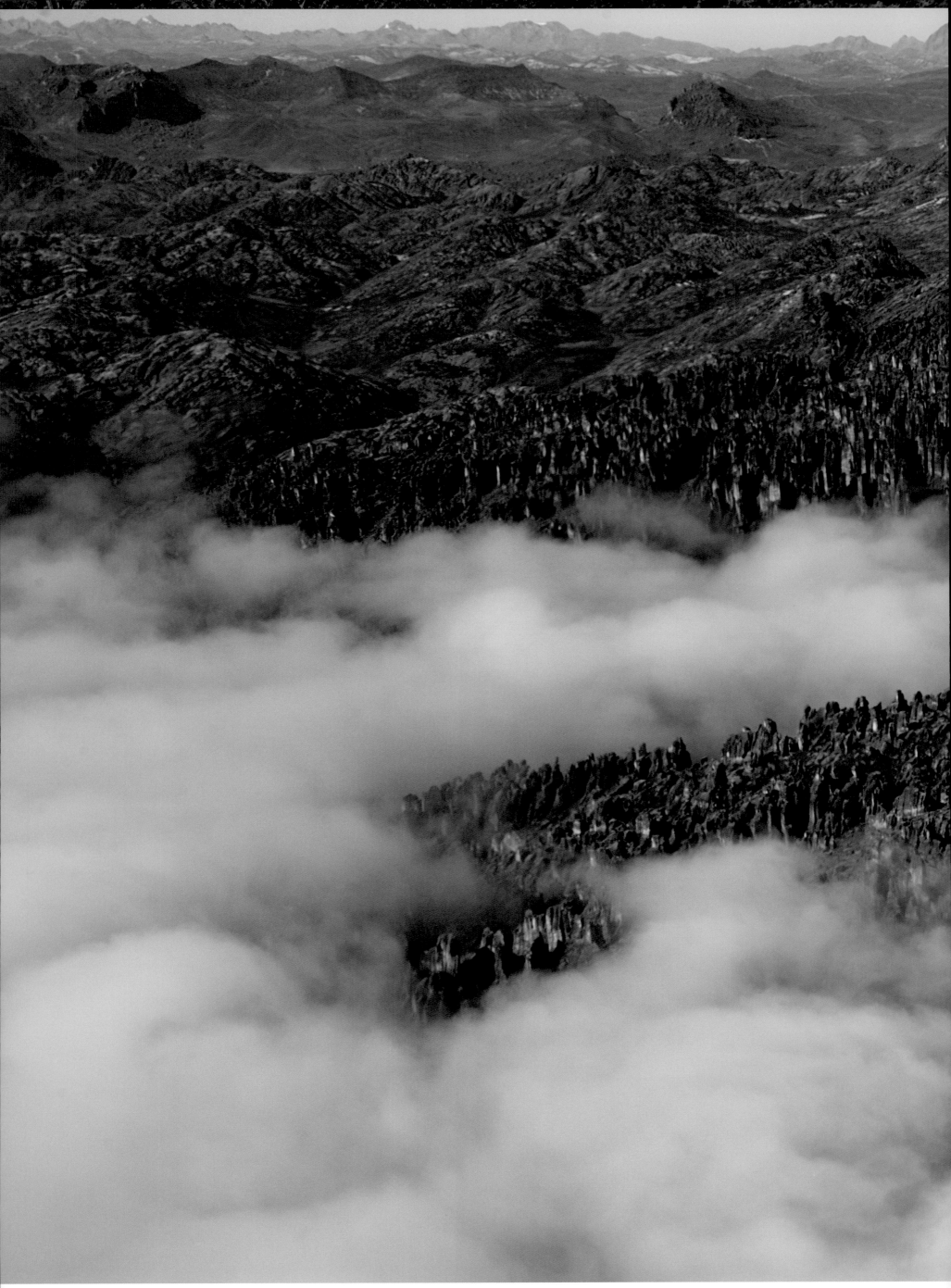

Bank of clouds sweeps into the Stone Forest at Huayllay

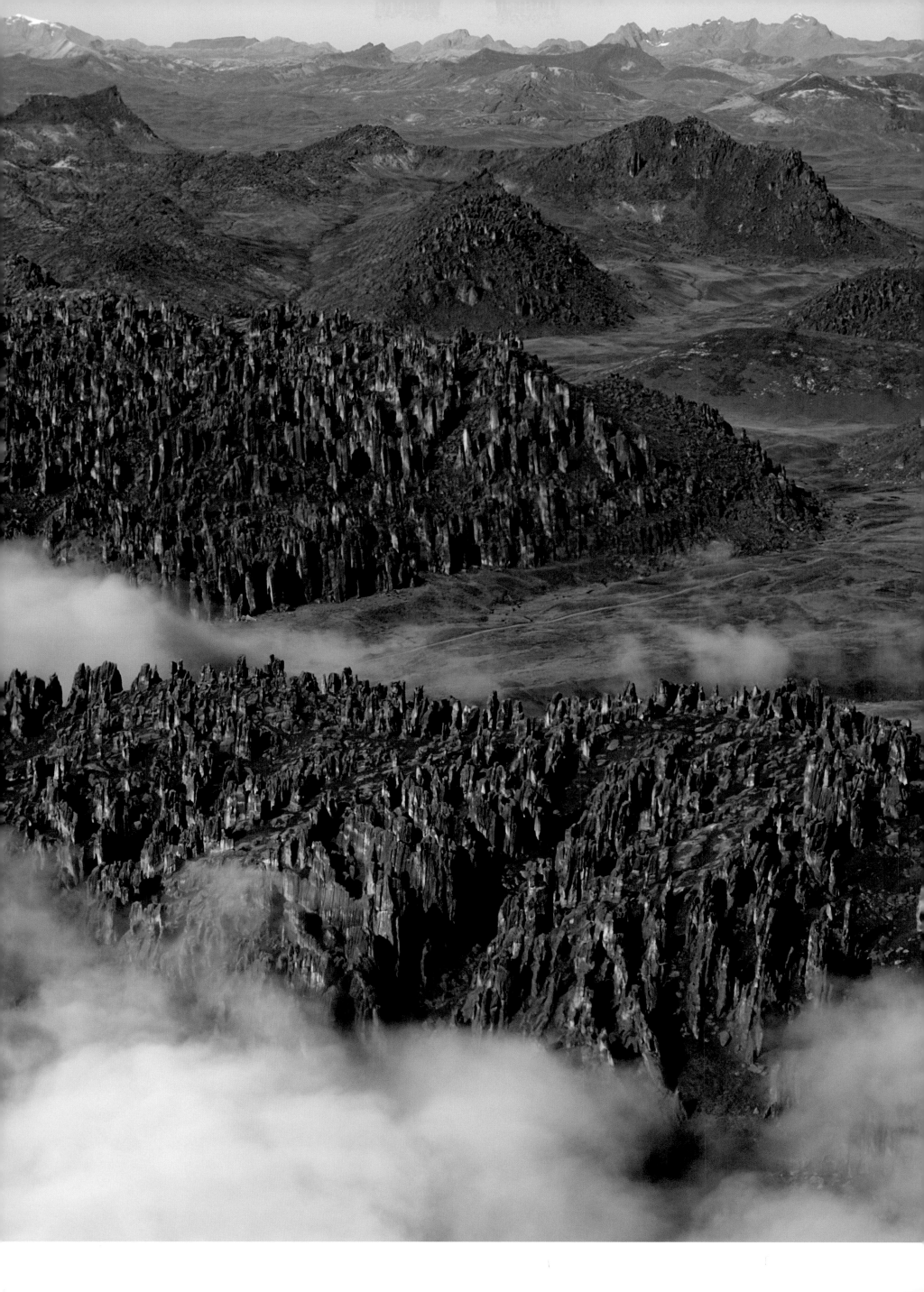

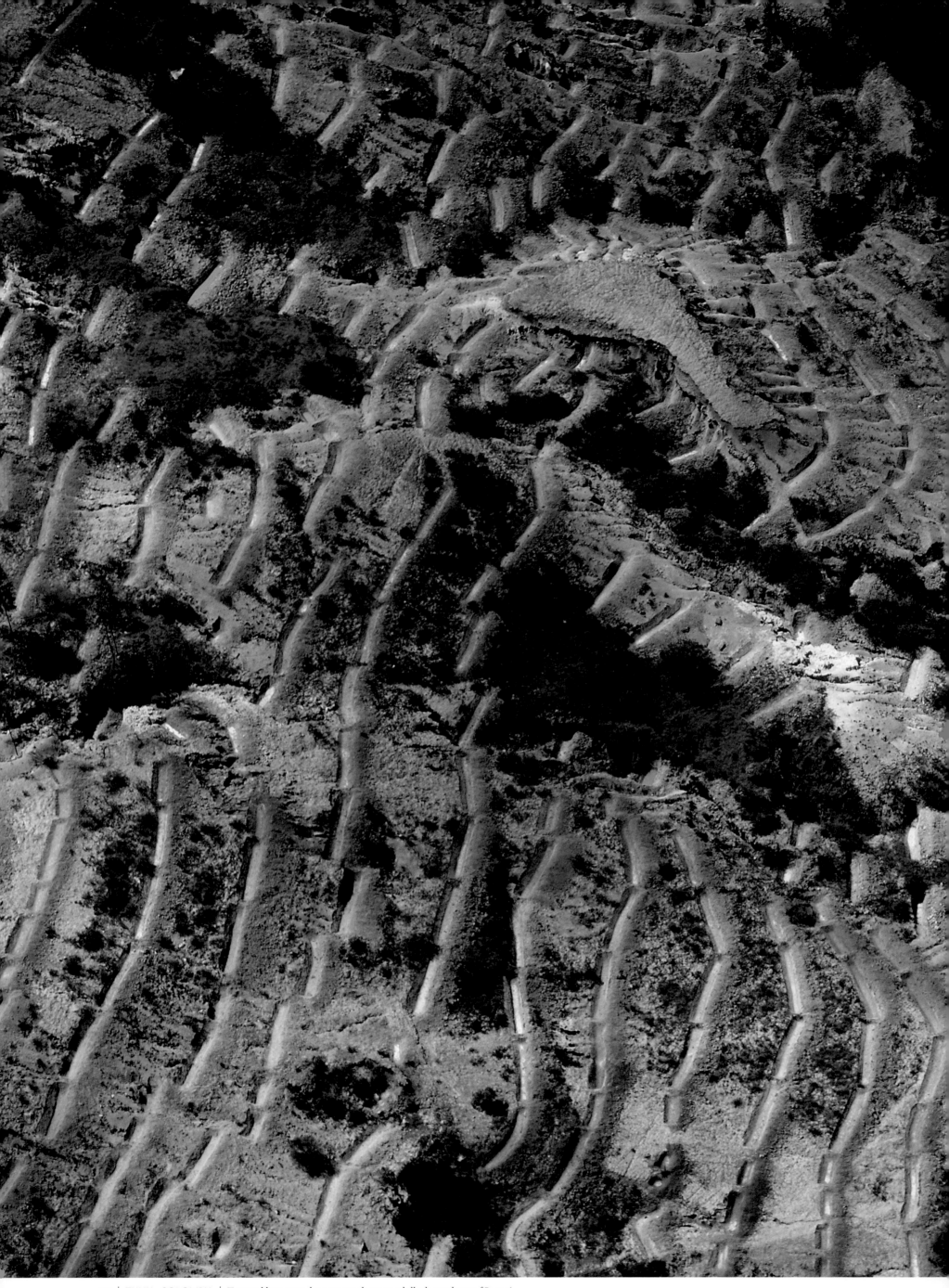

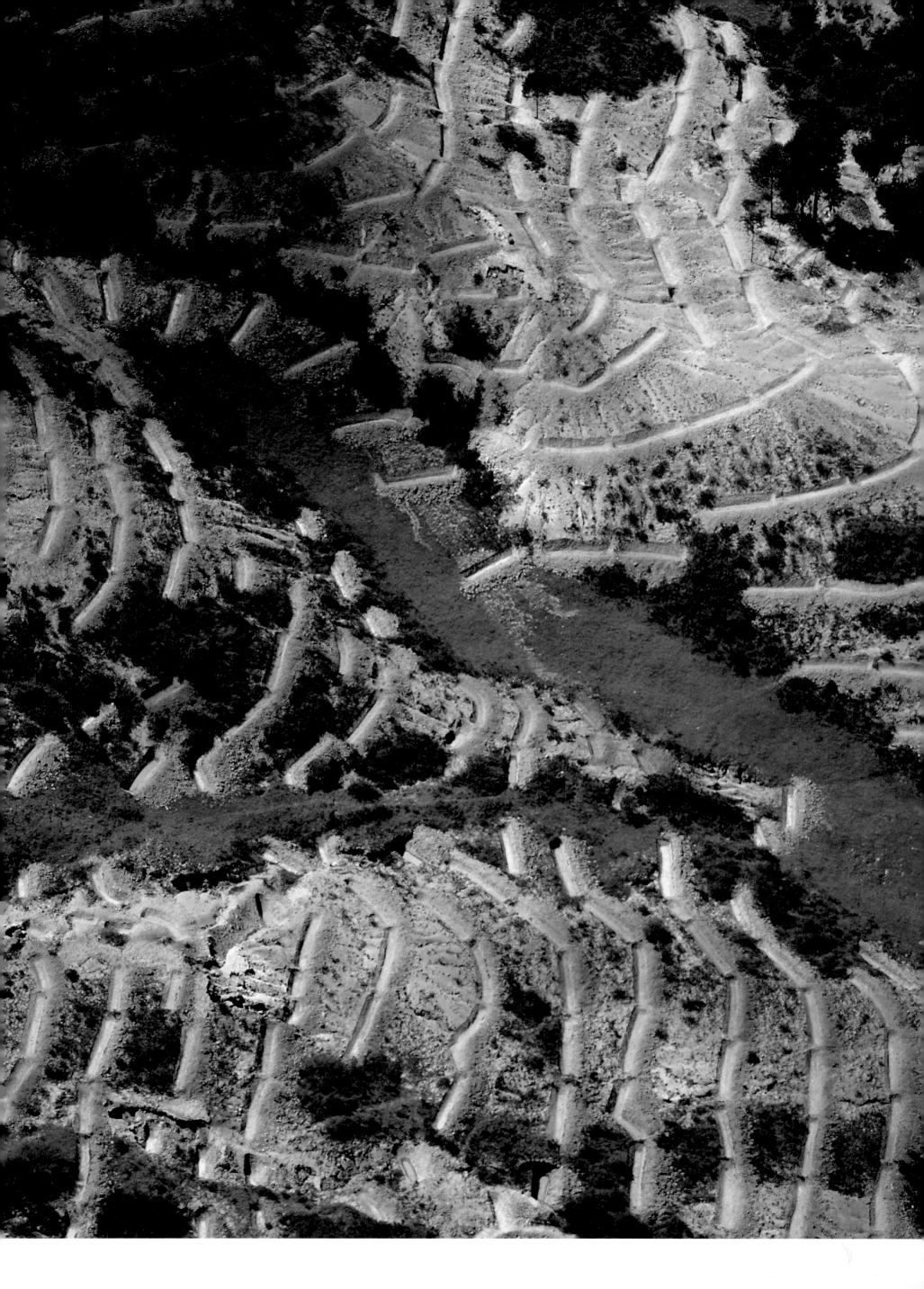

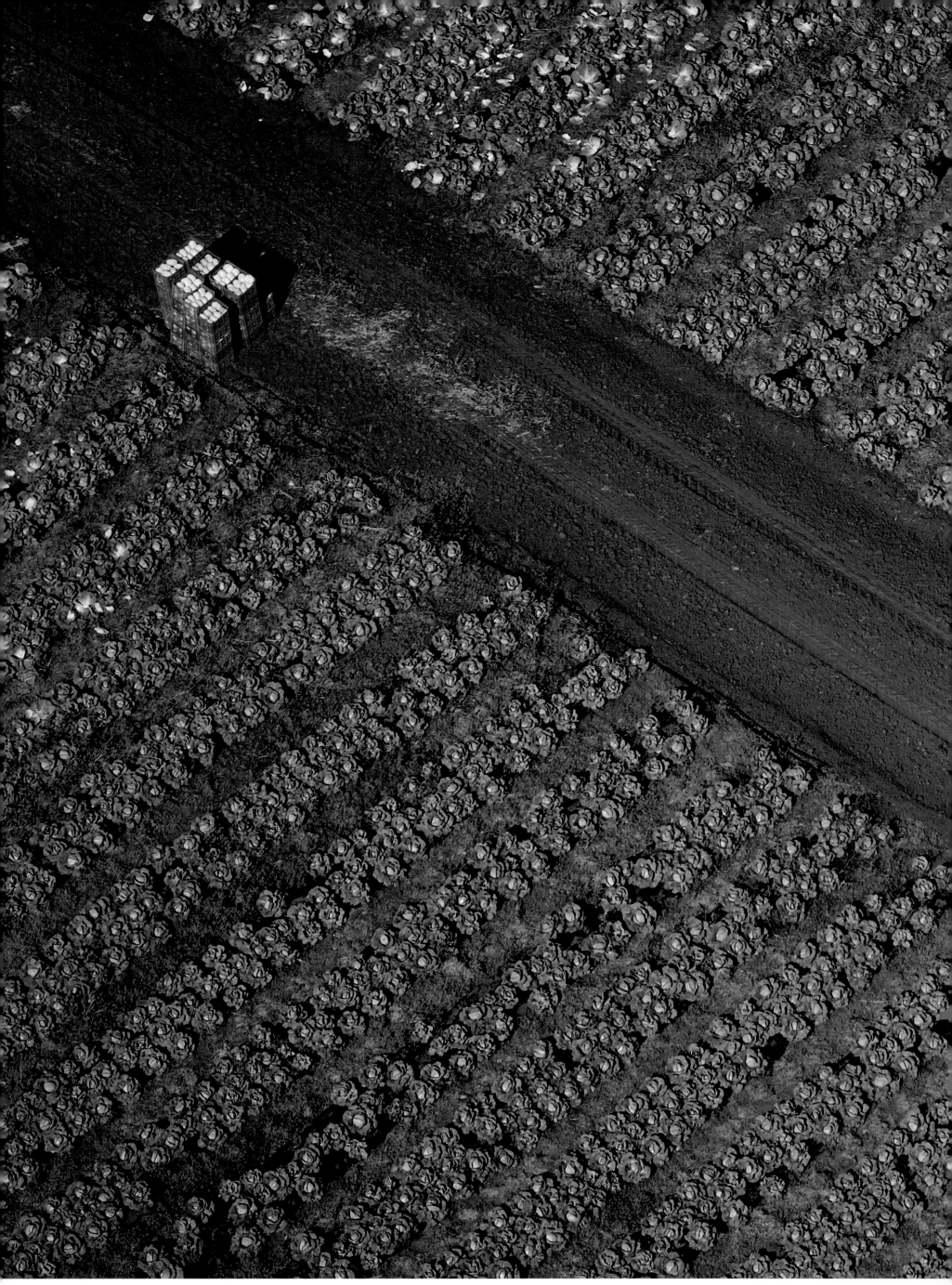

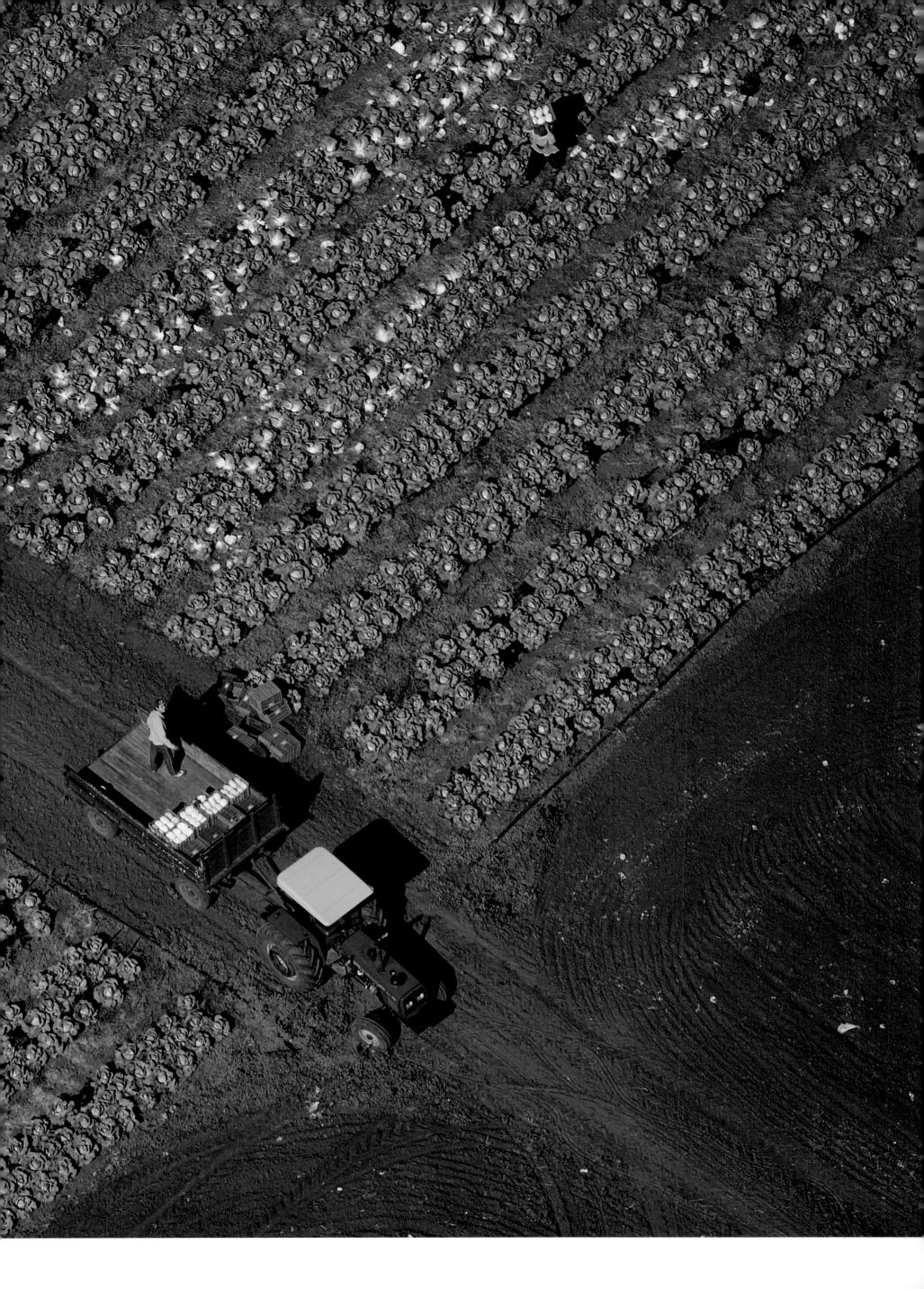

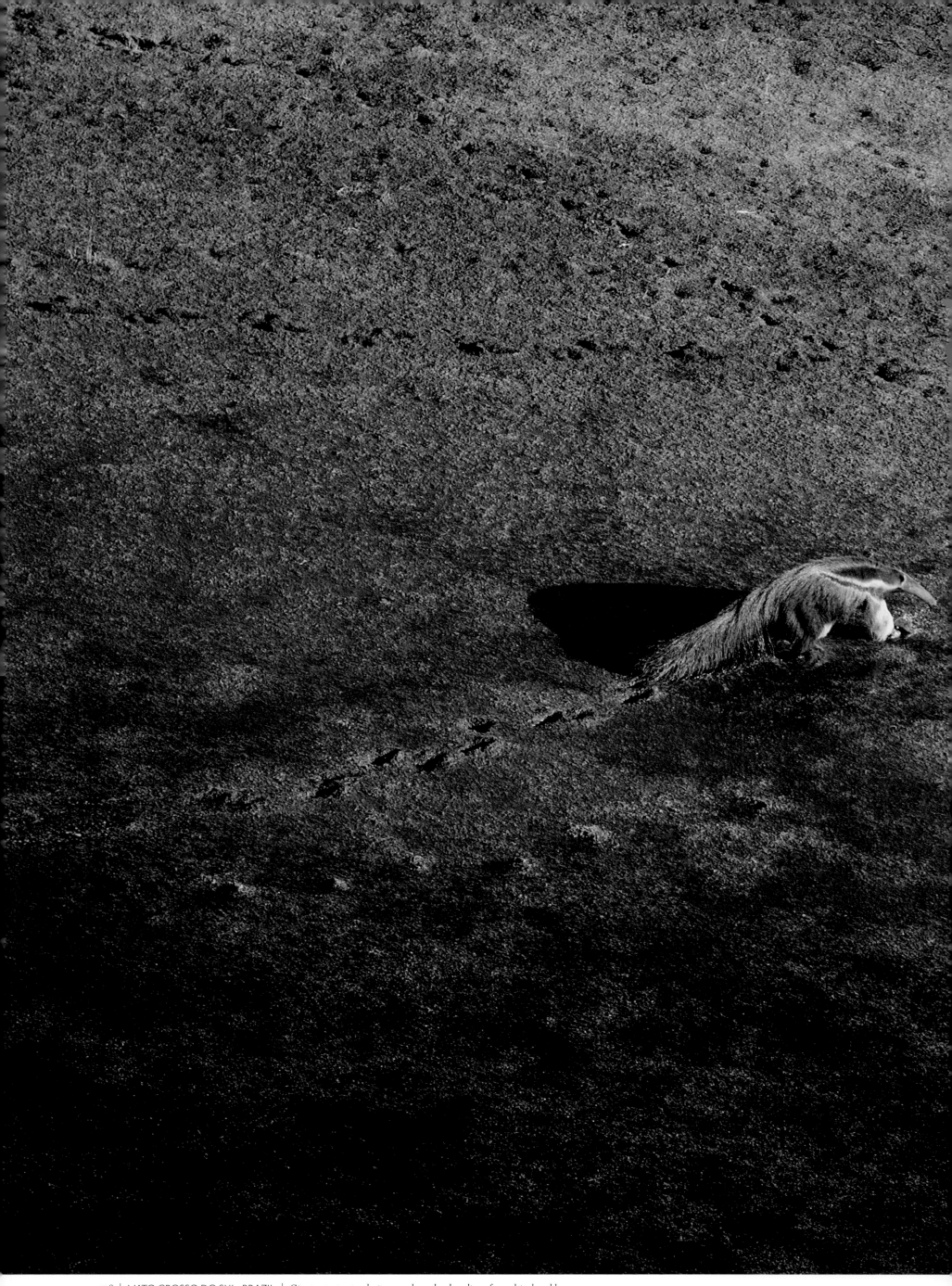

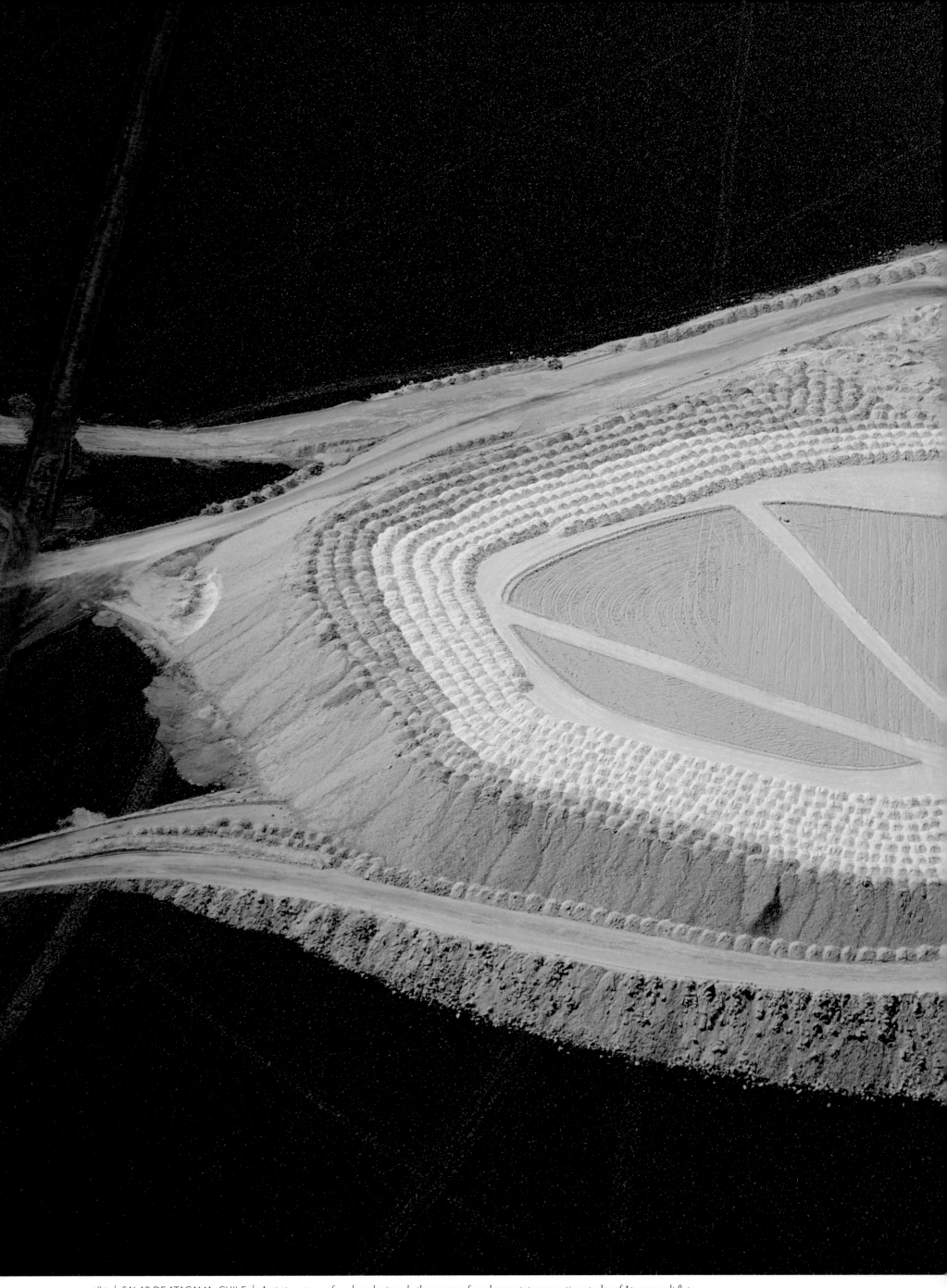

Artistic pattern of roads and mineral piles emerges from large mining operation at edge of Atacama salt flats

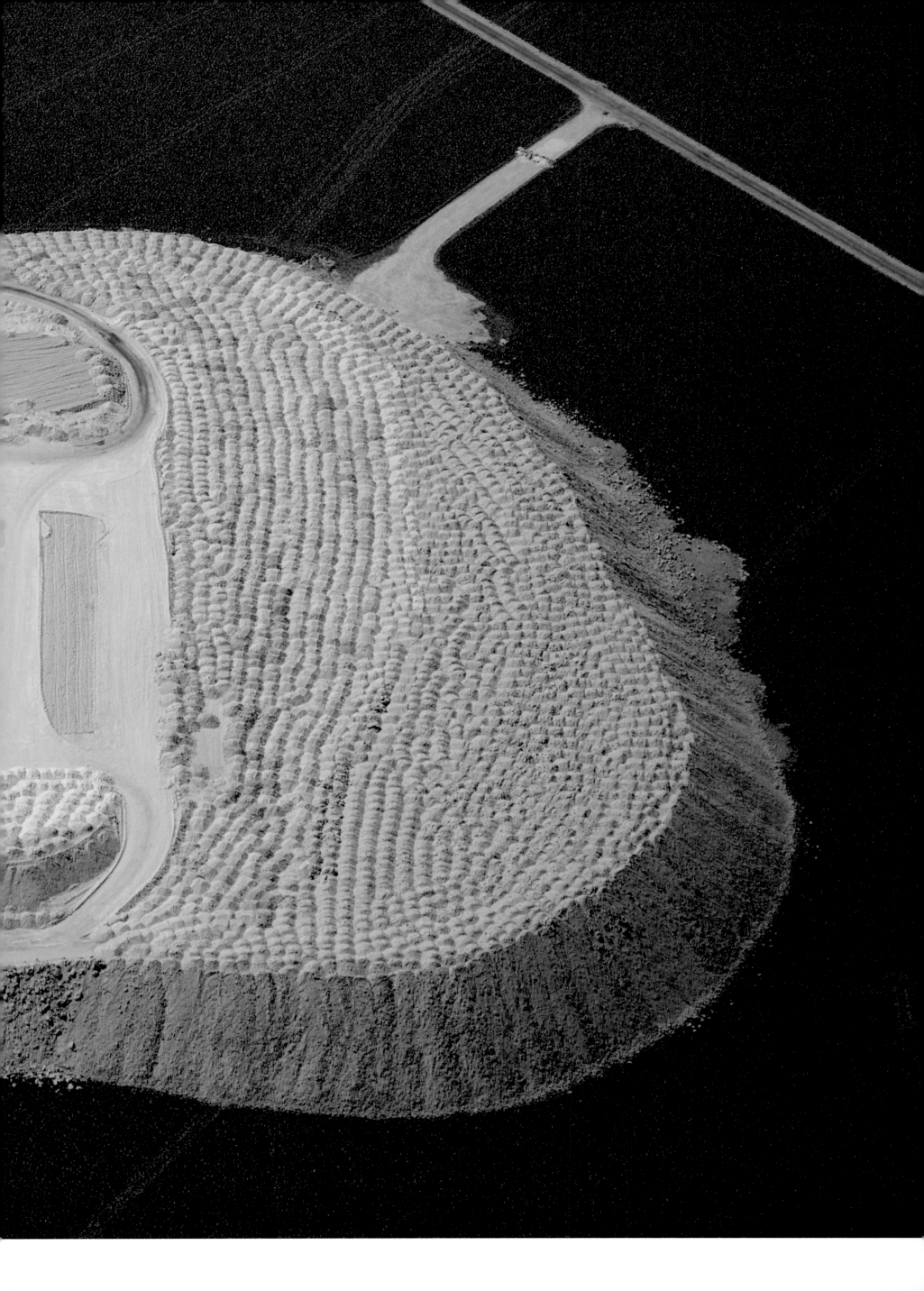

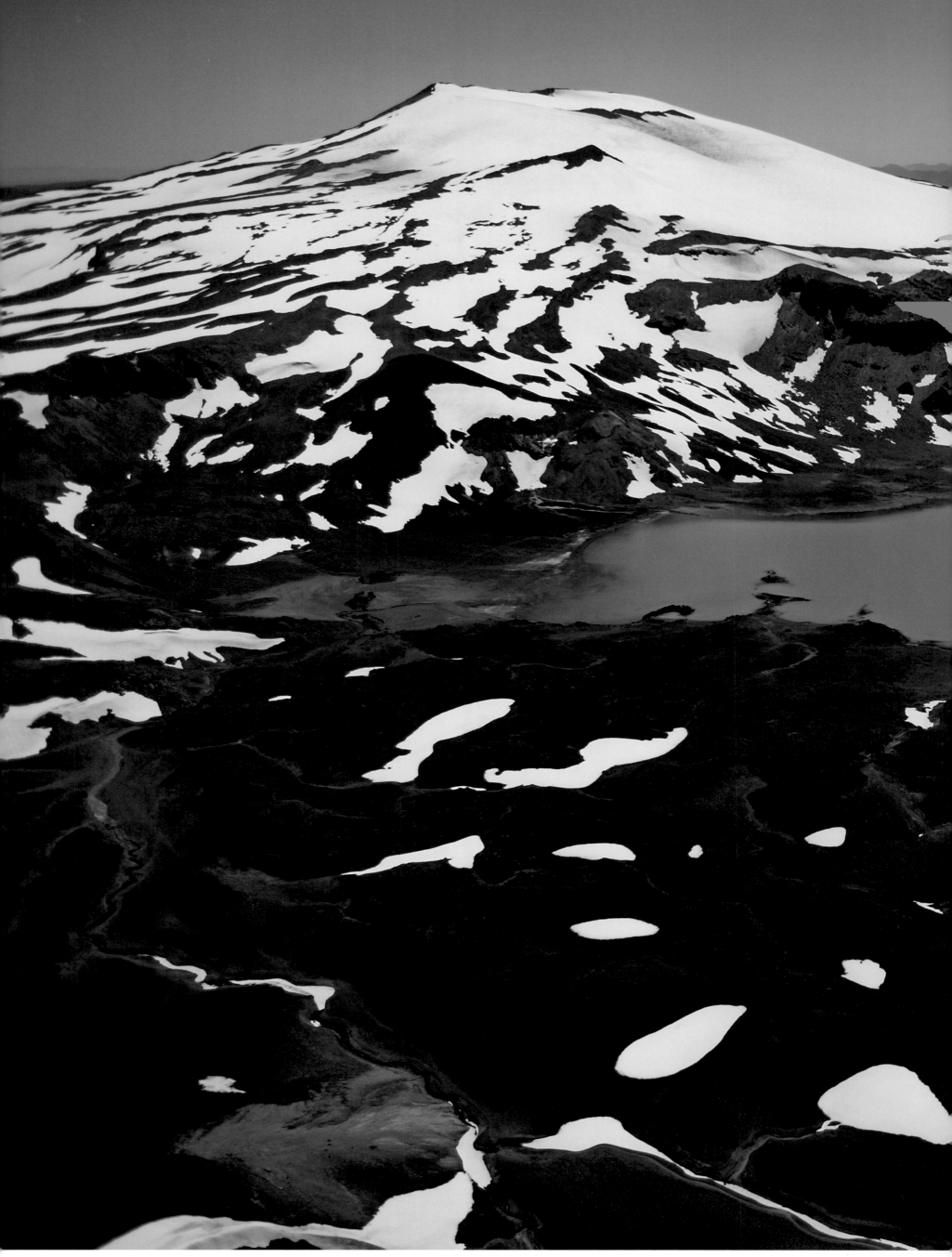

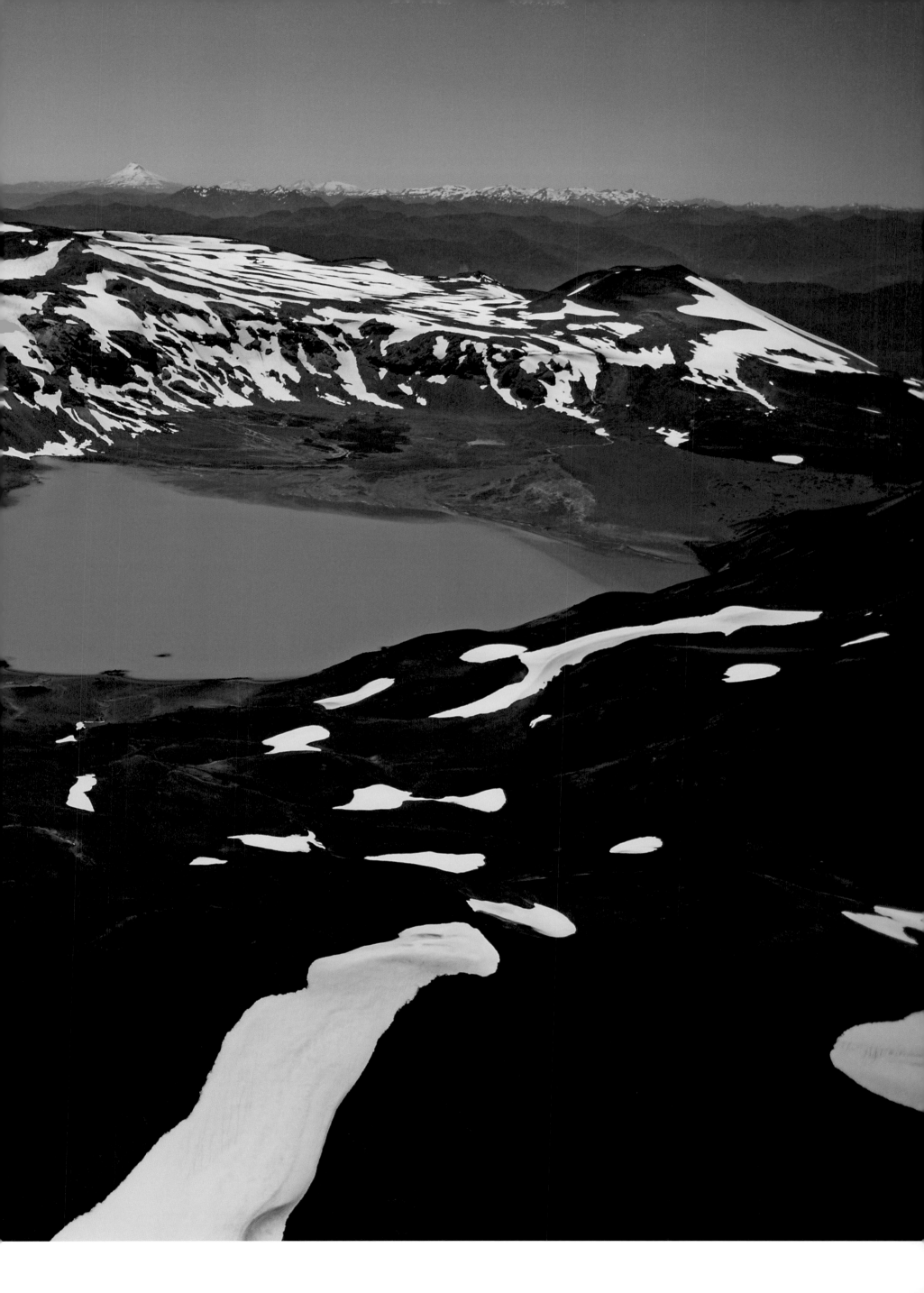

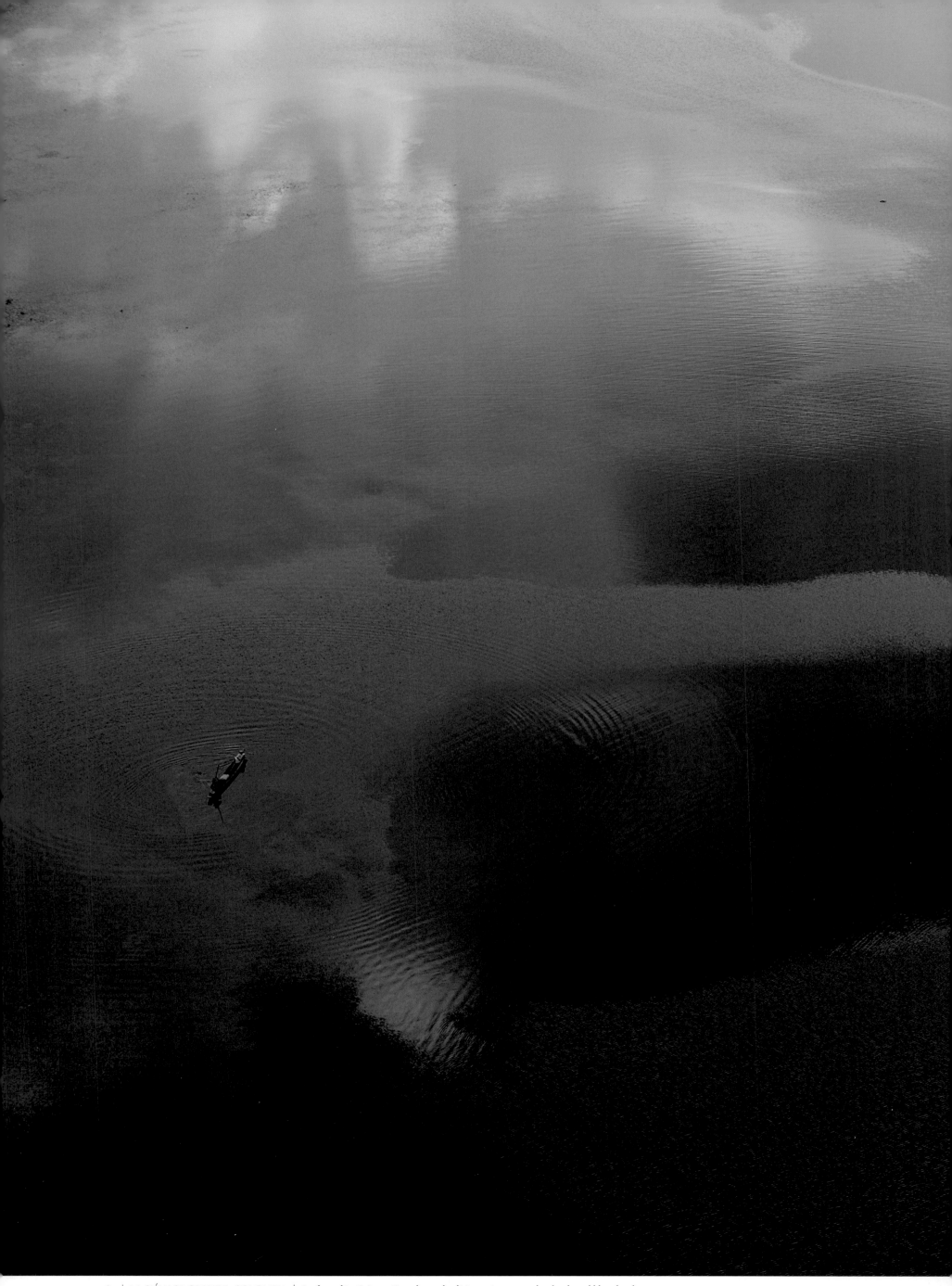

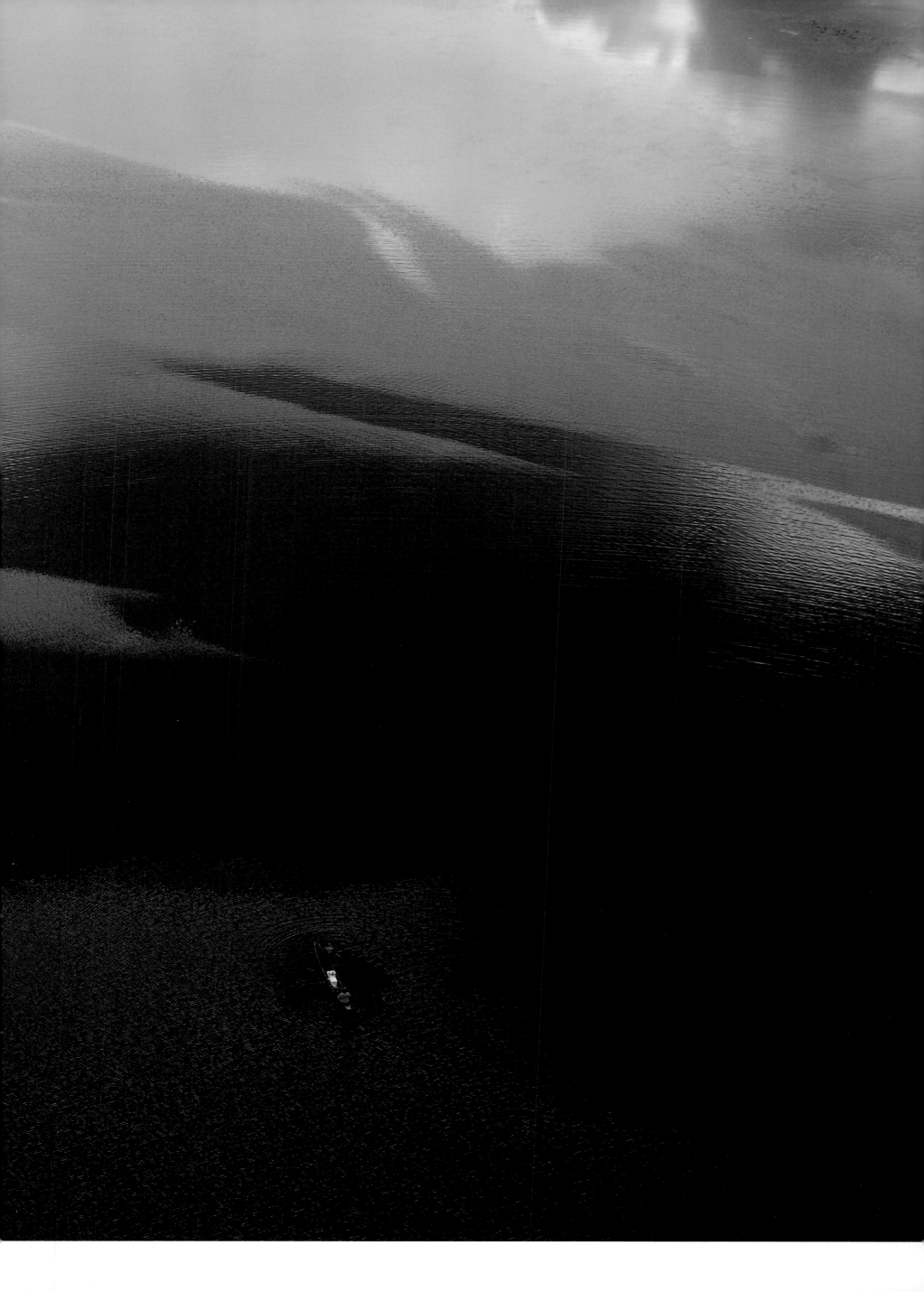

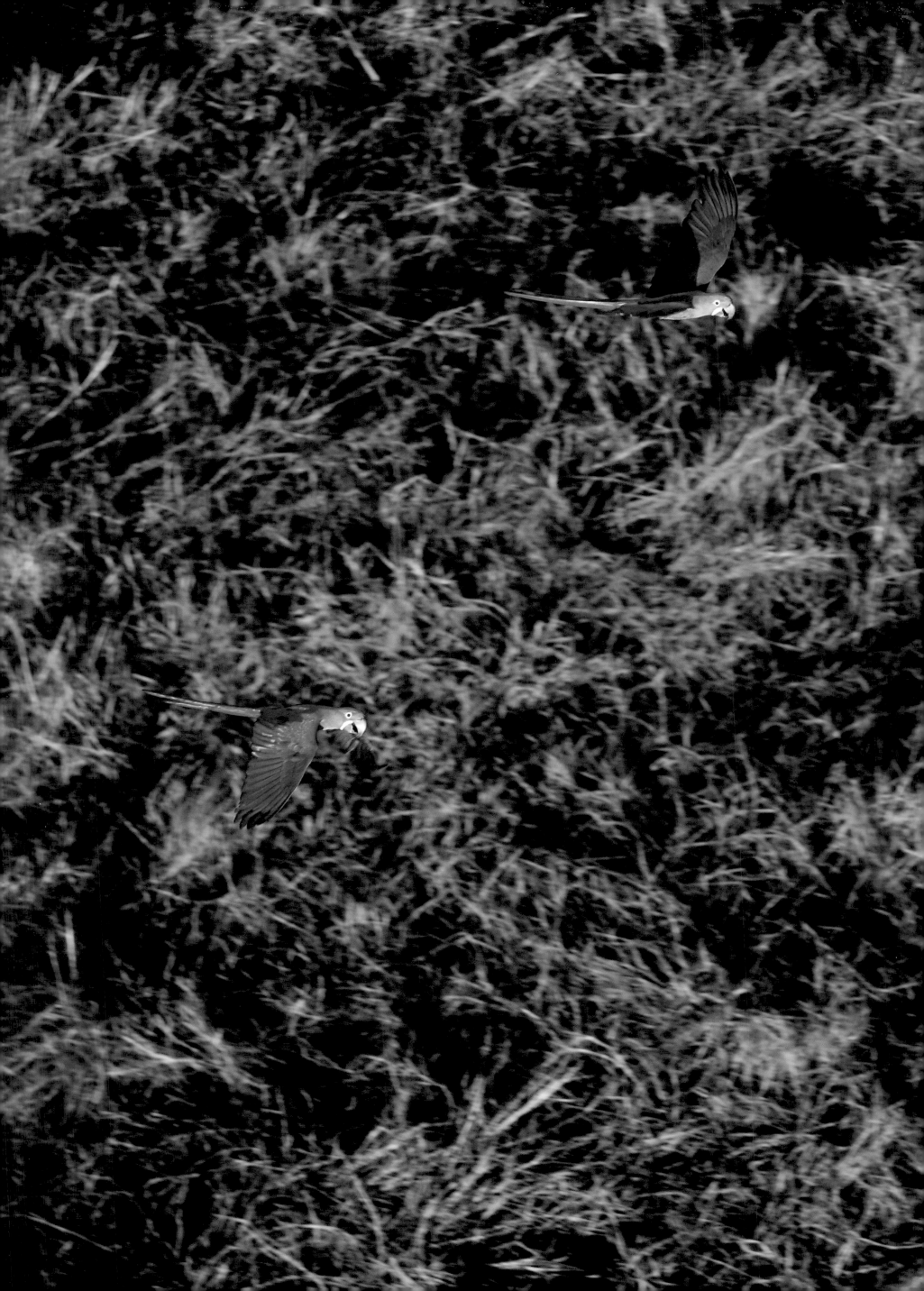

The Shaman and the Condor

STEPPING INTO THE VAN THAT WOULD DELIVER US TO THE CEREMONIAL GROUNDS, I WAS SURPRISED TO SEE THE SHAMAN already seated inside. Instinctively, I embraced Nazario and felt an immediate comfort in his unmistakable but gentle spirituality. In the Latino tradition, Nazario kissed me on my cheek, and the sensation seemed to linger unusually long. Nazario spoke no English, and I not a word of Quechua, so we communicated only through our eyes and our guide-interpreter.

Physically, Nazario is not a large man. His face is distinctive, with a prominent nose and deep-set, piercing eyes. But his legs are his most memorable feature. Only after having been struck by lightning as a young man was Nazario chosen from among his siblings to succeed his father as the spiritual interpreter of the coca leaves. The lightning that passed through his body bloated the veins in his legs to a grotesque size that was impossible not to notice, but so too the musculature in his legs, hardened by seven decades of walking the hills around Cusco.

We drove toward the ancient Inca fortress of Sacsayhuaman, where we trekked to a spot used for ceremonial offerings and communion with the spirits. I watched in silence as Nazario carefully constructed a small mound consisting of both mundane objects, such as rice, seeds, and candy bars, as well as more culturally rich items, such as an alpaca fetus. Then Nazario asked permission to interpret the coca leaves on my behalf. What ensued was an eerie but unfailingly accurate portrait of my life...neither flattering nor critical, simply "spot on."

Inside my body, the shaman sensed the tug of strong knots that harbor stress—the Quechuan equivalent of baggage. Nazario took individual pieces of thread and snapped the threads in two around my ankles, knees, chest, and forehead as a way to break the knots and ease the tension.

Permitted to pose a single question, I asked the shaman, "How does one who is driven by fierce energy channel the energy in a constructive direction and not allow it to escape in harmful ways?" The shaman selected a handful of coca leaves and tossed them onto his shawl. An oddly configured stem landed closest to me; it had three leaves, two overlapping perfectly and the third pointing in the opposite direction and twisted upside down. Nazario explained that one must follow his own true path (the two aligned leaves), and it is only when we doubt ourselves (the third opposing leaf) that the negative energy created by indecision is released.

The most uncanny moment of all came on our way back to Cusco when Nazario spontaneously broke out in an ancient Quechuan chant about the Condor and the Fox. In it, the Fox asks the Condor what it is like to see the world from above...what is it that the Condor is able to perceive that we on Earth cannot? Prior to that moment, Nazario had been told nothing about what I do or why I was in Peru...nor did anyone (the guide included) know that the title already chosen for this aerial work was *Through the Eyes of the Condor.* —*RBH*

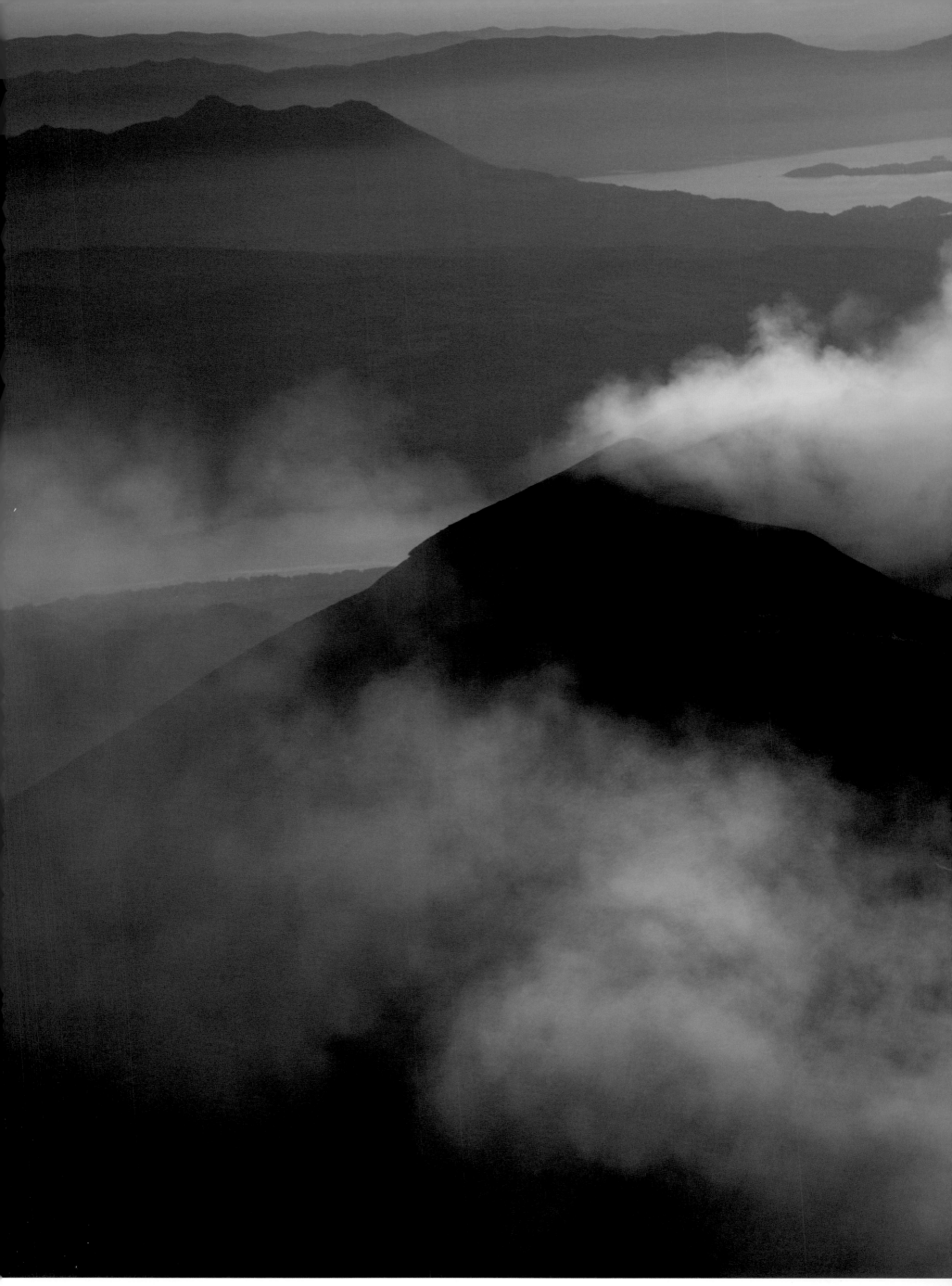

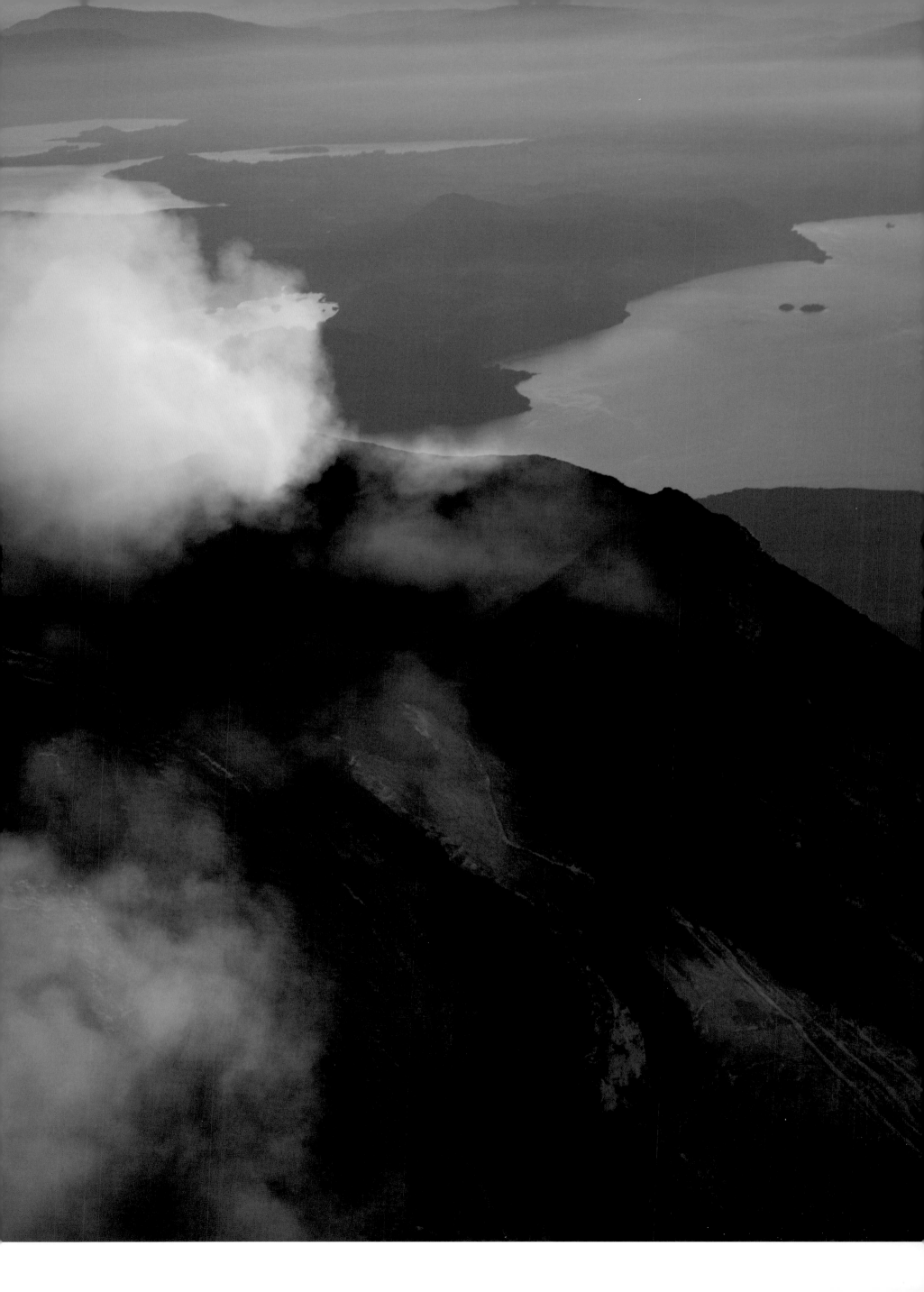

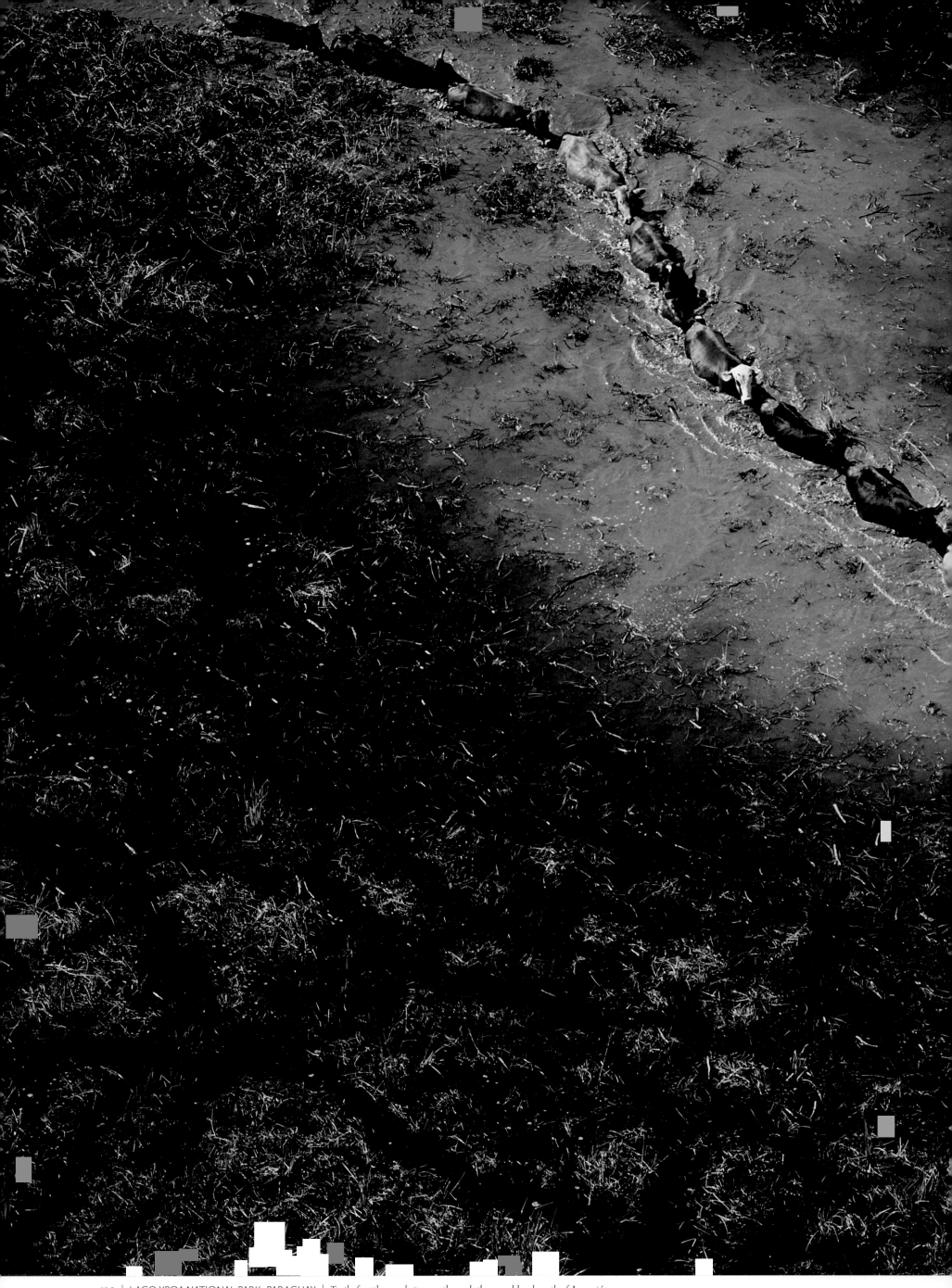

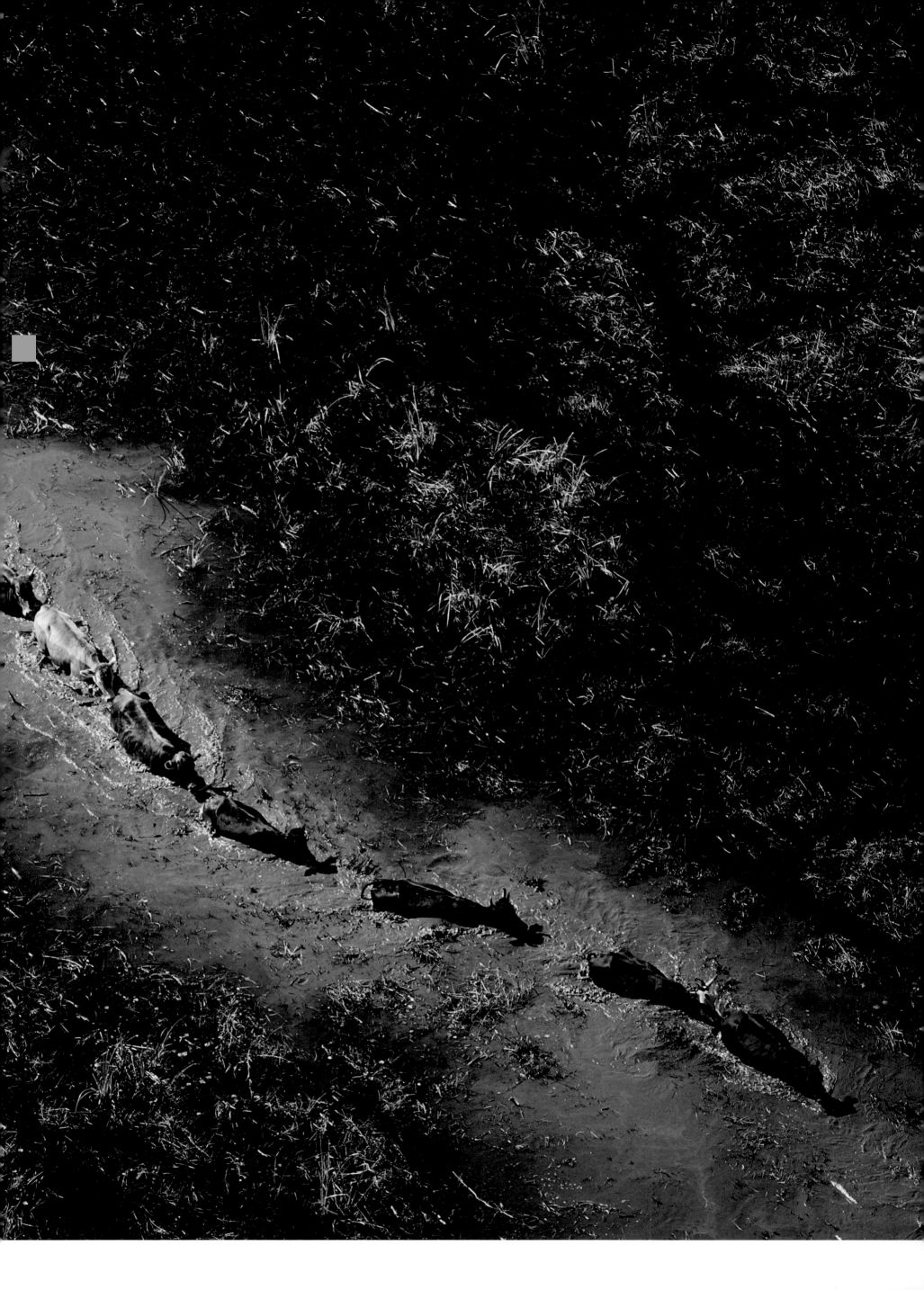

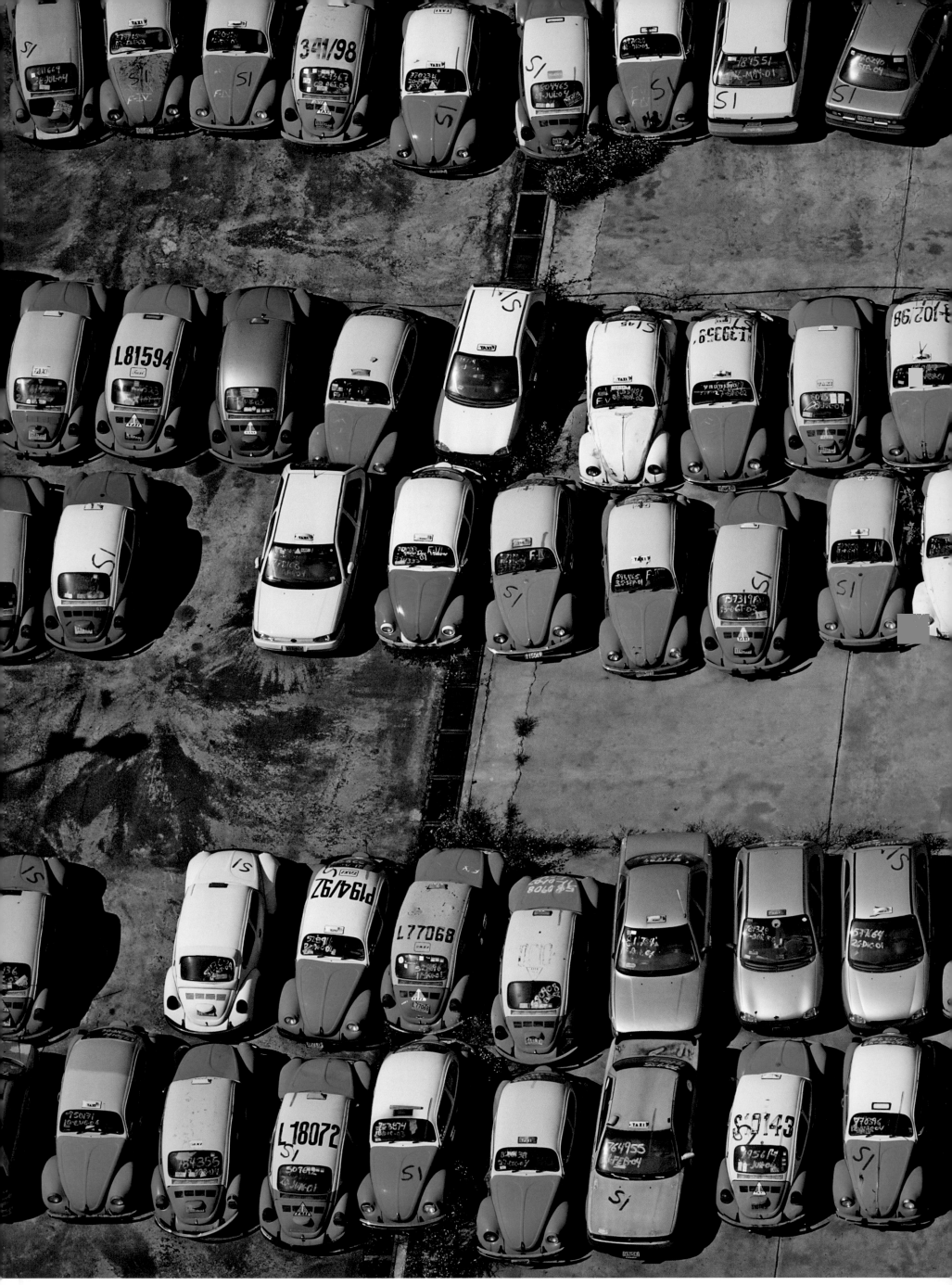

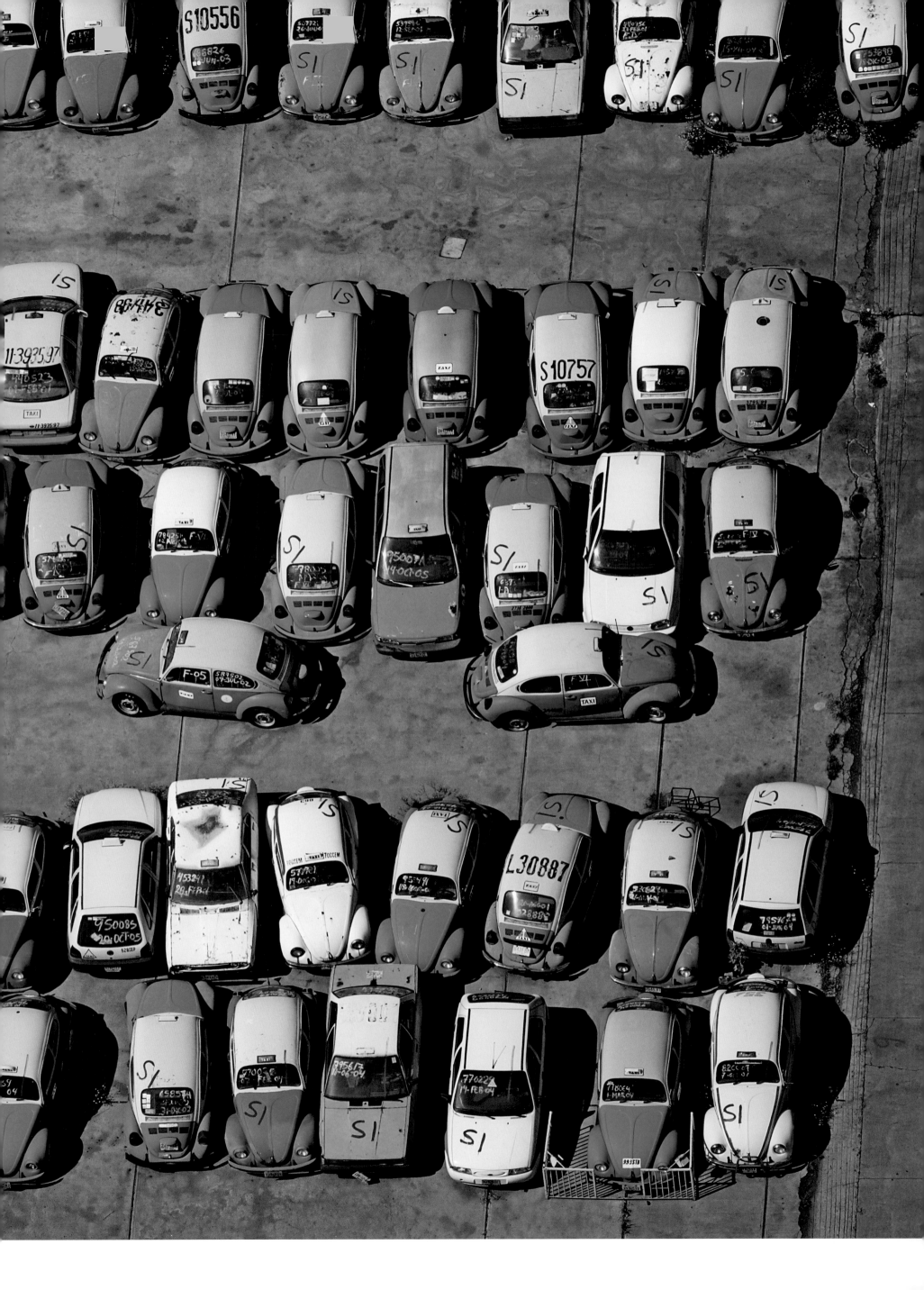

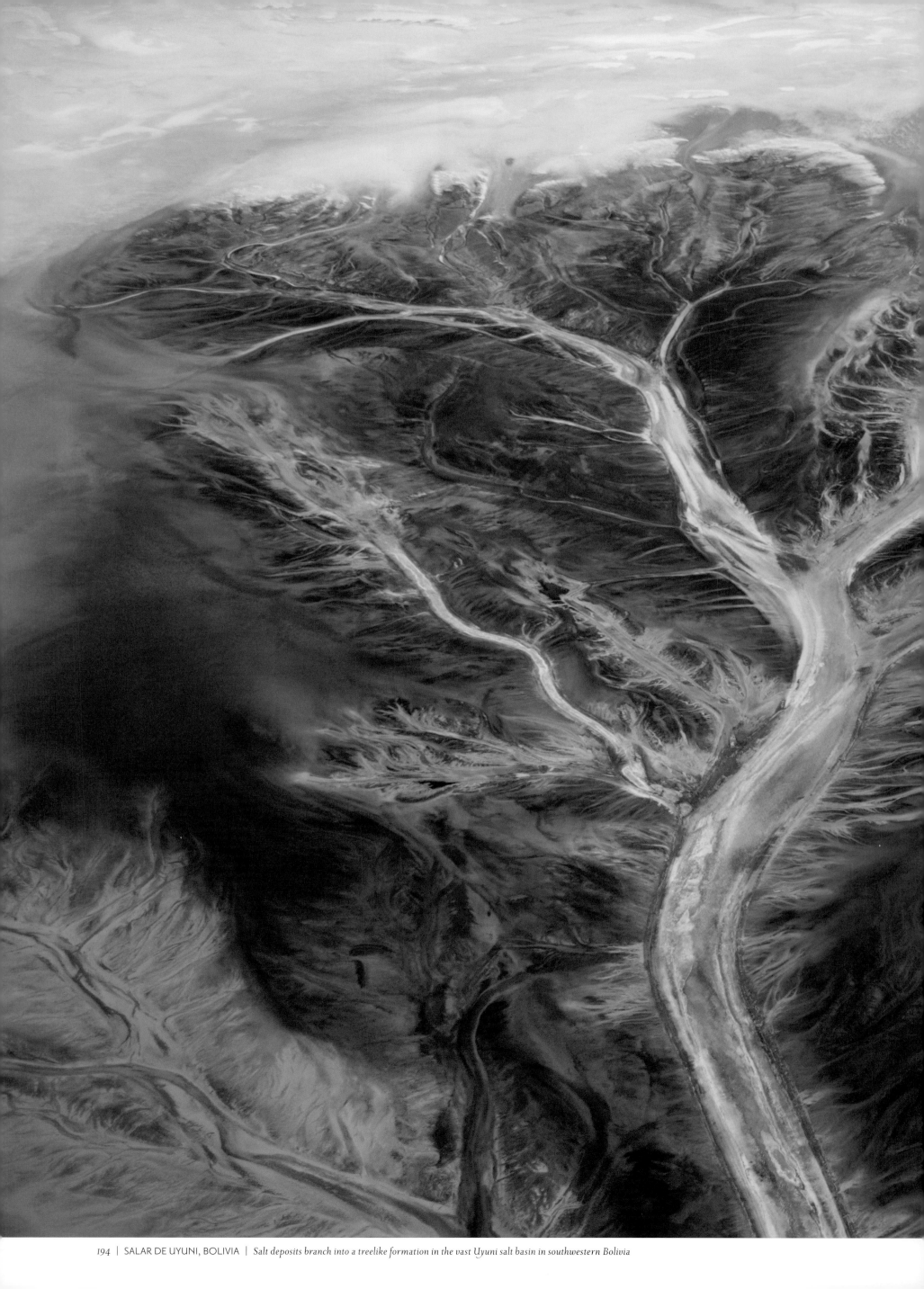

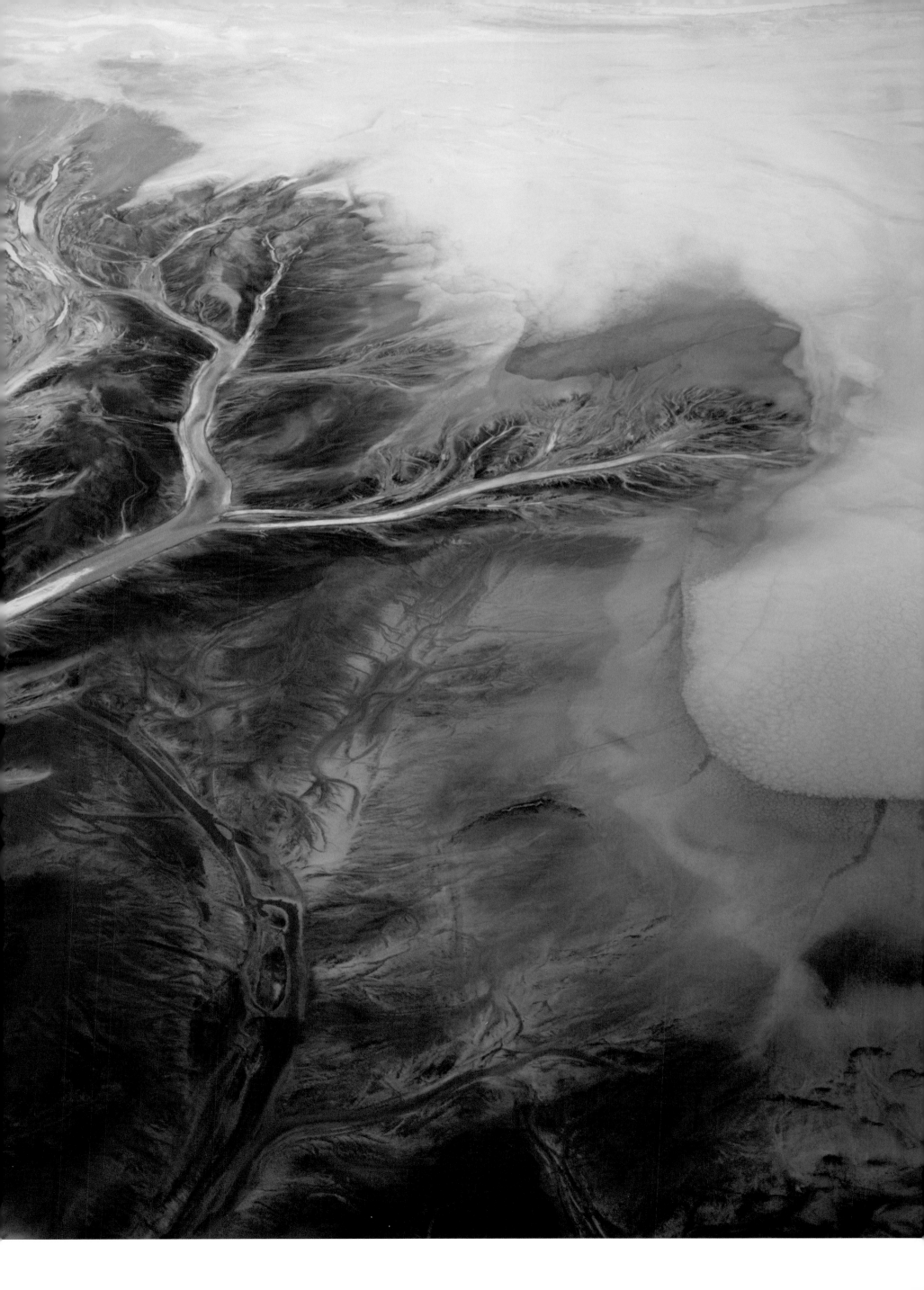

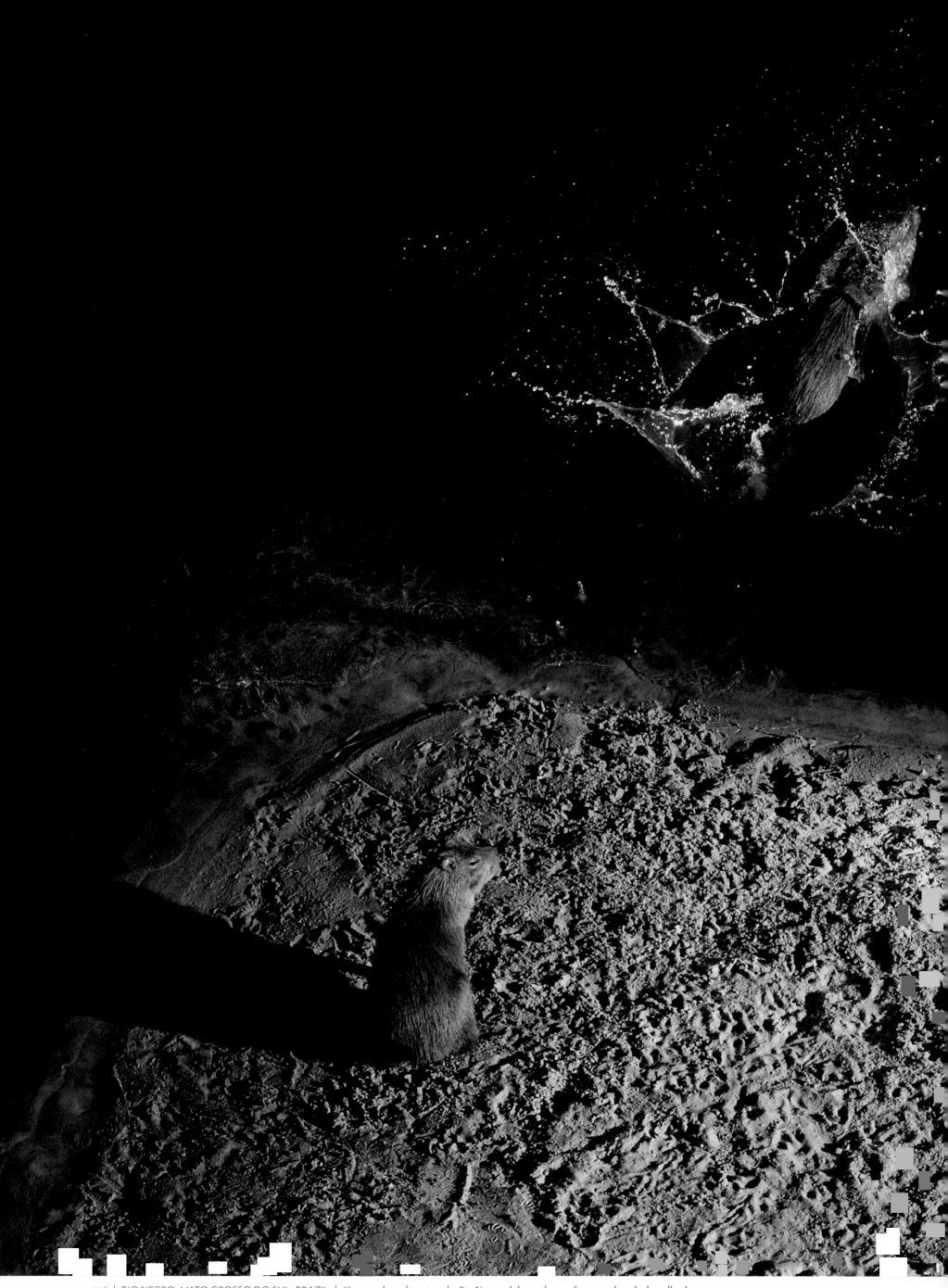

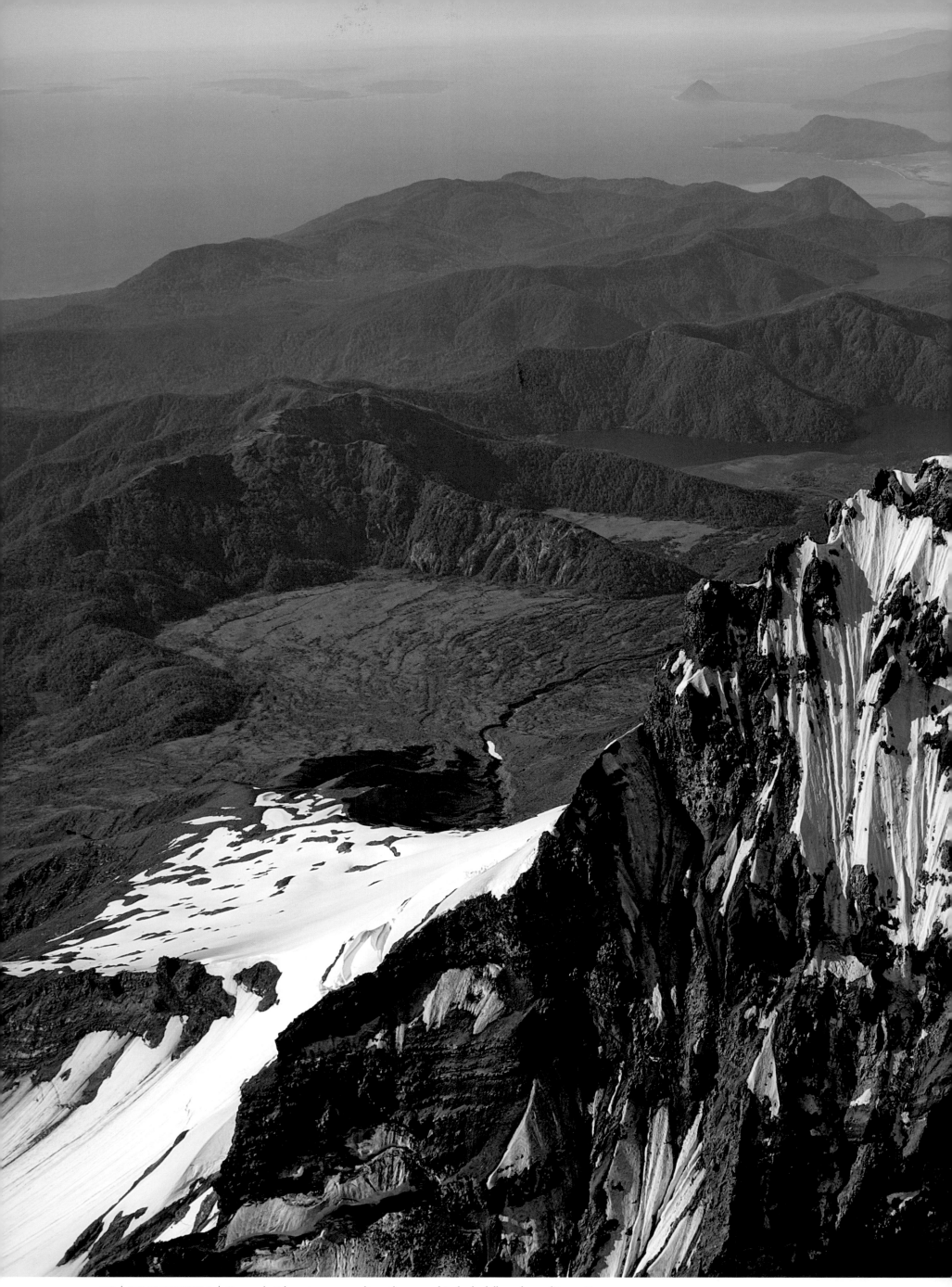

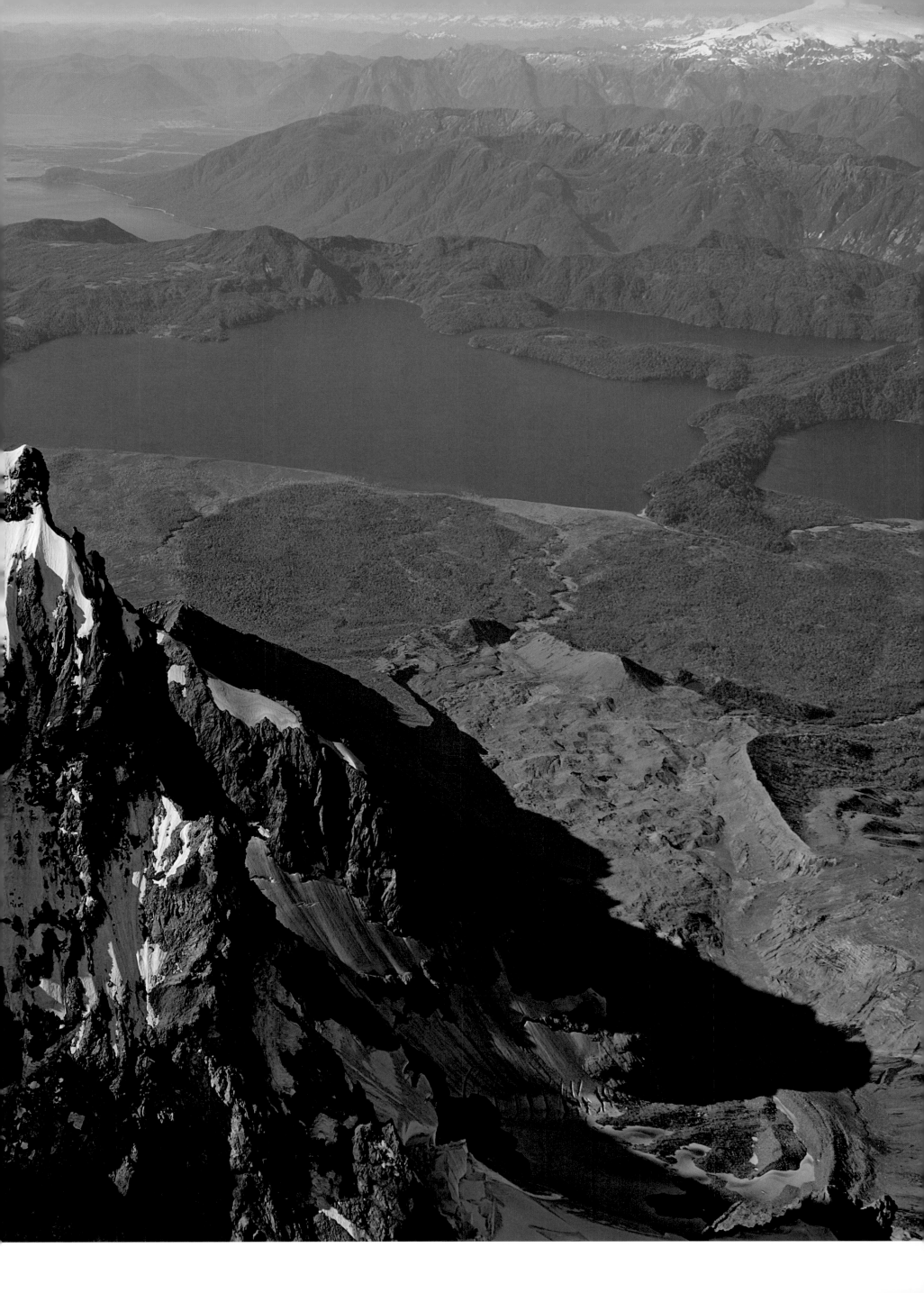

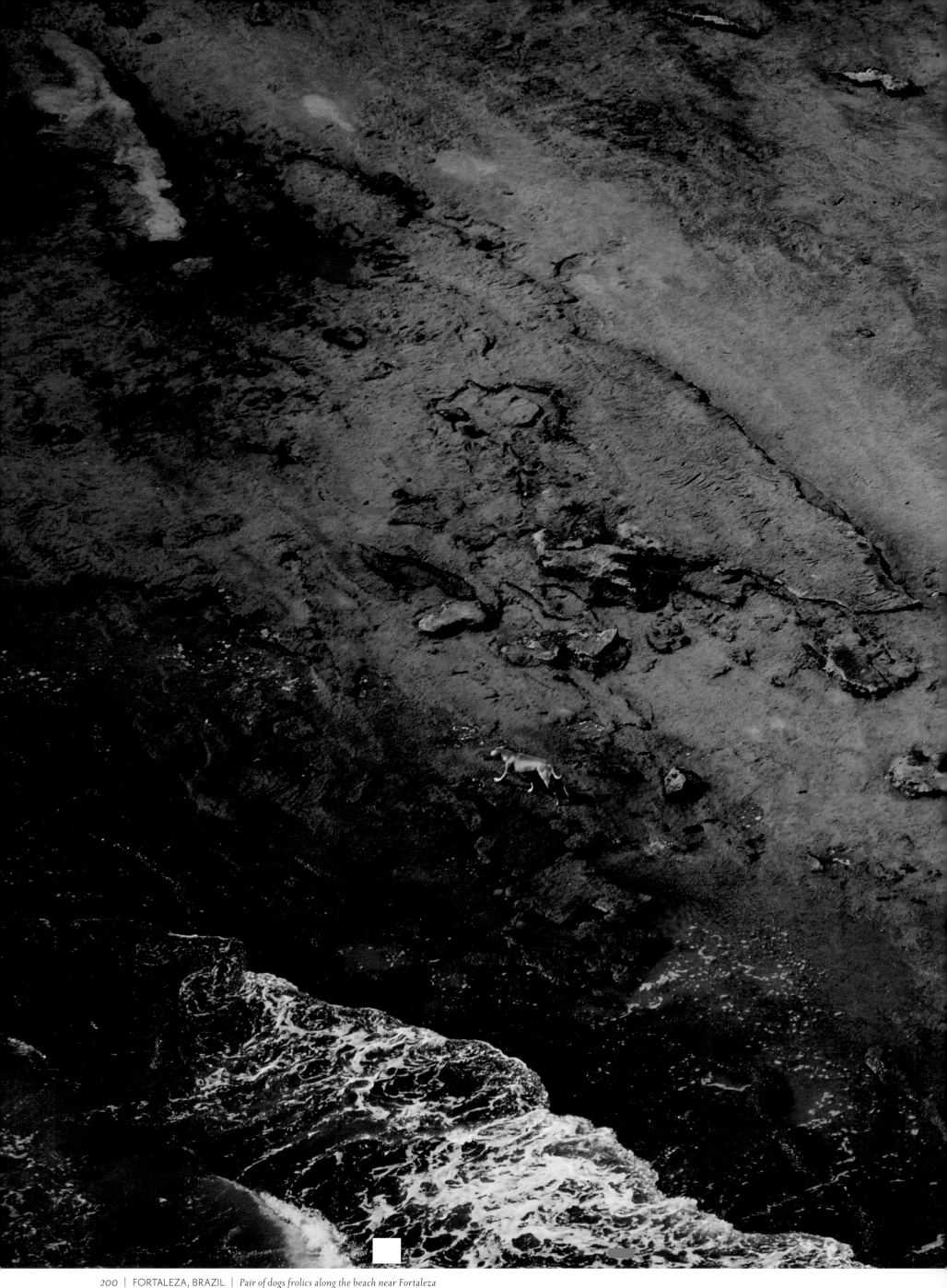

Pair of dogs frolics along the beach near Fortaleza

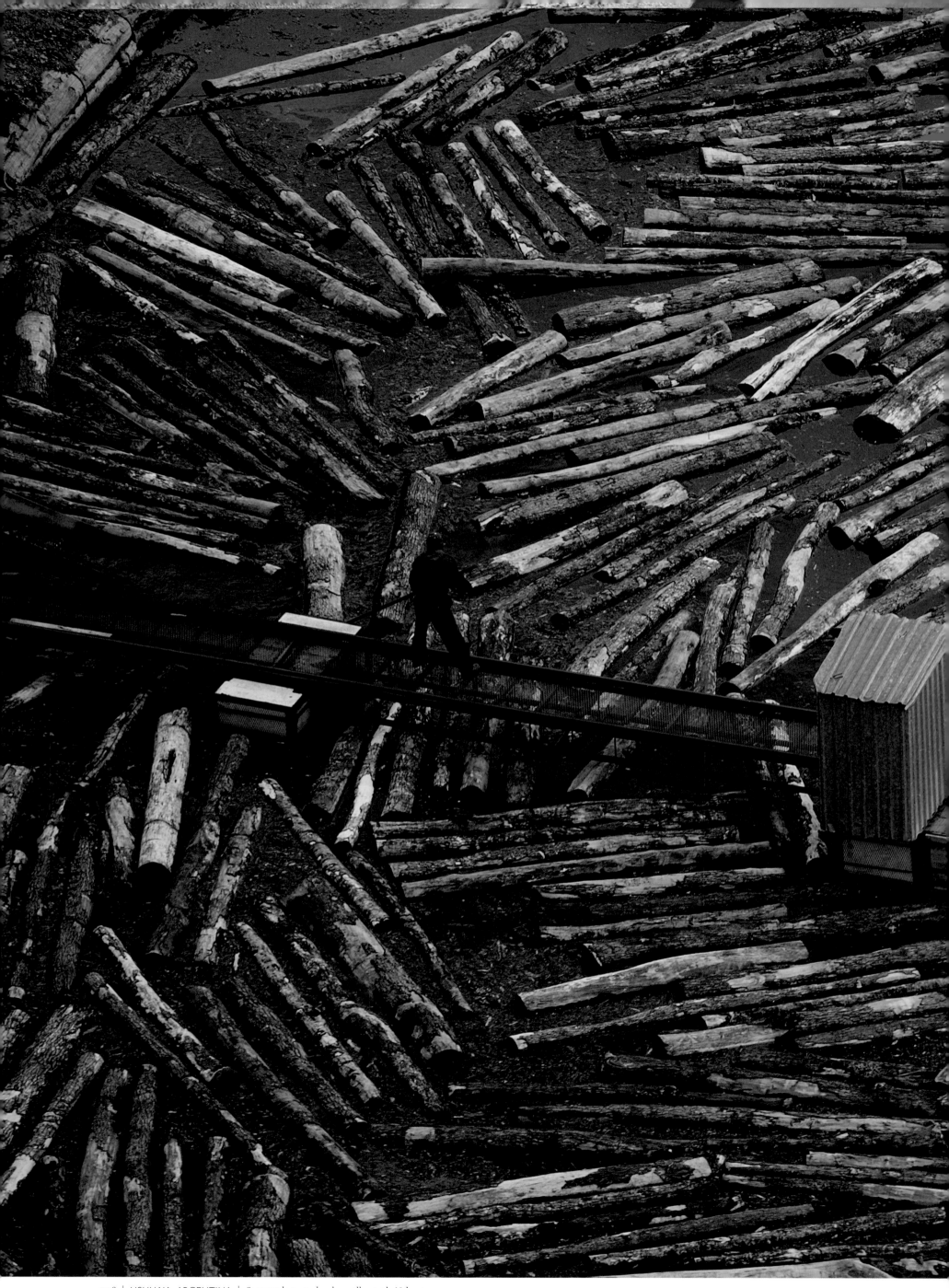

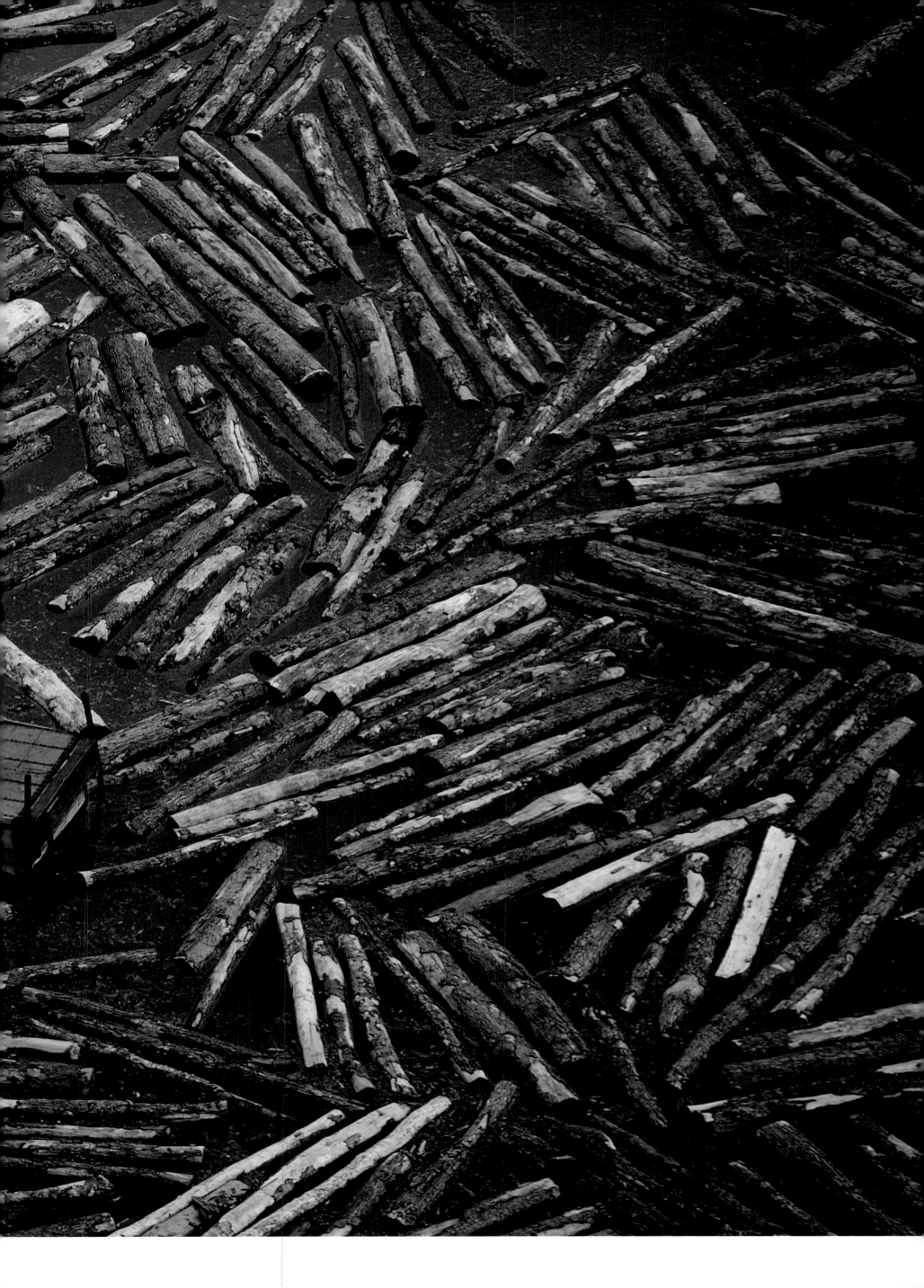

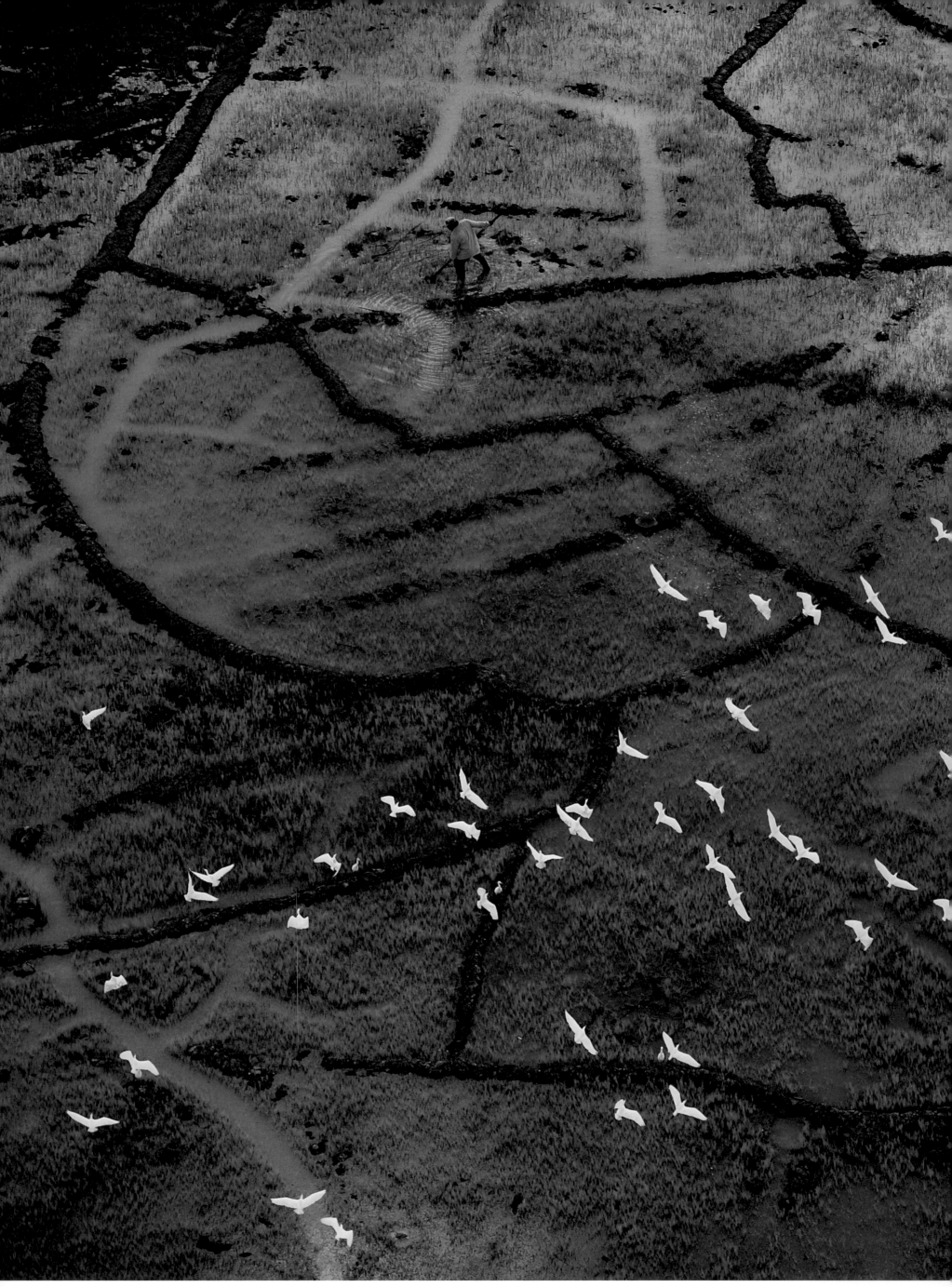

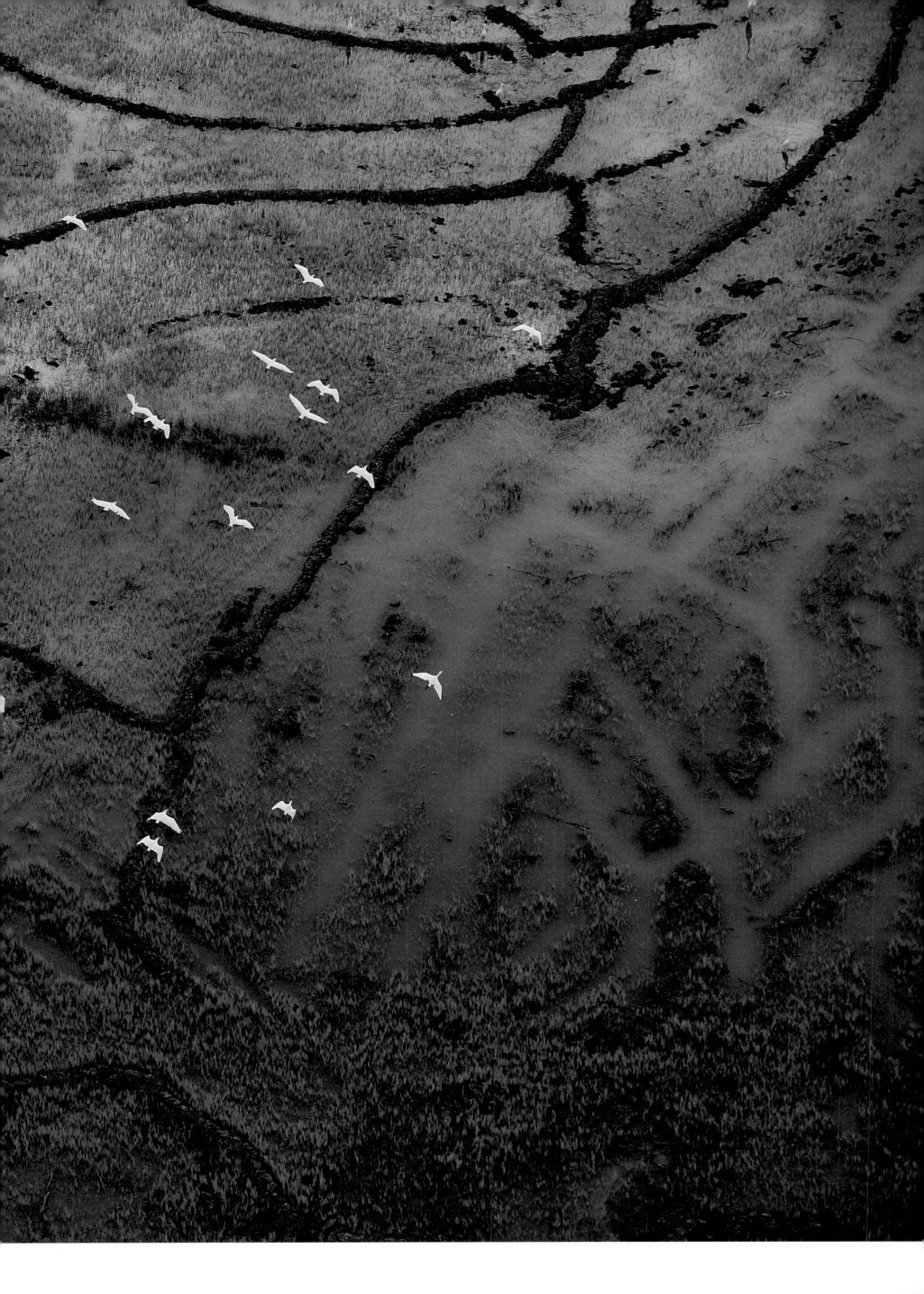

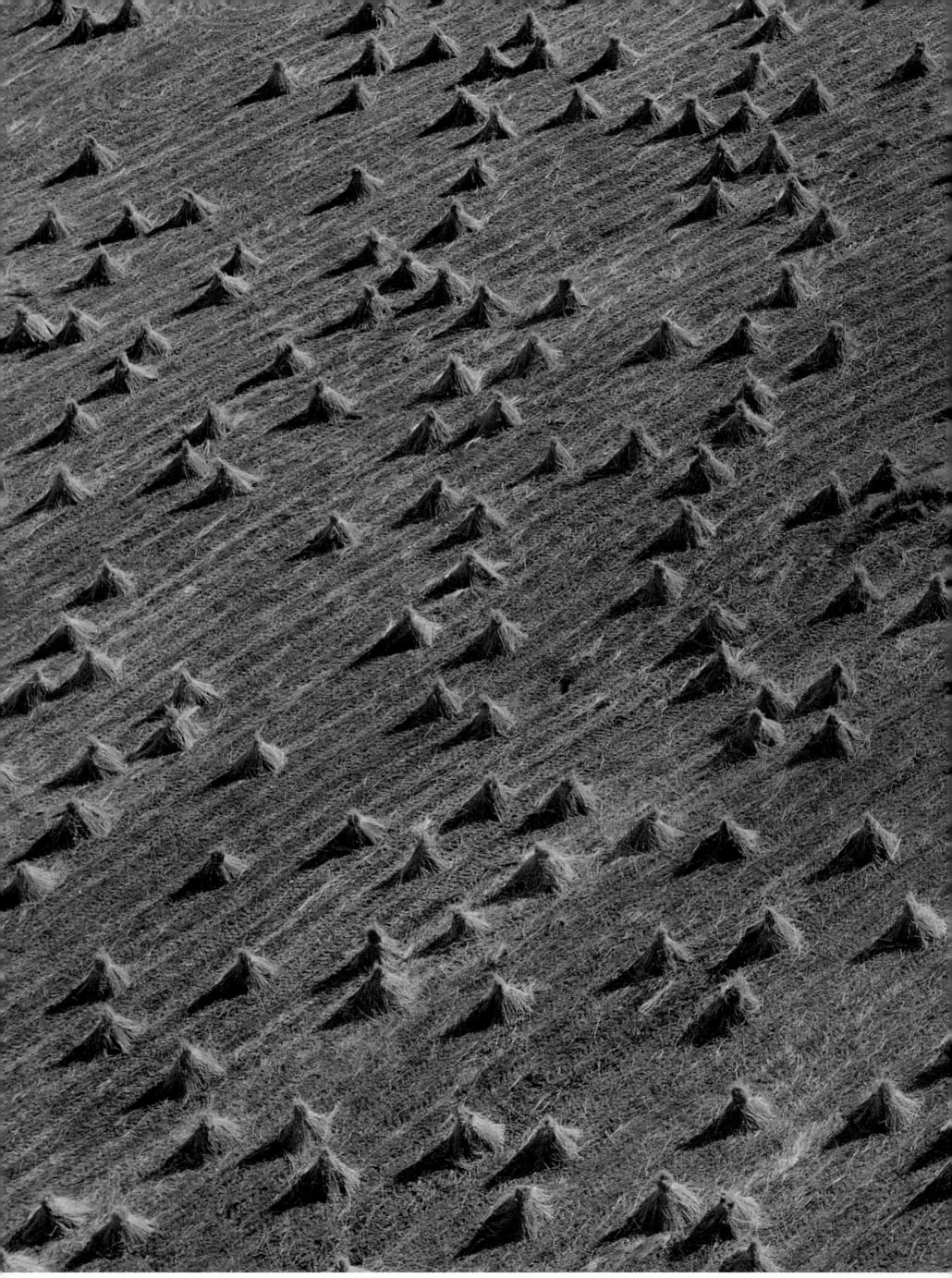

Stacks of gathered alfalfa cast their shadows in the late afternoon sun west of Puebla

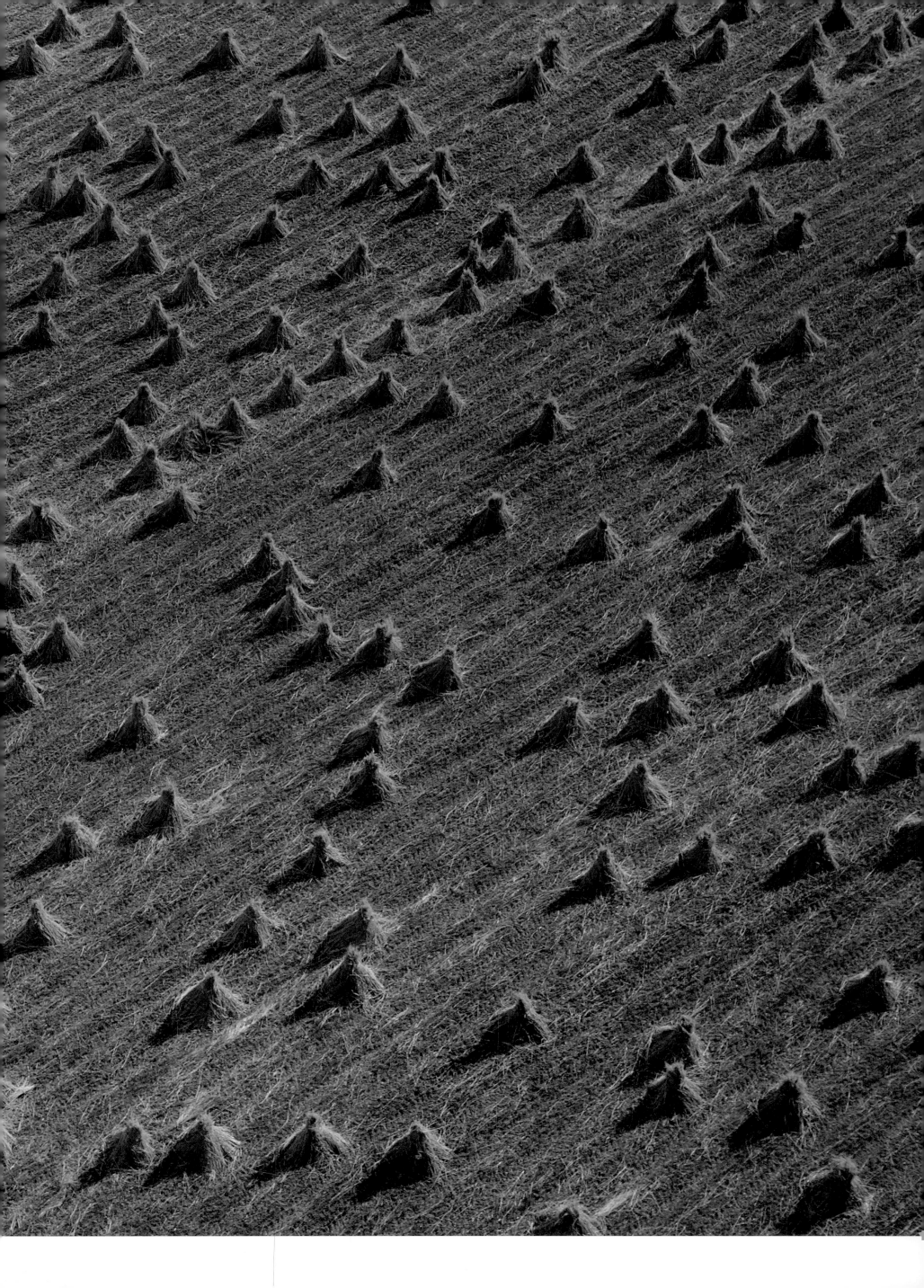

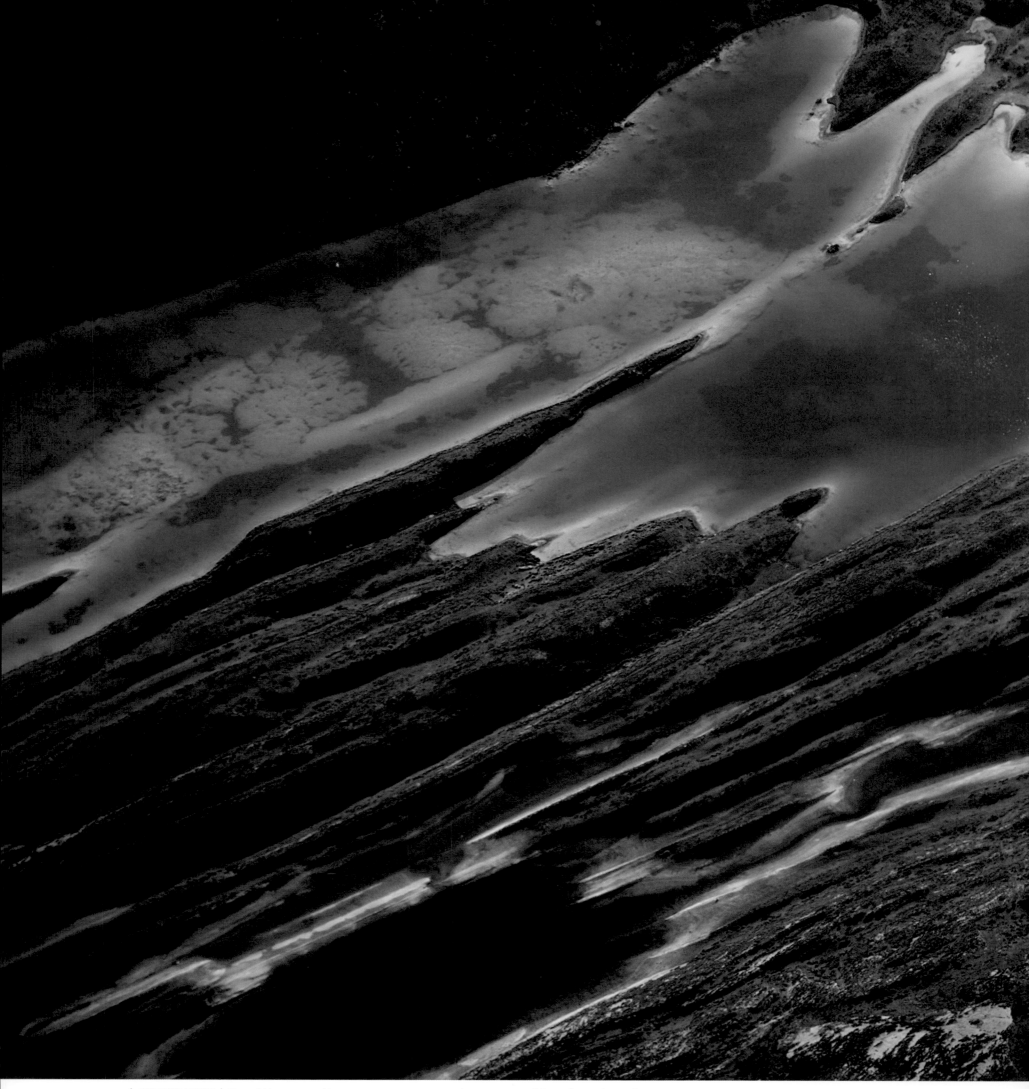

Emerald lagoons sparkle on a mountaintop in Cerro de Pasco region of the Andes northeast of Lima

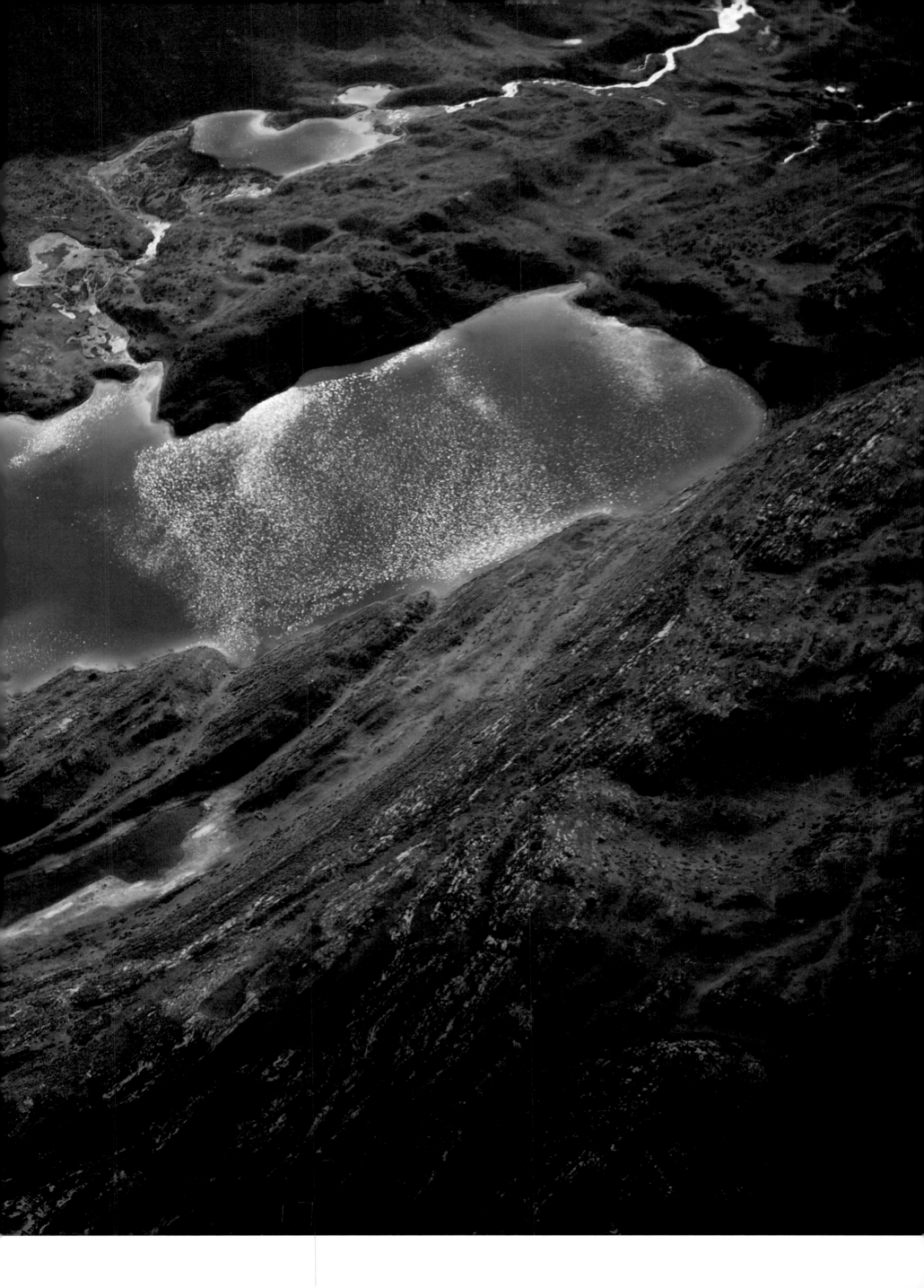

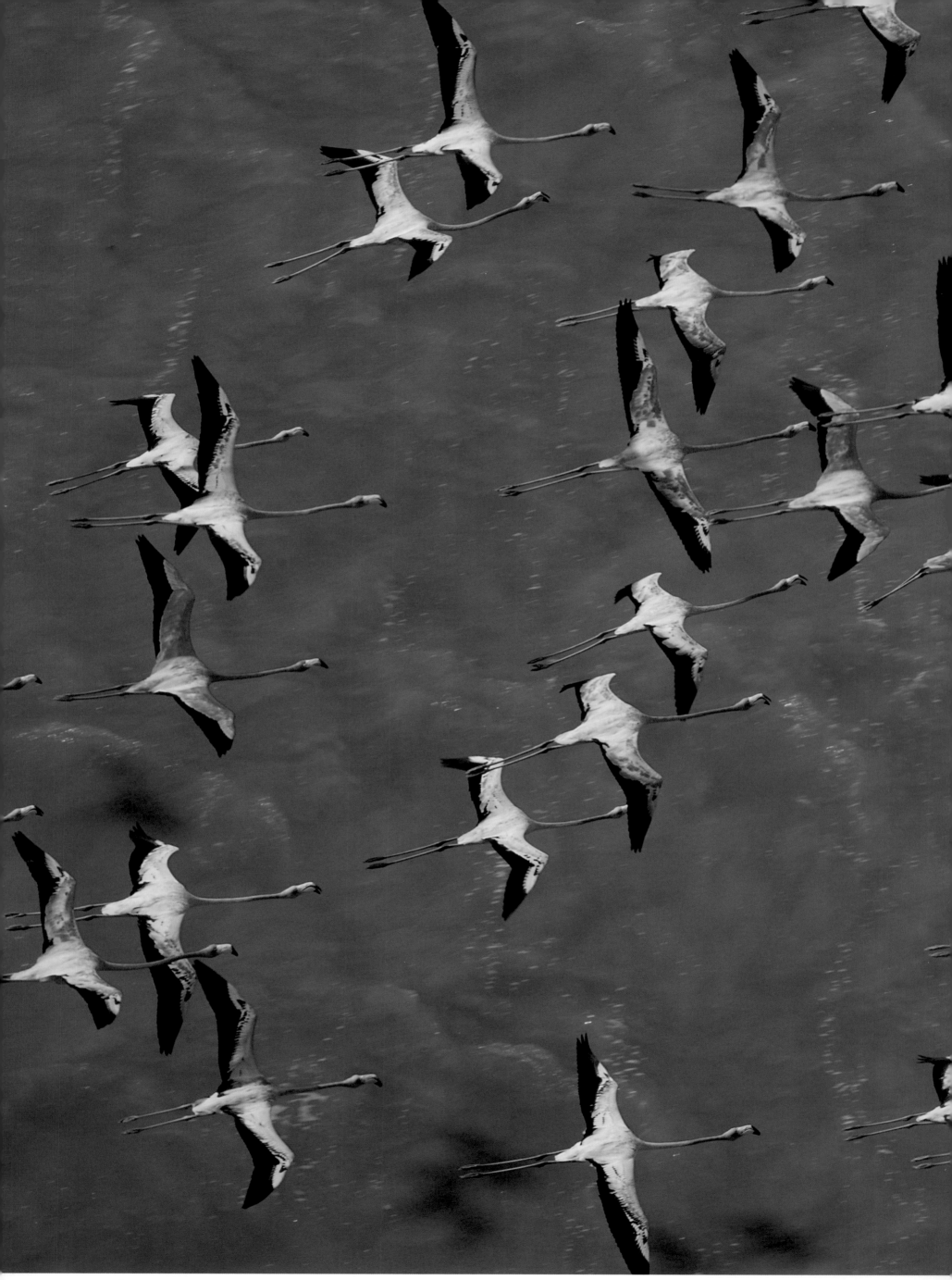

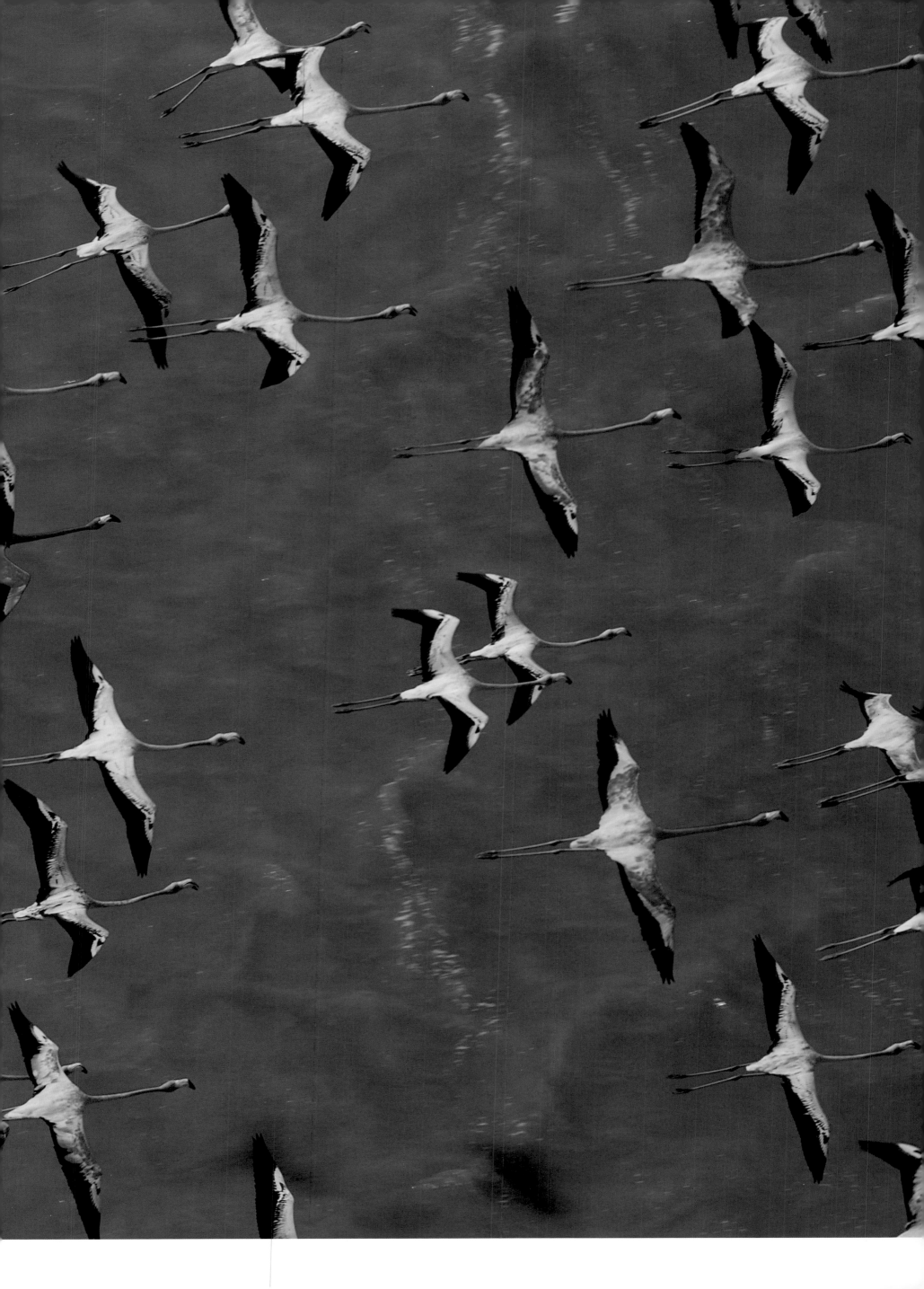

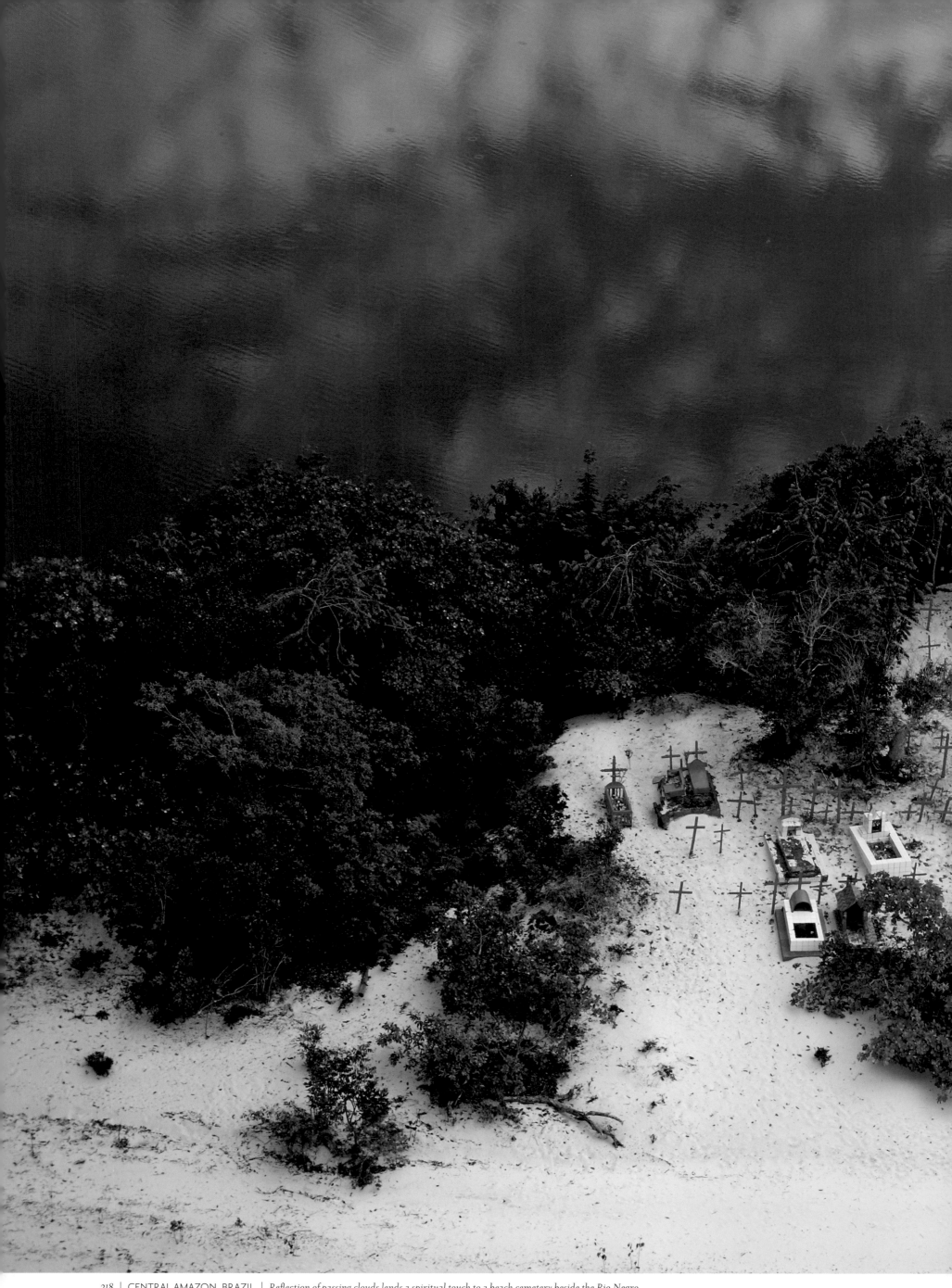

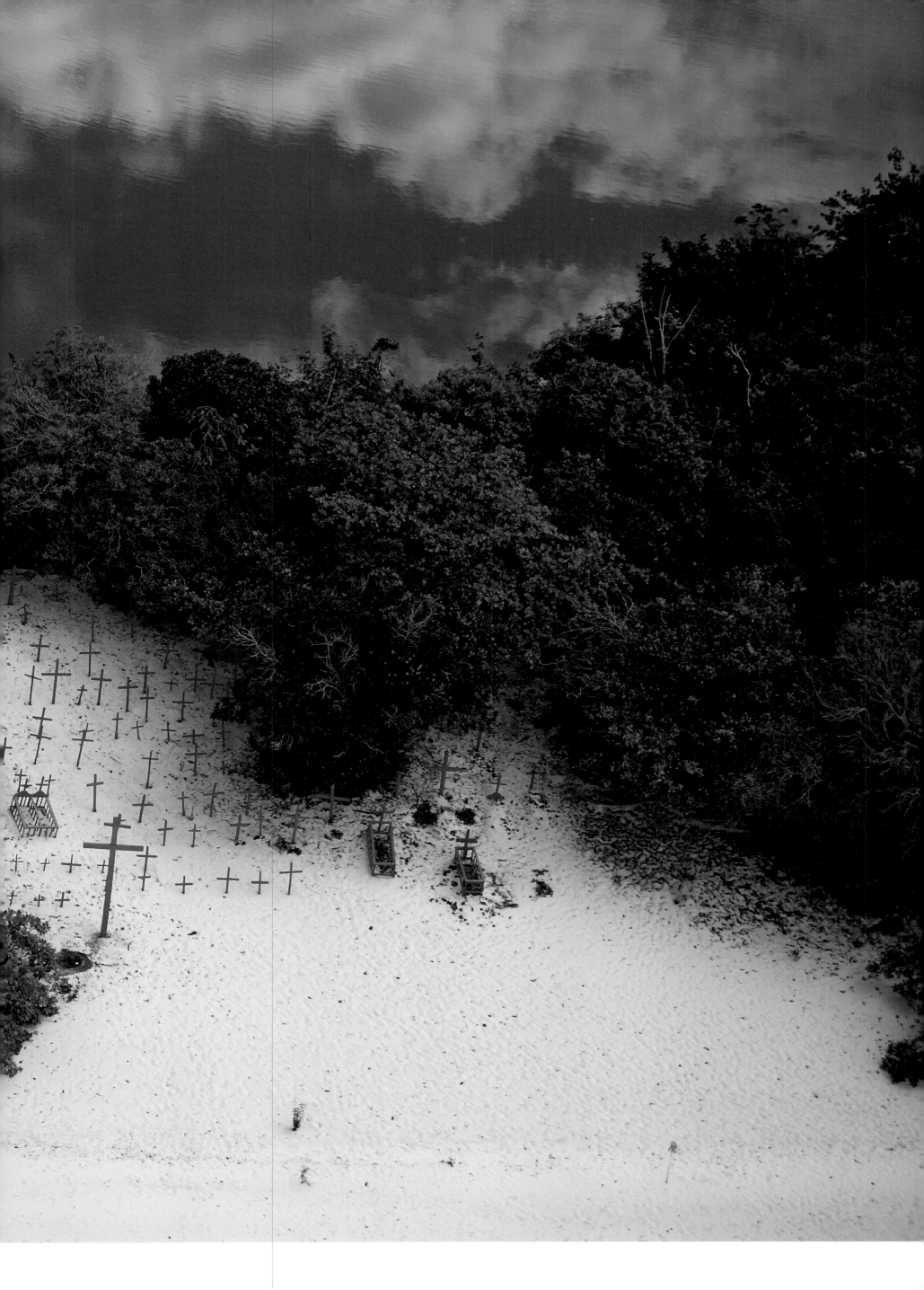

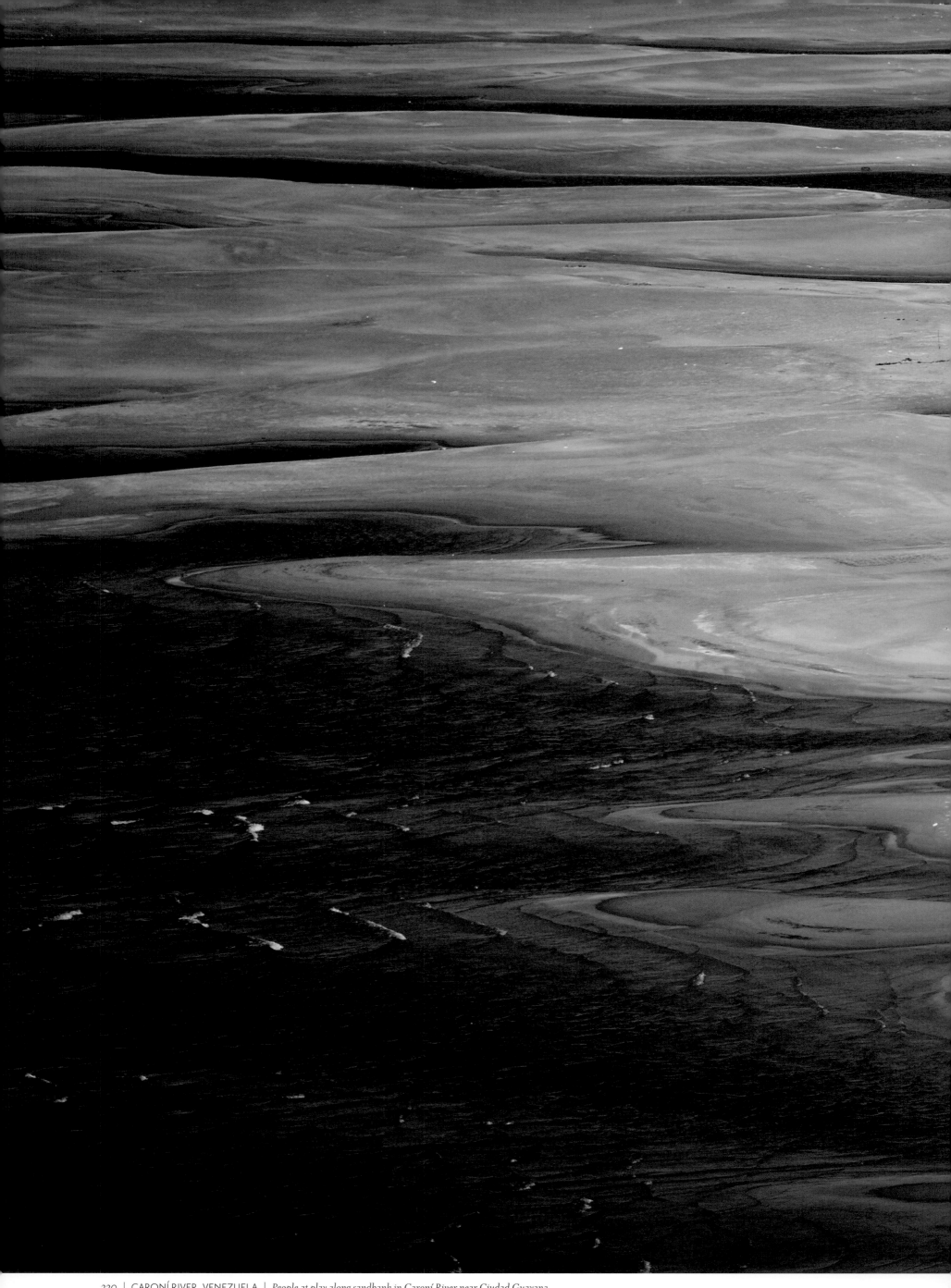

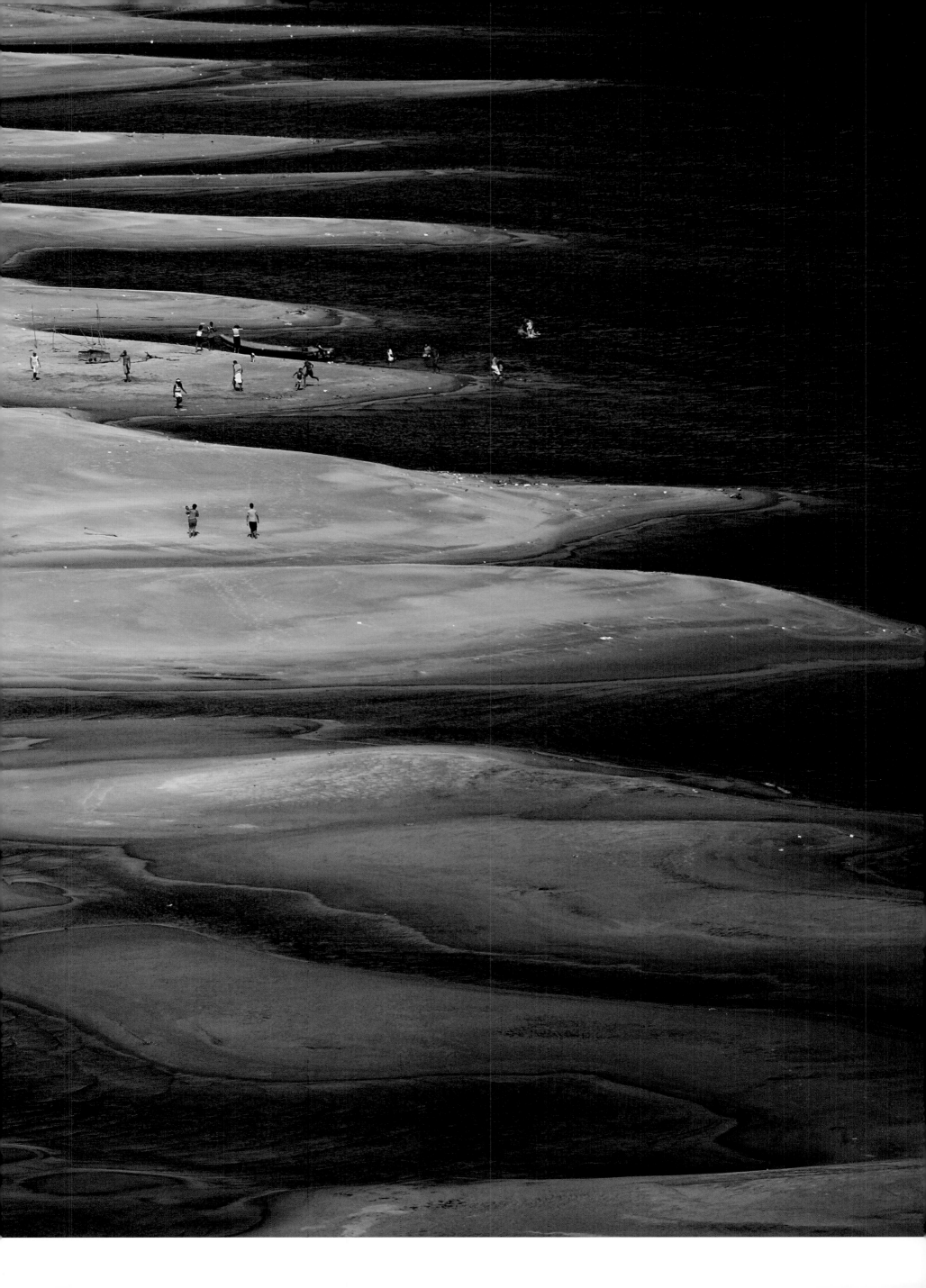

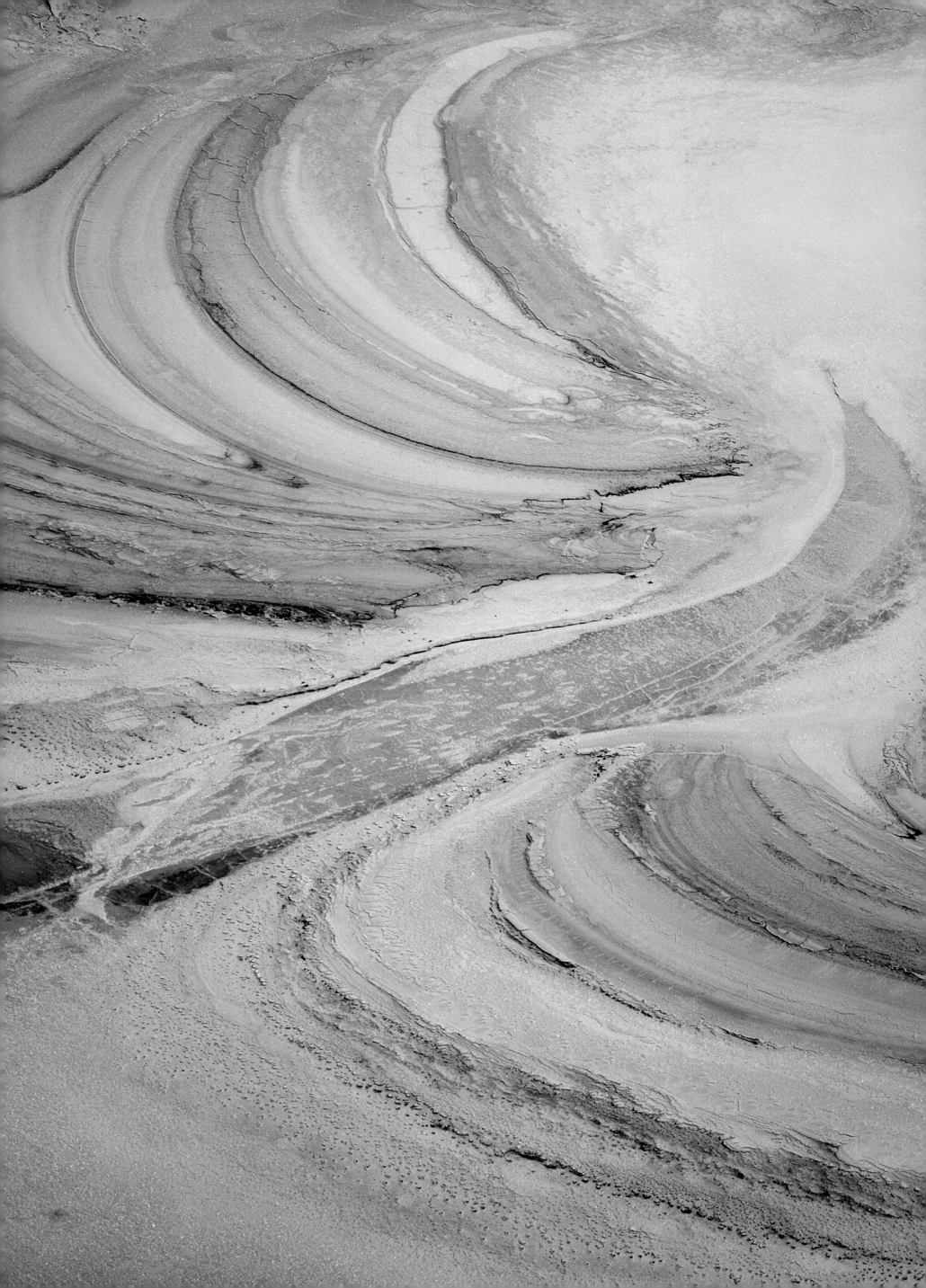

CUSCO, PERU

The Beauty of a Rear-View Mirror

AS I WANDER ACROSS THE CONTINENT OF SOUTH AMERICA AND STRAY NORTH INTO MEXICO AND THE CENTRAL AMERICAN corridor, I constantly encounter people who are able to trace their cultural and spiritual roots—or even their actual lineage—back hundreds or even thousands of years. In the case of direct descendants of the Inca or Maya, there is an unbroken link to ancestors whose achievements and dignity provide an ever renewable source of binding the present to the distant past…an anchor within the turbulent seas that have washed one political wave after another upon the shores of Latin America.

Even the mestizos, who must look over both shoulders—to Europe on one side and to the Andes on the other— in search of their roots, do so with evident pride in the diversity that has spawned their existence. Although not forgotten, the sins of the conquistadores have largely been forgiven by the passage of five centuries and the prolonged mixing of blood that stirs away the least savory of ancient ingredients.

But not so north of the Rio Grande; ours is a radically different heritage. The Native Americans who met up with our brand of conquistadores were ravaged to the point of near extinction. Their destiny was to mirror the free-fall that was the lot of the buffalo, their partner in existence and thus their companion in decline.

Deprived of any true link to the original inhabitants of this continent, as a nation we are deprived as well of the full-fledged beauty of a rear-view mirror. The specter of a vanishing breed of Native Americans creates an enormous blind spot in the mirror that makes us squint as we try to peer beyond its limits. Instead, we must look through a prism, a different kind of glass that breaks the light into scores of distant reflections that separate our heritage just as powerfully as they glorify our diversity. Our roots tangle their way through Europe, Asia, and Africa, diverging farther and farther away from one another.

But south of our borders, the search for the richness of a common past is not in vain, and the rear-view mirror offers up a kaleidoscope of images that brings forth the past and deposits it squarely in the present. It is not just in the tangible icons from centuries ago that dot the landscape—the ruins at Machu Picchu, the Maya pyramids, and the ever present 16th-century cathedrals. It is imbedded in the touch-and-feel fabric of daily life as well—the centuries-old Plazas de Armas that still pulse at the heart of towns large and small alike, and traditional Sunday markets that feature not the relics of the past but the handiwork of the present. Though the fashions du jour and newfangled inventions of today are clearly in evidence, I find both nostalgia and grace in the fact that what I see through the windshield has so much in common with the image in the rear-view mirror. —*RBH*

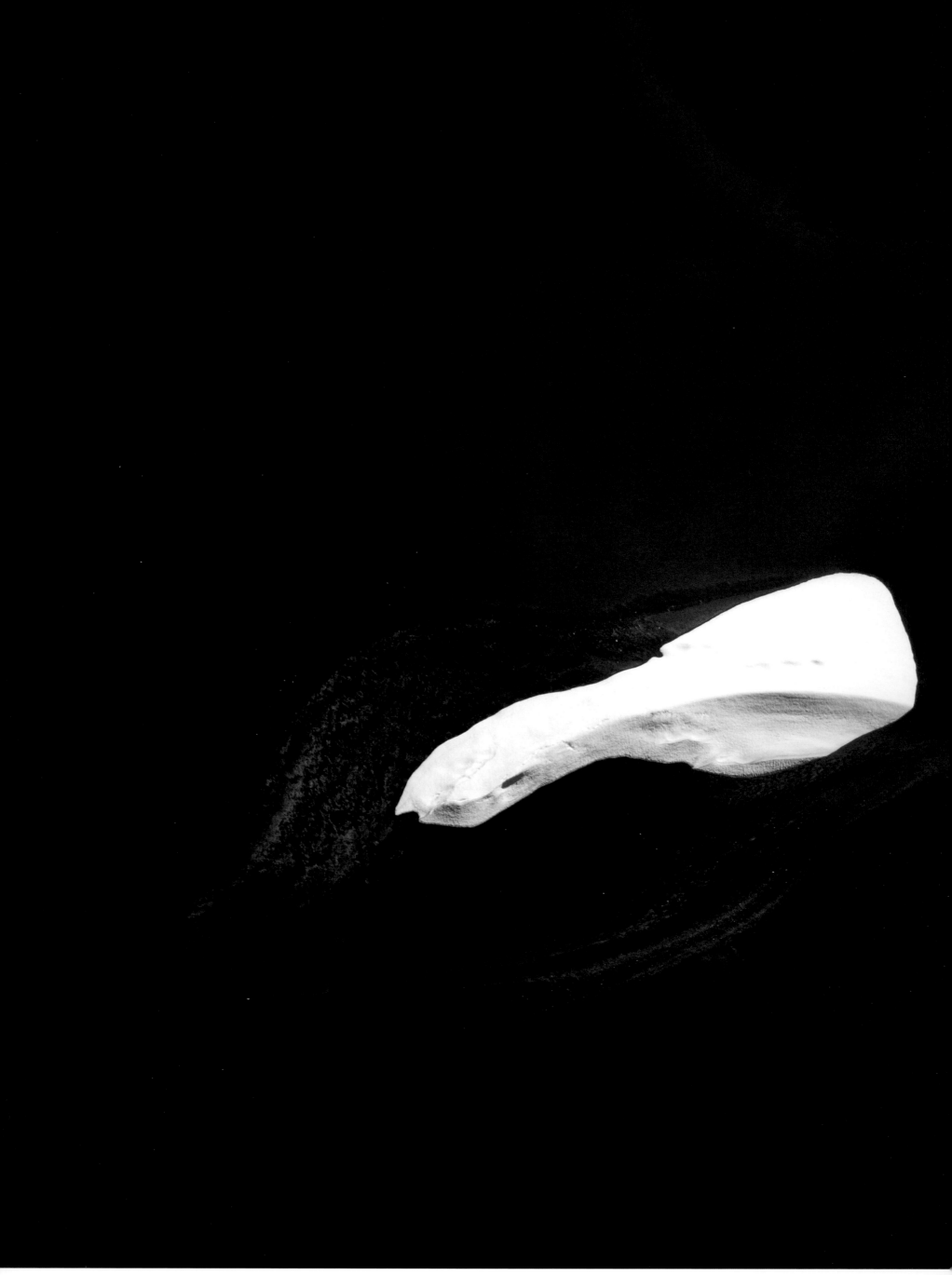

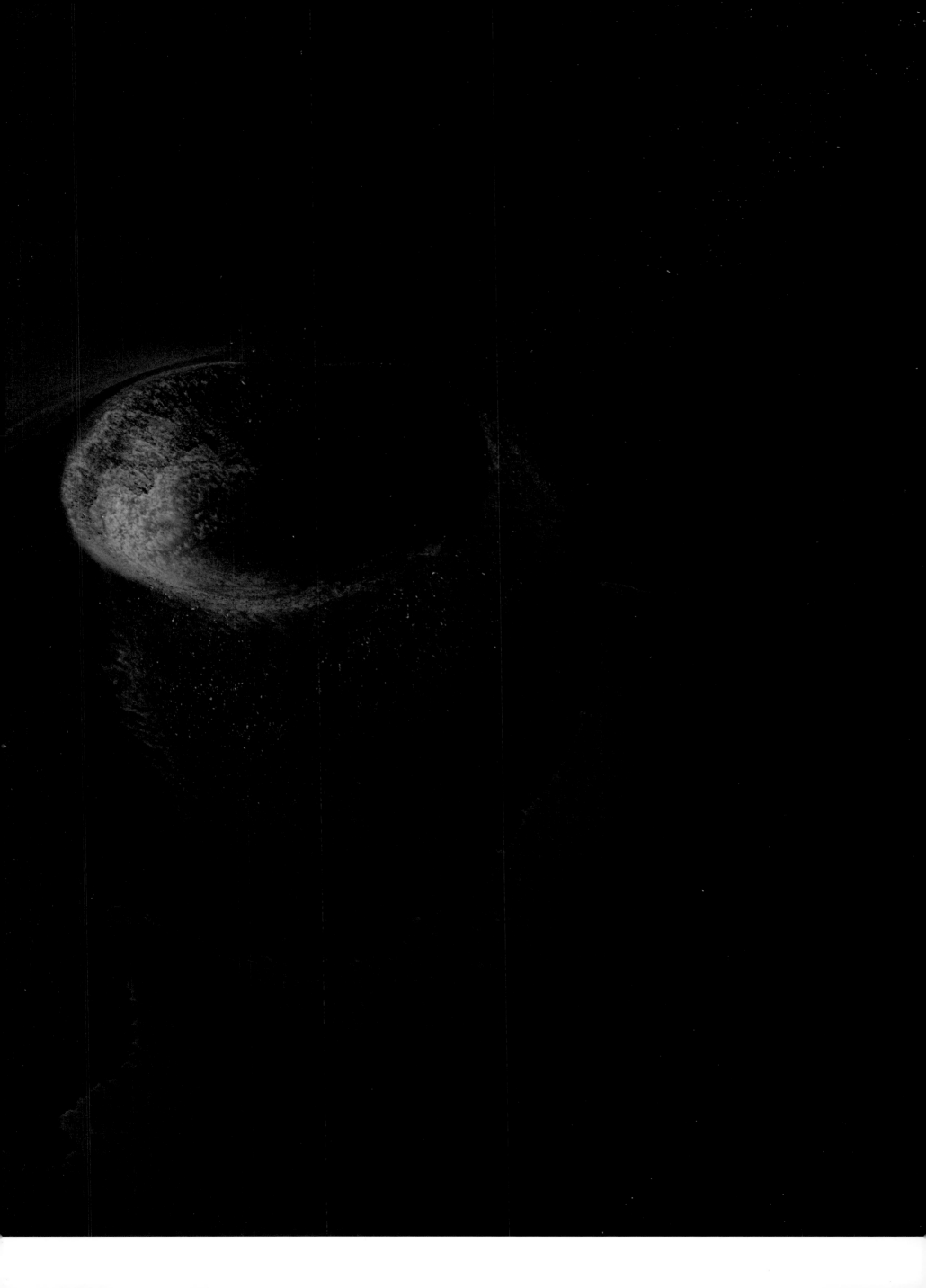

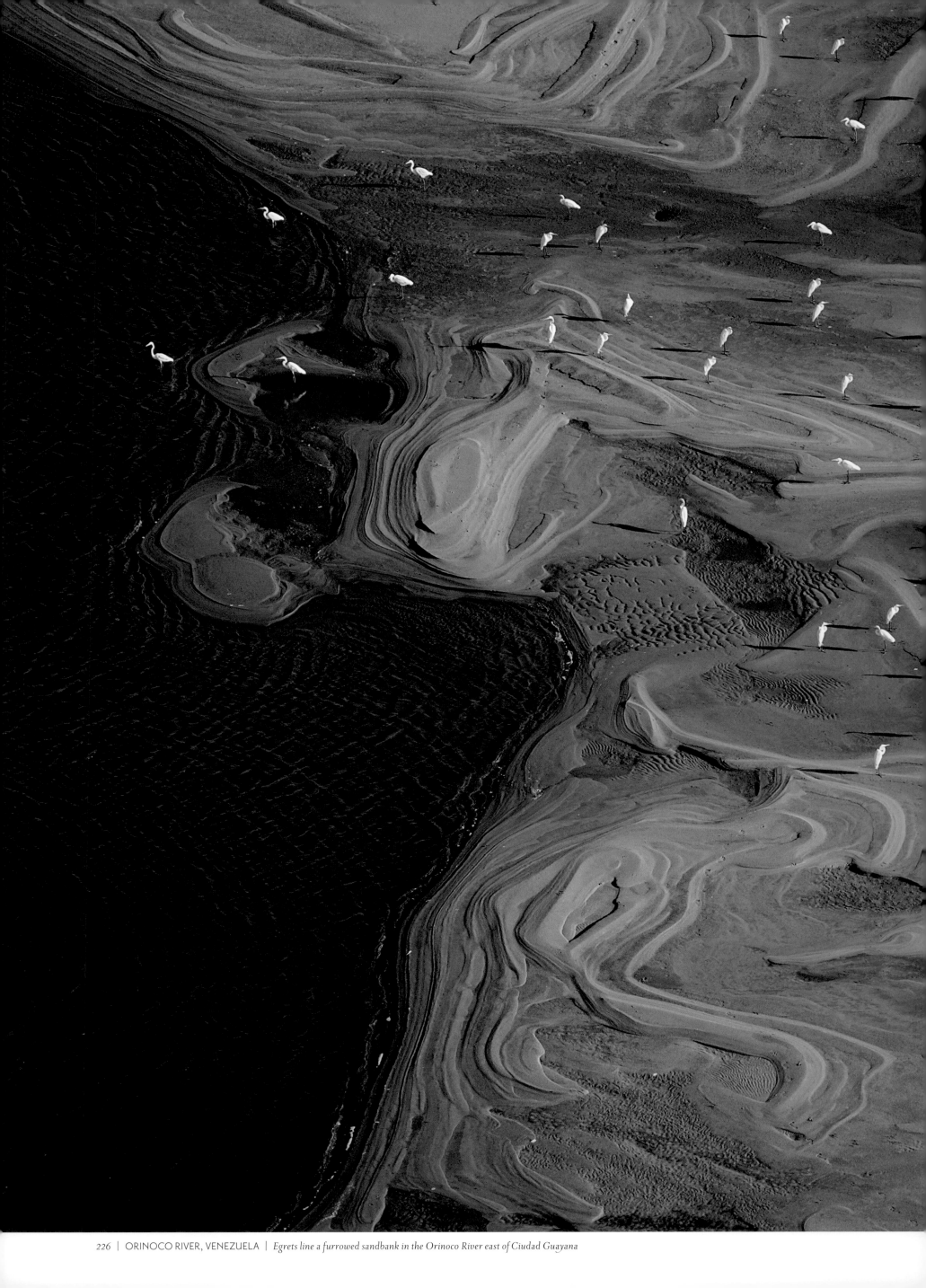

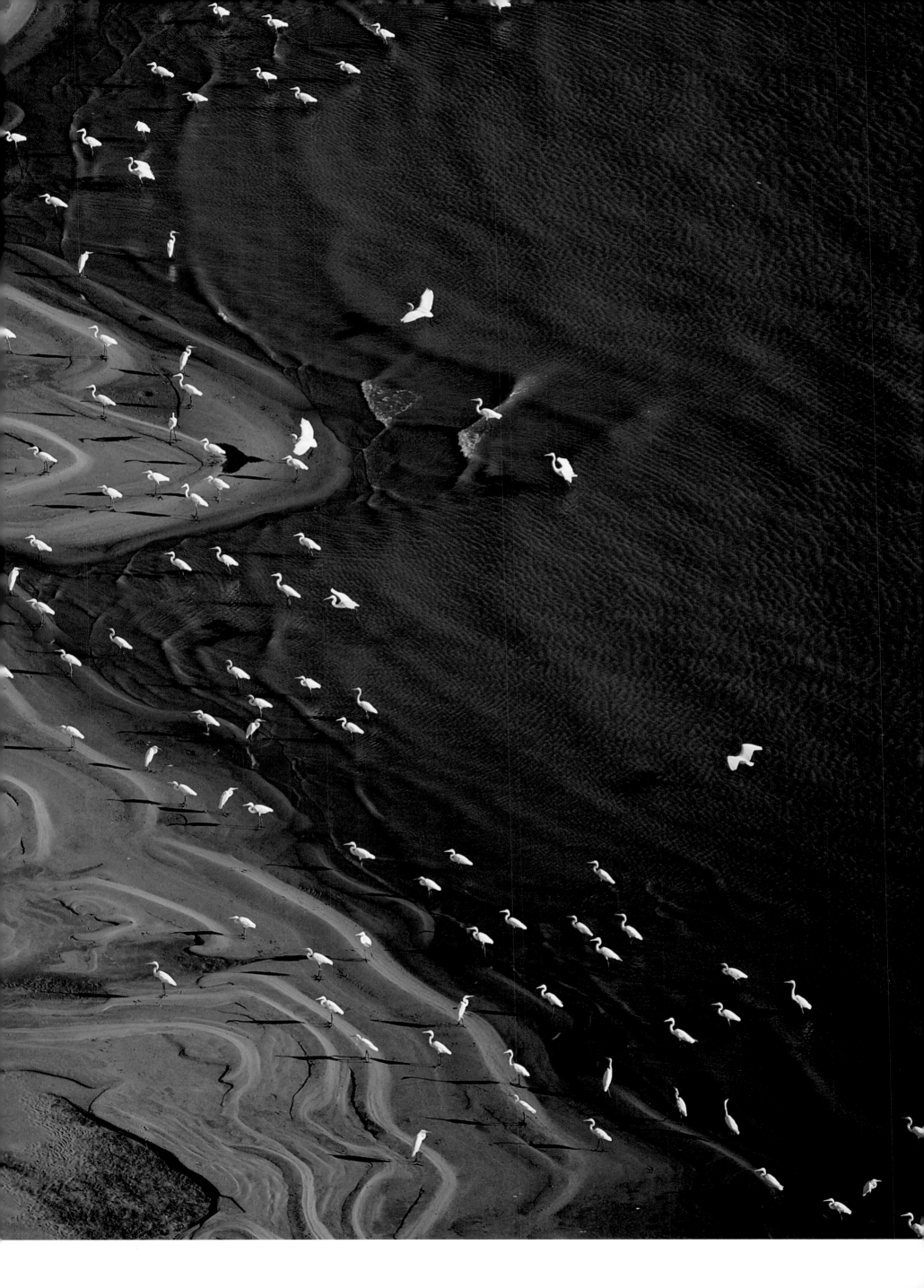

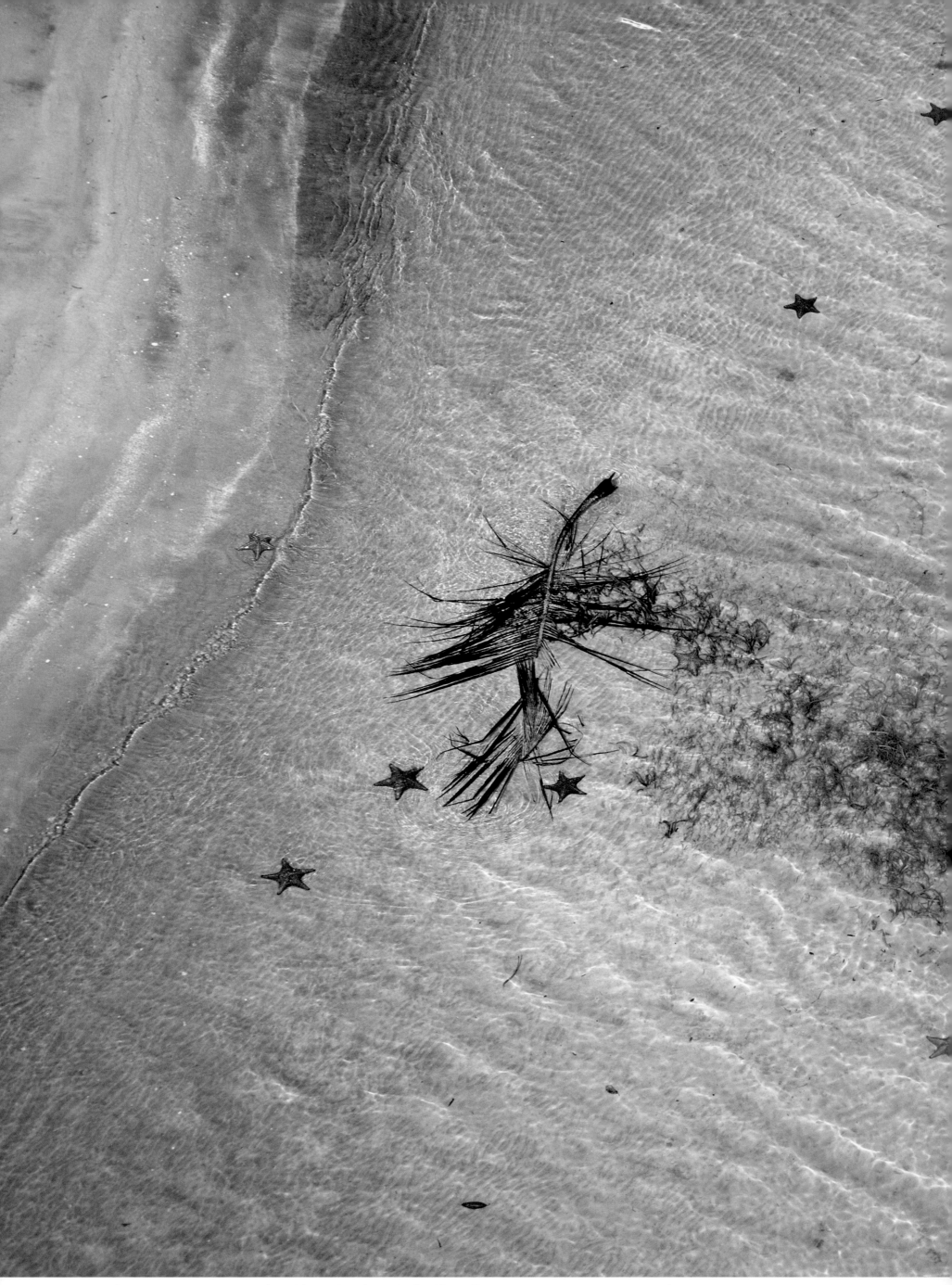

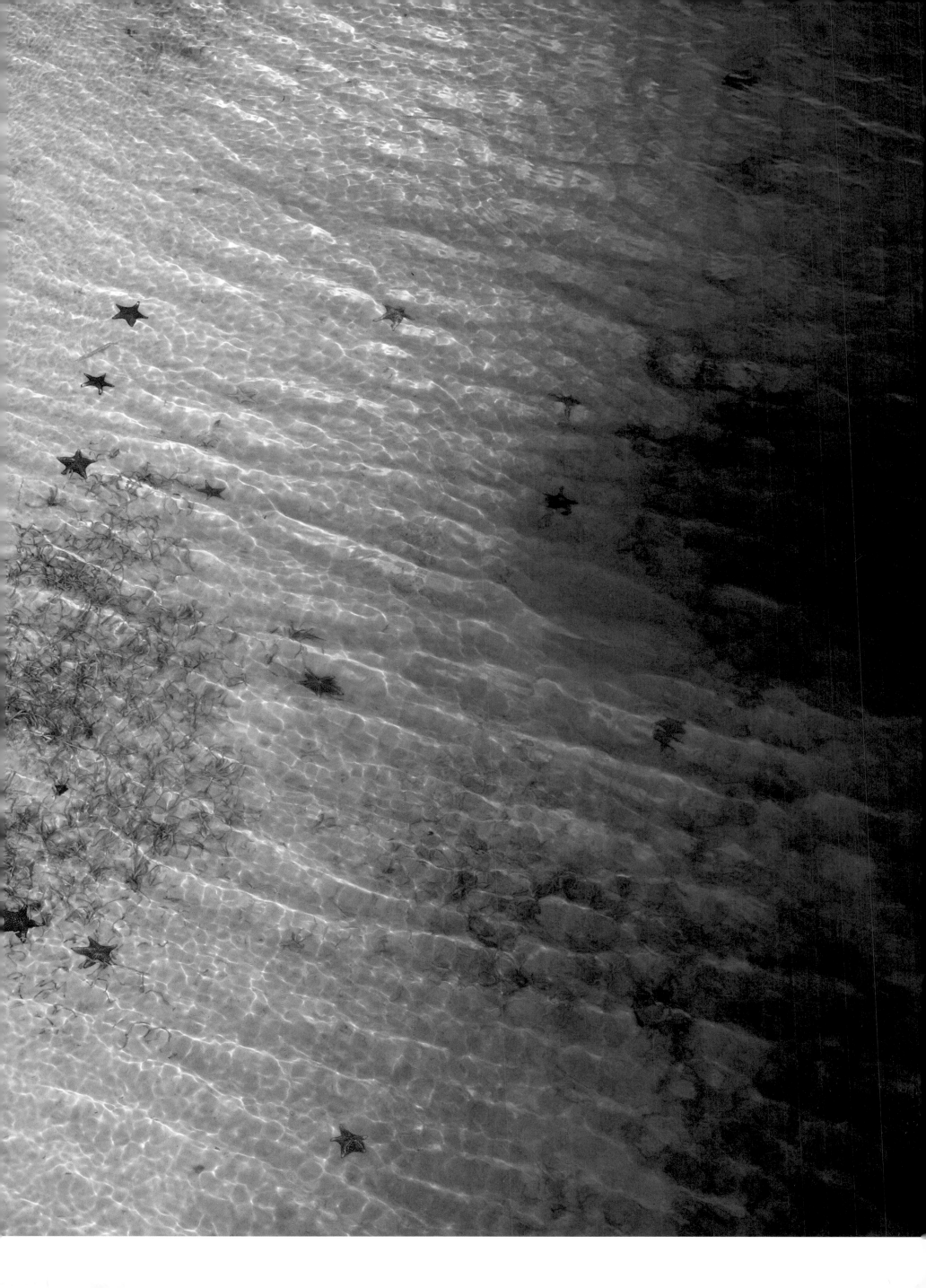

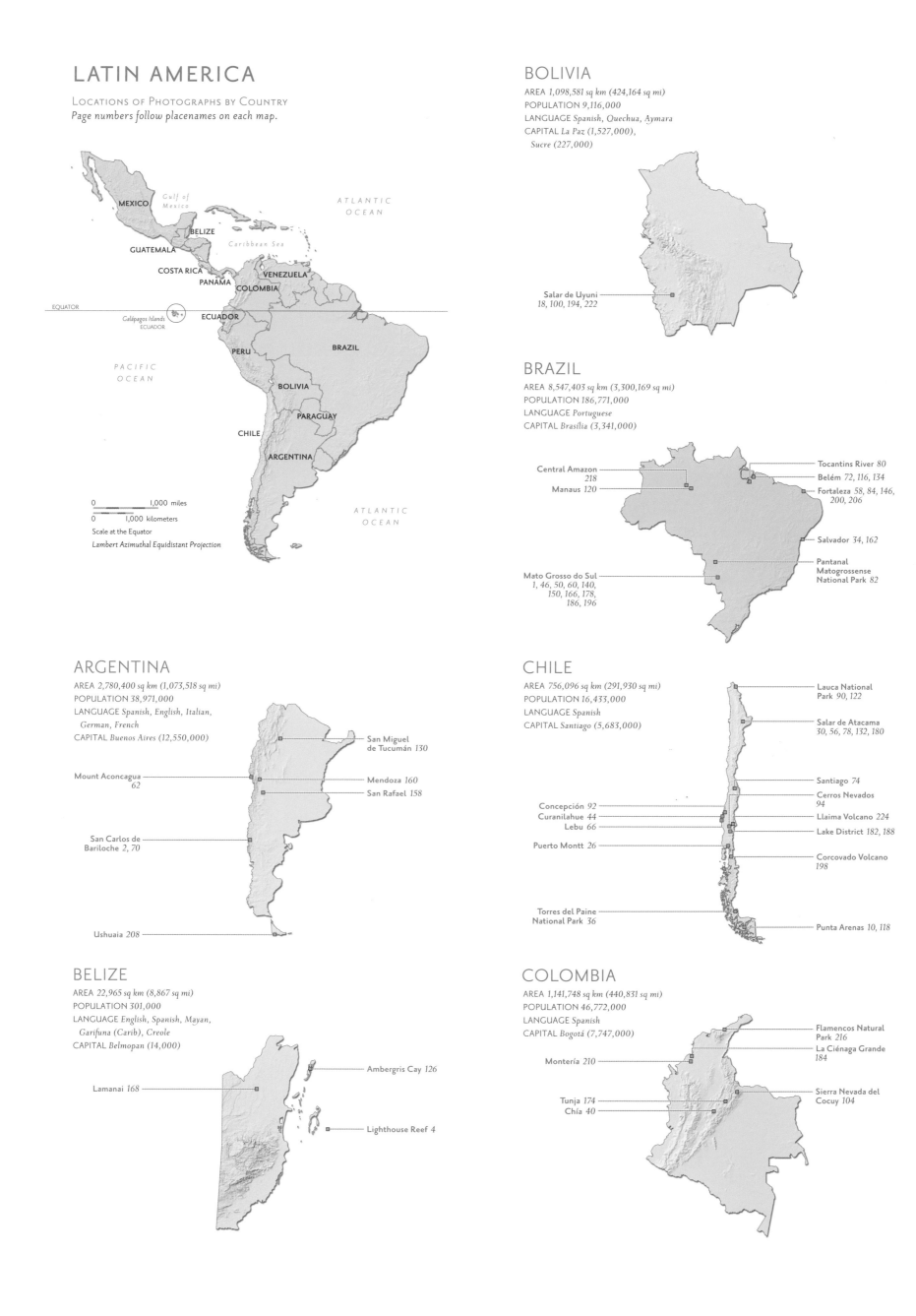

LATIN AMERICA

LOCATIONS OF PHOTOGRAPHS BY COUNTRY
Page numbers follow placenames on each map.

MEXICO

Gulf of
Mexico

ATLANTIC
OCEAN

BELIZE

GUATEMALA

Caribbean Sea

COSTA RICA

VENEZUELA

PANAMA

COLOMBIA

EQUATOR

Galápagos Islands
ECUADOR

ECUADOR

PERU

BRAZIL

PACIFIC
OCEAN

BOLIVIA

PARAGUAY

CHILE

ARGENTINA

ATLANTIC
OCEAN

0 1,000 miles
0 1,000 kilometers
Scale at the Equator
Lambert Azimuthal Equidistant Projection

BOLIVIA

AREA *1,098,581 sq km (424,164 sq mi)*
POPULATION *9,116,000*
LANGUAGE *Spanish, Quechua, Aymara*
CAPITAL *La Paz (1,527,000),*
 Sucre (227,000)

Salar de Uyuni
18, 100, 194, 222

BRAZIL

AREA *8,547,403 sq km (3,300,169 sq mi)*
POPULATION *186,771,000*
LANGUAGE *Portuguese*
CAPITAL *Brasília (3,341,000)*

Central Amazon
218
Manaus *120*

Tocantins River *80*
Belém *72, 116, 134*
Fortaleza *58, 84, 146,*
200, 206

Salvador *34, 162*

Pantanal
Matogrossense
National Park *82*

Mato Grosso do Sul
1, 46, 50, 60, 140,
150, 166, 178,
186, 196

ARGENTINA

AREA *2,780,400 sq km (1,073,518 sq mi)*
POPULATION *38,971,000*
LANGUAGE *Spanish, English, Italian,*
 German, French
CAPITAL *Buenos Aires (12,550,000)*

San Miguel
de Tucumán *130*

Mount Aconcagua
62

Mendoza *160*
San Rafael *158*

San Carlos de
Bariloche *2, 70*

Ushuaia *208*

BELIZE

AREA *22,965 sq km (8,867 sq mi)*
POPULATION *301,000*
LANGUAGE *English, Spanish, Mayan,*
 Garifuna (Carib), Creole
CAPITAL *Belmopan (14,000)*

Ambergris Cay *126*

Lamanai *168*

Lighthouse Reef *4*

CHILE

AREA *756,096 sq km (291,930 sq mi)*
POPULATION *16,433,000*
LANGUAGE *Spanish*
CAPITAL *Santiago (5,683,000)*

Lauca National
Park *90, 122*

Salar de Atacama
30, 56, 78, 132, 180

Santiago *74*
Cerros Nevados
94

Concepción *92*
Curanilahue *44*
Lebu *66*

Llaima Volcano *224*
Lake District *182, 188*

Puerto Montt *26*

Corcovado Volcano
198

Torres del Paine
National Park *36*

Punta Arenas *10, 118*

COLOMBIA

AREA *1,141,748 sq km (440,831 sq mi)*
POPULATION *46,772,000*
LANGUAGE *Spanish*
CAPITAL *Bogotá (7,747,000)*

Flamencos Natural
Park *216*
La Ciénaga Grande
184

Montería *210*

Sierra Nevada del
Cocuy *104*

Tunja *174*
Chía *40*

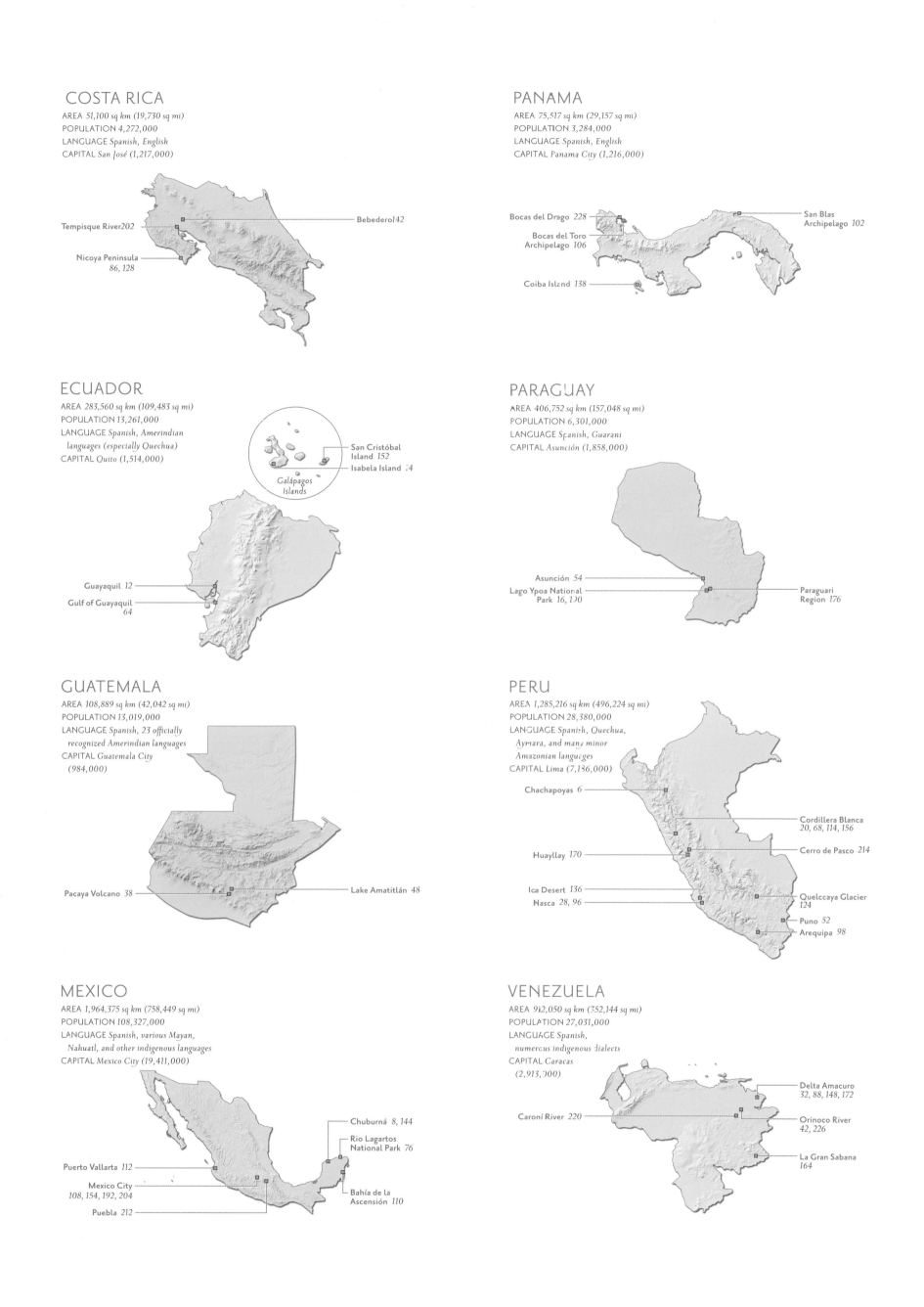

COSTA RICA
AREA *51,100 sq km (19,730 sq mi)*
POPULATION *4,272,000*
LANGUAGE *Spanish, English*
CAPITAL *San José (1,217,000)*

Tempisque River202
Bebedero142
Nicoya Peninsula
86, 128

PANAMA
AREA *75,517 sq km (29,157 sq mi)*
POPULATION *3,284,000*
LANGUAGE *Spanish, English*
CAPITAL *Panama City (1,216,000)*

Bocas del Drago *228*
San Blas
Archipelago *102*
Bocas del Toro
Archipelago *106*
Coiba Island *138*

ECUADOR
AREA *283,560 sq km (109,483 sq mi)*
POPULATION *13,261,000*
LANGUAGE *Spanish, Amerindian*
languages (especially Quechua)
CAPITAL *Quito (1,514,000)*

San Cristóbal
Island *152*
Isabela Island *14*
Galápagos
Islands
Guayaquil *12*
Gulf of Guayaquil
64

PARAGUAY
AREA *406,752 sq km (157,048 sq mi)*
POPULATION *6,301,000*
LANGUAGE *Spanish, Guarani*
CAPITAL *Asunción (1,858,000)*

Asunción *54*
Lago Ypoa National
Park *16, 120*
Paraguari
Region *176*

GUATEMALA
AREA *108,889 sq km (42,042 sq mi)*
POPULATION *13,019,000*
LANGUAGE *Spanish, 23 officially*
recognized Amerindian languages
CAPITAL *Guatemala City*
(984,000)

Pacaya Volcano *38*
Lake Amatitlán *48*

PERU
AREA *1,285,216 sq km (496,224 sq mi)*
POPULATION *28,380,000*
LANGUAGE *Spanish, Quechua,*
Aymara, and many minor
Amazonian languages
CAPITAL *Lima (7,136,000)*

Chachapoyas *6*
Cordillera Blanca
20, 68, 114, 156
Huayllay *170*
Cerro de Pasco *214*
Ica Desert *136*
Nasca *28, 96*
Quelccaya Glacier
124
Puno *52*
Arequipa *98*

MEXICO
AREA *1,964,375 sq km (758,449 sq mi)*
POPULATION *108,327,000*
LANGUAGE *Spanish, various Mayan,*
Nahuatl, and other indigenous languages
CAPITAL *Mexico City (19,411,000)*

Chuburná *8, 144*
Rio Lagartos
National Park *76*
Puerto Vallarta *112*
Mexico City
108, 154, 192, 204
Bahía de la
Ascensión *110*
Puebla *212*

VENEZUELA
AREA *912,050 sq km (352,144 sq mi)*
POPULATION *27,031,000*
LANGUAGE *Spanish,*
numerous indigenous dialects
CAPITAL *Caracas*
(2,913,000)

Delta Amacuro
32, 88, 148, 172
Caroní River *220*
Orinoco River
42, 226
La Gran Sabana
164

Acknowledgments

TO THE MEMBERS OF THE EXTENDED NATIONAL GEOGRAPHIC FAMILY, who embraced this vision of creating an aerial canvas of Latin America and dedicated the brilliant talents of a group of truly gifted artisans to the task at hand: *John M. Fahey, Jr., Terrence B. Adamson, Terry D. Garcia, Chris Johns, Bill Marr, Nina D. Hoffman, Kevin Mulroy, Lisa Lytton, and Margo Browning.*

TO THE MEMBERS OF THE BLUE PARALLEL FAMILY, who assumed the complex logistical task that was the backbone of this project: *Founder Emmanuel Burgio and Special Assistants Carolina Rosso and Ana Inés Hansen.*

TO THE MEMBERS OF THE HAAS FAMILY, who offered unmitigated encouragement and support to a man pursuing the dreams of a boy: *Candice and our daughters Samantha, Courtney, and Vanessa; and the four-legged members of the Haas clan—Oliver, Elmer, Chloe, Henry, Spencer, and Cooper.*

SPECIAL ACKNOWLEDGMENT TO LISA LYTTON, who executed the combined roles of project editor, illustrations editor, and designer with a blend of commitment, grace, and excellence that left its distinctive mark on this work.

SPECIAL ACKNOWLEDGMENT TO MARIE ARANA, whose introduction accents this portrait of Latin America with a lyrical voice that resonates with beauty and nostalgia for this unique region.

GOVERNMENTAL ACKNOWLEDGMENTS
We wish to gratefully acknowledge the cooperation of the following authorities throughout Latin America: Argentina: Administración de Parques Nacionales (Los Glaciares, Nahuel Huapi, Los Arrayanes, Calilegua, Los Cardones); Belize: Belize Audubon Society, Institute of Archaeology; Brazil: Parque Nacional do Pantanal Matogrossense— IBAMA; Colombia: Ministerio de Medio Ambiente Unidad Administrativa Especial del Sistema de Parques Nacionales Naturales; Costa Rica: Ministerio del Ambiente y Energía, Sistema Nacional de Areas de Conservación— SINAC; Ecuador: Parque Nacional Galápagos; Guatemala: Ministerio de Cultura y Deporte, Consejo Nacional de Areas Protegidas, Instituto Nacional para la protección de Antigua; Mexico: CONACULTURA—Instituto Nacional de Arqueología e Historia, Comisión Nacional de Areas Naturales Protegidas—Reserva de la Biosfera Ría Celestún; Panama: Autoridad Nacional del Ambiente Dirección Nacional de Areas Protegidas y Vida Silvestre; Paraguay: Fundación Moisés Bertoni; Peru: Instituto Nacional de Cultura, Instituto Nacional de Recursos Naturales.

Founded in 1888, the National Geographic Society is one of the largest nonprofit scientific and educational organizations in the world. It reaches more than 285 million people worldwide each month through its official journal, NATIONAL GEOGRAPHIC, and its four other magazines; the National Geographic Channel; television documentaries; radio programs; films; books; videos and DVDs; maps; and interactive media. National Geographic has funded more than 8,000 scientific research projects and supports an education program combating geographic illiteracy.

ISBN 978-1-4262-0132-5 PRINTED IN ITALY
Library of Congress Cataloging-in-Publication Data is available upon request.

Through the Eyes of the Condor
ROBERT B. HAAS
Introduction by Marie Arana

PUBLISHED BY THE NATIONAL GEOGRAPHIC SOCIETY
John M. Fahey, Jr., *President and Chief Executive Officer*
Gilbert M. Grosvenor, *Chairman of the Board*
Nina D. Hoffman, *Executive Vice President; President, Book Publishing Group*

PREPARED BY THE BOOK DIVISION
Kevin Mulroy, *Senior Vice President and Publisher*
Leah Bendavid-Val, *Director of Photography Publishing and Illustrations*
Marianne R. Koszorus, *Director of Design*
Carl Mehler, *Director of Maps*

STAFF FOR THIS BOOK
Lisa Lytton, Paraculture, Inc., *Project Editor, Illustrations Editor, and Designer*
Margo Browning, *Text Editor*
William Christmas III, Gregory Ugiansky, and XNR Productions, *Map Research and Production*
Clayton R. Burneston, *Supervisor, Pre-Press*
Mike Horenstein, *Production Project Manager*
Bronwen Latimer, *In-house Project Coordinator*
Jennifer A. Thornton, *Managing Editor*
Gary Colbert, *Production Director*

MANUFACTURING AND QUALITY MANAGEMENT
Christopher A. Liedel, *Chief Financial Officer*
Phillip L. Schlosser, *Vice President*
John T. Dunn, *Technical Director*

TECHNICAL DATA
Cameras: Canon EOS-1v 35mm SLR (TRIPS 1 AND 2); Canon EOS-1Ds Mark II Digital (TRIPS 3 THROUGH 12)

Lenses: EF 300mm f/2.8L IS USM; EF 70-300mm f/4.5-5.6DO IS USM; EF 70-200mm f/2.8L IS USM; EF 24-70mm f/2.8L USM; and EF 17-35mm f/2.8L USM (all Canon lenses)

FOR MORE INFORMATION, PLEASE CALL
1-800-NGS LINE (647-5463)
OR WRITE TO THE FOLLOWING ADDRESS:

NATIONAL GEOGRAPHIC SOCIETY
1145 17th Street N.W.
Washington, D.C. 20036-4688 U.S.A.

Visit us online at
www.nationalgeographic.com/books

For information about special discounts for bulk purchases, please contact National Geographic Books Special Sales: ngspecsales@ngs.org